UNDERWATER PHOTOGRAPHY

Underwater Photography

Scientific and Engineering Applications

Benthos, Inc.
*North Falmouth
Massachusetts*

Compiled by
Paul Ferris Smith

VNR VAN NOSTRAND REINHOLD COMPANY

Dedication

Harold Edgerton has spent his life inspiring and encouraging others in many ways as well as applying himself to diverse fields of interest. One field in which he has done both is the technology and practice of deep-sea photography. It is, therefore, with utmost admiration (coupled with a thoughtful gratitude to have known him) that we dedicate this volume to him. Many thanks, Doc, for your enthusiasm and your energetic support for this project.

Manufactured in the United States of America.

Published by Van Nostrand Reinhold Company Inc.
135 West 50th Street
New York, New York 10020

Van Nostrand Reinhold Company Limited
Molly Millars Lane
Wokingham, Berkshire RG11 2PY, England

Van Nostrand Reinhold
480 Latrobe Street
Melbourne, Victoria 3000, Australia

Macmillan of Canada
Division of Gage Publishing Limited
164 Commander Boulevard
Agincourt, Ontario MIS 3C7, Canada

15 14 13 12 11 10 9 8 7 6 5 4 3 2 1

Library of Congress Cataloging in Publication Data
Main entry under title:
Underwater photography.
 Based on papers presented at a symposium held at the Woods Hole Oceanographic Institution, April 21-24, 1980.
 Bibliography: p.
 1. Photography, Submarine—Congresses. I. Smith, Paul Ferris. II. Benthos, Inc.
TR800.U514 1984 778.7′3 84-2279
ISBN 0-442-27962-0

Contents

Preface

In 1967 *Deep Sea Photography*, edited by J. B. Hersey of the Woods Hole Oceanographic Institution, was published by the Johns Hopkins Press. Its preface included the statement that "this is a book about the use of photography as a tool for scientific study of the deep sea . . . [It] presents the development of the art of underwater photography at great depths and illustrates its use in several branches of oceanography." Since 1967 there have been significant advances in the use of photography as a tool for scientific study of the deep sea, and this research tool has become an engineering tool as well. The realization of this situation was a stimulus for the symposium that brought together many of the people who, in the ensuing years, had made significant scientific and engineering uses of underwater photography and thus had advanced this art and technology. The papers from that symposium compose the present volume.

There was an additional stimulus for gathering together in that some of the key people whose efforts were reported in 1967 were now beginning to retire and move away from the field. This then was also the time to close, as it were, the loop on their more recent contributions. One of these people is the editor of that first volume, J. B. Hersey, who opened the present symposium with his report on historic perspectives. Another is Dr. Harold Edgerton, who, with his invention of the strobe light and his innovative work in underwater photography, is regarded by many as the father of modern deep-sea underwater photographic technology. This recognition was made clear throughout the symposium by the number of people who referred to the important contributions he had made to the successes of their own efforts.

The organization of the symposium and this volume evolved around several aspects of underwater photography as they are currently being practiced. These include towed photographic systems; *in situ* systems; photography from submersibles; survey techniques; stereo photography and photogrammetry; films and processing; and special applications, new techniques, and systems.

One measure of the changes that have taken place since 1967 is the variety of institutions with which today's users are associated. In earlier years, deep-sea underwater photography seemed to be the almost exclusive domain of the Woods Hole Oceanographic Institution, the Lamont Geological Observatory, and the Massachusetts Institute of Technology. Now, in addition to the continued prominent role played by these laboratories, research organizations such as the Bedford Institute of Oceanography, Dartmouth, Nova Scotia; the French Centre National pour l'Exploitation des Oceans (CNEXO); the University of Hamburg, Germany; the National

Geographic Society; and the Saint Andrews Biological Station, New Brunswick, Canada, are active in the field as well as private industries such as InterSub, C. E. McGuire, Interstate Electronics Corp, and Benthos, Inc., the sponsor of this symposium.

ACKNOWLEDGMENTS

Without the support of Benthos, Inc., the symposium would never have been held. However, a symposium involves many people and many details—titles and abstracts, rooms and receptions, invitations and transportation—all requiring organization and communication that were ably handled by Kristianne Graham before and during the symposium, as those who participated know well and appreciate. The success of a symposium ultimately rests upon those who participate and contribute, and in this we are most fortunate. Since Hersey's book was the model for this event, we were particularly fortunate to have him open the meetings with his thorough review of the history of deep-sea underwater photography. Similarly, we were most fortunate to have Doc Edgerton, who is viewed by many as the father of deep-sea photography. Not only did he contribute one of his delightful lectures, but he also presented a paper on his most recent under-sea photography development. And finally we acknowledge all the participants. They came from ten foreign countries as well as from many parts of the United States and presented reports on their work covering almost every aspect of deep-sea photography.

Of course, long after the excitement of the event come the time-consuming details of publishing the proceedings. Having decided to publish a volume appropriate in quality to the subject increased the complexity of this phase because, among other things, high quality black-and-white glossies were needed for the illustrations. Consequently, in many instances authors who had used color slides had to be approached for reprints. It also meant transcribing, editing and, where necessary, obtaining permission to reprint. Kate Eldred of Marine Science International has guided us through all of these activities with utmost patience and care, for which we are extremely grateful. It was an education and we trust the end product merits your approval as you read this volume, whether you are a contributor or part of the audience.

PAUL FERRIS SMITH

Section I

Invited Papers

Historic Perspectives

J. B. Hersey
Science Applications, Inc.
McLean, Virginia

Photography in oceans, lakes, rivers, ponds, and even the MIT swimming pool is a very broad and difficult subject to put in perspective in a short paper. I shall therefore emphasize photography of the deep sea, but skip lightly over photography by free-swimming divers. I do this knowing full well that the latter group greatly outnumbers the deep-sea photographers.

First I shall give a brief summary of events from 1890 until now, tracing the development of purpose and achievement through the work of individuals. Then I shall return more or less to square one and dwell on some details. The earliest experiments in underwater photography were conducted during the 1890s by the French biologist Boutan. His work was reported at least in two journal articles, one published in 1893 and the other in 1898, and in a 332-page book published in 1900. (I have been unable to see these reports and thus can tell you only that he appears to have photographed animals in shallow water.) There are a few scattered reports of underwater photography in the first thirty years of the twentieth century. Principally, scientists wished to study animals of the ocean. During the mid-1930s, William Beebe tried to use a hand-held camera to photograph the wondrous creatures of the deep that he observed from his bathysphere at depths of up to 2500 feet in the water off Bermuda. This attempt was not successful. E. Newton Harvey, using a repeating camera suspended from a ship, took several thousand exposures in deep water without recording a

single image of any sort. Then Maurice Ewing, following his consuming interest in the seafloor, lowered a camera designed to make a single exposure when its mounting contacted the bottom. The mounting was a pole suspended from the hydrographic wire of *Atlantis* and so designed that the sea bottom would be well within the depth of focus of the camera when first contact was made. The opportunities for failure were legion, and for several years good clear pictures were regarded individually as cherished prizes. Several of these showed sand ripples on the bottom in deep water—a tell-tale sign of water currents where it was widely believed at that time, there were none.

With persistence and intelligent response to the demands of the sea the users of this camera and its descendants have taken many thousands of excellent bottom photographs showing more sand ripples and other evidence of erosion, and, of course, fish. It was an exciting start. During World War II, John Ewing and Rusty Tirey identified many wrecks and some sunken German submarines to ease the load on the antisubmarine forces of the Navy patrolling the continental shelf off the east coast of the United States. It was during this period that the number of successful bottom photographs jumped from tens to thousands. It was also during this period that Harold Edgerton first had an influence on underwater photography, and the strobe flash became an essential part of remote camera system design. Robot cameras were employed as well so that in principle, at least, several exposures could be made on a single lowering of the camera. Nevertheless, these cameras turned out to be in serious need of further development and often didn't work. Hence most of John Ewing and Rusty Tirey's thousands of pictures were made one to a lowering.

Maurice Ewing maintained an intense and active interest in camera system design and the results of underwater photography expeditions for the rest of his life. Many developments that steadily improved the wartime camera were carried out by Ewing and his colleague, Ed Thorndike. Ed's continued interest and contributions are well known to the community of deep-sea photographers.

With the war's end in 1945, several scientists were impressed by the potential of deep-sea photography, mainly as a geological tool. Harold Edgerton, impelled largely I suspect by his unquenchable enthusiasm for high-speed photography in all of its forms, helped many engineers and scientists get a good start with cameras and strobe lights.

In the early postwar years at Woods Hole, Dave Owen, who was one of my first shipmates on *Atlantis* in 1946, developed a strong and deep enthusiasm for deep-sea photography, and has made countless contributions since he first took deep-sea pictures during *Atlantis* cruise 151 to the Mediterranean Sea in 1951.

In the fifties, Edgerton and Cousteau experimented with many camera

mountings on submersibles, suspended on cables, and mounted on sleds. They first used the sonar pinger to observe the height of the camera above the bottom. At the Woods Hole Oceanographic Institution, we modified the Edgerton pinger by substituting an accurate electronic clock for its timing device. This modification enabled us to keep a detailed sonic record of each camera lowering. Its success also inspired us to apply the pinger to dredging the bottom and collecting piston cores. Several familiar names are associated with these early developments: Willard Dow, Syd Knott, Warren Witzel, Sam Raymond, Gary Hayward, and others. Each had much to do with the early development in Woods Hole of cameras and pinger applications.

Since that time, deep-sea cameras have been developed in many ocean science laboratories all over the world. An early one was developed by Tony Laughton, of the National Institute of Oceanography in England. Buck Buchanan and others at the Naval Research Laboratory were developing their own adaptation of the Edgerton camera in 1963, when the U.S. submarine *Thresher* went down with all hands. This disaster greatly speeded the completion of their development and a year later they and their camera found *Thresher*. I believe the *Thresher* search also marked a significant increase in the use of cameras in the deep sea. It was scarcely noticed at the time, but during the *Thresher* search well over two hundred thousand bottom photographs were produced. Today about half a million clear, high-quality, deep-sea photos are taken each year. These pictures are used in science mainly to explore the ocean floor.

The oil industry is making increasingly wide use of underwater photography, but largely in shallow water. Naval engineers frequently use underwater photography for surveying the sites of underwater cables, for inspecting munitions disposal areas, and for selection and survey of sites for a variety of undersea installations. The Navy maintains a photographic capability to make a prompt response for rescue, search, or salvage in the event of disaster at sea.

In broad outline, the capability just described is what is readily available today. There are several experienced manufacturers of camera systems, and there are many scientists who make effective use of deep-sea and other underwater cameras. Photographic techniques are familiar to ocean engineers of many specialties. The use of submersibles has permitted very sophisticated use of combinations of human observation, television, and photography.

Now I should like to go back and look at some aspects of the ocean and photography that have been and still are challenges. The clarity of ocean water has always been of prime importance to the undersea photographer. The pioneers of our field paid much attention to water clarity. A great deal of their work was done in shallow water where turbidity is high and highly

variable. John Ewing and Rusty Tirey in their war-time work paid much attention to the Secchi Disc readings they took from the old *Asterias*. John tells me that these readings were especially hard to come by in rough weather so they installed a viewing port in *Asterias'* hull—where I understand it still is. Dick Colburn recently reported it to be in good condition.

Sediment particles in suspension are frequently perceptible in deep-sea photographs; in stereo pairs they may make a very striking display. The concentration of suspended matter in sea water is critical to good photography; it may spoil the show altogether. But it is also an important indicator of processes at work in the benthic boundary layer. It is a tell-tale manifestation of near-bottom currents. Ten years ago, impressions were being formed about the detailed distribution of water clarity and its relationship to processes of the deep ocean, but I am not familiar with the findings of the past ten years.

Another important aspect of the world of underwater photography is the unbelievably beautiful world of animals of the reefs, of the deep, and of the pelagic regions of the ocean. The shallow depths available to divers have been so handsomely exploited by Jacques Cousteau and a host of others that I have no useful comment about their work—I just look forward to the next opportunity to enjoy more of it. Years ago I was much impressed by some spectacular motion pictures of commercial fishing done by a Scottish fisheries organization.

The photographing of planktonic and nektonic animals of the open ocean constituted a stiff challenge for several of us many years ago. Dick Backus and I, with help from such people as Dave Owen, Tom Gifft, and others, tried to capture individuals of the deep scattering layers in photographs. The E. Newton Harvey experiment was merely repeated in the early stages of this work. Later we learned how to repeat it again, but this time electronically and automatically. After several frustrating years of poor photographs—if any—of unrecognizable fish, Dick finally succeeded in a sort of blaze of glory by driving *Alvin* into a dense throng of scatterers, and then suddenly turning on the floods and blazing away with the cameras. The result was gorgeous photographs of more myctophids than anyone has seen before or since. He successfully repeated this experiment several times. At about the same time, John Isaacs at Scripps reasoned that if one wanted to photograph fish, one had to offer more inducement than a camera or a strobe flash. He thought that food within the focal volume would help, and it did, in a most spectacular way. Some of his pictures focused on animals so large that they more than filled the field of view and we still don't know who they were. However, despite the well-recognized difficulties of getting scientifically useful animal pictures, we now know that it can be done.

The LIBEC of the Naval Research Laboratory, Deep Tow of Scripps, and ANGUS (Acoustically-Navigated Geological Undersea Surveyor) of Woods Hole, have been used extensively in many well-known ocean explorations. There are other recently developed camera systems of similar capability, such as Teleprobe of the U.S. Naval Oceanographic Office. Each can be used in a mode to photograph the ocean floor from a distance roughly 20 or more meters above the bottom. Handling techniques readily permit overlapping coverage, from which several uninterrupted profiles many miles long have been made. So far as I am aware, the first of these surveys was made with LIBEC by Buck Buchanan and his team from the Naval Research Laboratory as a preliminary to the FAMOUS (French-American Mid-Oceanic Undersea Study) project. Surveys of this sort have been repeated with both ANGUS and Deep Tow. All depend critically on spectacular improvements in the art of navigation, both surface and undersea, that go quite beyond the arts of deep-sea photography.

The procedures and techniques of these surveys is a most exciting modern saga. The first step is to develop detailed topography of the scene to be studied. This has usually been done either with the multibeam echo sounder of the Naval Oceanographic Office or with the French system. The next step is to develop detailed knowledge of the ocean floor from a survey by a towed camera that is itself navigated acoustically to an accuracy of 10 to 20 meters. Armed with photographic knowledge, the camera survey can be further refined until there is sufficient information to plan dives by submersibles that can inspect, sample, and further record details of the geologic or ecologic scene. This is a dramatic development, drawing together diverse talents from photography, underwater acoustics, and satellite navigation. A tremendous recent improvement is the use of digital photography, which has been successfully added to these procedures.

Thus far these surveys have been done in relatively familiar territory. The multibeam sounder essentially provided detail in an area that was already well surveyed. How efficiently could these methods be applied where sounding lines average 20 miles or more apart, or worse still in a region that is known from but a single sounding track over hundreds of miles of ocean? Probably many significant enterprises in the future would be long delayed or would founder on the expense of the preliminary surveys. It is just possible that this obstacle will be overcome in the near future because of a most exciting development in acoustic surveying, in part a follow-on to side-scan sonar. A group at the Naval Research Laboratory has recently reported on successful charting of principal topographic features in a circular area 1000 miles across, generally east of New Zealand. This work was done by one ship towing an acoustic array similar to a typical seismic profiling array, and detonating a series of 50-pound high-explosive charges at 2- to 4-hour intervals for no more than a few days. This

style of side-scan sonar might be useful as the first step in ocean geologic surveys of little-known areas—it might work wonders on a triple junction.

In preparing this paper, I wondered about the impact of the wonderful things we are doing with undersea photography on the rest of the world. In ocean science, we talk or write mostly to each other and the outside world scarcely knows of us. In ocean photography, the entire civilized world knows of us through Jacques Cousteau, and I appreciate what he does in this way. But his is largely a world of motion photography and divers and hand-held cameras. What of the rest of us, and of our gradually developing knowledge of the ocean through acoustics and photography? Public consciousness comes through books, encyclopedias, some public appearances, and the media. The occasional short press notice or one-of-a-kind television program probably has little lasting impact. How many people know of or can recall the three-issue spread in *LIFE* magazine on oceanography?

I decided to make a brief study of the possible public impact of our published books. In this case I chose *Deep-Sea Photography, Face of the Deep, and Photographic Atlas of the Mid-Atlantic Ridge Rift*. I queried a computer program that assisted about 2200 libraries in their inter-library loans. Of these, 32% were university libraries, 30% colleges, 20% public libraries, and 18% other types such as large industries or government offices. I asked who held which books. Results varied in detail, but grossly 10% of the libraries held all three. Among the 10%, universities dominated, colleges were second, public libraries third, and other libraries fourth. I decided that the interest of at least 220 librarians was strong enough to buy the books; universities might feel they ought to have them, colleges tagged along, and the remaining samples were too small to be significant, except possibly of small interest. I'm sorry that I could not design a satisfactory normalizing factor, but there it is. Let's face it. We remain a happily obscure group well headed toward conquering at least one aspect of 70% of the Earth's surface.

Time-Lapse Photography

Harold E. Edgerton

Massachusetts Institute of Technology
Cambridge, Massachusetts

I am often asked "Why is electronic flash so important under water?" This question is asked by those who know that ultrafast flashes can effectively stop the images of bullets and other fast-moving subjects. Nothing in the sea moves anywhere near as fast as a bullet, so fast exposure time is not the reason. Efficiency of the electronic flash system is the answer. A small battery has enough energy to expose thousands of photographs. This is important since all the equipment must be transported to the bottom of the sea and should be made as small as possible.

Many years ago, the late E. Newton Harvey asked me to help him take photographs of deep-sea fishes to illustrate a book that he was writing. I prepared a collection of circuit components on a breadboard, leaving it up to him to compress the assembly into a watertight container. When I saw him the following summer, I eagerly asked him for a look at the pictures. It was a disappointment when he told me that he had had some technical problems and only one image came out, but he was quite certain that it was only a finger print! From that time on, I became involved with many others who wished to do photography in the sea.

Our first underwater camera/strobes at M.I.T. were designed for 800 exposures during a single lowering. There are still a number of these camera/strobes around, and a few permanently on the ocean's bottom.

It was David Owen and Lloyd Hoadley (of Woods Hole Oceanographic

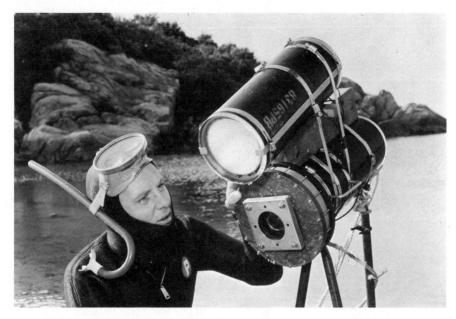

Figure 1. Sixteen-millimeter elapsed-time camera with strobe.

Institution) who first brought to my attention the use of elapsed-time photography for the study of sediments. The first pictures were on double-frame 35 mm film, so there was a problem getting them projected. We designed the dry-battery-operated strobe system for this effort at M.I.T.

An elapsed-time underwater system, with a 16-mm camera, was made with support from a National Geographic Society research grant (see Figure 1). I asked for enough funds to make three camera systems*—one to use, one for spare parts, and one to lose. These were built at the M.I.T. Stroboscopic Light Laboratory by Bill MacRoberts and others. The first camera is now resting on the bottom of Hudson Canyon after being loaned to Gilbert Rowe of WHOI. The second did work for the late Kenneth R.H. Read of Boston University and me. It is now on loan to Kjell Sandved of the Smithsonian Institution. He is studying the coral reef ecosystem at Carry Bow Key, Belize, British Honduras. The third camera was not needed for spare parts, so I loaned it to Robert Rines (Rines et al., 1976) some nine years ago for immersion in Loch Ness. Maybe I will get it back one of these days. At the moment, it is being overhauled for another go in the Loch in the summer of 1980. Details of these devices and their circuits are given in Edgerton et al. 1973.

We found that regulation of the voltage on the strobe lamp was very

* Based on a Flight Research Company Model 111B 16-mm motion picture camera.

important since the dry-battery power supply shows a rather large loss of voltage from start to finish. Without regulation, the exposure fades away so the end frames are very dim. Regulation for this unit was accomplished by a Zener regulator-controlled relay in the charging circuit. Once the capacitor was charged, the relay opened to hold the charge on the capacitor.

Dr. George Keller (formerly of NOAA, Miami and now at Oregon State University) asked us to build a deep-sea elapsed-time camera unit. He wanted a long time between pictures, much longer than the 20 seconds of our first attempts. He kept pressing for longer and longer times—30, 60, 180, seconds and so on. Finally I said, "Let's quit compromising. Let's design a system with a 1000-year interval!" This brought the discussion to a prompt termination. An interval of about one minute was selected for the task.

We built a system that operated in the range of 65-85 seconds for the entire 2000 photographs on a 50-foot reel of 16-mm film. This camera operated for more than 24 hours to expose a 50-foot reel (about 1.5 days). A report of this effort has been published (Keller and Shepard, 1978). I showed one of Keller's films at the Benthos Symposium, using a special L/W projector for studying this type of film in a frame-by-frame mode. The area studied was the continental shelf at 237 fathoms, slope station 37°16.22N and 74°28.36W.

Red crabs were present in all four films taken by Dr. Keller. The record referred to in the previous paragraph had many interesting biological specimens, which need to be studied by experts in life at the sea bottom.

At the conclusion of this paper, a reel of 16-mm color motion pictures was shown. In it appeared sand dollars, sea urchins, starfish, crabs, lobsters, and other active sea creatures. The film was exposed at shallow depths in Hodgkins Cove, Gloucester, Massachusetts by Ken Read (Edgerton *et al.*, 1973).

REFERENCES

1. Rines, R. H., C. W. Wyckoff, H. E. Edgerton, and M. Klein. 1976. Search for the Loch Ness monster. *Technology Review*, March/April, 25-40.
2. Keller, G. H. and F. P. Shepard. 1978. "Currents and sedimentary processes in submarine canyons off the northeast United States." Chap. 2 in *Sedimentation in submarine canyons, fans, and trenches*, ed. D. J. Stanley and G. Kelling. Stroudsburg, Pa.: Dowden, Hutchinson & Ross.
3. Edgerton, H. E., V. E. MacRoberts, and K. R. H. Read. 1973. An elapsed-time photographic system for underwater use. In *Nat'l. Geo. Soc. Res. Reports, 1966 Projects*, 79-87. Washington, D. C.: National Geographic Society.

Mapping the Mid-Ocean Ridge

Robert D. Ballard

Woods Hole Oceanographic Institution
Woods Hole, Massachusetts

INTRODUCTION

The first major contribution to the mapping of the Mid-Ocean Ridge occurred in 1854 when M. F. Maury (1855) published a topographic chart of the North Atlantic Ocean based upon cannonball soundings. That chart revealed for the first time an extensive ridge running down its central axis known then as Telegraph Plateau. In 1912, Sir John Murray published a more detailed chart of the Atlantic as well as the Indian and Pacific Oceans based upon additional wire soundings (Murray and Hjort 1912). That chart revealed the presence of similar ridges in all three oceans. The next significant contribution came with the German Meteor Expedition from 1925 to 1933 when single acoustic soundings were first made. The resulting chart by Maurer and Stocks (1933) added considerable detail to the Mid-Atlantic Ridge, showing it to be a continuous feature. The final step in the recognition of the Mid-Ocean Ridge for its world-wide dimen-

© Copyright 1980 Offshore Technology Conference
This paper was presented at the First International Symposium on the Scientific and Engineering Applications of Underwater Photography at Woods Hole, Massachusetts, April 21-24, 1980, and at the 12th Annual OTC in Houston, Texas, May 5-8, 1980. The material is subject to correction by the author. Permission to copy is restricted to an abstract of not more than 300 words.

sions came not from soundings but from seismicity. Work by Rudolph (1887), Tams (1931), Rothé (1954), and finally Gutenberg and Richter (1954) showed that the narrow oceanic belt of shallow seismic events could be correlated to the Mid-Atlantic Ridge. With that insight, Heezen and others (Heezen *et al.* 1959; Heezen 1960) used their extensive inventory of echo-sounding profiles to propose the existence of a global mountain range 70,000 kilometers in length, making it the largest geologic feature on the surface of the earth.

From 1960 to 1980, a tremendous amount of new information was obtained about this feature and its relationship to the evolving concepts of global tectonics. Paralleling this scientific exploration has been a continuous development in deep-water mapping techniques. The most intensive utilization of these new techniques occurred as a part of Project FAMOUS in the early 1970s. This science program sought to relate small-scale observations made from manned submersibles to the large-scale problems of plate tectonics. As a result, a series of investigative tools was employed to obtain a continuous spectrum of measurements that could span this great range of scales.

At the upper end of the spectrum was a need for a regional reconnaissance of the Ridge's tectonic fabric. This was accomplished using the U.S. Navy's multi-narrow-beam sonar SASS (Phillips and Fleming 1977) and England's large-area side-scan sonar GLORIA (Laughton and Rusby 1975). With these systems, scientists were able to obtain a broad structural picture of the Mid-Atlantic Ridge centered about 36° N and covering over 100,000 sq km. Segments of the rift valley and adjacent transform faults were then selected for additional investigation. Since the SASS data base is collected in a digital format on magnetic tape, these selected areas could be enlarged and redrawn at a finer contour interval. In addition, a single narrow-beam sonar system was used by the French to map a portion of the inner rift valley using bottom acoustic transponders for precise navigation (Renard *et al.* 1975). The Deep Tow system (Macdonald *et al.*1975) was used to obtain detailed topographic and magnetic profiles across the rift valley, the flanking crestal range, and the adjacent transform faults.

The next step in this investigation involved the use of photographic techniques as the study moved into the visual spectrum of scales. Initially, the Navy's LIBEC system (Brundage and Cherkis 1975) was deployed to obtain a series of large-area photographs in the proposed study areas. Then a new unmanned photography system, ANGUS, was used (Phillips *et al.* 1979) to obtain a series of photographic profiles across the rift valley and transform faults, including the microtopography along the track.

The final phase in the mapping program involved the use of manned submersibles. This began with a series of seven exploratory dives by the bathyscaph *Archimede* during the summer of 1973 (Bellaiche *et al.* 1974),

followed by a coordinated diving effort in 1974, again using the *Archimede* as well as the submersibles *Alvin* and *Cyana* (Ballard and van Andel 1977a; ARCYANA 1975).

Since Project FAMOUS, a series of investigations has been carried out in other segments of the Mid-Ocean Ridge and associated rifts. Although several of the mapping systems previously mentioned were used during these subsequent efforts, it was not possible for economical reasons to repeat such an intense technological program. As a result, a more cost-effective mapping effort was employed that utilized three of these systems in a fully integrated manner. They included the multi-narrow-beam sonar, the ANGUS photography system, and the submersible (*Alvin, Cyana,* and the bathyscaph *Trieste II*).

The principal studies that have been conducted since Project FAMOUS, which have used this integrated approach, are the Cayman Trough program in 1976 and 1977 (CAYTROUGH 1979), the Galapagos Rift studies in 1977 and 1979 (Corliss *et al.* 1979; van Andel and Ballard 1979; Crane and Ballard 1980a; Ballard, Holcomb, and van Andel 1979; Ballard, Holcomb, and van Andel 1980), a return to the Mid-Atlantic Ridge in 1978 (Ballard *et al.* 1978; Crane and Ballard 1980b), and the East Pacific Rise Program at 21° N (Rise Study Group 1980).

Although the scientific results of those programs are well documented, the integrated mapping approach used to collect that unique data base is not. The purpose of this paper is to accomplish that task so that the scientific and technical communities can better evaluate the conclusions that have been drawn from them.

CONSTRUCTION OF THE TOPOGRAPHIC BASE MAPS

A good topographic map forms the basis for all geological field mapping efforts on land. On such maps field geologists plot their observations and outcrop locations. The morphologic and structural features of the map are then used to extrapolate their observations over a larger area to produce a regional framework upon which they base their interpretations. The quadrangle map, the most commonly used topographic map, has a scale of 1:24,000 and contour interval of 20 feet or more.

Historically, the construction of bathymetric charts in the deep sea (the crude marine equivalent of a topographic map) has utilized a wide-angle echo sounding sonar transducer that is hull mounted, typically having a 30-degree cone angle, and operated at 12 kHz. Because of this wide angle, coupled with the pitch and roll of the ship, the resulting echogram was unable to resolve the complex topography of the Mid-Ocean Ridge, provid-

ing only a highly smoothed profile of interlocking hyperbolas. In addition, typical surveys in the past involved widely-spaced tracklines run in a grid pattern in which only a small percentage of the study area was actually insonified.

In the 1960s, the U.S. Navy and private industry developed a highly advanced multi-narrow-beam sonar for making detailed topographic charts of the deep sea. Since that time, other similar systems have been developed that have between 10 and 30 times the resolving power of standard oceanographic echo sounders. Although these systems have their own unique characteristics, they all operate on the same basic principles. This type of sonar consists of a T-shaped, hull-mounted array of projectors and hydrophones (Figure 1a). The array of projectors emits a narrow fan-shaped signal, which spreads out normal to the direction of ship motion (Figure 1b). The reflected acoustical energy is then received by a second array of hydrophones mounted perpendicular to the first. Various techniques are used to stabilize the projector array vertically (Figure 1c). At the time the reflected signals are received, the central beam relative to the ship's roll is selected. In some systems, the ship can experience up to 15 degrees of roll without loss of data.

Prior to conducting a survey, it is wise to determine the sound velocity gradient in various portions of the study area. With this information or its assumed equivalent, ray-bending calculations are made to correct the individual signals received by the hydrophones. A computer takes these individual digitized input signals and calculates their depth. A signal output pulse therefore results in a profile of 20 to 60 points, depending on the system used, the roll of the ship, and the signal-to-noise ratio. With a pulse rate of 10 seconds and a ship speed of 12 knots, the seafloor is insonified once every 60 meters along the ship's track (Phillips and Fleming 1978).

This profile of points is then merged with the ship's navigational data, which varies among the systems. The most accurate, and the one used most in the previously mentioned study, utilizes an MK 3 SINS Inertial Navigation System updated by satellite and Loran C navigational data. The result is a real-time printout of a contoured strip of topographic data (Figure 1d). The scale and contour interval is a matter of choice and a function of the computer plotting hardware aboard ship. Typically, a working scale of 1:136,000 and contour interval of 50 meters were used.

A survey is begun by making one or more diagonal lines across the study area. These crossings serve as tie lines as the mapping proceeds. Once a traverse line has been completed, the computer-contoured strip or topographic swath is removed from the plotter and placed beneath a mylar sheet that shows the latitude and longitude of the area, determined by the selected scale and projection. Drawn on it is the inertially navigated shiptrack annotated every few minutes. The cartographer then adjusts the

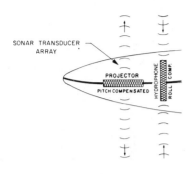

(a) "T" shaped hull-mounted configuration of projector and hydrophone arrays.

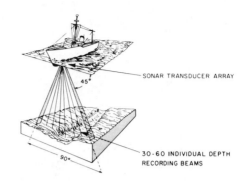

(b) Geometry of fan-shaped signal transmitted by projector array.

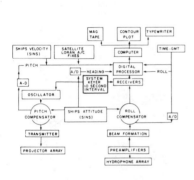

(c) Flowchart showing sonar signal and ship's altitude-navigation information processing technique.

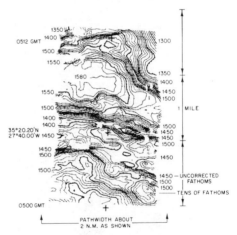

(d) Typical contour strip chart or swath drawn in real-time by computer-driven drum plotted aboard ship. The ticks on the bathymetric contours point upslope (after Phillips and Fleming 1978).

Figure 1. The multi-narrow-beam sonar system.

strip to the navigated track, aligning the shiptrack with the center beam annotated on the strip. He then traces that strip onto the mylar compilation sheet. With the tie lines completed, the ship then begins a series of east-west or north-south lines across the survey area. As before, these lines are then transferred to the compilation sheet at the end of each traverse. A mosaic of completed lines slowly takes shape, with the width of

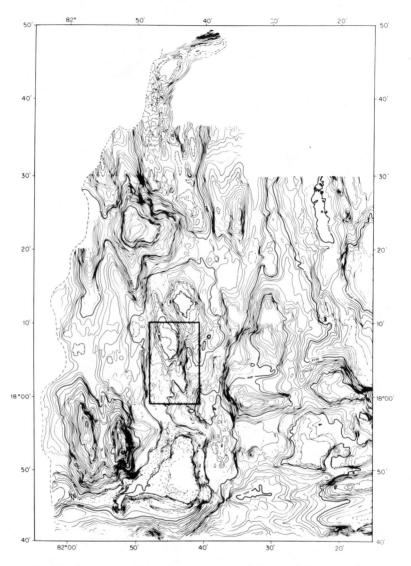

Figure 2a. Final topographic map generated by multi-narrow-beam survey in the Cayman Trough. The map made aboard ship was at 1:136,000 with a contour interval of 50 fms. Square in the center is region which was rerun at a smaller scale and finer contour interval, is shown in Figure 2b.

each strip varying along track as a function of water depth. By interlacing subsequent lines, it is possible to insonify the total area, leading to a topographic chart having little cartographic interpretation (Figure 2a).

One of the most valuable characteristics of the multi-narrow-beam sonar

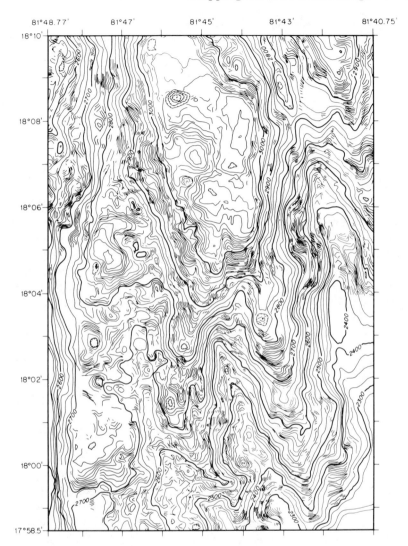

Figure 2b. An example of a selected area that has been rerun at a scale of 1:8,000 and contour interval of 5 fms.

systems is that the topographic data is all stored on magnetic tape. It is therefore possible to take any portion of the survey area and replay it at a finer scale and contour interval (Figure 2b). In our studies of the Mid-Ocean Ridge, it was common to run lines 50 kilometers either side of the rift valley axis. This provided us with the regional tectonic or structural setting. Based upon a morphologic and structural analysis of this chart (1:136,000), smaller areas were selected for follow-up investigations. After those selections were made, the appropriate tapes were rerun ashore at

1:36,000 (25-meter contour) and smaller areas at 1:8,000 (5-meter contour). These finer scale charts of the rift valley provided a tremendous amount of information about its volcanic and tectonic features even before additional work was conducted. The latter chart (1:8,000) formed the base map for our subsequent investigations and in large part insured the success of our recent cruises to the Mid-Ocean Ridge.

CONSTRUCTION OF GEOLOGIC PROFILES AND MAPS

As is the case with field mapping programs on land, it is impossible to visit and sample the total study area along a given segment of the Mid-Ocean Ridge. For that reason, a mapping strategy must be developed that is based on a series of traverses across the study area from which a regional geologic map can be constructed. Initially, a traverse spacing of one kilometer was used, running perpendicular to the strike (or isochrons) of the rift valley. In the Project FAMOUS program, these traverses were conducted by the submersible *Alvin*. This approach had four major drawbacks that led to the adoption of a new mapping procedure. One kilometer proved to be too wide a spacing, making it difficult and frequently impossible to map geologic features from one traverse to those on either side. Second, the submersible proved to be very inefficient at this task, covering only 1 to 2 kilometers per dive and averaging one dive every 1 to 2 days. As the submersible traversed the valley, the quality of the observational information was excellent when the submersible rose up a feature but was extremely poor as it descended down the other side, frequently losing visual contact. Although photographs were taken every 10 seconds during the traverse, they were at an oblique angle, making the mapping of features difficult; they covered a small area; and during the downward traverse of features, the bottom was frequently not photographed. This placed a heavy emphasis upon visual observations made by the divers, observations that could not be verified independently after the dive was completed.

For those and other reasons, the initial geologic traverses of the study area, or the "ground-truthing" of the topographic maps, was no longer done by the submersible but instead was done by the unmanned camera survey system ANGUS. Although ANGUS was used in Project FAMOUS and the Cayman Trough studies, it wasn't until the 1977 Galapagos Rift program that all three systems (multi-narrow-beam, ANGUS, and *Alvin)* were truly integrated.

For the Galapagos Rift Study, a segment of the rift valley from 86°06' to 86°11'W (centered at 0°47.5'N) was chosen for intense investigation. A

series of charts at 1:8,000 (2-meter contour interval) was constructed prior to the ANGUS field effort.

BASIC ANGUS CONFIGURATION

The ANGUS system presently consists of five principal subsystems (Figures 3 and 4). The fish or sled is towed from the surface by a conventional trawl wire/winch configuration found on most oceanographic

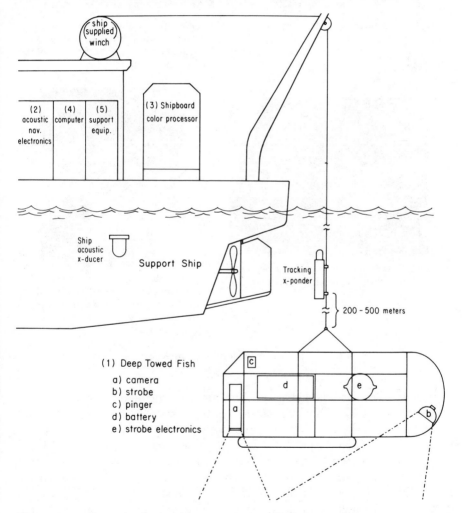

Figure 3. ANGUS shipboard system: (1) towed sled, (2) ACNAV system, (3) E-6 auto processor, (4) computer, (5) support equipment.

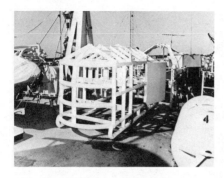

(a) Steel frame of sled without sub-systems mounted.

(b) Interior of photo processing van with the auto-processor on the right, refrigerator for film storage in center, and sink on left.

(c) Inventory of acoustical transponders and transponder test deck unit.

(d) Graphic recorders used by sled operator to monitor sled's altitude. Cal-Comp plotter on shelf above is used during post-lowering data processing.

Figure 4. ANGUS equipment.

vessels. The sled is just over four meters long and is constructed of heavy-duty 7.5-cm diameter steel pipe. It houses a 35-mm camera having a 16-mm wide-angle lens and a 400-foot reel of E-6 color film capable of taking 3,000 frames per lowering. Additional cameras having a 100-foot film capacity and 35-mm lens are sometimes added to provide close-up pictures along the traverse. Two 750 watt-second strobes mounted four meters from the camera and 0.5 meters above the horizontal plane provide a 1500 watt-second flash at an average repetition rate of 20 seconds. Energy for the strobes is supplied by five 6-volt lead-acid batteries immersed

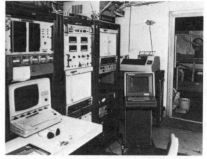

(e) Navigator's control center including HP-2100, ACNAV deck unit.

(f) Infoton to the left, x-y plotters in center, and Tektronic on right with hard copier above it.

Figure 4. *Continued*

in an oil bath, permitting them to function at ambient pressures. This 30-volt power supply is used to charge a large capacitor bank contained within a 17-inch glass sphere. A pinger consisting of a 12-kHz transducer provides both direct and seafloor-reflected signals. These signals are displayed on the surface ship, providing altitude control for the operator. The sled is normally flown at an optimum altitude of 10 to 12 meters, resulting in a total photographic coverage between 100 and 250 square meters. Towed at a speed of 0.5 to 1.0 knots and fired every 20 seconds, the camera can take a continuous overlapping series of pictures. The sled also contains an additional 12-kHz pinger connected to a thermistor that telemeters to the surface the ambient water temperature around the sled.

After the sled is lowered into the water, an acoustical relay transponder is mounted on the wire above the sled. The distance between sled and relay is a function of the water depth and the amplitude of the topography, normally ranging between 100 and 300 meters. Fortunately, the weight of the sled (10,582 kg) and the slow tow speed result in no appreciable horizontal separation between sled and relay. An acoustical transponder navigation system (ACNAV) is used to track the ANGUS sled. This system consists of a series of bottom transponders typically buoyed above the seafloor by glass ball floats to a height of 100 to 200 meters. The network of transponders varies in size from 2 to 10 transponders with an average baseline spacing of 1.5 the water depth. A towed "polywog" housing a transceiver is used to interrogate the network and receive replies as well as to receive the direct signal from the relay. The depth at which the transceiver is towed varies as a function of ship noise, normally it is 30 meters. The transceiver and associated electronics in the deck unit provide

the computer with the acoustic travel time information as the ship and sled are maneuvered within the transponder network.

The computer currently used by ANGUS is an HP-2100 single user/single operation computer. The primary functions performed by the computer involve the setting and surveying of the transponder network; real-time navigation of the camera traverses during which microtopographic and temperature profiles are made; providing additional tracking services for a wide variety of other on-station programs (coring, dredging, heat flow, etc.); the installation of bottom setting instrument systems; and post-station data processing of both ANGUS and *Alvin* traverses.

Once an ANGUS camera traverse has been completed and the sled recovered, the E-6 color film is unloaded and taken to an onboard film processing facility where an auto-processor develops the 3,000 frames of color positive film in three hours. This rapid processing provides the scientist with the opportunity for immediate study of the results of the lowering and provides the system engineers with a chance to check the system's performance.

The ANGUS system also includes a variety of support equipment in the main laboratory, including an inventory of 3.5-kHz and 12.0-kHz echo sounders and recorders, intercom systems, and navigation and sled support equipment.

OPERATING PROCEDURE

Satellite navigation is used to direct the ship to the selected operating area. At some point during its transit to the study area, the ship will enter the multi-narrow-beam data base. The ship's wide-beam 12-kHz echo sounder is then turned on to record a topographic profile of the seafloor along the ship's track. The satellite fixes are then used as a first-order estimate of the ship's position. They are then plotted on the Navy multi-narrow-beam chart. The topographic profile along this estimated trackline is then compared to the profile measured from the ship and a best fit is made, providing a second-order estimate. The ship's course and speed are held as steady as possible during this period to minimize the dead-reckoning error between satellite fixes.

Since all of the study programs have been carried out in the rift valley of the Mid-Ocean Ridge, its unique topographic features are used during this phase of the study program. At some point the ship will cross one of the inward-facing fault scarps that border the inner rift on either side of the valley. Having acquired that wall, the ship reverses course and deploys one of the acoustic transponders. The remainder of the network is installed on high points within the area to provide good acoustical paths

to ANGUS and the ship. Once the installation is completed, the net is surveyed and the precise geometry of the net is determined. During the survey, echo-sounding profiles are collected from which a first-order estimate of the network's position relative to the multi-narrow-beam sonar base map is made and the ANGUS mapping program can begin.

A copy of the 1:8,000 base map is mounted on an x-y plotter tied to the ACNAV computer. Drawn on this map is the desired ANGUS coverage. The typical line spacing is 200 to 400 meters with the lines running slightly oblique to the strike of the valley axis. By running basically parallel to the axis instead of perpendicular, the number of collisions of the sled with fault scarps within the valley is dramatically reduced and visual contact is almost continuous.

The tracking system is placed in the "SHIP ONLY" mode and the desired interrogation rate is thumb-wheeled into the computer, commonly at a 30-second repetition rate. The position of the ship is now plotted on the base map. Also displayed on an Infoton is a listing of important navigational data including the following information: SHIP, day, month, year, hour, minute, second, position in meters north and east (x and y) of selected origin; depth in meters of towed transceiver; round trip travel times in milliseconds to transponders A, B, and C; calculated speed over the bottom in knots based upon previous position; calculated course over the bottom in degrees based upon previous position. This listing is also printed in hard copy form and recorded on magnetic tape.

Using this information and indicators of the ship's gyro heading, wind direction and speed, and the turns on the ship's propellors (in some cases the ship has cyclodial propulsion or bow thrusters), the ANGUS navigator is able either to request changes in course and speed or to effect those changes himself if the control of the ship has been transferred to the ACNAV computer laboratory.

The navigator's responsibility is to move the ship to the desired ANGUS launch position and hold the ship into the wind and sea. As this is accomplished, the movement of the ship is monitored on the x-y plotter and Infoton. Once ANGUS has been lowered into the water and the relay transponder is clamped to the wire, the tracking system is placed in the "SHIP/FISH" mode and the desired delay time between the ship interrogation and fish interrogation is thumbwheeled into the computer, typically 10 seconds later. A second listing now appears on the Infoton: FISH, day, month, year, hour, minute, second, position in meters north and east (x and y) of selected origin; depth in meters of relay transponder plus height above sled; round trip travel times in milliseconds to transponders A, B, and C; round trip travel time in milliseconds from ship to relay transponder; and calculated speed and course over the bottom in knots and degrees based upon previous position.

The navigator uses the SHIP and FISH information to maneuver the ship in such a way as to insure that the camera track follows the desired grid coverage. The sled operator sitting next to the navigator monitors the height of the sled above the bottom as well as the tension of the cable. With this information he either requests that cable be let out or taken in. In some cases the sled operator has direct control of the winch and performs this function himself. With an ambient stress normally ranging between 6,000 and 8,000 pounds and a breaking tension of 20,000 to 30,000 pounds, the sled operator monitors the sled's periodic impacts with the bottom as he attempts to avoid such impacts and maintain a constant altitude at 10 to 12 meters. Should the sled collide with the bottom and become trapped, the sled and navigation operators work closely together to work it free. This is typically done by keeping the cable tension below 12,000 pounds as it is taken in and the ship is maneuvered back over the sled's position. Again, since the sled is heavy and is suspended less than 100 meters or so behind the vertical plane of the ship, freeing the sled can normally be accomplished in a few minutes. In a few cases, however, it has taken up to two hours.

With the camera repetition rate set at 20 seconds, it takes 16 to 17 hours to expose the 400-foot film load. With an average tow speed of 0.8 knots, each lowering can traverse 23 to 25 km. When the film is all exposed, the sled is recovered and navigational tracking is halted to permit some post-lowering data processing. During the hour of recovery, the navigational data is rerun through a velocity filter normally set at 5 knots or less. The FISH position as a function of time is then plotted by a Cal-Comp plotter at the working scale of 1:8,000 relative to the x- and y- origin in meters (Figure 5a).

Once the sled is recovered, the film is unloaded and immediately processed in a completely automated color laboratory that develops the E-6 film using filtered seawater. While this is taking place, the camera is reloaded and a second lowering begun. Within three hours the film is developed and dried. Since it is positive film, it can now be loaded on a reviewer and projected on a screen. In the lower left-hand corner of each frame is a LED display of the precision navigation time. An initial review of the film is made and the associated annotations recorded along the preliminary x-y plot at 1:8,000. This annotated plot is then placed on a light table and transferred to the multi-narrow-beam sonar topographic chart. As the lowerings proceed, more and more information is transferred to this base map and a geologic map slowly evolves. Based upon this evolving map, modified ANGUS lines are given to the navigator for subsequent lowerings, directing the mapping more on the unique geology of the area than on a predetermined coverage.

Depending upon the availability of computer time, additional data processing takes place. The altitude data, for example, is digitized in

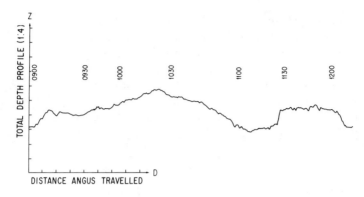

(a) *x-y* plot annotated with time and typically made at 1:8,000.

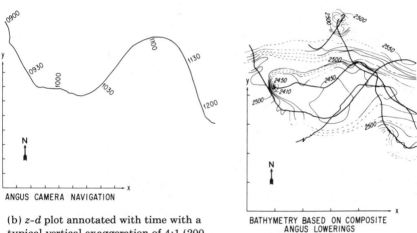

(b) *z-d* plot annotated with time with a typical vertical exaggeration of 4:1 (200 m/inch vs. 50 m/inch).

(c) Composite *x-y* plots of various lowerings in a particular transponder with annotations of total depth. Composite plot has been contoured and will be used as second order with multi-narrow-beam sonar map.

Figure 5. Typical ANGUS navigational plots.

meters and merged with the *x*, *y*, and *z* of the sled, producing a microtopographic profile of the bottom traversed by the sled on each lowering. Initially this plot is a distance (200 m/inch) vs. total depth (50 m/inch) plot with time annotations (Figure 5b). Once the exact orientation of the transponder network is determined, the profiles can be projected onto a line either parallel or perpendicular to the strike of the valley.

The total depth information is then merged with a composite of the various x-y plots at a scale of 1:8,000 (Figure 5c). This summary of bathymetric information is then contoured by hand. With this bathymetric map, the total ANGUS coverage can be hand-fitted to the multi-narrow-beam sonar map at the same scale. This provides a second-order fit of the transponder network to the base map, providing a final latitude and longitude frame of reference for all of the ANGUS observations, and a final geologic map is produced.

FOLLOW-UP STUDIES

The analysis of the final geologic map can lead to a wide variety of follow-up studies. In fact, historically these follow-up studies have begun while the mapping program was still underway. These efforts have fallen into three basic subgroups: ANGUS saturation coverage, use of ACNAV in specialized experiments, and the use of the submersible *Alvin*.

Angus Saturation Coverage

In our recent investigations of the Galapagos Rift, for example, a series of hydrothermal vents was located during the initial mapping traverses. The coordinates for the vents were then determined by noting the LED times displayed in the vent photographs and finding those times in the listing of the navigational data. The x, y, and z of a particular vent were then entered in the computer and displayed on a Tektronix display as a cursor at a desired scale of perhaps 1,000 meters/inch. This scale setting is also displayed on the Tektronix, as well as any transponders that might be in the immediate area. As in the case of a normal ANGUS lowering, the navigator uses this and other information to maneuver the ship to the vent location. The sled is then lowered into the water, the relay attached, and the navigator then carefully moves the ship back and forth, saturating the vent area with photographic coverage. Once the photography begins, the navigator will change the scale on the Tektonic to 50 meters/inch, allowing him better to judge the total coverage.

Specialized Experiments

Since the ANGUS navigation is accomplished by attaching a relay transponder to the trawl wire above the sled, it is possible to track a wide variety of other instruments in a similar manner. These include dredges, cores, heat probes, CTD sensors, etc. It is also possible to install instrument systems on the bottom using the same approach. Instead of using a

relay, for example, a normal transponder with an acoustical release can be attached to the end of the hydro wire. An instrument system like an Ocean Bottom Seismograph or time-lapse camera platform can be suspended from the release at the bottom of the transponder. This combined package is then lowered over the side. As it is lowered to the bottom, the ship is maneuvered in such a way so as to position the package over the desired point on the seafloor where the instrument is to be installed. The position of the package is not only displayed on the x-y plotter or Tektronix, but the interrogation response from the transponder holding the experiment is also displayed on a separate x-y plotter. As this transponder nears the bottom, its seafloor reflected signal is also received and displayed on the x-y plotter. The navigator can then continue to lower the package until the desired release altitude is reached. Once that is accomplished and the package is positioned over the installation site, the transponder is commanded to release the package, after which it transmits a confirming double-interrogation ping. In many cases, the submersible is then vectored to the drop site and additional tasks are carried out using its manipulator to set up the experiment on the bottom and turn it on. Other times, the experiments are commanded to begin with an acoustical signal from the surface or they begin automatically. Later, the experiments are recovered by the submersible or commanded to release weights and return to the surface.

Submersible Studies

The configuration of *Alvin* during Project FAMOUS and its operational techniques were described by Ballard and van Andel (1977b). During that program, *Alvin* was used to make geological traverses that ANGUS now does and was not equipped with many sophisticated instrument systems. Since that time, however, many new systems have been built and used successfully on the various programs. These include a sophisticated water sampling and *in situ* analysis system (Corliss *et al.* 1979), a variety of geophysical systems including seismic, gravity, and magnetic instruments (RISE Study Group 1980), and a number of specialized biological experiments (Galapagos Biology Expedition Participants 1979).

This trend towards specialized experimentation and away from regional reconnaissance is continuing, with the submersible being used to study particular geologic problems that cannot be fully investigated using ANGUS. This most commonly occurs in vertical terrain such as fault scarps in which the geologic section is exposed. From a geological point of view, the single most important task carried out by the submersible is the collection of rock, sediment, and water samples within the area mapped by ANGUS. Although a variety of sampling tools has been developed, including diamond-bit drills and large hydraulic impact hammers, the most successful procedure has been the use of prybars and the submersible's mechanical arm.

FUTURE TRENDS IN MAPPING THE MID-OCEAN RIDGE

The author believes that new advances in digital imaging, fiber optics, frame storage systems, bubble memories, microprocessors, power systems, feedback manipulators, and other devices could lead to the development of a new generation of unmanned vehicles that would prove more efficient and more cost effective than manned submersibles. In 1979, the first digital color television system utilizing charge-coupled devices was successfully used on *Alvin* in the Galapagos Rift cruise. It was mounted on a separate hydraulic manipulator on which were also mounted two 750-watt incandescent lights. The camera had a macro-zoom lens, and the digital images were recorded within the pressure sphere on a 1-inch tape deck. The quality of the images was excellent, commonly providing a view far superior to that obtained by looking out one of the viewports.

As such digital imaging systems evolve, coupled with the development of more powerful light sources, the role of submersibles in marine mapping programs will become even more confined to precision sampling and manipulation.

ACKNOWLEDGMENTS

It is obvious that the mapping approach discussed in this paper involved a large number of engineers and technical personnel. To begin with, the author wishes to thank the U.S. Naval Oceanographic Office and in particular Cdr. Don Puccini and Dr. William Hart of Code 3510 for their great assistance in making the Navy's multi-narrow-beam sonar systems available to this large-term study program. Were it not for these incredible mapping facilities, the significant scientific results from this study would not have been possible.

The crew of R/V *Lulu* and submersible *Alvin* have spent an amazing period of 16 years working to make manned submersible operations a meaningful part of marine science. Under the leadership of William Rainnie, Larry Schumaker, and Jack Donnelly, the Deep Submergence Group has overcome countless obstacles to improve the submersible's operating reliablity and extend its diving range. For years, *Alvin* was attacked by many who called it an expensive and worthless research tool. Few, if any, say that now.

With multi-narrow-beam sonars at one end of the spectrum and *Alvin* at the other, it was the dedicated efforts of the ANGUS Group which brought it together, leading to a major step forward in geological mapping efforts. At the center of *Alvin* and ANGUS's success has been William Marquet, whose engineering talents in the development of our acoustical navigation system, as well as his many contributions in instrumentation and humanis-

tic management kept a dedicated team of individuals working long hours under rugged working conditions at sea.

This paper was written while the author was at Stanford University and was partially supported by the Office of Naval Research and the National Science Foundation.

The author also wishes to thank the National Geographic Society, and in particular Emory Kristof, for their tremendous support in the development of the *Alvin* and ANGUS photography systems and our at-sea auto-processor.

REFERENCES

Arcyana, X. Y. 1975. Direct sea-floor observations in submersibles of an active rift valley and transform fault in the Atlantic near 36°50'N. *Science* 190:108-116.

Ballard, R. D., and van Andel, Tj. H. 1977a. Project FAMOUS: Morphology and tectonics of the inner rift valley at 36°50'N on the Mid-Atlantic Ridge. *Geol. Soc. Amer. Bull.* 88:507-530.

Ballard, R. D., and van Andel, Tj. H. 1977b. Project FAMOUS: Operational techniques and American submersible operations. *Geol. Soc. Amer. Bull.* 88:495-506.

Ballard, R. D., Holcomb, R. T., and van Andel, Tj. H. 1979. The Galapagos Rift at 86°W: 3, Sheet flows, collapse pits, and lava lakes of the rift valley. *J. Geophys. Res.* 84:5407-5422.

Ballard, R. D., Holcomb, R. T., and van Andel, Tj. H. 1980. The Galapagos Rift at 86°W: 6, Volcanic and tectonic evolution of the rift valley from 86°01' to 86°15'W. In preparation.

Ballard, R. D., Atwater, T., Stakes, D., Crane, K., and Hopson, C. 1979. AMAR '78, Preliminary results IV: AMAR rift valley—Evidence for cycles in the evolution of rift valleys. *EOS, Trans. Amer. Geophys. U.* 59:1198.

Bellaiche, G., *et al.* 1974. Inner floor of the rift valley—First submersible study. *Nature* 250:558-560.

Brundage, W. L., and Cherkis, N. Z. 1975. Preliminary LIBEC/FAMOUS cruise results. *U.S. Naval Res. Lab. Report 7785.*

Caytrough. 1979. "Geological and geophysical investigation of the Mid-Cayman Rise spreading center: Initial results and observations," in *Deep Drilling Results in the Atlantic Ocean: Ocean Crust, Maurice Ewing Series 2*, 66-93. Washington D.C.: Amer. Geophys. Union.

Corliss, J. D. et al. 1979. Exploration of submarine hot springs on the Galapagos Rift. *Science* 203:1073-1083.

Crane, K. and Ballard, R. D. 1980a. The Galapagos Rift at 86°W: 4, Structure and morphology of hydrothermal fields and their relationship to the volcanic and tectonic processes of the rift valley. *J. Geophys. Res.,* In press.

Crane, K. and Ballard, R. D. 1980b. Volcanics and structure of the FAMOUS-Narrowgate Rift: Evidence for cyclic evolution. *Earth and Plan. Sci. Letters.* Submitted 1980.

Galapagos Biology Expedition Participants. 1979. Galapagos '79: Initial findings of a biology quest. *Oceanus* 22(2):2-10.

Gutenberg, B. and Richter, C. F. 1954. *Seismicity of the Earth.* Princeton, N. J.: Princeton Univ. Press.

Heezen, B. C. 1960. The rift in the ocean floor. *Sci. Amer.* 10:1-14.

Heezen, B. C., Tharp, M., and Ewing, M. 1959. The floors of the oceans: I, The North Atlantic. *Geol. Soc. Amer. Special Paper #65.*

Laughton, A. S. and Rusby, J. S. M. 1975. Long-range sonar and photographic studies of the median valley in the FAMOUS area of the Mid-Atlantic Ridge near 37°N. *Deep-Sea Res.* 22:279-298.

Macdonald, K. et al. 1975. Near-bottom geophysical study of the Mid-Atlantic Ridge median valley near 37°N: Preliminary observations. *Geology* 3:211-215.

Maurer, M. and Stocks, T. 1933. Die Echolotungen des . . . Meteor*Wiss. Ergebn. Deutsch Atlant. Esped . . . Meteor . . .,* 1925-1927, Bd. II, 4-32.

Maury, M. F. 1855. *Physical Geography of the Sea.* New York, N.Y.: Harpers.

Murray, J. and Hjort, J. 1912. *Depths of the Ocean.* London: John Murray.

Phillips, J. D. and Fleming, H. S. 1978. Multi-beam sonar study of the Mid-Atlantic Ridge rift valley, 36°-37°N. *Geol. Soc. Amer. Map Series* 19:1-5.

Phillips, J. et al. 1979. A new undersea geological survey tool: ANGUS. *Deep-Sea Res.* 26:211-226.

Renard, V., Schrumpf, B., and Sibuet, J. C. 1975. "Bathymétrie détailée d'une partie de vallée du rift et de faille transformante prés de 36°50'N dans l'Océan Atlantique." CNEXO, Paris.

Rise Project Group. 1980. Hot springs and geophysical experiments on the East Pacific Rise. *Science.* In press.

Rothé, J. P. 1954. La zone seismique Mediane Indo-Atlantique. *Phil. Trans. Roy. Soc. London* A222:387-397.

Rudolph, E. 1887. Uber submarine Erdbeben und Eruptonen. *Gerl. Beit. Geophy.* 1:133-373.

Tams, E. 1931 Die Seismicity der Erde. *Handbuch der Experimentalphysik* 25, Pt. 2: 361-437.

van Andel, Tj. H. and Ballard, R. D. 1979. The Galapagos Rift at 86°W: 2, Volcanism, structure, and evolution of the rift valley. *J. Geophys. Res.* 84:5490-5406.

Section II

Towed Systems

4

A New Undersea Geological Survey Tool: ANGUS*

J. D. Phillips
Applied Seismology Group,
Massachusetts Institute of Technology,
Cambridge, Massachusetts

A. H. Driscoll, K. R. Peal,
W. M. Marquet and D. M. Owen
Woods Hole Oceanographic Institution
Woods Hole, Massachusetts

INTRODUCTION

Considerable difficulty is usually experienced in attempts to integrate seafloor observations obtained from tethered, near-bottom devices with other, independently navigated information. This largely results from the methods generally used to deploy and locate tethered bottom cameras and sampling tools. Typically these devices are lowered on a long wire that is strongly affected by ship's motion and currents. In most cases the device location is inferred by estimating the azimuth and distance between the ship and the device from the surface orientation of the tether wire, the wire length, the water depth and the height (altitude) of the device above the sea floor (Hersey 1967). This method is clearly inadequate for detailed studies because a large catenary of unknown dimensions and orientation may form in the submerged tether wire. This effect can displace the sea floor device well away from the surface ship in any direction. In deep water with strong currents, this horizontal offset can approach the water depth! Added to this is the fact that only sporadic satellite and radio navigational

* Contribution No. 3766 of the Woods Hole Oceanographic Institution. This paper originally appeared in *Deep Sea Research:* 26A, 211-225. © Pergamon Press Ltd. 1979.

fixes are available in most remote, deep-ocean areas. Thus, it has been virtually impossible to relate the many thousands of photographs and samples collected during the last half century to specific small-scale topographic features seen on modern bathymetric contour charts or along other survey tracks. Accordingly, to overcome these problems new approaches to seafloor surveying have recently been developed; these utilize acoustic transponder systems for precise underwater tracking of both tethered devices (fish) and submersible vehicles.

BACKGROUND

The first geologically oriented approach to seafloor surveying was initiated by the Marine Physical Laboratory (MPL) of the Scripps Institution of Oceanography in the early 1960s. The resulting system, generally known as Deep Tow, makes use of a long-baseline array of transponders (beacons) on the seafloor and a towed fish whose transponder is linked to the surface ship by electrical signals multiplexed up the tether cable (Spiess and Tyce 1973). This is a pulsed, range-range type system that provides not only both high-resolution navigation and bathymetric information (± 5m) but also allows additional types of observational data to be transmitted via the cable to the surface ship. Although numerous studies have successfully employed the MPL system, its application has not been widespread in other laboratories because of its relative complexity and high cost. Expensive, coaxial tow cables and large, specially designed, slip ring-type winches are required. In addition, the system does not have a direct automatic digital acoustic signal acquisition capability. Thus, it requires added personnel to interpret and process the analog travel-time information.

A system similar to Deep Tow, in that it also utilizes a coaxial cable-winch system for linking the fish and ship transponders, has been developed by the Naval Research Laboratory (NRL) for search and salvage operations (Van Ness, Mills, and Steward 1966). In the NRL system a small array of transponders on the hull of the surface ship replaces the seafloor transponder array. This is a range-bearing type system that uses the ship's gyrocompass for determining the array orientation and fish location. A seafloor transponder can be deployed for precise geographic fixing. The system also has automatic digital acoustic signal acquisition with computer processing and the ability to take water samples and make water temperature and geomagnetic observations.

Another approach to tracking tethered devices is to link the surface ship and fish transponders solely by acoustic signaling through the water. This method has the advantage of not requiring special cables or winches. Its

disadvantages are a slightly reduced navigational precision (\pm 10 m) due to unknown variations of sound velocity along the additional fish-ship water travel path, greater susceptibility to acoustic noise generated by the ship, a reduced frequency bandwidth for transmitting data to the ship, and total reliance on batteries for all fish electrical systems. However, for a simple geological survey device that has no major power-consuming instruments, transmits only a few data, and only requires positional accuracy commensurate with the smallest bathymetric relief resolvable along the fish's path (\approx 10 m), a total acoustic-link system appears to be more than adequate.

Accordingly, when it became apparent in 1971 that high-resolution geological information would be required for the planned deep-submersible investigations aboard DSRV *Alvin* in 1974 on the Mid-Atlantic Ridge near the Azores Islands (Project FAMOUS*), it was decided that an acoustically-linked survey method should be developed that would allow direct integration of tethered and submersible vehicle observations. These new systems were termed ANGUS for Acoustically Navigated Geological Undersea Surveyor and ALNAV for the *Alvin* navigation system. In this report we describe the technique and apparatus of the ANGUS system and present some results obtained during its initial deployment in the FAMOUS area. A preliminary description of the ALNAV system was given by Hays (1974).

TECHNIQUE

A pulsed, range-range technique is employed for acoustic tracking of all ANGUS system devices. It uses a long-baseline array of moored seafloor transponders (beacons), a hull-mounted transducer on the ship, and a relay transponder near the tethered fish (Figure 1). Ship and fish tracking and control functions are from a compact operations console in the ship's scientific laboratory (Figure 2). Typically, the moored transponders are first deployed and located relative to one another. A reconnaissance bathymetric survey is then conducted to provide a base contour chart that can be geographically positioned from satellite navigation fixes or directly related to an existing contour chart (Phillips, Peal, and Marquet 1976).

An attractive feature of the ANGUS system is its extensive use of automatic digital acoustic signal acquisition, digital magnetic tape recording, and shipboard computer navigation processing. Continual visual track plotting at various scales is done on cathode ray tube (CRT) and other graphic display units (Figure 2). This allows real-time observation of the fish and ship positions and permits maneuvering the ship to desired seafloor targets. In practice, the fish is guided along preselected courses or

* French-American Mid-Oceanic Undersea Study.

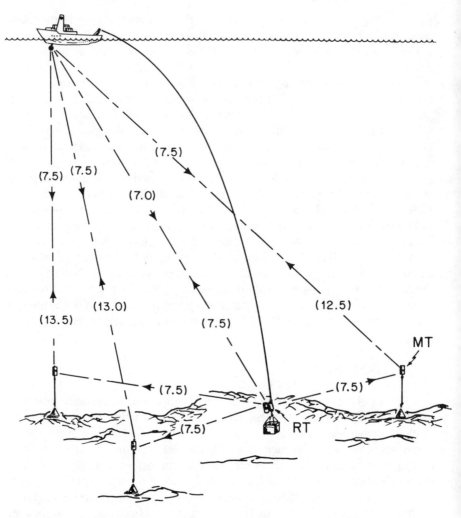

Figure 1. Schematic representation of the ANGUS acoustic navigation technique. Acoustic ray path directions of sound transmission at the various frequencies (kHz) used are shown by arrows along the dashed lines. MT, moored transponder; RT, relay transponder.

relative to existing bathymetric contour charts, which are superimposed on the CRT screen (Figure 3). Altitude is continuously monitored with a bottom-finding pinger mounted in the fish and displayed on an analog precision graphic recorder (PGR). In addition, periodic determinations of fish altitude-depth and position are recorded from the digital acoustic

Figure 2. Typical arrangement of shipboard components of ANGUS system showing the ship's speed controls–indicators immediately adjacent to the Tektronix 4010 CRT display screen (center) and the Dillon winch speed-cable out indicator to the upper right. The AMF coder–power amplifier and digital receiver, Infoton Line printer, Datum digital clock, and WHOI system controller are in rack at far left. The Cal-Comp drum plotter and Teletype line printer are to the right of the field of view. The Hewlett-Packard 2100 computer is out of sight to the left.

navigation system (usually every 20s). With these procedures it has been practical to fly the ANGUS fish at a nominal 5 m above the bottom. Only when crossing near-vertical scarps of large relief is it difficult to maintain a constant altitude.

Another aspect of the ANGUS system is its flexibility for tracking devices other than the basic camera fish. For example, rock dredge, sediment core, and heat-flow probes have been located precisely by simply attaching the relay transponder on the wire above these devices. Acoustic tracking of expendable sonobuoys for locating microearthquakes has also been accomplished (Spindel *et al.* 1974).

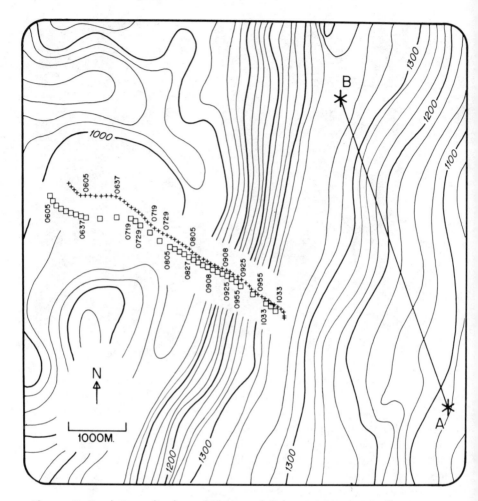

Figure 3. Real-time display of ship and fish positions on Tektronix 4010 Cathode Ray Tube (CRT) plotter screen. Squares and crosses are ship and fish position, respectively, for part of camera lowering 5 on *Atlantis II* Cruise 77, Sta. 34, 18 August 1973. The bathymetric contours were drawn on a clear plastic film superimposed on the CRT screen.

APPARATUS AND OPERATION

Acoustic Navigation

The navigation system uses two or three AMF model 324 recoverable transponders each moored about 100m above the ocean bottom, and an AMF model 320 relay transponder on a tethered device (Figure 1). The

shipboard acoustic gear consists of a hull-mounted Massa sonar transducer driven by the AMF model 200 coder and power amplifier; an AMF model 205, 4-channel digital ranging receiver, and a Datum digital time of day clock (Figure 2). A Hewlett-Packard 2100 computer with a nine-track magnetic tape unit, a Tektronix 4010 graphics CRT terminal, Cal-Comp drum plotters, and a specially-designed system timing control unit is used to process the acoustic data and display the navigational information in real time (Eliason 1974; Peal 1974a, b).

Operation of the ANGUS system's acoustic navigation program logic as diagrammed in Figure 4 can be divided into three procedures: ray tracing, surveying, and navigation.

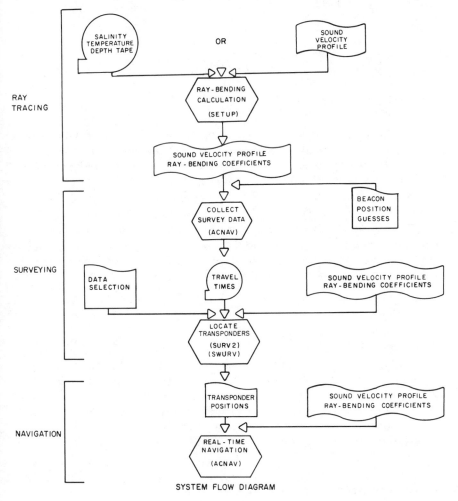

Figure 4. ANGUS computer data processing system flow diagram.

Ray Tracing

Because sound velocity in the ocean varies with pressure, temperature, and salinity a sound ray in the ocean does not follow a straight line. Thus, the slant range (Sr) to an acoustic transponder is not strictly proportional to the travel time (t). Following Officer's (1958) exposition of ray pathbending in a horizontally stratified ocean, we assume the sound velocity (c) to be a function of depth only.

Program SETUP finds an approximate solution to this problem in two steps. First, N sets of travel times and slant ranges are found by numerical integration. The second step is to use the N travel time and slant range pairs $(t^{(1)}, Sr^{(1)})$, $(t^{(2)}, SR^{(2)})$, . . ., $(t^{(N)}, Sr^{(N)})$ to solve a polynomial of the form

$$Sr^* = (A_0 + A_1r + A_2r^2)r, \tag{1}$$

where r is a first approximation of the slant range using the average sound velocity (\bar{c}): $r = \bar{c}t$. This polynomial function is then used during succeeding operations to approximate the relationship between slant range and observed travel time. The coefficients of equation (1) are found by using least squares techniques and are then passed to the survey and navigation programs for estimating the slant ranges.

Some care is taken in selecting the average sound velocity \bar{c}. The program allows for a 40-point depth versus sound velocity profile. For rays traveling through most of the water column, the complete profile is averaged to obtain a \bar{c}. However, for the rays traveling between a fish and a transponder, for example, only the relevant part of the depth profile is used to obtain the average sound velocity.

Surveying

Knowledge of the relative position of two or more seafloor transponders (beacons) is required to locate a tethered relay transponder, submersible, or sonobuoy. The relative geometry of a two-transponder is simply defined by the baseline between the transponders and their depths and is estimated by taking a series of slant range measurements with the surface ship along tracks nearly normal to the baseline. Survey program SURV2 of the ANGUS computer programming system utilizes this two-transponder survey method. However, the two-transponder survey method will not be considered further here because a three-transponder net is usually deployed to attain greater navigational precision.

(a) *Survey Program SWURV.* Considerable improvement in transponder position estimates is gained by using the three-transponder survey scheme. The principal benefits are: automatic computer estimation of the transponder positions with an evaluation of the errors in these positions and an indication of errors caused by the survey geometry. The complete error analysis used in the survey program SWURV is presented by Smith, Marquet, and Hunt (1975). Here we only outline the process to demonstrate the ease with which a scientist can use this powerful tool.

Briefly, the relative positions of the three transponders are determined from slant range observations taken by a ship at a number of discrete survey stations (points). The transponder positions are then estimated using a nonlinear least squares analysis method (Lowenstein 1965; McKeown 1971). The geometrical configuration of survey points around the transponder array is a compromise between the analytical requirement for widely spaced points and limitations imposed by the available ship time. In any case, simultaneous returns from all three transponders must be collected at six or more points in the operating area. Also the survey points must not be in the shape of a conic section (circle, ellipse, two-intersecting lines, etc.) to avoid nonunique solutions in the least squares analysis (Vanderkulk 1961). Examples of four typical transponder array survey data sets are shown in Figure 5.

(b) *Error estimates.* The actual survey points to be used in the analysis are selected visually from the dead-reckoned plot of the data collected after transits to carefully planned locations. Program SWURV converts the travel times at these points to slant ranges using the average sound velocity and the ray bending coefficients previously computed. A slant range standard error that indicates the accuracy of these measurements is derived. This error is typically on the order of 1 m. The transponder positions are then estimated and the error associated with each survey point is found. A large error may indicate a faulty travel time measurement at that point. These points can be deleted and the process repeated using the remaining points.

Two additional error estimates are calculated by the program to give the user a quantitative measure of (i) the confidence limits on the transponder positions and (ii) the over-all quality of the survey geometry. Specifically, from the number and the location of the survey points, program SWURV evaluates a geometry error magnification term for each of the six unknown coordinates. These are shown in Table 1 for the four surveys diagrammed in Figure 5. The confidence limits for each transponder coordinate are found by multiplying the respective geometry magnification factor by the slant range standard error. The over-all quality of a survey is shown by the survey error index, which is the sum of the squares of the six geometry magnification factors.

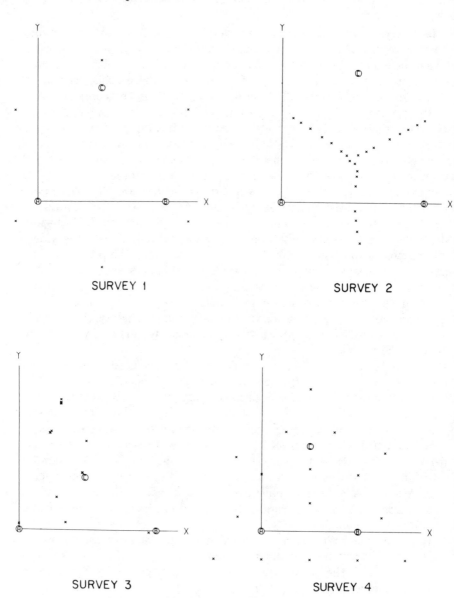

Figure 5. Hypothetical ship surveys of seafloor transponders A, B, and C. Crosses show ship positions for respective slant range measurements to the transponders.

Table 1. Survey Geometry Error.

Survey no.	No. of survey points	Geometry magnification factor						Survey error index
		x_b	x_c	y_c	z_a	z_b	z_c	
1	6	23.81	13.73	18.83	4.01	5.30	4.39	1173.58
2	24	6.95	11.90	5.71	4.15	4.33	4.00	274.41
3	17	4.65	4.90	2.22	0.77	0.84	0.64	52.30
4	16	1.16	1.46	1.10	0.57	0.57	0.51	5.59

The coordinates of transponders A, B, C are A = 0,0, z_a; B = x_b, 0, z_b and C = x_c, y_c, z_c.

The survey error index for Survey 1 (Figure 5) is large because the survey points form a nearly circular pattern thus yielding a weak solution. Survey 2 avoids this problem but concentrates too many points close together inside the array. Survey 3 has more widely spaced points but they are not evenly distributed over the array. Survey 4, which has the smallest error of the four shown, has many widely spaced points well distributed throughout the area. For this survey, assuming a slant range standard error of 1 m and using the magnification factors from Table 1, the confidence limits on the transponder coordinates vary from 0.5 to 1.5 m. Typically, the over-all system accuracy is estimated to be on the order of 5 to 10 m (Spindel, Durham, and Porter 1975).

Navigation

Each seafloor transponder (beacon) consists of an acoustic receiver, an acoustic transmitter, and processing and control circuitry. All receivers are tuned to a common interrogation frequency f_{ship} (Figure 6). Each of the transmitters, however, replies at a different frequency (f_{t1}, f_{t2}, f_{t3}).

When a submersible or tethered fish vehicle is to be tracked, a relay transponder is attached near the vehicle (Figure 1). This transponder uses a different receiver frequency f_{fish} and transmits at the frequency f_{ship}. As the ship position is always necessary to solve for the nonship vehicle position, the basic interrogation sequence is always: ship, nonship, ship, nonship, . . . where "nonship" can be a tethered fish, submersible, or sonobuoy. An example of a real-time plot for successive ship and fish positions during a camera station as displayed on the shipboard cathode ray tube (CRT) plotter is shown in Figure 3. Following is a brief description of the various interrogation cycles of the ACNAV navigation program (Hunt *et al.* 1974).

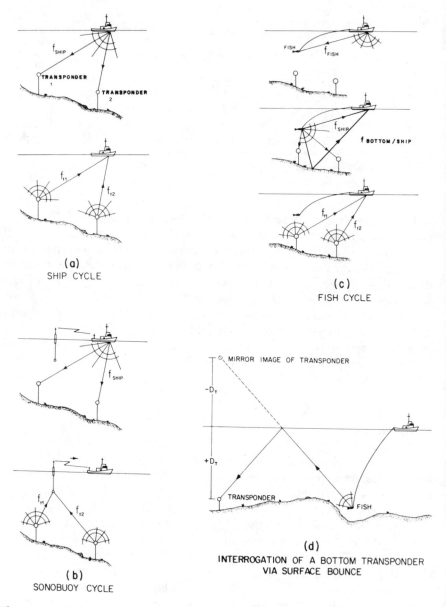

Figure 6. ANGUS acoustic signaling method. Ray paths are indicated by arrows.

(a) *Ship cycle* (Figure 6a). At the start of the ship cycle, a pulse at a frequency f_{ship} is generated. When this signal is recognized by a seafloor transponder, it generates a reply pulse at its frequency. When one of these return pulses is detected by the shipboard receiver, the effective round-trip travel time between the ship and the respective transponder is determined. From this, the distance from the ship to that transponder can be found. If two or more transponder returns are detected, solution for the ship position is possible. The baseline ambiguity is resolved by the computer program using data from the third transponder or operator inputs.

(b) *Sonobuoy cycle* (Figure 6b). When the nonship cycle uses a sonobuoy, the replies from the seafloor transponders are received by the sonobuoy and transmitted (via radio) to the shipboard receiver. If we assume that the radio transmission time from the sonobuoy to the ship is negligible, then the elapsed time measured is the travel time from the ship to the respective seafloor transponder to the sonobuoy. Replies from two transponders, combined with knowledge of the ship position, allows solution of the sonobuoy position. Expendable sonobuoys capable of receiving the transponder replies include U.S. Navy type SSQ-57.

(c) *Fish cycle* (Figure 6c). At the start of the fish cycle, the shipboard system generates a pulse at frequency f_{fish} that causes the relay transponder to transmit a reply pulse at frequency f_{ship}. In this case, the round-trip travel time gives the ship-to-fish distance. The seafloor transponders also receive the f_{ship} signal generated by the relay transponder, causing them to reply on their respective frequencies. When one of these signals is detected by the ship receiver, the resultant time represents the distance from the ship to the fish to the seafloor transponder and back to the ship. A scheme similar to that described above was reported by Boegeman, Miller, and Normark (1972).

(d) *Fish altitude* (Figure 6c). During the fish cycle, the f_{ship} signal can be received at the ship via two paths: direct from the fish and reflected off the seafloor. The former return is the one used to locate the fish as described above. However, when the fish is near the seafloor, the time-delayed, bottom-reflected signal can be used to measure the fish height above the seafloor directly. By combining this altitude information with the fish depth, the seafloor bathymetric profile can be computed directly in real time. In places where poor seafloor reflectivity does not provide a sufficiently strong bottom reflected fish signal or when ultra-high resolution topography is desired, altitudes observed by the bottom-finding pinger mounted on the fish are digitized and merged with the fish depth information to obtain the bathymetric profile.

(e) *Surface bounce navigation* (Figure 6d). Difficulty has sometimes been experienced during real-time processing of the fish or submersible data in unusually rough terrain because the direct signal path from the vehicle to a

seafloor transponder is blocked by a hill. However, a signal from the vehicle can reach a topographically blocked bottom transponder by traveling to the sea surface and then to the transponder. In this situation an operator observing the travel times displayed by the receiver will notice an abrupt large increase or "jump" in the travel time on the appropriate receiver channel. This "surface bounce" reflected signal path is illustrated in Figure 6d. This signal path is equivalent to an imaginary transponder at depth -D_T, directly over the real transponder. Although this surface bounce path is well known, it has not been widely used for navigation. However, we found that the transition to the surface bounce path was sharp and despite the increased noise in the surface bounce travel times compared to direct path signaling, useful vehicle positions can be calculated. To utilize this phenomenon, it is assumed that two bottom-moored transponders are used. Under these conditions four vehicle-to-transponder signal path combinations are possible. Accordingly, program ACNAV simply calculates the ship-to-vehicle distance for each path and then selects the combination of signal paths that maintains the shortest distance between the ship and the vehicle.

Towed Camera Fish

The initial problem encountered in developing a tethered geologic survey system was to design a rugged fish that would provide easy access to the deep-sea survey camera and acoustic navigation-data telementary devices. The fish must also withstand collisions with the seafloor. Accordingly, it was decided that a simple, cage-like, rectangular frame made of steel tube sections would be the best configuration. A prototype was constructed of lightweight rectangular tube sections, but it was easily damaged by bottom collisions.

The current MARK I fish framework incorporates a large, rounded, heavily reinforced nose section and bottom skids that allow the fish to slide over bottom obstacles (Figure 7). To provide higher inherent strength the framework was constructed from heavy wall (Schedule 80) 7.5-cm diameter pipe sections. All joints subject to stress were either cross braced or supported by gussets. Also, heavy cross members were extended beneath all instruments to prevent their loss if jarred loose from their mountings by bottom collisions. The over-all dimensions of the fish are approximately 1.5 × 4 × 2m.

The camera used was an EG&G MK-1 underwater survey camera (35 mm), with two EG&G MK-1 survey strobes and 24-V battery pack. An EG&G model 220 bottom-finding pinger and an AMF mode 1023 telemetering pinger were also included. The telemetering pinger transmitted bottom

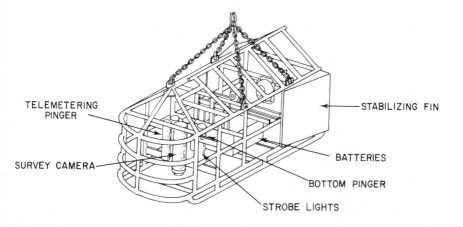

TELEMETERING PINGER

STABILIZING FIN

SURVEY CAMERA

BATTERIES

BOTTOM PINGER

STROBE LIGHTS

Figure 7. ANGUS towed camera fish (MARK I). The survey camera is in the forward section. Two strobe lights are at rear. Pingers and battery pack are in center section.

water temperature and was also used on heat flow probes for telemetering geothermal data. Each photographic data frame included a digital real-time display synchronized with the navigation timing system to provide exact locations of the photographs along the fish track.

Field Operation

Launching and recovering the nearly 2000-lb (909-kg) MARK I fish is accomplished through an A-frame over the stern of the ship. Although the fish is large and heavy, its rugged construction is such that it can be launched in any reasonable sea state with a high degree of safety to both personnel and equipment. During normal deployment the fish is lowered on a trawl wire attached to a four-point chain bridle. Adjustment is made within the bridle to compensate for the normal nose-down attitude the fish assumes during the tow. A swivel between the trawl wire termination and the chain bridle provides additional freedom for the fish in the event of accidental bottom contact.

The close proximity of the fish to the seafloor suggested that a small compass could be suspended below the fish and photographed in the camera field of view to orient photographs. However, frequent loss of the compass due to bottom contact necessitated development of a self-steering capability for the fish so that the acoustic navigation track of the fish alone could be used to orient the photographs. Accordingly, two large stabilizing fins were incorporated to provide drag on the stern (Figure 7). A comparison of compass-oriented photographs with orientations inferred from acoustically navigated tracks in the low currents near the bottom in the FAMOUS area showed precise following of the fish axis along the track.

INITIAL RESULTS

Deployments

The first deployment of the prototype ANGUS fish was aboard the *Atlantis II* (cruise 73) at two acoustic transponder arrays in the northern FAMOUS median rift valley of the Mid-Atlantic Ridge (Figures 8 and 9). During the cruise the fish was towed at nine camera stations and recovered a total of 3900 useful photographs and about 30 km of near-bottom bathymetric and temperature profiles. The acoustic navigation system was also used to locate 10 dredge hauls. One camera was lost as a result of a bottom collision.

During *Atlantis II* cruise 77 the MARK I fish was used extensively

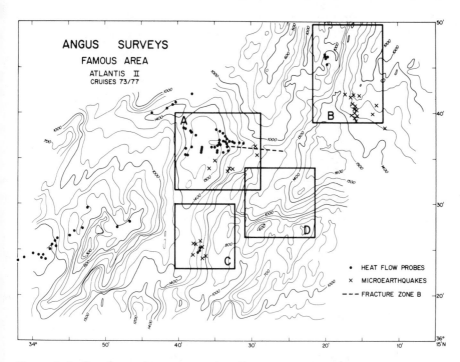

Figure 8. Index chart of FAMOUS rift valley at Fracture Zone B. Boxed areas show location of ANGUS acoustic transponder surveys made during *Atlantis II* cruises 73 and 77. Bathymetric contours are in uncorrected fathoms. Microearthquake and heat flow probe locations are shown by crosses and circles, respectively.

for a second geological study of the FAMOUS area. This cruise resulted in a total of 12 camera stations along 30 km of bathymetric profile at three acoustic transponder arrays (Figures 8 and 9). Over 10,000 good quality photographs were obtained. Also 12 dredge hauls, 100 heat flow probes, and 30 microearthquakes (Spindel *et al.* 1974) were located. No instruments were lost and the only item seriously damaged was a strobe light unit that flooded when the Pyrex housing cracked under pressure.

The ANGUS system was deployed in the FAMOUS area for a third time (1974) in conjunction with DSRV *Alvin* operations (Phillips *et al.* 1976) and in the Cayman Trench (1976) and Galapagos Ridge (1977) area during RV *Knorr* cruises 42, 54, and 64. The latter two deployments with a new improved MARK II fish (Driscoll 1978) have more than quadrupled the number of observations reported here for the *Atlantis II* cruises 73 and 77. Unfortunately, the cycloidal propulsion system of *Knorr* generated consid-

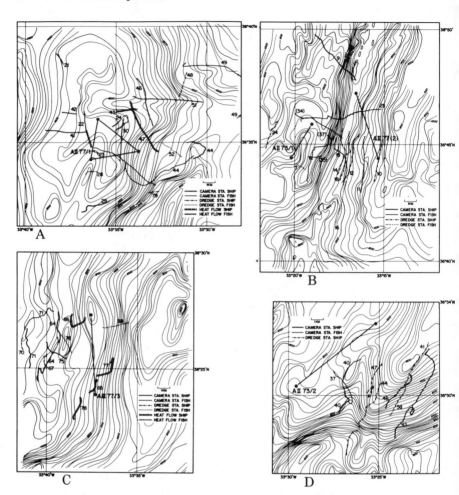

Figure 9. Chartlets showing position of ANGUS camera, dredge, and heat flow stations made during *Atlantis II* cruises 73 and 77. The location of each chartlet within the FAMOUS area is shown in Figure 8. Solid straight lines connecting the transponder pairs show the navigation baseline arrays used for each acoustic survey area. (a) Fracture Zone B—west end. Transponder array All 77-1. (b) North FAMOUS rift valley. Transponder arrays All 73-1 and 77-2. (c) South FAMOUS rift valley. Transponder array All 77-3. (d) Fracture Zone B—east end. Transponder array All 73-2.

erable acoustic noise that degraded the performance of the ANGUS navigation system. However, adequate acoustic navigation has been acquired for most *Knorr* stations.

Photographic and Bathymetry Data Format

Examples of typical, time-keyed photographs taken of the volcano-tectonic terrains in the FAMOUS rift valley are shown in Figure 10 (*Atlantis II,* cruise 73, Sta. 34). Figure 11 shows the position of these photographs on the high resolution bathymetric profile observed along the camera fish track. The seafloor morphology shown on the profile was inferred after examination of the more than 2200 photographs taken almost continuously at this station. Similar bathymetric profiles were also obtained during water temperature, heat flow, sediment, and rock sampling (dredging) operations. Simply by noting the time intervals when the tethered device was in contact with or near the bottom, the location of a bottom observation or sample relative to the local bathymetry can be determined. Sharp changes in the trawl wire tension and short interruptions of acoustic communication usually provide reliable indicators of bottom contact for dredge sites.

A complete summary of all *Atlantis II* 73 and 77 station operations has been included in a catalog compiled by Hays and Heirtzler (1977) of FAMOUS area studies.

ACKNOWLEDGMENTS

The help of A. J. Erickson in the development of the prototype camera fish is gratefully acknowledged. Also the efforts of A. H. Eliason in the design of the acoustic navigation system and its initial shipboard tests were most appreciated. Helpful suggestions were made during the building of the various ANGUS fish by J. Leiby and E. Young. Invaluable assistance at sea was provided by Captain J. Pike and Boatswain K. Bazner of the *Atlantis II.* In fact, without their help and the close cooperation of all the officers and crew of *Atlantis II,* and the scientists on board during the various cruises, the ANGUS system could not have been developed. Finally, the authors extend their sincere thanks to Drs. W. Bryan, W. K. Smith, and R. P. Von Herzen for their encouragement and critical review of the manuscript. Support for the ANGUS system has been provided by the National Science Foundation under Grants GA-35976 and GX-36024, with partial support from the Office of Naval Research Contract N000014-74-C-0262; NR083-004.

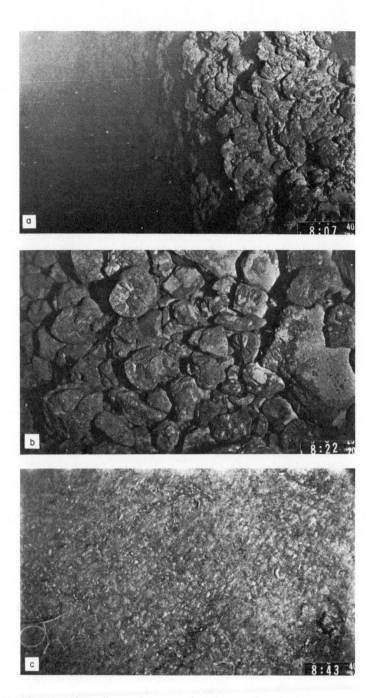

Figure 10. Typical seafloor photographs obtained with the ANGUS camera system in the FAMOUS rift valley (*Atlantis II* cruise, 77, Sta. 34, camera lowering 5, 18 August 1973). An interpretation of the seafloor morphology accompanies each photograph. The station location and its bathymetric profile are shown in Figure 9, chartlet B and Figure 11, respectively. (a) GMT

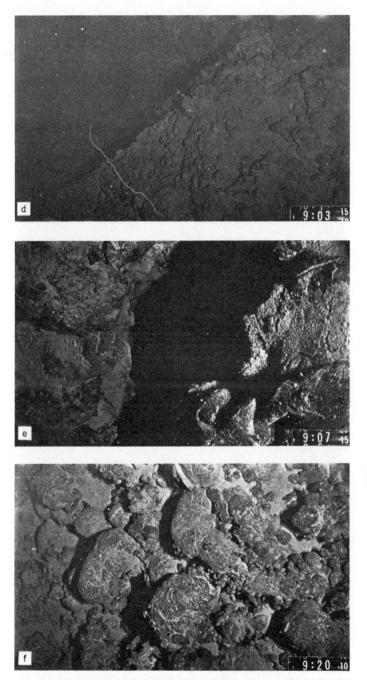

0807: large fault scarp exposing fractured pillow lava tube. (b) GMT 0822: talus pile consisting of broken pillow lava tubes. (c) GMT 0843: floor of sediment-filled depression showing profuse benthic fauna. (d) GMT 0903: fault scarp. (e) GMT 0907: open fissure exposing fractured pillow lava tubes. (f) GMT 0920: intact pillow lava tubes undisturbed by fractures.

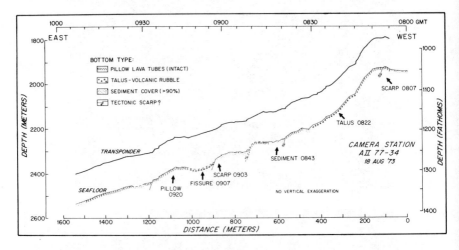

Figure 11. Bathymetric profile obtained with ANGUS towed fish across west wall of FAMOUS rift valley (*Atlantis II*, cruise 77, Sta. 34, camera lowering 5, 18 August 1973). The station location is shown in Figure 10, chartlet B. A morphologic interpretation of the profile based on all the seafloor photographs obtained along the fish track is shown beneath the profile line. A dashed line indicates region where no seafloor depths were obtained acoustically from the towed fish. Arrows point to the positions of the photographs shown in Figure 10.

REFERENCES

Boegeman, D. E., G. J. Miller and W. R. Normark. 1972. Precise positioning for near-bottom equipment using a relay transponder. *Marine Geophysical Researches* 1:381-392.

Driscoll, A. H. 1978. An improved ANGUS fish. Woods Hole Oceanographic Institution Technical Report. In preparation.

Eliason, A. H. 1974. Timing control unit operating and service manual. Woods Hole Oceanographic Institution Technical memorandum, WHOI Ref. 74-2, 95 pp. (Unpublished.)

Hays, E. E. 1974. Advanced marine technology: Technical progress report. Woods Hole Oceanographic Institution Technical Report, WHOI Ref. 74-27, 44 pp. (Unpublished.)

Hays, H. and J. R. Heirtzler. 1977. Station locations for *Atlantis II* cruises 73 and 77, *Knorr* cruise 42, and *Alvin* dives: FAMOUS area. Woods Hole Oceanographic Institution Technical Report, WHOI Ref. 77-9, 12 pp. (Unpublished.)

Hersey, J. B. 1967. The manipulation of deep-sea cameras. In *Deep sea photography*, ed. J. B. Hersey, 55-67. Baltimore: Johns Hopkins University Press.

Hunt, M. M., W. M. Marquet, D. A. Moller, K. R. Peal, W. K. Smith, and R. C. Spindel. 1974. An acoustic navigation system. Woods Hole Oceanographic Institution Technical Report, WHOI Ref. 74-6, 67 pp. (Unpublished.)

Lowenstein, C. D. 1965. Computations for transponder navigation. *Navigation symposium*, Marine Physical Laboratory, Scripps Institution of Oceanography, Technical Report MPL-U-2/65, pp. 305-311. (Unpublished.)

McKeown, D. L. 1971. Evaluation of an acoustic positioning system. In *Proceedings of tenth annual Canadian hydrographic conference*, pp. 195-205.

Officer, C. B. 1958. *Introduction to the theory of sound transmission with applications to the ocean.* New York: McGraw-Hill.

Peal, K. R. 1974a. Acoustic navigation system operating and service manual. Woods Hole Oceanographic Institution Technical Memorandum, WHOI Ref. 74-4, 35 pp. (Unpublished.)

Peal, K. R. 1974b. Operation of the HP2510A Coupler/Controller in the Acoustic Navigation System. Woods Hole Oceanographic Institution Technical Memorandum, WHOI Ref. 74-3, 86 pp. (Unpublished.)

Phillips, J. D., K. R. Peal, and W. M. Marquet. 1976. An integrated approach to sea floor geologic mapping: ANGUS and *Alvin*. In *Oceans 76 record*. Institute of Electrical and Electronic Engineers, Pub. No. 76CH11189, pp. 13-18.

Smith, W. K., W. M. Marquet, and M. M. Hunt. 1975. Navigation transponder survey: design and analysis. In *Ocean 75 record*. Institute of Electrical and Electronics Engineers, pp. 563-567.

Spiess, F. N. and R. C. Tyce. 1973. The Marine Physical Laboratory DEEP-TOW instrumentation system. Scripps Institution of Oceanography Reference 73-4, 37 pp. (Unpublished.)

Spindel, R. C., S. B. Davies, K. C. MacDonald, R. P. Porter, and J. D. Phillips. 1974. Microearthquake survey of Median Valley of the Mid-Atlantic Ridge at $36°30$ N. *Nature* **248**:577-579.

Spindel, R. C., J. L. Durham, and R. P. Porter. 1975. Performance analysis of deep ocean acoustic navigation systems. In *Ocean 75 record*. Institute of Electrical and Electronics Engineers, pp. 568-572.

Vanderkulk, W. 1961. Remarks on a hydrophone location method. *U.S. Navy Journal Underwater Acoustics* **11**:241-250.

Van Ness, M. N., R. L. Mills, and K. R. Steward. 1966. An acoustic ray ship positioning and tracking system. In *Proceedings national marine navigation meeting January* 1966. Naval Research Laboratory Report No. 6326, 86 pp. (Unpublished.)

The Use of a Photosled for Quantitative Assessment of Faunal Components along Transects

Hjalmar Thiel

*Institut für Hydrobiologie
und Fischereiwissenschaft
der Universität Hamburg
Hamburg, Germany*

INTRODUCTION

Quantification of standing stocks and their changes over time is one of the goals of modern biological oceanography. Suitable equipment is available for quantitative sampling of macrofauna and smaller organisms on and in sediments. Their density is high enough that grab samples, covering areas of 600 to 2500 cm², give reliable results. The megafauna, however, are too large and rare for quantitative assessment with grabs, and all towed sampling gear, trawls, and dredges never collect quantitatively. During the last few decades, underwater photography has developed (Hersey 1967a) a broad spectrum of applications. Photographic systems are able to detect the larger organisms; they provide information on their position on the sediment, on stones, or in holes; and they show the sediment surface structure, including bioturbation. The term *megafauna* was coined for those large organisms to be counted quantitatively from photographs (Grassle *et al.* 1975).

My own experience with tethered cameras, hanging down vertically and drifting along with the ship at a distance of 3 meters above the bottom, revealed a number of limitations. It is rarely possible to keep the camera at a constant distance from the bottom. As a result, the size of the area covered in single frames varies from frame to frame, so that the scale of the

organisms has to be figured differently and there is variable detectability of the organisms in the same series of photographs. In addition, because the ship drifts, its track is not a straight transect and the single exposures are not equally spaced. For these reasons a photosled was constructed that—by definition of a sled—glides along the transect with constant bottom contact. This method assures:

1. The camera maintains a nearly constant distance from the bottom and from organisms.
2. The distance between camera and objects is small.
3. Photographs are equally spaced.
4. The transect is straight.

This paper gives a brief description of the photosled and reports on the experiences gathered during transect photography in various environments.

Other photosled systems are the French "Troika" (Giermann 1966; Hersey, 1976b) and a sled-mounted camera (Wigley and Theroux 1970; Wigley, Theroux, and Murray 1975). For transect photography, manned submersibles are well suited (Barham, Ayer, and Boyle 1967; Grassle *et al.* 1975; Rowe, Polloni, and Haedrich 1975), but, of course, the need for technical and financial support is much greater for submersibles than for photosled work. Uzmann, Cooper, Theroux, and Wigley (1977) compare the two techniques for estimating abundance and distribution of selected megafauna and arrive at the conclusion that direct observation from a submersible is superior to photographic assessment, where the bottom topography does not allow the deployment of a photosled. Rice, Aldred, Billett, and Thurston (1979) mounted their camera system to their epibenthic sledge to combine transect photography with animal trawling. This technique serves both functions and helps in the determination of organisms from photographs.

DESCRIPTION OF THE PHOTOSLED

The photosled was described by Thiel (1970) and later developments within the system are given in Türkay and Thiel (1977). The sled itself was devised by Dr. W. Blendermann (Institut für Schiffbau der Universität Hamburg) for the following specific qualifications:

1. To carry and protect a heavy camera system suitable for deep-sea lowerings; and
2. To pass over obstacles about 0.6 m high without any difficulties.

To accomodate these characteristics, the sled (Figures 1 and 2) was 4.4 m long, 2.05 m wide, and 1.9 m high, including a roll-over frame for turning the sled back onto its skids in case it overturned. The sled weighs 1 mt.

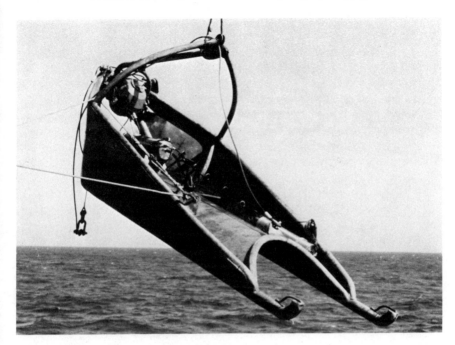

Figure 1. The photosled equipped with the camera (spherical pressure case), the flash beyond the camera, and the battery in the rear. The bridle hangs down the front of the sled and the safety wire runs across the top of the roll-over frame to the rear end.

The bottom plate (Figure 1) of the sled is bent up between the skids, so that bottom contact is as small as possible and so that any mud clouds that are stirred up are kept beyond and behind the sled.

For deep-sea transects, a long spool of film is required for more efficient use of towing time. Therefore, a Robot-motor-camera was chosen, equipped with a 60-m cassette, to give 1600 frames measuring 24 × 36 mm. No deep-sea housing large enough for this system was available, so it was encased in an aluminum alloy sphere, together with an adjustable timer for the exposure frequency (2.5 sec or more) and for presetting the start time. The inner diameter of the sphere measures 330 mm, the outer 420 mm. The sea-water-resistant sphere is mounted with four shock absorbers between the sled and the camera housing. It can be turned around its axis to adjust the photographic angle.

The camera is equipped with an Ennalyt lens 1:4.0/24 mm, with a 51° angle of view. The film level is mounted 1 m above the bottom and the focal distance is 1.3 m. While in the beginning cameras with a 24 × 24 mm

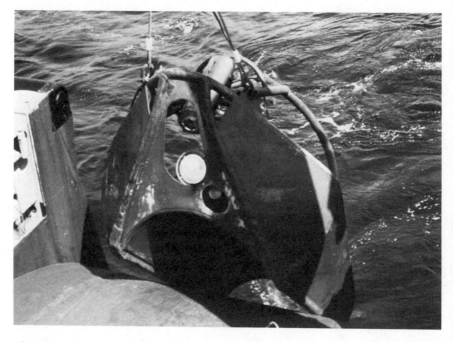

Figure 2. The photosled is being lowered. It is equipped with the Benthos Survey Camera, the flash, and the pinger, which is seen through the porthole below and to the right of the flash.

negative format were used, later a negative format of 24 × 36 mm was chosen when a data log was built in, to record frame number, time, and station data. The frame beyond the data log covers an area of 1 m² at a photographic angle of 30° from the vertical.

The flash unit is centrally mounted beyond the camera in a nearly horizontal position, to assure good modeling with the help of shadows of objects standing up from the bottom. The flash energy is 60 W-sec, the flash time 0.5 msec, and the recharging time 2 sec.

Two nickel-cadmium batteries with 24 volts are mounted in a pressure case at the back of the sled as an energy source for both the flash and the camera. Fully charged batteries contain enough energy for 3000-4000 flashes.

In addition to the described system, produced by Ingenieur Büro G. Eber, Mollhagen, in cooperation with IBAK, Kiel (both in West Germany), we successfully used the Survey Photographic System from Benthos, Inc., North Falmouth, Massachusetts. This camera can make twice the number of exposures in a single lowering as can the camera system described above.

The choice of film type is partly determined by the possibilities of

processing. Most of the materials are not regularly processed in great lengths (at least not in Europe). I recommend the types used for television films, because many companies process that material excellently. For the time being I am working with Kodak Negative II 100 ASA. This type has the additional advantage that the positive copy can be used for evaluating the photographs, while the negative original is stored safely and only handled for the preparation of prints. This procedure keeps the originals unscratched and in good condition.

Towing of the photosled was achieved from various research ships, on a 14- or 16-mm wire, connected to the sled's bridle via a weak link, 0.5 m of 8-mm wire. A 16-mm safety wire connects the main wire loosely with the back end of the sled. If the sled becomes entangled, the weak link should break first and the sled may then be pulled up back end first. This happened twice on rocky bottoms in the Red Sea, but the photosled was retrieved successfully both times. In shallow water deployments, 100 m of nylon rope between the ship's wire and the sled's bridle or the weak link takes off some extra tension from uneven bottom configurations and less sediment may be whirled up.

EXPERIENCES WITH THE PHOTOSLED

A photosled with bottom contact can easily disturb the bottom and whirl up clouds of mud, obscuring the images. This happens regularly when the sled first touches the bottom and it may happen during towing when dune-like structures have to be passed. Such events can be minimized by paying out the right amount of wire. Too short a wire could mean that no bottom contact is achieved or that the sled easily lifts up from the bottom when the wire tension increases slightly. Too much wire paid out may disturb the bottom if the slack hangs down into the sediment in front of the sled.

Optimal wire length has to be paid out, and this depends on such variables as the ship's speed, wire diameter and weight, the sled's weight, and its water resistancy. In most situations, speed over bottom cannot be measured accurately and currents along the bottom and in intermediate depths influence the optimal wire length to an unknown extent. For use with the photosled, but applicable to all other gear as well, Blendermann (1969) produced graphs from which the ratio of wire length to water depth can be determined. For the photosled system including the 16-mm wire, and with a speed of 2 knots (2 m/sec), a ratio of 2.5 is calculated for most depths. I used this factor successfully, allowing the factor to change to 2.2

when towing upslope or to 2.8 on downslope transects. The photographic success showed that Blendermann's graphs are very helpful.

For several years a 10-kc pinger (Institute of Oceanographic Sciences, Wormley, Great Britain) has been mounted parallel to the flash, sounding through the front opening. Most important for gear towed along the bottom is this pinger's event mark, signaled to the ship when proper bottom contact of the sled is reached. The wire length at the moment of first bottom contact is suboptimal because the sled lifts up easily when the wire tension increases slightly due to changes in bottom friction or ship's speed. With the help of the pinger, a wire length/depth ratio of 2 was worked out to be optimal. Pinger systems are range-limited by their capacity, and in my system the sound records faded away on the graph when 5000 m of wire were paid out over a depth of 3000 m. The application of factor 2, using 6000 m of wire, resulted in a good transect again. When both methods were evaluated, Blendermann's graphs and the pinger's records, it was found that quite a wide range of this ratio is applicable for successful photography of the sea bottom with its sediment structures and its megafauna.

Working on transects up- or downslope results in a change in the wire length/depth ratio, and this has to be adjusted several times. This can be done continuously or in intervals. With continuous heaving or rolling it is difficult to regulate the winch speed and to calculate the distance between exposures, because the sled's speed differs from that of the ship. With interval adaptation of wire length, some frames may not be useful, but the losses are minor.

The main problems in sled towing are related to bottom configuration. Sandy, rather hard bottoms (Figures 3 and 4) and most soft bottoms (Figure 5) do not create any difficulties, but rocky seabeds (Figure 6) and very soft muds can become dangerous. In the rocky, calcareous, fossil reefs around the edge of the continental shelf off Northwest Africa the photosled got stuck several times. On Josephine Seamount it dropped into a hole or fissure about 10 m deep, and in the Red Sea it was caught in rocks, when I tried to lower it down into the narrow and short Wando Terrace (1900 m deep) right beside the Atlantis II Deep. By careful maneuvering of ship and winch and steady observation of the tension meter, the photosled was always safely recovered. It showed some rock scouring marks, and once the camera sphere was turned and the plastic flash front was broken, but so far nothing serious has occurred. On Josephine Seamount the photosled was towed across a very heavily bouldered seabed (Figure 6) with no damage at all.

Other difficulties arose from deep mud bottoms. Trying to photograph the transition zone between the common deep sediments and the metalliferous muds of the Atlantis II Deep in the Red Sea, the photosled sank into

Figure 3. Sandy bottom with patches of *Coenosmilia fecunda* (Madreporaria) between sponge-covered coral debris and some *Ellisella flagellum* (Gorgonaria) with the lower left specimen carrying ophiuroids. (Great Meteor Seamount, *Meteor* cruise 19, 1970. 320–335 m depth, Kodak Ektachrome EF)

Figure 4. Sandy bottom with gastropod shells and flat biogenic rocks. (Red Sea, *Valdivia* cruise 19, 1981. 696–758 m depth, Kodak Color Negative II)

Figure 5. Abyssal plain muddy sediment with highly structured surface, fecal pellets, migration and feeding tracks, and with *Actinauge abyssorum* (Actinaria). (East Atlantic, *Walther Herwig* cruise 39/84, 1980. 5170 m depth, Kodak Plus X Negative)

the mud so deeply that the flash was totally clogged and the film did not receive any light. The same happened in the area of the East Atlantic abyssal hills. Some frames show mud clouds, and all the others were not exposed to light. To avoid this sort of failure, the first bottom contact of the sled should be made under conditions of optimal wire length and speed. The wire should be paid out while the ship is moving at 4 knots; that is, the sled should not come down to the bottom with factor 2. When the optimal length of wire is out, the ship should slowly reduce its speed to 2 knots, and the sled will then slowly sink to the bottom at the wanted speed and wire length right from the first bottom contact.

CONCLUSIONS

The photosled was successfully employed on several expeditions and in depths between 40 and 5400 m with a total of 55 lowerings, recording bottom and fauna from a variety of environments: the North Sea with gravel and ripple marked bottom, the tops of Atlantic seamounts

Figure 6. Rocky bottom. (Josephine Seamount, *Meteor* cruise 21, 1970. 215–240 m depth, Kodak Ektachrome EF)

with sandy sediments, biogenic rocks and large boulder fields, the continental shelf and slope of the Northwest African upwelling region with sands and muds, and the deep sea of the Atlantic Ocean, the Mediterranean, and the Red Sea with sandy sediments and oozes. The photos revealed information on megafauna standing stock, depth zonation, and patchy distribution (Türkay and Thiel 1977; Thiel in press a and b). The photosled proved to be a useful piece of equipment and became an important addition to sampling gear.

ACKNOWLEDGMENTS

The development of the photosled was made possible through funds from the Bundesministerium für Forschung und Technologie der Bundesrepublik Deutschland and the subsequent research was mainly supported by the Deutsche Forschungsgemeinschaft and partly by the above mentioned ministry. I am grateful to the Deutsche Forschungsgemeinschaft and to Benthos, Inc., for enabling me to participate in this symposium.

REFERENCES

Barham, E. G., N. J. Ayer, and R. E. Boyle. 1967. Macrobenthos of the San Diego Trough: Photographic census and observations from bathyscaphe *Trieste*. *Deep-Sea Res.* 14:773–784.

Blendermann, W. 1969. Diagramme zur Bestimmung der Längen und Kräfte für eine Schlepptrosse bei ebener Belastung. Hamburg: Institut für Schiffbau der Universität (Schrift Nr. 2163).

Grassle, J. F., H. L. Sanders, R. R. Hessler, G. T. Rowe, and T. McLellan. 1975. Pattern and zonation: A study of the bathyal megafauna using the research submersible *Alvin. Deep-Sea Res.* 22:457-481.

Giermann, G. 1966. Tauchkugel "Soucoupe Plongeante" und Fotoschlitten "Troika", zwei neue Werkzeuge für die geologische Unterwasserkartierung. *Dt. hydrogr. Z.* 19:170-177.

Hersey, J. B. (ed.). 1967a. *Deepsea photography.* Baltimore: John Hopkins Univ. Press.

Hersey, J. B. 1967b. The manipulation of deepsea cameras. In *Deepsea photography,* ed. J. B. Hersey, 55-67. Baltimore: John Hopkins Univ. Press. p. 55-67.

Rice, A. L., R. G. Aldred, D. S. M. Billett, and M. H. Thurston. 1979. The combined use of an epibenthic sledge and a deepsea camera to give quantitative relevance to macrobenthos samples. *Ambio Spec. Rep.* 6:59-72.

Rice, A. L., R. G. Aldred, E. Darlington, and R. A. Wild. In preparation. The quantitative estimation of the deepsea megabenthos; A new approach to an old problem.

Rowe, G. T., P. T. Polloni, and R. L. Haedrich. 1975. Quantitative biological assessment of the benthic fauna in deep basins of the Gulf of Maine. *J. Fish. Res. Board Can.* 32:1805-1812.

Thiel, H. 1970. Ein Fotoschlitten für biologische und geologische Kartierungen des Meeresbodens. *Mar. Biol.* 7:223-229.

Thiel, H. In Press, a. Zoobenthos of the CINECA area and other upwelling regions. *Rapp. P. -v. Réun. Cons. perm. int. Expl. Mer.*

Thiel, H. In Press, b. Community structure and biomass of the benthos in the central deep Red Sea.

Türkay, M. and H. Thiel. 1977. Unterwasserbeobachtung von Crustacea Decapoda Reptantia und Stomatopoda mit Hilfe eines Fotoschlittens. (In German and Japanese.) *Res. Crust.* 8:1-16.

Uzmann, J. R., R. A. Cooper, R. B. Theroux, and R. L. Wigley. 1977. Synoptic comparison of three sampling techniques for estimating abundance and distribution of selected megafauna: Submersible vs. camera vs. other trawl. *Mar. Fisheries Rev.* 39:11-19.

Wigley, R. L. and R. B. Theroux. 1970. Sea-bottom photographs and macrobenthos collections from the continental shelf off Massachussetts. *U.S. Fish. Wildl. Serv. Spec. Sci. Rep. Fish.* 613.

Wigley, R. L., R. B. Theroux, and H. E. Murray. 1975. Deepsea Red Crab, *Geryon quinquedens,* survey off Northeastern United States. *Mar. Fisheries Rev.* 37:1-21.

Photographic Systems Utilized in the Study of Sea-Bottom Populations

Roger B. Theroux

*National Oceanographic and
Atmospheric Administration
National Marine Fisheries Service
Woods Hole, Massachusetts*

INTRODUCTION

Since 1953 the Benthic Dynamics Investigation at the Woods Hole, Massachusetts, Laboratory of the Northeast Fisheries Center (NEFC), a component of the National Oceanic and Atmospheric Administration's (NOAA) National Marine Fisheries Service (NMFS), has been concerned with the distribution and abundance of sea-bottom dwelling invertebrates. This concern with the benthic fauna relates to the importance of a large number of its components in the diets of the commercially important species of groundfishes.

Initially, the principal area of investigation extended from the Bay of Fundy in the northeast to the Hudson Canyon in the southwest. Within this area intensive quantitative and qualitative sampling was conducted in the Gulf of Maine; on offshore fishing grounds such as Georges Bank, Browns Bank, and Stellwagen Bank; and on the southern New England continental shelf. Several thousand samples yielding information on surficial sediments and benthic organisms were obtained during the period from 1953 to 1963.

In 1963 the scope of the investigation broadened substantially as a result of participation in a joint program of study with the Woods Hole Oceanographic Institution (WHOI) and the U.S. Geological Survey (USGS)

(Emery and Schlee 1963). The study expanded to include the entire east coast continental shelf and slope between Nova Scotia and Key West, Florida. This program also provided several thousand quantitative and qualitative samples of sediments and their associated fauna. Up to the present, the Benthic Dynamics Investigation has garnered a total of more than 11,500 quantitative and qualitative samples from the sea bed.

The acquisition of samples during the early period (prior to 1963) was accomplished using traditional sampling devices including various bottom grabs, dredges, and trawls, all of which are relatively inefficient, tedious, and expensive to use (Wigley and Emery 1967). With the inception of the joint WHOI, USGS, and NEFC program, a different sampling strategy was initiated. In order to optimize the yield of data from grab samples, with their inherent bias of underestimating the surface-dwelling components of the epibenthic fauna (Wigley and Emery 1967), a new combination camera and bottom grab, developed at the University of Southern California (Menzies, Smith, and Emery 1963), was used to obtain quantitative samples for biological and geological analysis. Several thousand sample/photograph pairs were obtained from the study area, providing a great deal of detailed information on the distribution and relationships of the epibenthic macrofauna and sediments, hitherto unobtainable by traditional means, except at great expense with manned submersibles. Furthermore, the reluctance of biologists to identify organisms in photographs was, to some degree, overcome by the possession of sample/photograph pairs that were virtually identical in space and time (Emery and Merrill 1964; Emery et al. 1965).

Beginning in 1965, greater effort and emphasis was placed on obtaining information about the distribution, abundance, ecological relationships, and assemblages of the larger components of the benthos, the mega- and macrobenthos, composed of lobsters, crabs, shrimps, and other large invertebrates. Since these organisms have expansive distributions on the continental shelf and slope, obtaining the desired information would require wide ranging cruises of long duration and great expense if traditional sampling methods such as grab, dredge, trawl, or pot, were employed. To increase accuracy and efficiency, and to expedite the collection of data on the ubiquitous mega- and macrofauna—and based on the experience gained in photographic techniques and photo analysis during the course of the joint program—we began experimenting with photographic systems mounted on towed, bottom-contact sleds. The choice of bottom-contact sleds, rather than other underwater photographic systems available at the time such as pogo or towed fish configurations, was dictated by our need to maintain ground truth (a fixed distance from the bottom) in our quest for quantifiable data.

Four research cruises, specifically targeted to mega- and macrobenthic studies, were conducted between 1965 and 1974, using sled-mounted photo-

graphic systems and traditional gear, principally scallop dredges and trawls, for comparative evaluation. These studies used a total of three different photographic systems, four separate configurations of the systems, and two different sled designs as platforms. Over 34,000 photographs were obtained with these systems. The photographic systems used, and examples of the results obtained, are described and illustrated in the following sections.

COMBINATION CAMERA-GRAB

The combination camera-grab was a modified version of the Campbell grab-camera device described by Menzies *et al.* (1963). The modification, by D. M. Owen of WHOI, involved the replacement of the original Hasselblad camera-flashbulb system with one composed of two spring-driven 35-mm Robot "Star" cameras with 30-mm lenses on a stereo mount and a Honeywell Strobotron light source (Figure 1).

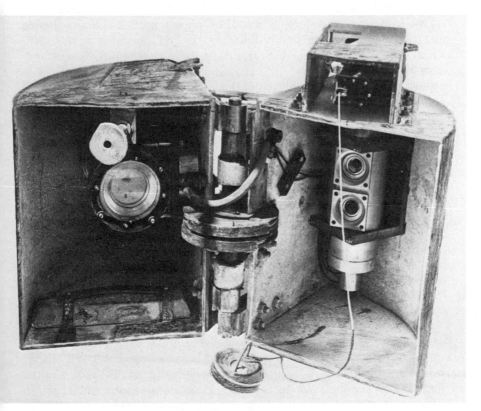

Figure 1. Combination camera–grab. Light source in left and stereo cameras in right bucket. Trip weight with compass and line are in foreground.

The grab is a heavy (250 kg (550 lb) empty air weight) clamshell type sampler whose large buckets enclose an area of 0.56 m² (6.03 ft²) and are capable of containing as much as 0.2 m³ (7.1 ft³) of bottom material. The stainless steel housings containing the photographic system elements are mounted, one within each bucket, in such a way that when activated at a distance of 1 m from the bottom, an area of 0.48 m² (5.2 ft²) is photographed, 72% of which is between the jaws of the grab (Emery and Merrill 1964; Emery *et al.* 1965).

The film load for these cameras is a standard 36-exposure magazine. One of the cameras was routinely loaded with black and white negative film (Plus X Pan rated at ASA 125) and the other with color transparency film (High Speed Ektachrome, Daylight Type, rated at ASA 160). The color photographs permitted the recognition of many organisms, especially smaller and encrusting types, whose color rendering in the black and white photos made them difficult, if not impossible, to perceive. The main advantage of black and white film was the relative ease with which it could be processed aboard ship to monitor focus, exposure, and other camera system functions.

This system provided many excellent photographs yielding valuable information on ecological and sedimentological relationships on the continental shelf and slope of the U.S. east coast. Several examples of representative photographs obtained with the camera-grab system are depicted in Figures 2, 3, 4, and 5. In addition to the works already cited, the interested reader may wish to consult the following for more information on results obtained with this system: Trumbull and Emery 1967; Wigley 1968; Wigley and Emery 1968.

TOWED SYSTEMS

Version I

The first version of a towed sled, used on the R/V *Albatross IV* in the summer of 1965, was 2.3 m (7.6 ft) long, 1.3 m (4.3 ft) high, 1.5 m (4.9 ft) wide, and weighed approximately 500 kg (1,100 lb) in air (Figure 6). The sled was of welded steel construction with flat plate steel runners 1.3 cm (0.5 in.) thick by 30.5 cm (12 in.) wide. The runners supported a framework consisting of upright triangles with reinforcing and connecting members constructed of 2.5-cm (1 in.) diameter solid bar stock steel. A 1-m diameter ring was welded between the uprights, perpendicular to the runners in the front third of the sled, and the photographic system was suspended within this ring. Two 1.9-cm (3/4 in.) thick plywood vanes fastened to the upright supports provided lateral stability during launch and retrieval, while four

Figure 2. Seafloor at station 1052 in the southern Gulf of Maine. Cruise: *Gosnold* 12; location 42°09' N, 69°14' W; depth: 194 m; lithology: sand and gravel with some pebbles to 8 cm. Identifiable animals: five burrowing sea anemones, *Cerainthus borealis.* Trip weight is visible at right center.

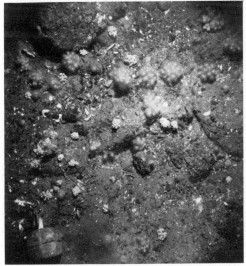

Figure 3. Seafloor at station 1158 southwest of Cape Sable. Cruise: *Gosnold* 22; location: 43°20'N, 66°13'W; depth: 61 m; lithology: mostly shell hash, with pebbles to 5 cm. Identifiable animals: northern coral, *Astrangia;* soft coral; bivalve shell remains; small starfish, and worm tubes.

hollow aluminum spheres, 16 cm (6 in.) in diameter, mounted at the top of the ring provided vertical lift and stability.

Photographic System. The photographic system consisted of a 35-mm Nikon F camera attached to a Nikon Electric Motor Drive, Model F 250. The lens was a 28-mm f/3.5 Auto Nikkor with a 74° angle of view. The camera was capable of 250 exposures from a 10-m (33 ft) film load (Kodak

Figure 4. Seafloor at station 1394 on the continental shelf south of Long Island, N.Y. Cruise: *Gosnold* 29; location: 40°44'N, 72°44'W; depth: 23 m; lithology: clean, quartzose sandy gravel, with some shell fragments. Identifiable animals: sand dollar, *Echinarachnius parma*; dead shells of northern cardita, *Cyclocardia borealis*; and surf clam, *Spisula solidissima*. Sand ripples, oriented NE–SW (note compass in trip weight) created by currents, reveal gravel fraction and shell in trough.

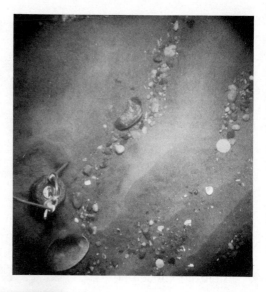

Figure 5. Sea bottom at station 1232 south of Cape Sable. Cruise: *Gosnold* 24; location: 43°10'N, 64°30'W; depth: 158 m; lithology: brown silty clay. Identifiable animals: worm tubes and holes. Sediment surface contains numerous tracks and other bioturbations.

Plus X Pan). Exposures were made at 15-second intervals once the sled reached the bottom.

The water-tight housing for the camera was a stainless steel cylinder with a viewing port of optical glass, mounted on a machined surface welded into the side of the cylinder. It was custom manufactured for us by Benthos, Inc. of North Falmouth, Massachusetts. In addition to the camera, the housing contained a 12-V power supply for the camera as well as a presetable

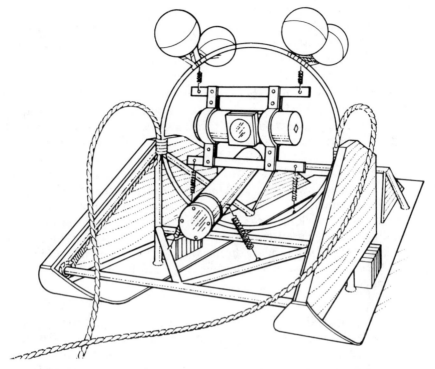

Figure 6. Towed bottom-contact camera sled, Version I.

delay timer switch designed to prevent unnecessary exposures during descent to the bottom.

The light source, also manufactured by Benthos, Inc. was a dry battery type, deep-sea electronic flash unit, of 100 watt-second output with a 12-second recycle rate. The flash tube was encased in a glass envelope to which a standard, 30.5-cm (12 in.) diameter, polished aluminum photo lamp reflector could be fastened with a worm gear type hose clamp. However, in order to reduce "hot spots" and increase light directionality, free-flooding snoots, constructed of PVC tubing, lined with reflecting aluminum foil and faced with graded neutral density filters sandwiched between clear acrylic plates were used instead of the standard reflector. The snoots were fastened to the housing over the flash tube envelope. The stainless steel cylindrical housing, with strategically placed pad eyes for ease of mounting, contained all of the strobe electronics and three 510-V batteries required to power the unit.

The camera and light source were electrically interconnected with Mecca M-16 series, #1726 female cable connectors on 18 AWG MCMB type neoprene jumper leads.

To aid in recovery, in case of loss during towing, a locating device consisting of a small, brightly colored buoy, tethered to the rear of the sled with a suitable length (2:1 scope for depth) of 0.9 cm (3/8 in) diameter polypropylene line was used.

System Configuration. The system configuration used on this sled placed the lens nodal point 1 meter above the bottom of the runners, along the central axis of the sled, facing forward at an angle of 45° from vertical. This placement resulted in a photograph covering 1.2 m² (13 ft²) of bottom area. The nodal point of the light source was 30.5 cm (12 in.) from the bottom, below and slightly forward of the camera, at an angle of 60° from vertical. This placement resulted in fairly uniform and directional illumination with good modeling of the area to be photographed. Both elements of the system were shock mounted within the sled's ring by means of several heavy-duty expansion springs under moderate tension to reduce vibrations generated by the runners during towing. The shock mounting, coupled with the fast exposure time (about 1/1000 to 1/1200 sec) ensured sharp images.

Method of Operation. The sled was launched through a stern ramp on the vessel by means of a movable gantry, and was towed from a V bridle attached to a steel cable. The bridle, of 3.2-cm (1.25 in.) diameter nylon hawser 3.1 m (10 ft) long, acted as a mild shock absorber. Its ends were fastened to a horizontal cross member just behind the leading edge of each runner, then were led up and back and made captive at the midpoint of each side of the ring. This arrangement kept the bridle out of the picture area and did not affect towing stability. The bridle was fastened by a swivel shackle to a 1.3-cm (1/2 in.) diameter steel wire cable for actual towing.

Towing speed was 1.5 to 2 knots, measured by a calibrated digital speed log. Tow duration was 15 to 60 minutes at a wire vs. depth scope of 1.5:1.

This sled, used at four stations on Georges Bank at depths ranging from 48 to 329 m (157 to 1,079 ft), provided 414 usable photographs of the bottom and its associated fauna, examples of which appear in Figures 7, 8, 9, and 10. Results of studies using this photographic system were reported in Wigley and Theroux (1970 and 1971).

Version II

The second experimental towed camera system was tested in April 1967 during a short cruise by the R/V *Albatross IV* to Georges Bank. The purpose of the cruise was to test and evaluate a system for photographing

Figure 7. Mating northern starfish, *Asterias vulgaris,* at station 5 south of Martha's Vineyard. Cruise: *Albatross IV* 65–11; location: 40°71′ N, 71°00′W; depth: 59 m; lithology: dark olive green sandy silt.

Figure 8. Asymmetric ripple pattern of the bottom at station 44 on southeastern Georges Bank. Cruise: *Albatross IV* 65–11; location: 41°14′ N, 67°04′W; depth: 64 m; sediment: brown sand. View is facing northeast, current flow creating ripples was northwesterly unearthing small pebbles and shell fragments.

large invertebrates, and to establish the northernmost occurrence boundary of the seastar *Astropecten americanus.* The sled platform described above, with modifications to the camera mounting arrangement, was used for these trials (Figure 11). The new mounting consisted of a framework constructed of galvanized structural Flexangle that was fastened to the bars of the sled by means of U bolts. The use of this material resulted in a great deal of versatility and flexibility in camera and light placement and viewing angles.

Photographic System. The camera used in this system was an EG&G Model 200 Underwater Camera equipped with a fully corrected Hopkins 35-mm focal length, f/4.5 lens, providing a 51° horizontal and 38° vertical angle of view in water. The film load consisted of 30.48 m (100 ft) of film

Figure 9. Red hake, *Urophycis chuss,* and sea scallop, *Placopecten magellanicus,* interrelationship. Cruise: *Albatross IV* 65–11; station 44 on southeastern Georges Bank. Environmental data same as for Figure 8.

Figure 10. Sea bottom at station 45 on southeastern Georges Bank. Cruise: *Albatross IV* 65–11; location: 41°14' N, 66°39'W; depth: 82 m; sediment: brown sand. Identifiable animals: green sea urchin, *Strongylocentrotus drohbachiensis;* Acadian hermit crab, *Pagurus acadianus;* Stimpson's distaff shell, *Colus stimpsoni;* sand dollar, *Echinarachnius parma;* ocean quahog shells, *Arctica islandica.*

capable of 500 exposures. The film used was Kodak Plus X Pan for black and white and High Speed Ektachrome for color. The camera was housed in a stainless steel tube with the lens oriented along the axis of the cylinder. Exposures on the bottom were made at 15-second intervals.

Light was provided by an EG&G Model 210 Underwater Light Source of 100 watt-second output with a 12-second recycle time. The stainless steel housing, similar to the one for the camera, contained, along with the strobe electronics, the 6-V power supply (a silver-zinc wet, four-cell, rechargeable battery) for the entire system (camera and light source), and a two-hour clock-driven mechanical time delay switch. The standard polished aluminum 30.5-cm (12 in.) diameter reflector provided with the unit was used.

A tethered buoy system, similar to that used on the first sled, served as a locating device in case of loss.

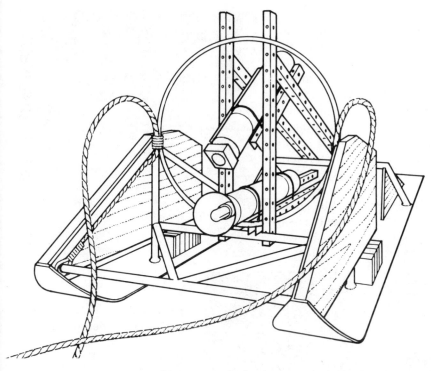

Figure 11. Towed bottom-contact camera sled, Version II.

System Configuration. Camera and light source housings were shock mounted to the Flexangle supports by means of automobile motor mounts and pipe hanger straps to prevent interference or damage caused by vibration. The nodal point of the camera lens was 1 m from the bottom, centrally located in the ring, facing forward at an angle of 60° from vertical. It photographed an area covering 8.06 m² (87 ft²). The nodal point of the light was 30.5 cm (12 in.) from the bottom, directly below and slightly forward of the camera, facing forward horizontally. This placement yielded the amount of bottom modeling sought for heightened subject visibility and contrast.

Method of Operation. The same launching and towing methods described for the first sled were used with this version.

Eight tows were made with this system at four stations ranging from 51 to 101 m (167 to 331 ft) in depth on Georges Bank. Fifteen hundred usable photographs were obtained (900 in black and white, 600 in color) with this system. Examples are shown in Figures 12, 13, 14, and 15.

Figure 12. View of the bottom at station 1 on south-central Georges Bank. Cruise: *Albatross IV* 67–6; location: 41°07'N, 67°39'W; depth: 51 m; sediment: fine gray-white sand with shell. Identifiable animals: sand dollar, *Echinarachnius parma;* northern starfish, *Asterias vulgaris;* Acadian hermit crab, *Pagurus acadianus;* moon snail, *Lunatia heros;* New England nassa, *Nassarius trivittatus.* Bioturbations are clearly evident.

Figure 13. Sea bottom at station 4 on southeastern part of Georges Bank. Cruise: *Albatross IV* 67–6; location: 40° 41'N, 67°20'W; depth: 101 m; sediment: fine olive-green silty sand with shell. Identifiable animals: starfish, *Leptasterias;* ocean quahog, *Arctica islandica,* shells overlain with sediment; bramble shrimp, *Dichelopandalus leptocerus.* A cratered cone and animal tracks are also visible.

Version III

The third bottom-contact photographic system was used in June 1973 during a research cruise of the R/V *Delaware II.* The purpose of this Megabenthic Invertebrate Inventory cruise was to develop a methodology for a rapid, economical inventory of the offshore stocks of lobsters, crabs, and shrimps. In addition to the towed photographic system, three other methods were tested: (1) direct sampling with otter trawls; (2) direct

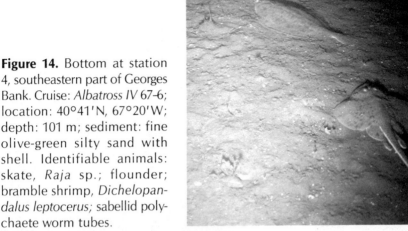

Figure 14. Bottom at station 4, southeastern part of Georges Bank. Cruise: *Albatross IV* 67–6; location: 40°41'N, 67°20'W; depth: 101 m; sediment: fine olive-green silty sand with shell. Identifiable animals: skate, *Raja* sp.; flounder; bramble shrimp, *Dichelopandalus leptocerus;* sabellid polychaete worm tubes.

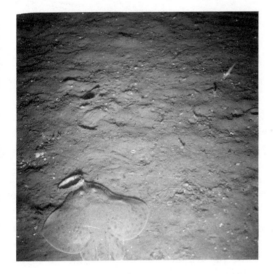

Figure 15. Another view of the sea bottom at station 4. Identifiable animals: skate, *Raja* sp.; shell of ocean quahog, *Arctica islandica;* bramble shrimp, *Dichelopandalus leptocerus.*

sampling with baited pots; and (3) visual observations from a submersible. The evaluation of the applicability of the different methods for megabenthos inventorying is reported in Uzmann *et al.* (1977).

Towed Underwater Benthic Sled (TUBS). The sled prototype, designed by the author and fisheries engineers at the NEFC, was 2.7 m (9 ft) long, 1.9 m (6 ft, 8 in.) high, 2.1 m (7 ft) wide, and weighed 1,225 kg (2,700 lb) in air (Figure 16). The superstructure was constructed of 6.4-cm (2.5 in.) diameter schedule 80 steel pipe welded to two 2.5-cm (1 in.) thick curved

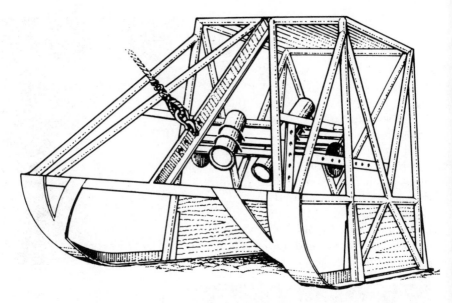

Figure 16. Towed Underwater Benthic Sled (TUBS). Bottom-contact camera sled, Version III.

steel plate runners 25.4 cm (10 in.) in width. A subframe assembly constructed of 7.6 x 7.6 cm (3 x 3 in.) by 0.95-cm (3/8 in.) thick angle iron was welded within the upper two thirds of the superstructure to provide support and variable points of attachment for rotatable camera and light mounts. The towing point, in the midline of the sled, was a reinforced flat steel bar 7.5 cm (3 in.) wide by 2.5 cm (1 in.) thick extending from the upper to the lower front support cross members. A series of 2.5-cm (1 in.) diameter holes bored into this member provided variable attachment points for fastening the towing hawser. Lateral stability, during launch and towing, was provided by two sheet steel plates, one on each side, welded to the inside lower third of the superstructure. Vertical stability, especially during launching, was provided by a perforated sheet of 1.9-cm (3/4 in.) marine plywood fastened horizontally within the uppermost structural members. Twelve (six on each side) 16-cm (6.3 in.) diameter, syntactic foam-filled, plastic, trawl headrope floats attached to the upper longitudinal structural members provided sufficient flotation to ensure an upright attitude during descent to the bottom. The center of gravity was kept low by the addition of 90.7 kg (200 lb) of lead ingots to each runner.

Photographic System. The camera of the photographic system used on TUBS was a Hydro Products deep-sea photographic camera Model PC-705 equipped with a fully-corrected Leitz water contact 43.7-mm f/2.8 lens

with a viewing angle of 65° in water and a data chamber providing time of day, frame number, and station number for each exposure. Fully loaded with 30.48 m (100 ft) of 70-mm (2¼ in. square) film (Kodak Plus X Pan for black and white, or Ektachrome EF Type 5241 for color transparencies), the camera was capable of providing 400 exposures. The cylindrical housing is of hard-anodized, epoxy painted aluminum, with a certified depth rating of 9,144 m (30,000 ft), and an operating depth range to 6,096 m (20,000 ft). Exposures were made at 10-second intervals on the bottom.

Light was provided by a Hydro Products deep-sea strobe Model PF-730. The power output of the strobe was 200 watt-seconds with a recycle time of 6 seconds. The strobe had a built-in parabolic reflector providing a uniform light pattern. Housing material and configuration were the same as for the camera.

Power required by both the camera and strobe was provided by a Hydro Products Model BP-708 battery pack. This pack provides 24 V DC power from 7 ampere-hour rechargeable nickle-cadmium batteries, as well as system on-off control and a mechanical, clock-driven, timer delay switch. Batteries were recharged (approximately 14 hours) by a Model BC-605 charger. A fully charged battery pack allowed the exposure of two rolls of film, about 800 exposures. The cylindrical housing was of material similar to that for the camera and strobe.

A large, inflatable buoy fastened to the stern of the sled by means of a suitable length of 0.95-cm (⅜ in.) polypropylene line served as a locating device.

System Configuration. The housings of the camera and strobe were fastened to rotatable mounts by means of large, stainless steel U bolts affixed with vibration-proof lock nuts. The mounts were fastened to the internal mounting frame by means of 1.3-cm (½ in.) stainless steel bolts and lock nuts, in the desired location and orientation and locked into position.

The camera lens nodal point in this system was 1 m from the bottom facing forward in the central longitudinal axis of the sled, at an angle of 45° from vertical. This placement resulted in a view of 4.29 m² (46.2 ft²) of bottom area between the runners from approximately the region of the forward upright support member to slightly forward of the leaning edge of the sled. The area covered was determined by mounting a frame containing a 10-cm grid equiplanar to the runners within the field of view and photographing it under water (Figure 17).

The strobe light, also along the midline, was positioned in front of the camera with its nodal point 1 m above the bottom and angled forward 60° from vertical, providing even illumination of the area viewed by the camera lens.

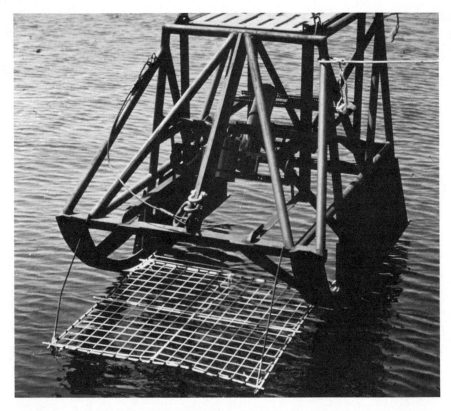

Figure 17. Preparation for calibration test of TUBS system. The calibration frame, at the focus plane, contains a 10 x 10 cm grid covering an area slightly larger than that viewed by the lens.

The battery pack was placed in the stern of the sled, for convenience in changing batteries, along the midline, on a support constructed of Flexangle.

Method of Operation. The stern of *Delaware II* is equipped with a ramp and a fixed towing gantry. The floor, or bed, of the ramp is movable, by means of hydraulic rams, from vertical (closing off the stern to the sea) to about 45° in the towing position. The gantry spans the ramp from the port to the starboard rails bisecting it at the midpoint. Variable attachment points along the gantry allow for optimum placement of towing blocks; the midline position was used for the sled. A heavy A-frame davit, fastened horizontally to the after surface of the gantry in the midline of the vessel, and extending beyond the fantail, was used in conjunction with a winch on the boat deck to position the sled in the chute prior to launch.

The sled was towed by the main winch trawl wire (2.5 cm diameter, 1 in.)

that was mated, by a swivel shackle, to 45.7 m (150 ft) of 6.4-cm (2.5 in.) diameter nylon hawser (acting as a shock absorber) that was, in turn, shackled to the towing bar of the sled. The hawser and wire passed through a large swivel block in the center of the gantry.

Launch preparations, with the vessel moving forward slowly, involved positioning the sled in the stern ramp with the rear of the runners awash (Figure 18), deploying the location buoy, and moving the vessel to the launch point. Upon arrival on station the ship's propellor was disengaged, and when it stopped, the winch brake was released launching the sled. The propeller was re-engaged after the hawser had passed through the towing block. Launching with the propeller turning often caused the sled to be overturned by turbulence striking the bottom of the runners; with the propeller stopped this problem never occurred. Tows were made at 1.5 to 2 knots, measured by a calibrated digital speed log, for from 30 to 75 minutes depending on local topography. Suitability of the bottom for

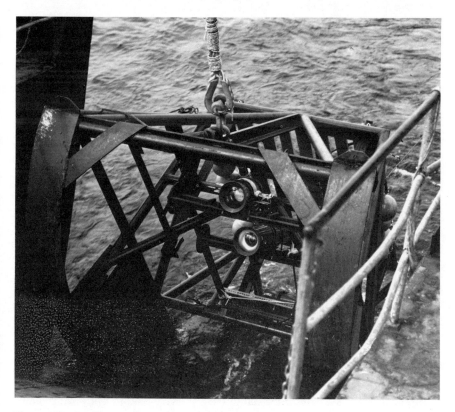

Figure 18. Position of TUBS in the stern ramp of *Delaware II* immediately prior to launch.

towing TUBS had been evaluated immediately prior to launch by means of fathometer tracings of the area. Wire scope was 1.5:1.

Retrieval of the sled was somewhat more complicated than launching since the position of the towing block on the gantry caused the sled to be suspended vertically within the ramp rather than resting on the floor of the ramp. Elevating the floor of the ramp to the vertical position allowed the sled to be stabilized on its runners within the chute. While in this position, a wire rope pennant permanently attached to the towing bar of the sled was passed over the top of the raised ramp and fastened, by means of a large jilson hook, to a hawser. The sled was dragged onto the deck by a windlass while simultaneously the ramp floor was lowered and the main wire was eased off.

The camera and battery pack were serviced on the main deck after each tow. The battery pack was replaced with a fully charged unit, the camera was reloaded with fresh film, and a short length (2 m) of exposed film was processed to monitor camera and light performance.

TUBS was towed a total of 51 times at depths ranging from 77 to 304 m (253 to 997 ft) in the Veatch Canyon area, yielding 14,000 analyzable photographs. These photographs permitted a detailed evaluation of the composition and distribution of the mega- and macrobenthos in the area as well as providing useful comparative data on the efficiency of this system versus the other survey methods used. Examples of photographs obtained are shown in Figures 19, 20, 21, and 22.

Version IV

Results obtained with TUBS in 1973 prompted us to use the sled again in 1974, this time on a cruise of R/V *Albatross IV* to survey the populations of the deep sea red crab, *Geryon quinquedens,* inhabiting the continental slope between Maryland and eastern Georges Bank. The primary purpose of this survey was to determine the distribution and abundance of the deep sea red crabs, with secondary objectives of determining the size composition of this crab stock and gathering additional biological information about the life history of this species. TUBS was used to obtain the distributional and abundance information, and a 16-foot semi-balloon otter trawl was used for direct measurements of a biological nature, such as size, weight, and sex. Results of this survey are reported in Wigley, Theroux, and Murray (1975).

Towed Underwater Benthic Sled (TUBS). The need to optimize the area viewed and covered for this survey necessitated some slight modifications

Figure 19. Bottom at station 23 in the Veatch Canyon area. Cruise: *Delaware II* 73-5; location: 39°55' N, 69°41' W; depth: 304 m; sediment: olive-green silty sand. Identifiable animals: burrowing sea anemone, *Cerianthus borealis;* jonah crab, *Cancer borealis;* porania starfish, *Porania insignis;* marlin-spike, *Nezumia bairdii;* sabellid polychaete worm tubes. Original in color.

Figure 20. Another view of station 23. Identifiable animals: burrowing sea anemone, *Cerianthus borealis;* jonah crab, *Cancer borealis;* spider crab; marlin-spike, *Nezumia bairdii;* sabellid polychaete worm tubes. Original in color.

to the original sled design. The length of the towing bar and its uppermost attachment point were altered, the rotatable camera and light mounts were replaced by rigid Flexangle and steel mounts, and provisions for the inclusion of a pinger type attitude/locating device were added (Figure 23). Otherwise, the sled was unchanged from its 1973 design.

Photographic System. The photographic system was the same as the one used in 1973 with regard to the camera, light source, and battery pack

Figure 21. Bottom at station 21 in the Veatch Canyon area. Cruise: *Delaware II* 73-5; location: 39°56'N, 69°41'W; depth: 163 m; sediment: silty sand. Identifiable animals: mosaic worm, *Onuphis conchylega;* short-finned squid, *Illex illecebrosus.* Mosaic worms, which almost pave this area, are seen congregated around and preying on two dead short-finned squid.

Figure 22. Bottom at station 22 in the Veatch Canyon area. Cruise: *Delaware II* 73-5; location: 39°55'N, 69°41'W; depth: 229 m; sediment: silty sand. Identifiable animals: burrowing sea anemone, *Cerianthus borealis;* bramble shrimp, *Dichelopandalus leptocerus;* munid crab, *Munida,* sp.; red hake, *Urophycis chuss.* The association of bramble shrimp and burrowing sea anemones depicted in this photograph was commonly seen in this area. Also involved in this behavior pattern were jonah crabs, munid crabs, lobsters, and fishes.

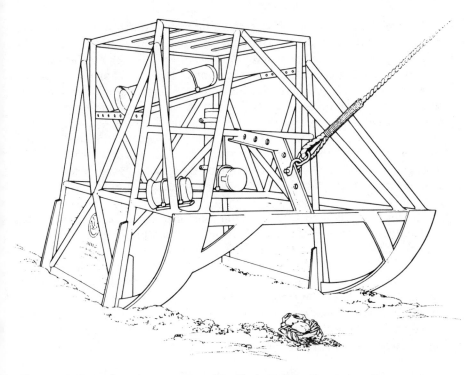

Figure 23. Towed Underwater Benthic Sled (TUBS). Bottom-contact camera sled, Version IV.

(see Version III); however, for this survey only Kodak Ektachrome EF Type 5241 color transparency film was used. The 1973 study showed that color photographs resulted in greater accuracy of identification and heightened visibility of the target organisms. Also, due to the greater depths to be sampled on this survey, the tethered buoy locating device became impractical and was replaced by a Hydro Products Model B-1055C chronometric abyssal pinger. This acoustic battery-operated pinger housed in a cylinder of hard anodized aluminum provides 12-kHz pulses with pulse lengths of 2 to 3 milliseconds at a precise pulse repetition rate of 1 per second in the vertical position and 2 pulses per second at tilts of 45° or more off axis. It is capable of operating to depths of 7,620 m (25,000 ft) for 10 days. The varying pulse rates of the pinger were useful in ascertaining the position of TUBS on the bottom after launching. Pinging rate was monitored on an EDO fathometer aboard the vessel during descent and towing. If a two-per-second pulse rate was heard, either at touchdown or during the tow, the towing wire was hauled in until the sled was righted (one-second pulse rate), then payed out again to its normal depth.

System Configuration. Camera and light placement on this version of TUBS differed significantly from the original configuration. One of the prime requirements for this survey was to survey as much area as possible within the alloted ship's time. To accomplish this, the camera was placed as high as possible on the mounting frame. A forward looking viewpoint was not possible because of the presence of the towing hawser, so a viewpoint perpendicular to the sled axis was used. The lens nodal point in this configuration was 1.75 m (69 in.) from the bottom, angled down 16° from horizontal on the right side of the sled. Thus, the area viewed by the lens was 147.3 m^2 (1,586 ft^2) as determined by mock-up tests photographing grid patterns in the Benthos, Inc. testing pool, and by tests in Vineyard Sound.

The light source and its cradle were fastened by U bolts to the main horizontal structural member just behind its juncture with the top of the runner. The nodal point of the strobe reflector was 1 m off the bottom, angled down 10° from horizontal and about 30° aft of perpendicular.

The battery pack and its cradle were bolted to the central cross member on the right side of the sled, and the pinger was fastened vertically, by means of pipe hanger straps, to the after, left vertical support member. Placement of these elements counterbalanced the weight of the camera and light source on the opposite side.

Method of Operation. The length of TUBS and the position and size of the movable gantry at the stern of *Albatross IV* initially posed some handling problems. The gantry, although able to handle TUBS in the stern ramp, was not capable of depositing the sled completely on the main deck, which is approximately 0.75 m (30-32 in.) below the inboard portion of the stern ramp. With the gantry in the inboard, horizontal position, the rear third of the runners remained on a large steel roller at the top of the stern ramp, where it was a safety hazard and was difficult to service. The remedy was the construction of a curved steel plate (to protect the roller) conforming to the curvature of the roller, affixed to a platform constructed of heavy-gauge channel and angle iron, reminiscent of an automobile servicing ramp, parallel to the deck at the height of the stern ramp and inboard of it to house the sled. The forward portion of the platform was provided with two removable channel iron ramps for dragging the sled from the platform to the deck when necessary.

Towing was effected from the port drum of the main trawl winch with 1,190 m (650 fms) of 1.6-cm (⅝ in.) and 3.111 m (1,700 fms) of 2.2-cm (⅞ in.) diameter steel wire cable. The smaller cable mated to the larger permitted attaining the desired sampling depths and reducing the weight of the entire array; at the deepest depths sampled, 30,118 kg (13,690 lb) of sled

and wire were in the water; the main trawl winch clutch has a 33,000 kg (1,000 lb) capacity. The nylon hawser shock absorber was used as before.

Launching involved positioning the sled on the stern ramp by means of the gantry, steaming slowly ahead to the launch point, then stopping the propeller and launching the sled. The propeller was re-engaged after the hawser had passed through the towing block. Towing speed, duration, and wire scope (1.5-2 knots, 75 min, and 1.5:1, respectively) were the same as for previous uses. Also, prior evaluation of topography with fathometers was routinely carried out at each sampling site.

Reversing the launch procedure was all that was required for retrieval after the tow. The entire launch/retrieve operation involved only two persons, the winch operator and the gantry operator.

Camera and battery pack were serviced after each tow, each receiving fresh film and batteries, respectively, in preparation for the next tow. As was the custom on all of our photographic missions, a short length (about 2 m) of film was processed to monitor camera and light performance. The exclusive use of color film on this cruise did not present any special problems. Although processing time was somewhat longer for color film than for black and white (Ektachrome process E-4 time is 56 minutes versus about 26 minutes for black and white), a trawl tow followed the camera tow so ample time remained, while on station, to process and examine the previously exposed film and make whatever adjustments may have been required.

During this survey TUBS was deployed 58 times at 50 sampling stations at depths ranging from 252 to 1,463 m (827 to 4,800 ft) along the east coast continental slope from Baltimore to Corsair Canyons. A total of 18,175 photographs were taken, examples of which appear in Figures 24, 25, 26, and 27.

CONCLUSIONS

The use of underwater photographic systems in the study and assessment of sea-bottom populations has finally been accepted by biologists as a sampling tool although, in some cases, somewhat reluctantly (Fell 1967; Owen, Sanders, and Hessler 1967).

Photographs supplementing samples, as is the case with the camera-grab system, yield a great deal more information about the local distribution, ecological relationships, life habits, locomotory mechanisms, and body positions of the epifauna as well as information on bioturbations and sediment topography than would be available by inference from grab samples

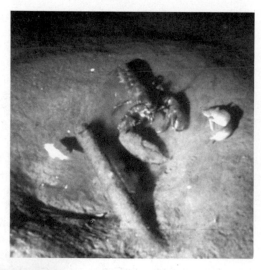

Figure 24. A large American lobster, *Homarus americanus,* in excavating its crater habitat unearthed what appears to be a transmission cable or large pipe. A hake, *Urophycis* sp., and blackbelly rosefish, *Helicolenus dactylopterus,* are also visible, Station 13 on the continental slope south of Hudson Canyon, Cruise: *Albatross IV* 74-7; location: 39°14' N, 72°23' W; depth 326 m.

Figure 25. Sea bottom at station 14 on the continental slope south of Hudson Canyon. Cruise: *Albatross IV* 74-7; location: 39°14'N, 72°21'W; depth: 384 m. Two deep-sea red crabs, *Geryon quinquedens,* and a burrowing sea anemone, *Cerianthus,* are visible. This cratered bottom is typical of red crab habitats.

alone. Conversely, photographs alone do not allow accurate taxonomic determinations and other biological measurements (size, weight, length, sex, and maturity). In addition, photographs do not yield any information at all about buried organisms (the infauna). Ideally, then, quantitative biological samples should be supplemented by photographs of the actual site sampled, and photographs of the sea bottom should be supplemented by samples.

Underwater photography from towed systems that provide ground truth (bottom-contact devices) offers a distinct advantage, especially with regard

Figure 26. Example of parallel traces often seen in areas intensively fished by lobster and crab fishermen. Photo is from the area shown in Figure 24.

Figure 27. Evidence of bioturbations on the continental slope south of Martha's Vineyard at station 5. Cruise: *Albatross IV* 74-7; location: 39° 52′ N, 70°56′ W, depth: 841 M.

to areal scope, rapidity, and economy of sampling, over traditional methods for the conduct of reconnaissance surveys relating to the quantitative distribution and abundance of epibenthic mega- and macrofaunal populations.

REFERENCES

Emery, K. O. and J. S. Schlee. 1963. The Atlantic continental shelf and slope, a program for study. *Geol. Surv. Circ.* 481, iv.

Emery, K. O. and A. S. Merrill. 1964. Combination camera and bottom grab. *Oceanus* 10(4): 2-7.

Emery, K. O., A. S. Merrill, and J. V. A. Trumbull. 1965. Geology and biology of the sea floor as deduced from simultaneous photographs and samples. *Limn. and Oceanog.* 10(1): 1-21.

Fell, H. Barraclough. 1967. Biological applications of sea floor photography. In *Deep-Sea Photography*, The Johns Hopkins Oceanographic Studies No. 3, ed. J. B. Hersey, pp. 207-221.

Menzies, R. J., L. Smith, and K. O. Emery. 1963. A combined underwater camera and bottom grab: a new tool for investigation of deep-sea benthos. *Int. Revue ges. Hydrobiol.* 48(4): 529-545.

Owen, D. M., H. L. Sanders, and R. R. Hessler. 1967. Bottom photography as a tool for estimating benthic populations. In *Deep-Sea Photography*, The Johns Hopkins Oceanographic Studies No. 3, ed. J. B. Hersey, pp. 229-234.

Trumbull, J. V. A. and K. O. Emery. 1967. Advantages of color photography on the continental shelf. In *Deep-Sea Photography*, The Johns Hopkins Oceanographic Studies No. 3, ed. J. B. Hersey, pp. 141-143.

Uzmann, J. R., R. A. Cooper, R. B. Theroux, and R. L. Wigley. 1977. Synoptic comparison of three sampling techniques for estimating abundance and distribution of selected megafauna: Submersible vs. camera sled vs. otter trawl. *Mar. Fish. Rev.* 36(12): 11-19.

Wigley, R. L. and K. O. Emery. 1967. Benthic animals, particularly *Hyalinoecia* (Annelida) and *Ophiomusium* (Echinodermata), in sea-bottom photographs from the continental slope. In *Deep-Sea Photography*, The Johns Hopkins Oceanographic Studies No. 3, ed. J. B. Hersey, pp. 235-249.

Wigley, R. L. 1968. Benthic invertebrates of the New England fishing banks. *Underwater Naturalist* 5(1): 8-13.

Wigley, R. L. and K. O. Emery. 1968. Submarine photos of commercial shellfish off northeastern United States. *Comm. Fish. Rev.* March 1968: 43-49.

Wigley, R. L. and R. B. Theroux. 1970. Sea-bottom photographs and macrobenthos collections from the continental shelf off Massachusetts. *USFWS Spec. Sci. Rep. Fish.* 613.

Wigley, R. L. and R. B. Theroux. 1971. Association between post-juvenile red hake and sea scallops. *Proc. Natl. Shellfish. Assoc.* 91: 86-87.

Wigley, R. L., R. B. Theroux, and H. E. Murray. 1975. Deep-sea red crab, *Geryon quinquedens,* survey off northeastern United States. *Mar. Fish. Rev.* 37(8): 1-21.

The Development of a Bottom-Referencing Underwater Towed Instrument Vehicle, BRUTIV, for Fisheries Research, 1973–1979

T. J. Foulkes

Fisheries and Environmental Sciences
Department of Fisheries and Oceans
Biological Station
St. Andrews, New Brunswick, Canada

The development of BRUTIV (Figure 1), our Bottom-Referencing Underwater Towed Instrument Vehicle, began in 1971 when we at the St. Andrews Biological Station, inspired by the work of Dessureault (1970) and Conti (1971), decided to automate our diver-operated Towed Underwater Research Plane, TURP (Foulkes and Scarratt 1972) so that we could survey the sea bed and observe fish behavior with greater ease and safety and to greater depths (Figure 2).

Our 1963 EG&G 35-mm camera system had already been successfully used from TURP to provide photographs of lobster grounds in water as deep as 60 feet (Foulkes and Caddy 1973). It seemed a simple matter to replace the SCUBA divers with a pressure-proof electronic control package containing a small echo sounder and a hydraulic system from a Batfish (Dessureault 1970) to activate the diving planes to maintain a preset altitude. By utilizing an existing conductive tow cable, we planned to monitor altitude during trials, but it was presumed at that time that once the system was debugged, a simple BT wire could be used to tow the vehicle while it happily photographed the sea bed.

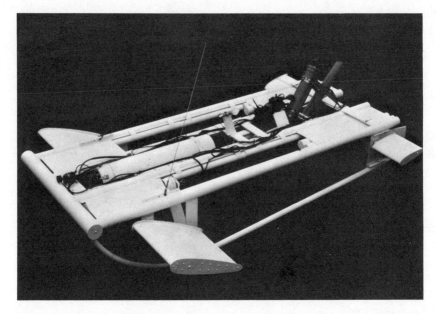

Figure 1. BRUTIV II (from above).

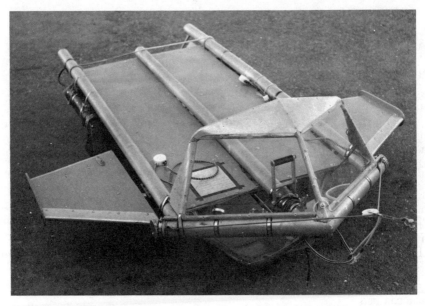

Figure 2. Diver-operated TURP.

The original prototype (Figure 3) launched in 1973 was very much of a part-time project and used second-hand materials. Electronics expertise was provided by the Bedford Institute of Oceanography where our servo system design was transformed into the functional electronic circuit that continues to form the heart of the BRUTIV flight control system.

Altitude is sensed by an echo-sounder system within the control package. An adjustable reference voltage represents the desired altitude, and wing-angle feedback in the servo loop dampens out oscillations and eliminates hunting or porpoising. The characteristics of the echo sounder and feedback system have been experimented with at length along with various arrangements and areas of diving planes to achieve the best performance over most sea beds encountered to date. BRUTIV will overshoot its desired altitude by about 2 meters after a crash dive from the surface, but thereafter will follow most sea bed profiles within a few inches.

BRUTIV's fixed wing areas provide inherent resistance to heave forces transmitted down the tow cable from the ship. A system of spring-loaded sheaves on the deck of the tow vessel acts as a surge accumulator and helps maintain a more constant tow line tension.

A depth mode was provided in the control circuit to take the vehicle down to within range of the echo sounder and then automatically switch over to altitude mode or, if the altitude signal failed, the flight control system would revert back to the depth mode. With changeable depths and temperamental switches, excursions into the mud dictated the need for more operator

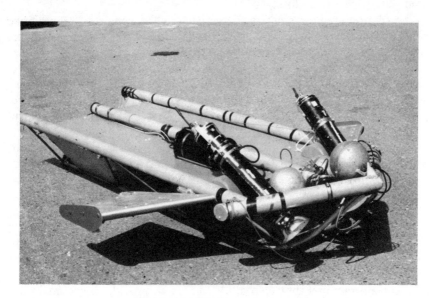

Figure 3. BRUTIV I prototype.

monitoring and control. Flight mode is now selected from the surface using two of 16 tone controls.

Our original MKI control system (Figure 4) was designed to provide continuous surface monitoring of altitude and one other parameter via CD signals up the center conductor and shield of the armored tow cable. A surface tone control was added to override the automatic flight control system so the operator could surface the vehicle at any time, or cause it to fly over potential obstacles in its path as seen on the ship's echo sounder (Figure 5). A dive control was also found necessary to dive BRUTIV down through thermoclines or secondary reflections that occasionally interfered with the echo sounder. A somewhat more refined control system based on a digital echo sounder was built in 1975, but this was found to have inherent stability problems incompatible with smooth flight over the sea bed.

Roll control is provided by a fully automatic gravity-referenced pendulum incorporated into the linkage to the wings. Providing friction and slope in the joints is kept to a minimum, roll is kept within a few degrees.

One of the most important design features of both TURP and BRUTIV is that they float and are therefore self-rescuing. Positive buoyancy is inherent in the main frame tubes, which are designed to withstand the pressure at the vehicles' greatest operating depth. A weak link and underwater unpluggable electrical connector in the tow line at the vehicle ensure that should an accidental collision or overload occur, the vehicle will break free and glide to the surface. This feature has, in practice, several times saved our vehicles from otherwise certain loss.

The photographic system used on BRUTIV I consisted of modified EG&G Model 200 35-mm systems with 100 watt-second strobes. These were mounted in various attitudes on the vehicle in our attempts to optimize photography of the sea bed in our murky waters and capture pictures of whatever fish might be in our path before they were frightened away. For this purpose, oblique, forward-looking camera angles were used, whereas for quantitative population density estimates a downward-looking arrangement is preferred (Figure 6).

In our murky northern waters, range seems to be most critical. The bottom-following capability of BRUTIV is within a few inches under good conditions, but the average altitude for any given tow may vary a foot or two from the nominal reference setting, depending on tidal currents, scope ratio and depth.

The BRUTIV I system had no remote trim control so that to change its altitude a foot or so meant opening up the control case, by which time conditions would again have changed. Thousands of photos were wasted by flying just a foot or so too high. Eventually we realized that not only was a trim control required, but also a TV camera to provide direct, real-time, qualitative information on range, clarity, and bottom reflectance. Our Cohu

Figure 4. MK I control system, 1973.

Figure 5. Mother ship echogram showing flight path profile and potential obstacle.

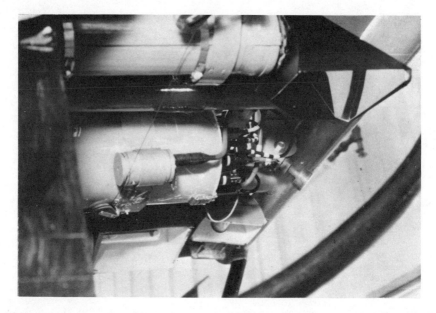

Figure 6. Underside of BRUTIV's nose showing feedback pot and camera system, 1979.

TV was tried on BRUTIV I in 1976 and a reasonable video signal was transmitted up the 1100 feet of ³⁄₁₆ -inch diameter armored coaxial tow cable.

By this time the frame of what *was* an ultra-light, 120 pound diver's sled had been severely overloaded by carrying on deck, through rough seas, about 200 pounds of equipment. Late in 1976 we decided to build a new system, BRUTIV II, based on the sum of our experience.

The new vehicle (Figure 7), launched in 1977, was designed to be much more rugged to withstand deck handling and accidental collisions. Some rearrangement of the hydraulic system was required to provide the impeller with unobstructed flow, and extra buoyancy tubes were added for trim.

The new tow cable was 3000 feet of 0.26-inch diameter armored coax, and the buoyancy members were operational to 200 fathoms. On our first dive to 90 fathoms, however, our altimeter transducer failed, so for some time we thought we were limited to about 70 fathoms. Recent tests to 200 fathoms in our pressure tank failed to destroy any spare transducers, so the first one must have been a lemon.

The TV and 35-mm cameras were originally mounted obliquely near the tail and the lights were aimed downward at the nose, closest to the sea bed (Figures 1 and 7). At an altitude of about 10 feet they were to provide uniform illumination of the field of view. This designed survey altitude was optimistic. Getting farther out to sea with a bigger BRUTIV in bigger

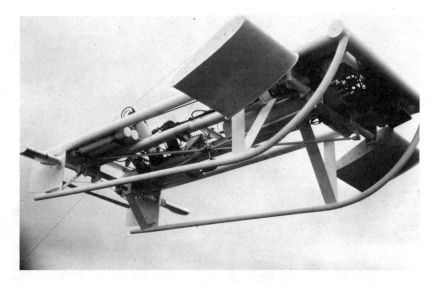

Figure 7. BRUTIV II (from below).

boats did not help the visibility. In most of the waters of the Bay of Fundy, seven feet is about the limit of range for good photographs. At this altitude our camera arrangement did not provide uniform illumination, so the camera was fitted with its 45° mirror and repositioned on one side at the nose of BRUTIV with the TV light and strobe on the other side (Figure 6).

Photographs with this arrangement have a smaller but more easily calculated field preferred for population studies. We will ultimately move the TV camera forward as well, but maintain its forward rake so that obstacles and avoidance reactions of nervous fish can be observed better.

[1982 Update: The latest camera arrangement (Figure 8) has the strobe looking obliquely ahead from the tail and the camera(s) looking down from near the nose. This arrangement produces shadows that emphasize relief while minimizing backscatter from suspended particulate matter.]

The new BRUTIV seemed less successful in photographing fish than its prototype, but this has been difficult to quantify, partly because fish populations have declined. Some fish apparently avoid white objects, so to reduce avoidance reactions, BRUTIV's highly visible white was changed to greenish blue. An orange flag on a pop-up snowmobile pennant is highly visible when BRUTIV is on the surface. Strobes and radio beacons can also be added to locate BRUTIV should it come adrift.

The TV system has presented problems both in its electronic compatibility with the tone control system and in its demands for light. Television has been both the key to photographic success and the cause of our need for

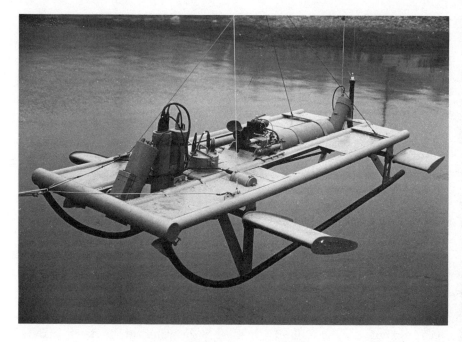

Figure 8. Update: 1982 BRUTIV.

continued development of the BRUTIV system. Good TV was essential for good photographs because it could not only indicate what range was required but could also, within the limits of resolution, indicate whether or not we were over an area of sea bed worth photographing. Once provided with this information, our scientists became more and more discerning as to what they photographed, and more demanding as to the quality of the TV picture that allowed them to make such decisions. Incorporation of the TV into the BRUTIV system developed with the second vehicle from a selectable data option to a prime requirement.

The BRUTIV II control system (Figure 9) was built to provide surface control over camera systems and vehicle trim with the same capability of overriding the underwater automatic control system that we had with the first package. Separate tones are used for each function, such as latching relays for lights, cameras, flight mode, and so on (Table 1). A tone control also operates a stepping relay that sends DC analog signals from any one of 10 variables such as pitch, roll, depth, and speed (Table 2). Altitude is also sent to the surface for continuous display as an analog signal. This DC analog signal shares the center conductor of the tow cable with the video signal.

A digital data system, designed and built in 1977, proved to be quite

Figure 9. MK II control system, 1978.

incompatible with the broadband video TV signal. Transmitting the TV as an RF signal was, at that time, considered impossible because of the much greater losses in our tow cable, connectors, and slip rings at such a high frequency.

Table 1. BRUTIV II Surface Tone Controls

(1) Power, On/Off	(9) Rudder: right
(2) TV camera, On/Off	(10) Rudder: left
(3) 35-mm camera, On/Off	(11) TV iris: open
(4) TV lights, On/Off	(12) TV iris: close
(5) Trim: up	(13) Flight mode, altitude
(6) Trim: down	(14) Flight mode, depth
(7) Dive	(15) Advance data channel
(8) Climb	(16) Spare channel

Table 2. Variable Data Channels

(1) 5-volt reference	(6) Roll: 45°
(2) Battery voltage	(7) Wings: 45°
(3) Speed: 0–10 knots	(8) Temperature: 0–50°C
(4) Depth: 0–1000 feet	(9) Spare
(5) Pitch: 45°	(10) Spare

Power for all BRUTIV's cameras, lights, and electronics is provided by rechargeable nickel-cadmium batteries located inside the underwater control package (Figure 10) and in separate 7-volt packs (Figure 11) that are interchanged with freshly-charged packs during film changes. Ever since we blew up a strobe light stuffed with overcharged batteries, we've been very nervous and cautious with underwater battery packs.

[1982 Update: The electronics, lights, and cameras on BRUTIV are now powered by a single rechargeable 28-volt, 15 amp-hour, lead-acid battery, housed in a separate container and replaced during film changes.]

As the requirement to watch TV grew from infrequent spot checks of camera performance and visibility to full-time monitoring of sea bed and flight performance, our underwater battery power became more inadequate.

A surface charging system was considered to help provide some of the power. With the Cohu camera we needed at least 60 watts for light and another 60 for everything else, except for the 35-mm system that used the separate battery packs. Our armored coaxial tow cable was already full of AC and DC signals going up and down, so in order to send a DC charging current down, the data up had to be switched off the line. Also, because of the common ground (the outside armor), the all-important altitude signal was adversely affected. AC current could not be used because of the video signal coming up the line. Our tone controls were also AC, and for their reliable operation even the TV had to be interrupted. Flying with the charger on meant flying BRUTIV visually over the sea bed, watching the TV monitor and ignoring the altitude readout. The extremely limited range and poor resolution of the TV made operation too uncertain. Furthermore, the tow cable simply had too much resistance to send even half the required power. In 1979 it seemed as if we had created a monster that flew quite well but had got somewhat out of hand electronically and needed special trainers to manage it. The cry from the scientist for simplicity of operation and quality of information was met by the cry from the electronics shop for more conductors in the tow line!

For years, I have maintained that the secret of the success of BRUTIV's bottom-following capability is the low mass-to-wing-area ratio of the vehicle and the use of a relatively low mass, low drag tow cable. To test this premise and to quell the cries of frustration, we have designed a new system (Figure 12) based on a new tow cable, 2000 feet long, of RG11 type Triax, chosen especially for its low resistance and impedance. It will be hair-faired and Kevlar-reinforced to minimize drag and mass. This will enable us to use the previously abandoned RF TV signal with which our tone control signals and AC power are compatible. All our data can then be monitored on alphanumeric displays with the TV picture. Backing up this system, depth and altitude information essential to safe vehicle operation will be transmitted as AC signals for analog display. The new tow cable will be tested in the fall

Figure 10. BRUTIV II underwater control package.

Figure 11. Seven-volt camera battery packs.

1980-1981 BRUTIV Control / Data System

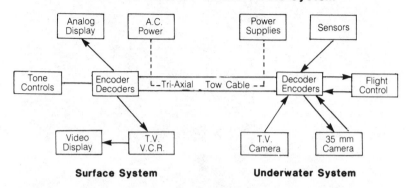

Figure 12. Proposed BRUTIV III control system.

of 1980 and, if successful, new underwater and surface control packages will be constructed. A new vehicle, BRUTIV III, is also being considered. This would carry our new TV and 35-mm cameras, leaving the old BRUTIV as a complete back-up system.

[1982 Update: The new tow cable referred to above was not successful. Video transmission was improved but RF transmission still involved too many losses. Frequency multiplexing and power transmission were therefore impossible. Furthermore, the large diameter, 0.58 inches, of this cable caused too much drag despite its hair-type fairing, and after a few dozen deployments it was found that the outer shield had disintegrated. We are now considering a fiber optics cable with computer-controlled communications. This will satisfy the demands of the scientist for data as well as meet this engineer's criteria for low mass and drag.]

ACKNOWLEDGMENTS

I would like to thank Jean-Guy Dessureault for providing initial inspiration and continuing help, and Dave McKeown, Paul Thorburn, and Ken George for their electronic expertise. The cooperation from the Metrology Division of Bedford Institute of Oceanography is much appreciated.

Bill McMullon's professional care and interest in producing good underwater photographs are sources of continuing inspiration matched only by his tireless efforts in processing BRUTIV's miles of often uninspiring underwater film.

I owe Udo Buerkle and Sam Polar, without whose patience and perseverance we would not now be so very close to our objectives, at least the promise of achieving them.

REFERENCES

Dessureault, J. G. 1970. *"Batfish,"an undulating towed body.* Dartmouth, N. S.: Atlantic Oceanographic Lab.

Conti, U. *et al.* 1971. *Towed vehicle for constant depth and bottom contouring operations.* Berkeley: Univ. of Calif.

Foulkes, T. J., and D. J. Scarratt. 1972. A diver-controlled towed underwater research plane. *Fish Res. Board Can. Tech. Rep. No. 295.*

Foulkes, T. J., and J. F. Caddy. 1973. Towed underwater camera vehicles for fisheries resource assessment. *Underwater Journal.* IPC Science and Technology Press, Ltd.

APPENDIX

BRUTIV Specifications

	Mk I (Turp)	Mk II (existing)	Mk III (proposed)
Size (feet)	8 x 6 x 1.5	10 x 8 x 2	10 x 8 x 2.5
Weight (loaded)	220 lb	530 lb	500 lb
Wing area (effective)	34 sq ft	30 sq ft	36 sq ft
Buoyancy	15 lb	20 lb	20 lb
Tow cable	1100 ft armored Coax, 0.18 dia	2600 ft armored Coax, 0.26 dia	4000 ft optical fiber
Depth capability	60 fath	150 fath	300 fath
Scope ratio	2.5–5	2.5–5	2.5–5
Speed range	2–5 kts	2.5–6 kts	2–6 kts
Flight control	Auto altitude referencing servo	Auto altitude or depth servo	Auto altitude or depth servo
Surface control	2 channels	16 channels	Microprocessor
Data	Altitude + one other variable	Altitude, 1 DC variable + video	Video and acoustic imaging, + data
Photo camera	35-mm f4.5 EG&G 100-joule strobe	35-mm f4.5 EG&G 100-joule strobe	35-mm f3.5 Benthos or EG&G 35-mm pair 200- or 400-j strobe
TV camera	None	COHU series 2000	Rebikoff DR 646, Edo-Western B & W, or Zenith color
TV lights	None	Two 60-watt quartz halogen	Two 50-watt quartz halogen
Power	7 V and 12 VDC hydraulic system 10 x 10 impeller	7 V and 28 VDC hydraulic system 11 x 17 impeller	24 VDC battery, hydraulic system 12 x 17 impeller
Underwater duration	2 hours	4 hours	4 hours

Producing Video Images of Fishing Equipment Operating in situ as Well as Observing Fish Actually Being Caught

R. Paul Bennett
NORDCO Limited
St. John's, Newfoundland, Canada

INTRODUCTION

One of the most successful methods of harvesting ocean fish species is deep sea dragging or "otter trawling." Figure 1 shows the equipment used for harvest of fish species near the bottom. During 1976 the Grand Banks of Newfoundland yielded 150,000 metric tons using this method compared with 200,000 metric tons for all other methods combined. From the ship's winches to the netting that actually holds the fish there are a large number of distinct yet interrelated parts. Their interconnection and matching to the towing vessel has generally been a matter of trial and error with only rudimentary design considerations. Success has been measured by whether the net was full of fish. The ability to put instruments in or near a net and to observe it under actual operating conditions is a dramatic step forward in fisheries research and development.

General

This paper describes the application of low-light underwater television as a tool for fisheries research involving SCUBA divers observing trawling equipment operating on the Grand Banks of Newfoundland, Canada. Fisheries research is expensive, especially if ship time is required, and it was

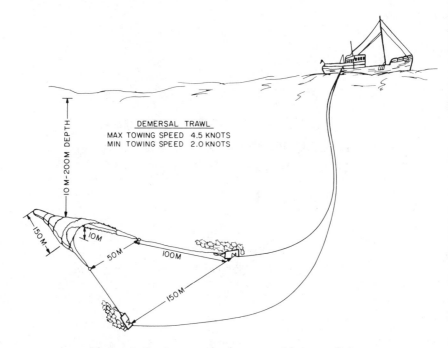

Figure 1. Equipment for harvest of bottom fish.

therefore important to envision projects that had minimal requirements for sophisticated hardware, and that would be operational from commercial fishing boats, including the 20-30 meter class.

Although this work takes place in depths of less than 35 meters, the prospect of divers working on fishing equipment being towed at speeds of up to 3 knots means high personal risk and the likelihood of frequent hazardous situations, with the resultant high probability of an accident. To alleviate these concerns, particularly as they would affect the diver's psychological well-being to carry out the task, a rugged, simple maneuverable wet-towed submersible was built.

Historically, this rather aggressive approach to the observation of moving fishing gear has a limited number of precedents. These include: The Fisheries Laboratory, Aberdeen, Scotland (Main and Sangster 1979) whose towed submersible we have imitated; the Fisheries Research Board of Canada, St. Andrews, New Brunswick Laboratory (Caddy and Watson 1969) who commissioned a Perry Cubmarine, PC3B, to attempt trawl observation in the Bay of Fundy; and the earlier work of the *Atlant* (Marlyshevsky and Korotov 1967).

The following list highlights the present and proposed uses for this type of photographic application as it pertains to fisheries.

1. Marine biologists and statisticians benefit from real-time comparisons of their echo sounder traces of fish densities with frame-by-frame video images.
2. Television has become an expected forum for most information dissemination systems. The production of good quality video signals of fish capture technology will clearly present operating concepts normally requiring the interpretation of instrument readings where such instruments existed.
3. Fishing gear technologists can observe their designs in operation on a full-scale basis.
4. The vehicle, towed at 3 knots, will accumulate data on shallow fishing grounds, and will be capable of covering on the average a 10-meter by 5000-meter corridor in 40 minutes.
5. The fishing equipment now used for stock assessment can be calibrated for catching efficiencies from the observed catch rate.

Financial

This work is designed to maximize scientific research and minimize operating expense. That is, there is no heavy financial commitment required such as a large research boat and complex instrumentation and support staff. In particular, a research project would require an 18-meter commercial fishing boat, five crew members, four divers, and three scientific/support people, plus the submersible, a towing winch, and the television equipment. Figure 2 depicts a typical operational overview.

The Submersible Vehicle

The concept requires camera work while the fishing equipment is being towed through the water at speeds up to 3 knots. Attempts have been made to have the divers swim to the net and film while holding onto the mesh. However, the extreme danger to the divers and the problems with communications, camera cabling, etc., made this method unrealistic except in very controlled cases.

The submersible vehicle developed to carry out this work was conceived by the Aberdeen Marine Laboratory, Aberdeen, Scotland (Main and Sangster 1979). NORDCO adopted this design and constructed a similar vehicle, as shown in Figure 3. It is constructed from tubular steel with maneuverable port and starboard diving planes, a bow-mounted rudder, and a controllable ballast chamber above the divers' heads. To protect the divers against water turbulence, a transparent Lexan shield is secured to the bow portion of the vehicle. A braided nylon rope is used as a towing cable, while the television and communication cables are tethered to the vehicle. Apart from the winch,

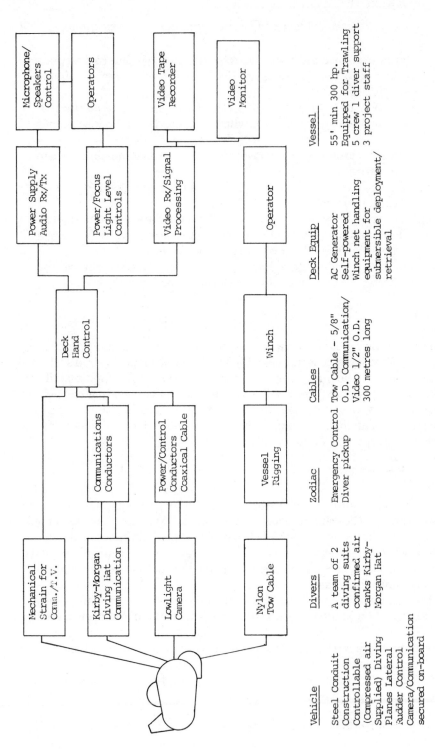

Figure 2. Operational overview.

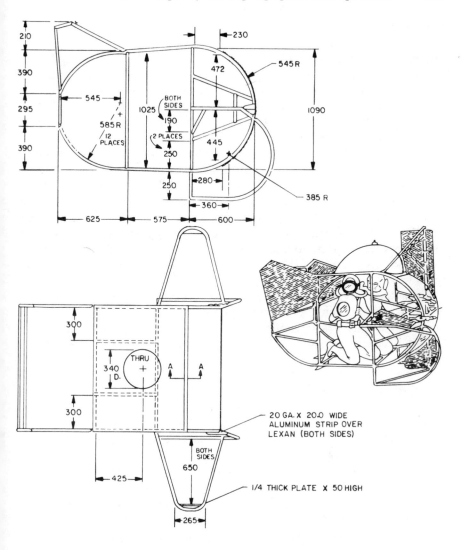

FIGURE NO. 3

Figure 3. Towed wet submersible frame.

which is used to control the distance astern from the towing vessel, the divers have complete control over starboard–port, and dive–surface maneuvering using the control planes and the compressed air ballast system. The over-all construction is simple yet rugged, providing the divers with a secure environment. One diver acts as the submersible pilot and one acts as the camera operator.

The Divers

The operation normally involves five diving personnel: a dive marshall plus two teams of two divers each. The divers are suited for SCUBA diving with the addition of a soft diving hat to prevent loss of the conventional face mask from water turbulence, and to provide telephone-quality communications for procedural instruction and a permanent high-quality record of diver/surface interaction on the video tape. Because the divers are operating from a towed vehicle, the use of double air tanks does not impede task flexibility and at the same time extends a dive to 40-50 minutes within no-compression limits.

The divers board and leave the submersible while it is being towed at the surface astern of the fishing vessel when the support personnel are satisfied that all equipment is operating properly. Once communications have been established, the submersible is piloted to the fishing equipment. One diver maneuvers the submersible while the second diver operates the camera, receiving directions from the scientific staff who monitor the live video on the towing vessel.

Since the researchers can communicate with the divers as well as view the live video pictures, only a minimum amount of jargon has been found to be necessary for diver acceptability. The most apparent problem has been a lack of diver attentiveness during prolonged sequences of the same subject matter.

The Camera

To date, three diver-held low-light cameras have been used. These are: the EDO Western 1643 SIT, the Hydro Products TC 125 SIT, and the Hydro Products TC 125 standard.

The camera is deployed with the submersible, where it is secured in a holster ready for diver use. Under normal operating conditions the camera is well protected from shock by the submersible. In addition, the camera and its reinforced cable and connector, in the vicinity of the submersible, are of sufficient strength to tolerate being dragged in a free fall position during an emergency situation.

The diver who is the camera operator normally cradles the camera in his lap for starboard or stern vantage points. Certain securing locations on the submersible permit the camera to be used as if on a tripod where prolonged sequences are required on a relatively stationary subject.

The fishing equipment generates a significant amount of turbulence and therefore visibility levels are poor. However, the use of a low-light camera and the avoidance of the actual mud clouds has proven to be the most effective means of recording good quality images. To introduce artificial light would tend to create its own set of problems (Cousteau 1968), illuminating suspended

particles, and the validity of data from biological work on fish behavior would be negated if such lighting was considered. (Under midsummer sunlight, at a depth of 20 meters, 32°C, and using an Edo Western 1643 SIT Camera, good quality video was possible up to 10 meters from the camera face plate.)

VIDEO PROBLEMS

In keeping with the moderate financial profile that this type of development is based upon, our production problems have been resolved through a trial and error process. The following discussion touches on the major points of some of our problems and how they have been resolved to date.

The camera's neutral density filter impeded visibility, at times down to 2 meters where 10 meters should have been possible. The filter's purpose is to protect the vidicon tube from damage due to excessive light levels. However, our application is being conducted in shallow depths (less than 35 meters) under ambient light conditions. The "horizon" for direct surface light, highly reflective objects, diver bubbles, and reflective silt all affect the filter to varying degrees. The following measures were taken:

1. Highly reflective equipment, such as easily reflected colors, aluminum surfaces, etc., was avoided.
2. Divers were trained to lessen the problem of direct surface light by keeping the camera positioned below the "horizon."
3. The video tape was reviewed with the divers at the conclusion of a dive, providing the necessary feedback to permit quick diver response to problem areas.
4. The camera tended to detect and focus on the closest discernable object rather than on the intended subject matter, necessitating the diver to maneuver as closely as possible to the desired area of interest. For example, it was necessary to land the submersible on top of the net, cut a hole in the mesh, and position the camera through the mesh. This exercise increased the element of danger, but provided good quality pictures.

The video images often were improperly aligned and distorted. Potentially good sequences tended to be obstructed or of poor resolution, impeding species identification or detailed equipment assessment. Camera stability is an important requirement when you consider that the fishing equipment is a combination of a large number of moving segments. Most of the motion is damped by the water medium, but the otter boards and the ground equipment demonstrate erratic movement, depending on the bottom conditions. Again

the submersible vehicle simplified problems because the camera operator did not swim free as part of the task. Various locations were created on the vehicle where the camera could be supported. The diver would then locate himself so that prolonged periods of single-subject observation were possible, astern being the most productive vantage point. Also, minimum single subject observation time was set to permit remote focus and resolution adjustments.

Even with the fiber optic technology of super-human light detection, turbidity in the North Atlantic is a significant problem. It was noted that two consecutive sunny days over the same area yielded video images with 50% more clarity in one day's sequences over the other. This particular problem was due to fresh water run-off as a result of an overnight storm that dumped plant and mineral material into the bay. Scattering or absorption of light on these materials presents the greatest single problem for a well-organized mission. The North Atlantic has the highest levels of plankton bloom and mineral suspensions of the world's oceans. Where one can control such items, our experience shows that underwater television in northern waters has the greatest probable success under the following conditions:

1. Carry out research between midmorning and midafternoon in midsummer sunlight.
2. Operate when wind conditions are calm and have been calm for the preceeding 24-hour period.
3. Avoid diving after a rain storm where landfall run-off is expected.
4. Avoid the seasonal plankton bloom periods.
5. Prepare a flexible program to make use of poor visibility days.

CAMERA COMPARISON

Three specific cameras have been used in conducting this work:

1. An Edo Western 1643 SIT low-light level camera;
2. A Hydro Products TC 125 SIT low-light level camera; and
3. A Hydro Products TC 125 television camera.

Table 1 outlines a comparison of the various camera specifications. Briefly, the Edo Western 1643 SIT and the Hydro Products SIT Models were comparable for the tasks. However, the Edo Western was superior in the following areas.

1. It was more ruggedly constructed, and was able to withstand mechanical shock with a cable connector better than the Hydro Products version.
2. The Edo Western camera had a remote control that altered the sensitivity of the neutral density filter.

Table 1. Comparison of camera specifications

Camera Make	Model	Light compension	Resolution	Sensitivity	Power	Optical		Mechanical	
						Lens	Focus	Weight in Water	Shock
EDO Western	1643 SIT	5×10^6:1	650 lines	20×10^{-4} fc	13 VDC	12.5 mm; 63° angle of view in water	Faceplate to infinity	3 lb	15 g
Hydro Products	TC125 SIT	5×10^6:1	400 lines	5×10^{-4} fc	15 VDC	12.5 mm; 46.5" angle of view in water	5 cm to infinity	17 lb	Not available
Hydro Products	TC125	1×10^4:1	600 lines	1×10^{-1} fc	13 VDC	12.5 mm; 46° angle of view in water	1 cm to infinity	8 lb	Not available
Sub Sea Systems	SL-85	10×10^6:1	500 lines	20×10^{-4} fc	13 VDC	13 mm; 80° angle of view in water	—		

3. The Edo Western camera was equipped with a 63° angle of view in water and a focus range from the lens face to infinity.
4. The dynamic range was greater and the vidicon face plate sensitivity was also greater.
5. The Edo Western's weight in water was considerably less than the Hydro Products version, therefore it was preferred by the divers.
6. The Burton stainless connector on the Edo Western camera seemed superior to the Bratner model used on the Hydro Products camera.

THE FUTURE

The manned wet submersible project for Newfoundland research was implemented within six months of conception, including diver training and deployment from a 60-foot fishing boat. This met the requirements set forth by our clients and scientific staff. However, the research work involving fish species has been limited because of no-decompression diver depth limits and the associated extra precautions manned submersible diving entail.

NORDCO is preparing to design, develop, and test a remote-controlled vehicle for fisheries research. Its primary pay-load will be a television system using charged-coupled technology as well as recticle scaling. A number of design areas will need special consideration and these include: controlling the stability of the vehicle to permit a minimum 400-line resolution television picture; relying on the monitored video images to reference the vehicle with known locations on the fishing equipment; using impeller-driven hydraulics as the vehicle's maneuvering power to limit noise effects on fish species; and optimizing the size of the electro-mechanical towing cable to have a minimum affect on the hydro-dynamic performance of the vehicle as it maneuvers around the fishing equipment. Most of the fishing that is of interest for research occurs in 100 m of water and therefore the vehicle must be capable of diving to at least 800 m from a design point of view.

CONCLUSION

A cursory glance at the existing fish capture technology operating in North America will quickly reveal that it has not been developed as have other food gathering processes. The use of underwater photography, and in particular television, could help out in this dilemma. As the oil and gas industries encourage the marine service industry to develop even more sophisticated cameras and submersibles, fisheries research will benefit and perhaps even influence the design of such equipment.

REFERENCES

Main, J. and G. I. Sangster. 1979. *A study of bottom trawling gear on both sand and hard ground.* Department of Agriculture and Fisheries for Scotland, Report No. 14, 155N 0308-8022.

Caddy, J. F. and J. Watson. 1969. Submersible for fisheries research. *Hydrospace,* March.

Marlyshevsky, V. N. and V. N. Korotkov. 1967. *Fish Behavior in the Area of the Trawl as Studied by Bathyplane.* FAO Conference on Fish Behavior in Relation to Fishing Techniques and Tactis. Bergen, Norway (unpublished).

Cousteau, J. Y. 1968. Seeing in the sea, a report and a challenge. In *Underwater Photo Optical Instrumentation Applications Seminar Proceedings,* p. 15. San Diego, California.

New Application for Ocean Bottom Survey Using Submersibles and Towed Sleds

D. Chayes, H. Chezar, J. Farre, M. Rawson,
and W. B. F. Ryan

Lamont-Doherty Geological Observatory
Columbia University
Palisades, New York

With the aid of our deep-ocean photographic systems, we study the microtopography of the sediment cover of passive margins and the igneous bedrock of the oceanic ridges and seamounts. Our cameras have helped explore such varied locations as submarine canyons off the New England coast, precipitous escarpments in the Bahamas, and pillow lavas on the flanks of Hawaii, the Galapagos Rift, and Reykjanes Ridge.

We consider oblique angle and lighting to be important in order to create shadows that will allow us to determine heights and shapes of features in relief. On research submersibles such as *Sea Cliff, Turtle,* and NR-1, we shoot in the subhorizontal plane and separate the strobes and cameras for the maximum feasible distance and shadow detail.

On soft substrate, we tow our camera sleds directly on the seafloor. The camera looks forward to view clear areas undisturbed by mud clouds. We deploy a near-buoyant vehicle that can be maneuvered in and out of crevasses. The vehicle is tethered on a buoyant tow rope approximately 100 meters behind and below a 500-kilogram depressor. The sled is balanced to have a strong righting moment, causing the cameras to remain near horizontal even on steep slopes (Figure 1).

For rough terrain where we would have risked entangling a towed camera sled, we have carried out our scientific observations with manned submersible

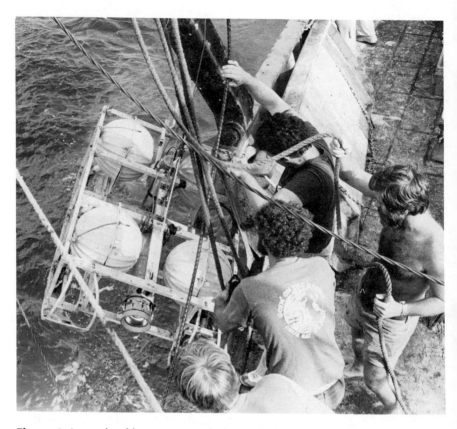

Figure 1. Launch of bottom-towed photo sled. The sled is equipped with a 70-mm camera, a pinger, batteries, strobe, and flotation so as to have 20 kilograms of negative buoyancy.

vehicles such as *Alvin, Trieste,* and NR-1 or have used a flying type of unmanned towed camera vehicle.

With the flying mode our biggest problem is getting the proper camera-light separation for satisfactory oblique lighting. Our philosophy is not to build big heavy vehicles that require large ships with special launch and recovery cranes or A-frame systems. To resolve the lighting problems we have selected strobes that diffuse light through lenses for even illumination and thereby minimize hot spots that create harsh and high-contrast images.

Until the spring of 1980 we have been using nonconducting tow cables that allow us to use a variety of ships. We are presently developing a real-time low-light level TV that will be used in the summer of 1980 with long-range side-scan sonars and 20,000 feet of coaxial armored cable. The system will be handled with a portable traction winch and portable cable

handling system borrowed from the Marine Physical Laboratory at Scripps Institution of Oceanography.

Navigation requirements vary from mission to mission. In the rift valleys where we study a reasonably small region (50 sq km), we set arrays of bottom-moored transponders and navigate our camera vehicles and submersibles by acoustic slant-range measurements. Our computer-generated plot displays the transect in a geodetic coordinate system rather than a local x-y grid system, so that the photo runs can be immediately integrated with the surface surveys. In rift valleys where we need to cover a large area (500 sq km), we use bottom-tracking doppler x, y, and z velocity measurements calibrated to the Loran C and satellite reference frames by slant-range tracking from the surface ship. For steep escarpments where acoustic slant-ranging would be extremely difficult because of shadowing and doppler tracking would not work due to overhanging cliffs, we navigate the submersibles with a short base-line system involving a surface ship that is precisely located by radio ranging to local shore beacons (Figure 2).

For distances up to 200 km from shore, such as in the Bahamas, we chose to lease a commercial navigation system called "Maxiran." This equipment utilizes a moist-air duct about 100 meters thick just above the sea surface that assists signal propagation well beyond the horizon. Working on the steep slopes off the coast of Hawaii, we acquired a "Mini-Ranger" unit that depends upon a line-of-sight transmission range.

Photo transects in submarine canyons average 10 to 18 kilometers in length, which is too long to be practical for bottom-moored transponder navigation systems in moderate water depths. As a consequence we track the towed vehicle with slant-range and bearing measurements from the surface vessel, which in turn is precisely located by radio-ranging navigation equipment. For the distant off-shore region of Baltimore Canyon, we borrowed an "Argo" system from NOAA. On Georges Bank we used hyperbolic Loran C. In all cases, each sled fix must be calculated in an absolute geodetic coordinate system. The precision of this navigation procedure is provided by post-cruise analysis of bottom photographs that show sled ski tracks at computed track intersections. Navigation misalignment of the intersections is less than 50 meters with the radio-ranging systems and less than 100 meters with Loran C.

Our camera systems provide the flexibility of high-capacity 35-mm 400-foot film spool loads (Figure 3) or high-resolution 70-mm formats on 100-foot film lengths (Figure 4). We shoot 200 ASA High Speed Ektachrome transparency film almost exclusively. Priority is given to processing all exposed films at sea. This allows us a constant monitoring of both film exposure and system functioning. The scientist can then see immediately the materials for planning additional camera runs. Since the processor system could not have its own self-contained van, we chose an automatic film processor with the following

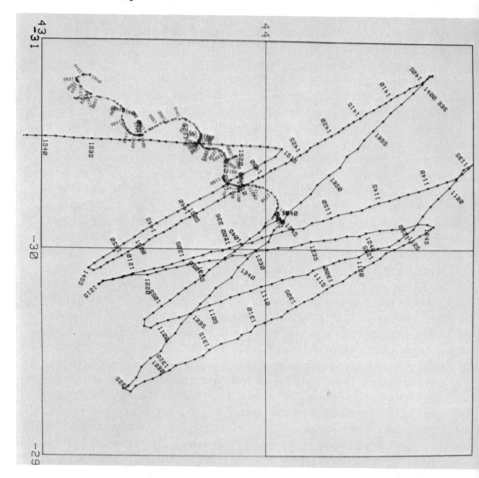

Figure 2. Computer-generated track of *Alvin* dive #866 (sinuous line) and R/V *Lulu* (straight lines). The submersible track is calculated with a short base-line slant-range technique not requiring bottom-moored transponders.

requirements: small in size, light in weight, and easy to install. We further require the ability to custom process film with varying development time, which is impossible to achieve with the larger continuous strip processors. We thus have the option of being able to push or pull various sections of the same film strip for maximum light resolution. The disadvantage of the machine is that films must be cut into 5-foot strips prior to processing. Although this necessitates mounting all films as individual slides, it gives the advantage of random versus linear serial access. The disadvantage is that scientists tend to walk off with the originals. Serial data on film strips is ideal for permanent archives, but slides definitely increase the

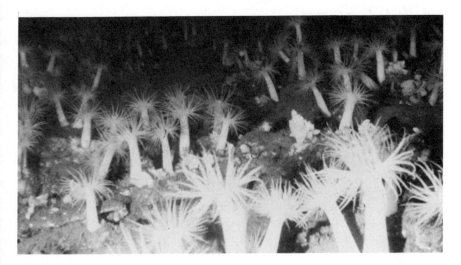

Figure 3. 35-mm format of anemone garden on the south wall of Baltimore Canyon, 185 m water depth.

Figure 4. 70-mm format of avalanche deposits on crater wall from the Mediterranean Ridge, 2900 m water depth.

efficiency of repeated analyses and reduce the chances of scratching the original film emulsion.

We have chosen to have a digital data registration for each photo frame. The common correlation unit is time. Our sleds and the submersibles we use are all equipped with an externally mounted and self-recording data logger that registers time, pressure depth, magnetic heading, speed through water, temperature, and conductivity on ¼-inch magnetic tape. Some of the data are used to smooth the navigation track. All of the data are eventually printed on each slide mount. The slides are then put into Logan slide boxes. The advantage is quick retrieval of all pertinent scientific information without any special viewing equipment beyond a light table or hand viewer. The risk of losing individual slides has to be balanced against the number of times a slide will be conveniently viewed.

A Photosled in Puget Sound

Leslie Smith, Richard Heggen,
and David Jamison

Marine Research and Development Center
Department of Natural Resources
Olympia, Washington

INTRODUCTION

The Marine Land Management Division of the Washington Department of Natural Resources manages 2,000,000 acres of subtidal marine lands. This land is leased for such activities as open water disposal, outfalls, aquaculture, shellfish harvesting, docks, floats, and marinas. In recent years there has been a marked increase in use and development pressures in the Puget Sound area. To judge where activities can be permitted and what environmental concerns must be met, more information is needed on the nature of these benthic environments. The subtidal inventory project was designed to meet the need for this baseline data using a towed photographic sled as its primary inventory tool.

The project in its initial phases involved reviewing and testing inventory tools and methods. An underwater sled housing Super 8 cameras and strobes designed by Jay Mar, Inc. was found to be suitable for our purposes. A prototype of the sled was constructed and tested in the field. From June to September of 1979 a pilot study on a 6,000-acre area of southern Puget Sound was carried out using this system. Another survey tool used in the study was a recording fathometer used in conjunction with the photographic sled to provide permanent records of depth contours for each transect. Research associating the recorded sonar return with the actual substrate

type is in progress and will potentially provide valuable survey data. Further investigations involved the use of a Van Veen bottom grab for sediment and biological analysis and SCUBA diving observations and sampling.

SITE DESCRIPTION

The Puget Sound terminates in its southern region in a series of relatively shallow inlets averaging five miles in length and one-half mile in width. They are characterized by 14-foot tidal exchanges and high currents. This area was chosen as the site for the subtidal inventory pilot study because of its proximity to the DNR Marine Research facility on Budd Inlet, Olympia, Washington (Figure 1).

MATERIALS AND METHODS

The Photographic Sled

The photographic sled is constructed of $\frac{1}{16}''$ stainless steel tubing $1\frac{3}{4}''$ in diameter. The frame shape is rhomboidal. When viewed from the side, the height is 50'', the width is 40'' at the top and 48'' at the base, and the length is 87''. The base is fitted with 4'' wide galvanized runners which allow the sled to glide easily over soft substrates. The internal frame which holds the cameras and strobes is constructed of aluminum tubing and attached to the top of the sled with breakaway connectors. The breakaway system is designed to withstand 500 pounds of pressure before releasing the camera-strobe frame. This insures recovery of the photographic equipment should the sled become fouled while being towed. The photographic equipment is attached to the frame with adjustable stainless steel mounting brackets. All fasteners on the sled are stainless steel. The sled frame is drilled to allow flooding when submerged, reducing buoyancy to the lower part of the sled. Six 10'' aluminum otter trawl floats are attached to the upper sled frame to provide 84 pounds positive buoyancy. This allows the sled to right itself easily and assume the proper towing attitude. The sled, outfitted with cameras and strobes, weighs approximately 300 pounds in air and 75 pounds in water. (Figure 2)

The Camera System

The camera system consists of two time-lapse Super 8 Minolta XL 401 cameras and two 200 watt-second xenon strobes encased in Jay Mar underwater housings. The cameras utilize standard 50-foot Super 8 film cartridges and

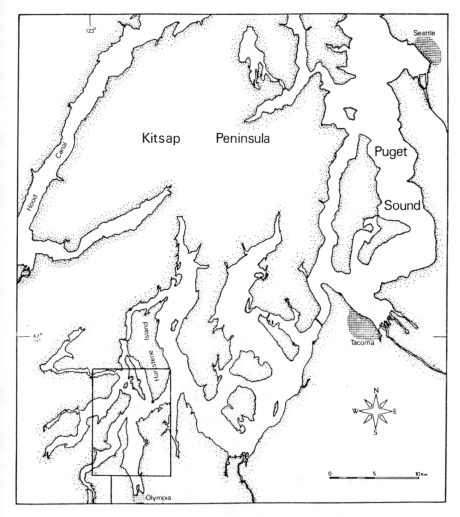

Figure 1. Pilot study area in southern Puget Sound.

are capable of exposing 3500 frames per cartridge. A programmable digital timer triggers the cameras to fire at a delay interval ranging from 1 frame per 11 seconds to 1 frame per 24 hours. The strobes require 12 volts direct current which is provided by a 12-volt 60 amp-hour automobile battery mounted on the sled. Each camera and strobe is encased in an anodized aluminum housing. The housing consists of a 2″ type G plexiglass front port, a cylindrical center tube, and a rear bulkhead connector plate. Each end plate is held in place with two stainless steel self-locking snaps. An underwater seal is provided on each end of the housing using "O" rings. The

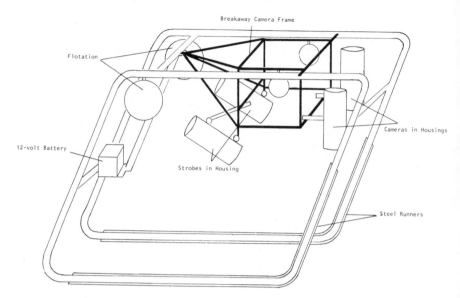

Figure 2. Diagram of the photographic sled, with breakaway camera–strobe frame shown as solid line structure.

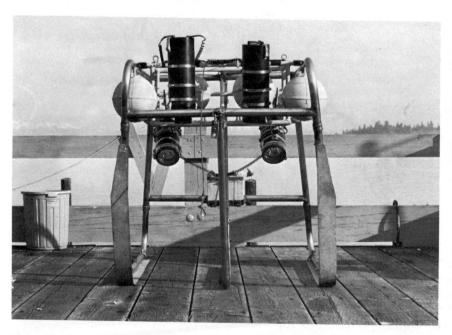

Figure 3. Three views of the photographic sled on the dock. The breakaway subassembly holding the cameras and strobe light sources is clearly evident.

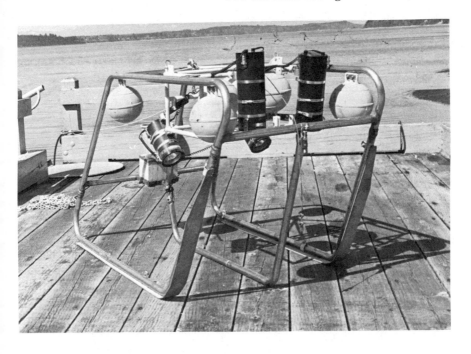

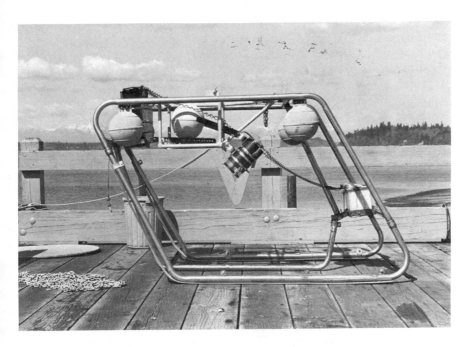

system is rated to a depth of 450 meters. Each camera and housing weighs approximately 21 pounds in air—2 pounds in water—and has external dimensions of 6'' in diameter by 17'' in length. Each strobe and housing weighs approximately 14 pounds in air—1.5 pounds in water—and has external dimensions of 6'' in diameter by 11'' in length.

The cameras are mounted on the forward part of the sled at a distance of 3.5 feet from the bottom to the focal plane. The cameras are angled towards each other, allowing each to photograph the same 22'' × 12'' area of substrate. This enables each frame to be viewed in stereo for greater depth perception and resolution. The strobes are mounted at the rear of the sled, pointing forward towards the substrate being photographed. A digital LED timepiece enclosed within the camera housing provides a time reference for every photograph taken. The time recording enables relocation of each data frame along a transect line.

Survey Methods

A 27' work boat has been used as the towing vessel for the photographic sled. The sled is towed with a single 5/32'' stainless steel cable. Lowering and raising of the sled is accomplished using a deck-mounted electric winch and A-frame superstructure. An InterOcean Model 715 depth meter is used to measure the amount of cable out in order to obtain a 3 to 1 scope of cable length to depth. A Ross Fineline S400 B recording fathometer with 49.5 Khz transducer and 22° beam angle is used to correlate depth with the photographic information. Visual ranges and time are recorded on the sonar printout to determine the position of the sled for later analysis.

The benthic photographic surveying is carried out along shore-to-shore transect lines. The transects are laid in a zigzag pattern across inlets at approximately one-half-mile intervals. The transect locations are determined with the use of 1:12,000 scale aerial photographs and navigation charts. Shoreline landmarks, line of sight, and compass bearings are followed to maintain position in the field. The photographic sled glides over the surface of the substrate when towed at speeds of 2 knots or less. When towing speed is increased to more than 6 knots the sled will lift off the bottom and fly over the substrate. This technique is used to avoid obstructions which are noted by the pilot on the fathometer recording. Depth is monitored on the fathometer to maintain the 3 to 1 cable length to depth ratio. A flexible sediment probe is mounted on the sled frame and visible in the camera field of view. This serves to stir the substrate when the sled is in motion, distinguishing between mud and sand substrates.

The cameras and strobes are set at a 15-second delay interval between frames. This produces a data frame approximately every 50 feet when a towing speed of 2 knots is maintained.

Film Analysis

The film is reviewed with a projector modified for single-frame stop-action projection. An additional projector can be used for stereo viewing. Each data frame is analyzed visually for macrobenthic organisms, sediment types, algae, and diatom coverage. Note is taken of holes, depressions, mounds, fecal castings, and tracks that may suggest the presence of certain organisms. Investigations in the field by divers using SCUBA accompanied the film analysis process.

The information from the photographs is recorded on data sheets and later transferred to area maps. Densities of benthic organisms, sediment types, and other information is plotted along the mapped transect lines at each data point. Isopleth charts are created from this data base for easy visual interpretation.

RESULTS

The pilot phase of the subtidal inventory project served to determine the necessary equipment and methodology for an applied survey, as well as to define its potentials and limitations. The proper sled design and camera strobe placement was determined through field testing. Problems involving balance and buoyancy were encountered. The sled had a tendency to bury its nose when towed over soft substrates and steep topography. This was solved with the use of weighted runners and upper flotation.

The film review process has provided the project with a species list of macrobenthic organisms for the area surveyed. (Table 1). Data was collected

Table 1. Species List for Subtidal Inventory Pilot Study

Anthozoa	**Asteroidea**
Halcampa sp.	*Evasterias troschelii*
Tealia sp.	*Pynopodia helianthoides*
Metridium senile	*Crosaster papposus*
Virgilaria sp.	*Dermasterias imbricata*
Ptilosarcus gurneyi	
	Holothuroidae
Gastropoda	*Parastichopus californiensis*
Dentronotus giganteus	
Dirona sp.	**Crustacea**
Pleurophyllidia california	*Cancer productus*
Tritonia sp.	*Telmessus cheiragonus*
Polinices lewisii	
	Osteichthyes
Bivalvia	*Sebastes caurinus*
Panope generosa	*Parophrys vetulus*
Penitella penita	*Pleuronichthy coensus*
	Hydrolagus colliei

from the photographs on the density and distribution of *Panope generosa*, the commercially harvested geoduck clam. This information is proving useful in expanding the previous geoduck surveys carried out by SCUBA divers from the Washington Department of Fisheries and can be used to evaluate potential lease tracts for commercial harvesting.

CONCLUSION

The Super 8 photographic sled has proven to be a valuable and economical method of benthic investigation. The system offers a means of acquiring general descriptive information for a large area of subtidal land without relying primarily on time-intensive techniques. The photographs produced by the system supply data on biological and physical factors necessary to assist in proper management of the submerged lands. The compiled data is presently being reviewed along with available benthic literature for the Puget Sound area to help determine rare versus common habitats and areas of significance to commercially and recreationally important species. The photographic survey system will be implemented in a long-term synoptic inventory of the Puget Sound subtidal lands. Other applications include site specific surveys to monitor environmental impact and assist in the location of aquaculture sites, spoil disposal sites, artificial reefs, and marinas.

Section III

In situ Operations

Current Zonation and Bedforms on Nova Scotian Continental Rise Determined from Bottom Photography

Brian E. Tucholke and Charles D. Hollister

Woods Hole Oceanographic Institution
Woods Hole, Massachusetts

Detailed bottom-photograph surveys of the Nova Scotian continental rise (39.5°-42°N, 60°-64°W) were made in preparation for long-term deployment of highly instrumented bottom moorings in the High Energy Benthic Boundary Layer Experiments (HEBBLE). Photographs show that contour-following bottom currents are directed mostly west to southwest along the lower rise and that there is strong zonation in current intensity (Figure 1). From 4900 m to about 5100 m a very thick, intense nepheloid layer is present and the seafloor often is obscured in bottom photographs; current speeds are estimated from bedforms in legible photographs to be greater than 40 cm/sec. From 4800 m to 4900 m, strong contour-parallel currents estimated at 20-40 cm/sec have created ubiquitous current lineations, and longitudinal triangular ripples oriented parallel to the flow are abundant (Figure 2). The longitudinal triangular ripples are symmetrical in cross section, 10-30 cm high, 30-100 cm wide, and have a spacing of several meters. Between 4400 m and 4800 m, moderate current smoothing and lineation of the seafloor occur beneath weaker currents, and activity of benthic organisms becomes more apparent (Figure 3). Current strengths steadily decrease upslope to essentially tranquil conditions between 3700 m and 4000 m where benthic biologic activity is abundant.

Large-scale bedforms such as the longitudinal triangular ripples, and mounds 10-20 cm high with current-deposited "tails," probably are formed

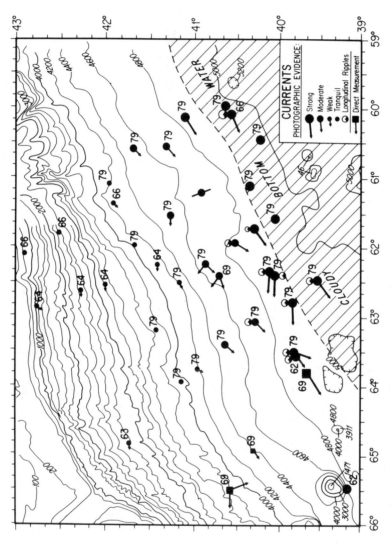

Figure 1. Preliminary assessment of average current directions and intensities on the Nova Scotian continental rise. Based on bottom photographs (dots) and short-term direct current measurements (boxes; from Zimmerman, 1972). Two-digit number shows year in which data were obtained (1962 to 1979); the pattern of westward, contour-parallel flow appears stable over this 17-year period. Bathymetric contours in corrected meters.

Figure 2. Longitudinal triangular ripple photographed at 4910 m (38°48.9′ N, 63°30.0′ W). Note cloudy bottom water. Current orientation is east–west, but absolute direction cannot be determined from the morphology of the ripple (tails on smaller features in other photographs show current to the west). Arrow shows true north. Area photographed is about 1.7 m along bottom of frame, 2.0 m along top, and 1.5 m along edges.

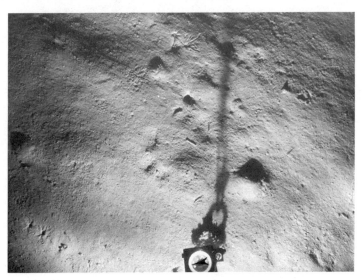

Figure 3. "Mound-and-tail" and "crag-and-tail" features photographed at 4481 m (40°37.1′ N, 63°24.2′ W). Westward flow at this depth is weaker than in Figure 2, bottom water is clearer, and biologic activity is more pronounced. Finest-scale features probably can be created and erased by bottom currents within weeks. Other data as in Figure 2.

over periods of months to years by strong, "vector-averaged" flows. These features show the dominance and long-term geologic significance of west- to southwest-flowing abyssal currents on the rise. At the opposite end of the spectrum, small (less than 1 cm) "crag-and-tail" structures, fine lineations, and "cornices" on larger bedforms probably can be formed or erased within days to weeks (Figure 3). Current directions determined from these evanescent features are more randomly distributed, and they indicate significant short-term variability in the abyssal flow.

ACKNOWLEDGMENT

This research was supported by ONR Contract N0014-79-C-0071 to the Woods Hole Oceanographic Institution.

REFERENCE

Zimmerman, H. B. 1972. Bottom currents on the New England continental rise. *J. Geophys. Res.* 76:5865-5876.

Time-Lapse Recording of Deep-Sea Sediment Transport

Mark Wimbush and Larry A. Mayer

Graduate School of Oceanography
University of Rhode Island
Kingston, Rhode Island

INTRODUCTION

The eighteenth-century English poet Edward Young (1683-1765) described the bottom regions of the ocean as "chambers deep, where waters sleep," and this image of the tranquil abyss prevailed in literary and scientific thought until the middle of the twentieth century when deep-sea cameras were used to take pictures of the ocean floor (Ewing, Vine, and Worzel 1946; Menard 1952; Ewing, Worzel, and Vine 1967). Even in these early photographs sediment ripples were sometimes visible. Since then, ripples and other bedforms in the deep sea have been observed in numerous photographs, proving that benthic currents are actively modifying the deep-sea bed (Heezen and Hollister 1971). Figure 1 shows four examples of such photographs. This indirect evidence for energetic bottom currents was later confirmed by direct observation. Variable and strong (greater than 10 cm/sec) currents have been measured in the deep sea, by moored recording current meters[1] and free drifting floats, beginning with the Aries observations (Swallow 1971). These strong currents tend to be near boundaries of the oceans, especially western boundaries, or in channels where the flow is constricted.

[1] The first really successful moored current meter was the Richardson meter (Richardson *et al.* 1963), which recorded current speed and direction with a camera-a specialized example of deep-sea photography!

Figure 1. Deep-tow photographs of ripples. Arrows show current direction, and are 1 m long. (a) Symmetric wave ripples. Horizon Guyot; water depth 1700 m; maximum measured current 17 cm/sec. (b) Long-crested low-energy current ripples. Hatton Drift, 3000 m; 22 cm/sec. (c) High-energy linguoid ripples. North Carnegie Ridge; 2625 m; 19 cm/sec (probably formed by faster episodic flows). (d) Mud ripples. Charlie-Gibbs Transform fault; 3650 m; 21 cm/sec. *(From Lonsdale and Spiess 1977)*

We would of course like to know how these currents modify the underlying sediment and create the bedforms. Laboratory flume studies of the interactions of currents and sediments have shown that the dynamic behavior of sediments is not easily predicted from knowledge of the flow conditions and sediment characteristics, except in ideal conditions (steady flow, uniform spherical grains, flattened bed, no mucous films, etc.). Hence *in situ* experiments are

necessary to study natural current-sediment interaction. This is most conveniently done with current measuring devices to record the flow conditions and time-lapse cameras to record the sediment behavior.

Apparatus of this type, combining some sort of current recording with sequence photography of the bottom, has generally been designed for experiments on the continental shelf (Owen *et al.* 1967; Summers 1967; Miller *et al.* 1972; Cacchione and Drake 1979; Sternberg and Creager 1965; Sternberg 1967, 1971a and b; Sternberg *et al.* 1973; Sternberg and Larsen 1975; Cater *et al.* 1976; Heath *et al.* 1976; Butman and Folger 1979; and Butman *et al.* 1979). Deep-sea versions have been tried (Sternberg 1969, 1970; Thorpe 1972), but the only abyssal-benthic record in which significant sea bed disturbances were recorded was a 202-day sequence taken in a mid-Pacific manganese nodule field (Paul *et al.* 1978; Thorndike *et al.* 1980), and here the disturbances were all due to biological activity.

Perhaps the deepest record of current-induced sediment movement is one that was obtained at an archibenthic site: 710 m depth in the eastern Florida Straits (Wimbush and Lesht 1979; Wimbush *et al.* 1980). In this paper we describe the apparatus with which that record was made, together with recent improvements. We also give a brief account of the observations made with the apparatus and plans for its future use.

THE ORIGINAL APPARATUS

In 1975 we decided to build an instrument system to record concurrently benthic currents and resulting sediment disturbances in the deep ocean. It seemed appropriate to do so, because among the thousands of photographs of the deep-sea floor that had been taken by that time there were many that showed sediment ripples or other clear signs of current disturbance. Also, during the previous decade, other scientists (especially Richard Sternberg) had been building instruments of this type and deploying them on the continental shelf.

Laszlo Nemeth began construction of our system at Nova University in Florida early in 1976. The principal effort went into the design and construction of the photographic subsystem. Since we had a limited budget, a commercial deep-sea camera and strobe light was not a feasible option. However we did have some 16-mm film transports salvaged from old Richardson current meters (Richardson *et al.* 1963), and we decided to use these. This decision led to an exciting possibility: we could take our sequence of photographs as a time-lapse motion picture and detect sediment movement using the eye's extraordinary capability to discern very small changes in a cinematographically presented picture. To accomplish this we changed the mask size to that of a standard 16-mm movie frame, and devised a simple mechanism to position

the frames precisely relative to the film perforations. This electro-mechanical mechanism works in the following way. The film transport sprocket drive has eight pairs of teeth and is driven by an 8:1 reducing worm gear, so that one rotation of the worm advances the film by exactly one perforation (corresponding to one frame). This worm is driven through a shaft by a low-power Portescap motor-gear assembly. Attached to the shaft is a disk with a single radial slot. An electro-optical limit switch is used to detect this slot. The limit switch contains a light-emitting diode (LED) and a phototransistor, and is placed across the disk so that radiation from the LED is prevented from reaching the phototransistor unless the slot in the disc is aligned with the sensing axis of the limit switch. The photographic subsystem is controlled by CMOS electronic logic clocked with a quartz crystal, and this circuit allows bursts of n photographs to be taken every $m \times$ 15 minutes, where $1 \leqslant n \leqslant 9$ and $1 \leqslant m \leqslant 99$. A new cycle begins $m \times 15$ minutes after the beginning of the previous cycle, with power applied to charge the strobe light. Twenty-eight seconds later, power is simultaneously applied to the motor and the LED. The motor advances the film while it rotates the disk, and as the slot in the disk enters the optical limit switch, radiation from the LED passes through the slot and falls on the phototransistor. This causes the strobe to fire, forming an image on the film. After n such strobe flashes, power is shut off from strobe, motor, and LED. Note that the camera is shutterless and that the film is moving when the pictures are taken. These simplifications are possible in the deep sea because of the lack of ambient light.

To obtain information on bedform relief we decided to have a stereo pair of cameras, and in the initial design this was accomplished by driving two cameras with a common shaft and enclosing them in a single large-diameter pressure case. Figure 2 shows the camera pair and its controlling electronics, with the pressure case removed. The optics consist of a pair of Leitz Elcan C205 6.64-mm focal length water contact lenses. The optical axes of the two cameras are 10 cm apart. The camera pressure case contains, in addition to these cameras, a battery pack of 30 alkaline D-cells, connected as six 5-cell diode-protected parallel batteries. This provides enough power for the entire photographic system to operate up to a year taking 4000 pictures, which is the capacity of the 100-foot roll of 16-mm film used by each of the cameras.

Figure 3 shows the over-all instrument frame in its 1976 configuration. The stereo cameras look directly downward at a 143×104 cm patch of the sea floor, which is obliquely illuminated by a Vivitar 283 strobe unit in a pressure housing with barn-door light concentrators. This camera-strobe arrangement emphasizes any relief in the sea bed and minimizes image contrast degradation due to light scattering from suspended particles.

The Vivitar strobe has a maximum flash discharge of 60 joules. But the actual amount of light is controlled (with an energy-conserving thyristor

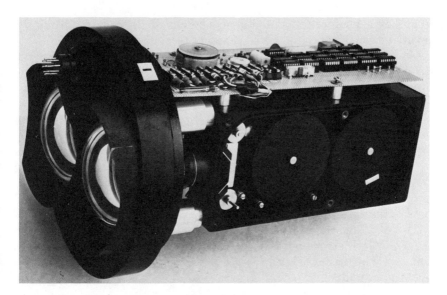

Figure 2. 16-mm time-lapse movie stereo underwater camera pair and controlling electronics, with pressure housing removed.

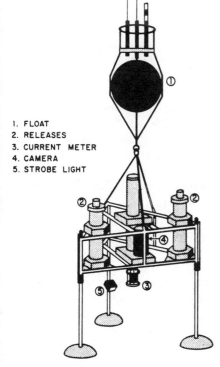

1. FLOAT
2. RELEASES
3. CURRENT METER
4. CAMERA
5. STROBE LIGHT

Figure 3. The original TRIFFID camera/current meter apparatus. Each side of the tripod frame is 160 cm long.

circuit) by a photocell mounted alongside one of the cameras. Thus the apparent scene brightness is held constant throughout the film.

A vector-averaging current meter (VACM) is mounted at the center of the tripod frame (Figure 3). The VACM records average northerly and easterly current components computed from a Savonius rotor, a vane, and a magnetic compass. It also records temperature.

The retrieval subsystem consists of flotation (with radio transmitters and flashing light to aid in location on the surface) and two acoustic releases. The releases are situated in two of the three corners of the tripod frame, and the subsystem was designed so that activation of either acoustic release would cause separation of lead anchor weights at the bases of all three tripod legs. Separated from the anchor weights, the apparatus is buoyant and floats to the surface.

The VACM and acoustic releases were manufactured by AMF Corporation (now EG&G). Instrument elevations (above the base of the anchor weights) were: cameras (first nodal point) 113 cm; strobe light discharge tube 52 cm; VACM rotor midpoint 70 cm.

THE FIRST EXPERIMENT

At the suggestion of Wilford Gardner, a region 58 km due east of Port Everglades, Florida, was selected as a promising location for observation of sediment ripples at depth. The region is on the eastern flank of the Florida Straits at 710 m, with a bottom slope downward to the west of slightly less than $1°$. In May 1976, a Decca Hi-Fix precision navigation system was set up to provide good coverage of the region, and in early June a survey of the bottom at our sampling site was conducted with a free-fall camera. The resulting photographs showed that 75% of the bottom appeared to be covered by a layer of rippled sand. The rest of the bottom was free of ripples.

Despite the patchiness of the ripples, in midsummer we decided to go ahead with the experiment. The cameras were loaded with Ektachrome 7256 film and set to take one stereo photograph every quarter of an hour ($n = m = 1$). The current meter was set to record averages of current and temperature every eighth of an hour. The apparatus was dropped at 26°06′N, 79°31′W on June 29, 1976, and was successfully recovered by acoustic command on July 15. Although all instruments functioned well during the first attempt, the patch of bottom in the field of view of the cameras was devoid of ripples. Grain motions were occasionally visible and did correspond with current speed peaks in the VACM record.

For our second attempt, the apparatus was prepared as before except that

programming controls on the camera electronics were set to take sequences of three stereo photographs at ten-second intervals once every hour ($n = 3$, $m = 4$). On July 23, 1976, it was dropped within 700 m of the first launch position. A month later, acoustic release commands were given, but because of excessive friction and inadequate buoyancy the apparatus did not leave the bottom. On September 4 it was located with an underwater television camera lowered from the U.S. Navy R/V *A. B. Wood*. When nudged by the camera, the apparatus broke loose and returned to the surface.

The following year (1977) the site was visited with the research submersible *Alvin*, and several surficial sediment samples were taken in the rippled area. The sediment was found to be a moderately well sorted medium carbonate sand, consisting chiefly of foraminiferal tests.

The stereoscopic color films from the second attempt contain an interesting 6-week record of sediment suspension and a pattern of ripple formation, migration, and decay related to distinct features in the current record. It also shows several instances of sediment disturbance by crab, urchin, and other organisms. Figure 4 shows an example stereo pair from this film. The film was studied frame by frame with an L&W Mark IV analyst-type 16-mm motion picture projector, and the observed sediment behavior was plotted as a three-level time series in which each film frame was assigned a particular value depending upon whether sediment suspension, ripple migration, or neither was occurring at the time. This time series is shown as the top trace in Figure 5.

Analogous, predictive, three-level sediment behavior series were produced from the current meter record (second trace in Figure 5) using various combinations of critical initiation and termination current speeds. Since one goal was to determine the best set of critical current speeds, these were not specified *a priori*. Instead, for each mode of transport, initiation and termination speeds, U_i and U_t, were allowed to vary independently, so that all possible combinations (within a reasonable range of values) were tested.

The predictive records were compared to the observed film record hour by hour and scanned for errors. In the case of ripple migration we defined an error to be either an instance when migration was predicted and no motion occurred or an instance when migration was not predicted and either type of motion occurred. We therefore assumed that ripple migration is occurring during all periods of sediment suspension. The bottom is often obscured from view during suspension events, but this assumption is reasonable. Errors in predicting suspension were considered to occur when suspension was predicted and did not occur or when suspension was not predicted but did occur. The success of a particular pair of critical values (initiation and termination) was quantified by summing the square of the difference Δ between the observed value and the operative critical value. Specifically, we

Figure 4. Sample stereo pair (reproduced here in black and white) from the six-week deployment at 710 m depth in the Florida Straits. The visible bottom area is 143 × 104 cm. Short edges of photo are oriented 016°T towards top of page (determined from VACM compass indication). The dark object at the top of the picture is the base of the current meter. Parts of two of the anchor weights are visible. The pale object on the left is an Accuquartz watch (overexposed). The pale object in the center is a fish. Stereo pair may be viewed with the viewer supplied in Hersey (1967), or in Cravat and Glaser (1971).

Figure 5. Time series from 6-week deployment in the Florida Straits. From the top: Observed sediment behavior, current speed record, predicted sediment behavior, ripple migration prediction error, suspension prediction error.

take the over-all prediction error for a given U_i and U_t and transport mode to be

$$E = E\epsilon^2/N; \quad \epsilon = \frac{\Delta}{\delta}$$

in which N is the number of points in the series, and δ is the standard deviation of the variable being tested as a predictor.

This type of error analysis implied that optimum prediction was obtained with $U_i = 20$ cm/sec, $U_t = 18$ cm/sec for ripple migration, and $U_i = 21$ cm/sec, $U_t = 23$ cm/sec for sediment resuspension. The three lower traces in Figure 5 are based on this optimum prediction, showing the predicted sediment behavior record and records of ϵ for the two modes of sediment transport. For further details on this analysis and on the sediment characteristics, see Wimbush and Lesht (1979).

Another goal of this experiment was to relate the rate of ripple migration to super-critical current speed. This study is currently under way, but postulating a relationship of the form

$$U_{\text{sediment}} = C(U_{\text{water}})^j$$

the data from one ripple sequence suggests $j = 6 \pm 1$ (Figure 6). It may or may not be coincidence that these data are in excellent agreement with Owens' (1912) empirical result: $j = 6$, $C = 2 \times 10^{-10}$ (cm/sec)$^{-4}$. (Owens' (1912) field measurements were for medium siliceous sand in 18° water of 10-50 cm depth at the mouth of a river.)

For public presentation, a sound track was added to the film to give an impression of the current speed and the passing of time. This sound track was generated with a microprocessor circuit developed by Donald Dorson. The current speed data fed to the microprocessor were converted to an audio tone whose frequency was linearly related to the speed. Superimposed on the tone were clicks to mark the passing days.

THE SECOND EXPERIMENT

Although the intention from the beginning was to make an apparatus suitable for use at depths of up to 6 km, the camera and strobe pressure cases used in the first experiment were designed only for 1 km depth, as a test of the concept. For further experiments, heavier cases in higher strength alloys were made.

In 1977 Roger Flood was planning a series of dives in the submersible *Trieste II* to study the furrows on the Bahama Outer Ridge (Figure 7). He invited us to join the expedition and use the submersible to place the apparatus within a furrow. There it would record any sediment motions that might take place on the rippled walls.

Because the apparatus was to be manipulated with a manned submersible, all implodable components had to be pressure cycled according to a specific routine to 50% overpressure. This caused one of our glass camera windows to

Figure 6. Graph of observed ripple migration speed plotted with observed current speed. Florida Straits, 710 m.

fracture. It seemed as if we might not be able to participate in the experiment, until Alan Driscoll offered to lend us a Benthos 35-mm deep-sea camera system. Figure 8 shows the apparatus incorporating the Benthos system in the docking well of the *Trieste II* mother ship.

The apparatus was free-dropped in a known field of furrows at 4600 meters depth. A 37-kHz pinger had been attached to help the submersible find it on the seafloor. Five days after the apparatus was dropped, the submersible did indeed find it and redeployed it on the rim of a furrow (Figure 9). It was left here for another eight days, when it was recovered by the submersible. (The release mechanism had jammed, preventing both acoustic releases from dropping the anchor weights).

The 35-mm film record was converted into a 16-mm movie by painstakingly reshooting each frame after its projected image had been positioned precisely on a screen. However, this motion picture record shows only one clear indication of hydrodynamic disturbance of the bottom. This is the washing

Figure 7. View from the *Trieste II* porthole looking directly along a furrow on the Bahama Outer Ridge, from within the furrow.

away of one small (approximately ½ cm) lump of sediment in the field of view of the camera at the beginning of the experiment. It is probable that this lump was a product of the disturbance caused by the apparatus landing on the sea bed. Hence its erosion may not be significant, except that it suggests the likelihood of erosion of biogenic forms in the environment. After the tripod is moved to the furrow flank, no erosional activity is visible in the film. In particular, we see no perceptible migration of the three flank ripples in the field of view of the camera (Figure 10). Most likely the duration of the deployment was simply insufficient for the slow and episodic sedimentary processes to be visible in the film record. For further details, see Weatherly and Wimbush (1980).

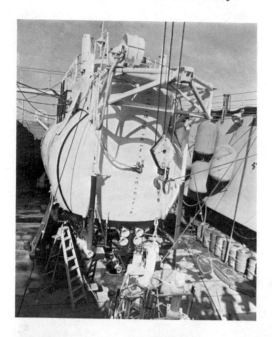

Figure 8. The TRIFFID apparatus near the bow of *Trieste II* in the docking well of USS *Point Loma*, prior to deployment September 1977.

Figure 9. The TRIFFID apparatus situated on the rim of a furrow at 4600 m depth.

Figure 10. View from the TRIFFID camera after it was situated on the rim of a furrow. Hanging ball is simply a device to give a visual indication of current flow. Sediment disturbance at base of picture was caused by tripod foot.

APPARATUS IMPROVEMENTS

By the end of 1977, several design deficiencies were apparent:

1. An Accuquartz watch in a pressure housing in the field of view of the cameras had been used to give a time check to each picture. It was hard to ensure correct exposure of this watch and as a result the hands were often unreadable (see Figure 4).

2. The release mechanism was unreliable. It was designed to drop weights at the bases of the three legs when either of the two acoustic releases was actuated. The complexity of this mechanism appeared to be responsible for its vulnerability to failure.

3. A single current meter gives no indication of the shear in the boundary layer. The instrument frame was not sufficiently stable to tilting moments to allow attachment of a vertical string of current meters.

4. The flat anchor-weight feet of the tripod frame apparently expelled planar jets of water across the sediment as they landed on it. These jets could modify or even eradicate the pre-existing bedforms. (The film from the 6-week deployment of the apparatus in the Florida Straits appears barren of bedforms until a strong current two days after the beginning of the film generates the ripples.)

5. The glass dome windows on the cameras were prone to failure under high pressure. This appeared to be caused by stress assymmetry due to off-center placement of the windows in the pressure case and cap.

6. Vertical resolution from the stereo pairs was of the order of 1 cm, when 1 mm was really needed to define the ripple profiles accurately. This low resolution was due to the small camera separation (giving 93% overlap in the stereo pictures), and the small 16-mm film format.

7. Cloudiness in the photographs is an insensitive and rough measure of suspended load. It is inadequate for studying this form of sediment transport.

The corrections for these design defects are as follows:

1. The time check for the 16-mm pictures is provided by a circuit that puts a string of green (0) and red (1) dots between the film perforations, representing the sequence number in binary or BCD code. This is accomplished by appropriately strobing a green-red LED whose light is directed to the film through an optical fiber during film advance.

2. The instrument frame is changed so that the entire lower portion of the frame is dropped when either acoustic release is actuated. The upper portion of the frame containing the instruments is made from fiberglass angles and is recovered. The lower portion is an iron tripod anchor that remains permanently on the seafloor.

3. The legs on the tripod anchor are splayed to provide stability against tipping, so that a string of current meters can be added above the instrument frame to profile the benthic boundary layer.

4. The feet of the tripod are imperfect catch-basin grates, which,

having a grid-like pattern of holes, expel less water horizontally on impact.

5 and 6. The photographic subsystem is changed considerably. The cameras consist of a single 16-mm time-lapse movie camera (with its glass dome window centered on the end cap), and two 70-mm Hasselblad 500 EL/M cameras in individual pressure cases, separated to give approximately 60% overlap in the 70-mm stereopairs. Two 7-segment LED displays are inserted in the film platen of each Hasselblad camera, and are driven by a frame counter. Thus a two-digit time check is written, without focusing optics, through the back of the 70-mm film. Because the film capacity in the Hasselblads is only 70 frames, a 70-mm stereo pair is taken only once for every 48 frames taken on the 16-mm movie film. For example, with the 16-mm camera set to take one frame every 2 hours, the 70-mm cameras take a stereo pair every 4 days, and the cameras will operate for 9 months.

7. A Bartz *et al.* (1978) transmissometer is added to monitor suspended particulate concentration. The output from this device can be recorded independently, or it can be fed to the VACM and recorded there in conjunction with the current and temperature.

Corrections 1 through 3 were implemented in 1978, and the apparatus was deployed for almost eight months on the eastern scarp of the Bermuda Rise. Currents were successfully measured at four levels from 70 cm to 62 m; however a loose bearing in the camera disengaged the film worm drive on launch and no bottom pictures were obtained.

Corrections 4 through 7 were implemented in 1979, and the resulting apparatus (Figure 11) was deployed on the Scotian Rise to be recovered in 1980.

FUTURE EXPERIMENTS

The apparatus described here is named TRIFFID. (Those who insist on acronymic interpretation are told that this stands for TRIpod For Filming in Depth.) A second apparatus is being built, and we hope to deploy these two TRIFFIDs in various dynamic regions of the deep oceans such as Kamchatka Trench, Horizon Guyot, and Carnegie Ridge in the Pacific, and Hatton Drift, Vema Channel, Oceanographer Canyon, and Blake Plateau in the Atlantic.

Sometimes a submersible will be needed for precise positioning, but generally we expect that the site on which a TRIFFID is dropped will be its deployment site. In a typical experiment it will remain deployed for one month to one year, recording sediment conditions every 15 minutes to 3

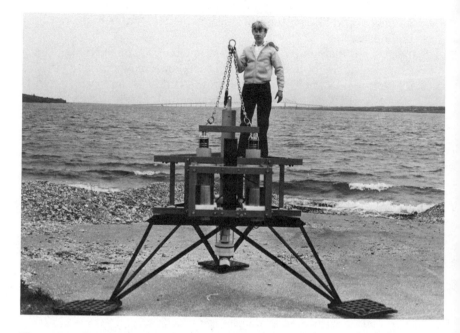

Figure 11. The new TRIFFID camera and current meter apparatus. Wimbush, atop the tripod, is 172 cm tall and is holding up the bridle to which a string of current meters and flotation devices would be attached.

hours, and recording vector currents, temperature, and light transmissivity at several levels in and above the benthic boundary layer every 3¾ to 15 minutes. Such records of the dynamic interaction between currents and sediments in the deep ocean will help us understand processes that have changed the face of the earth over geologic time.

ACKNOWLEDGMENTS

The U.S. Navy has provided support for this project under contracts N00014-75-0165 and N00014-76-C-0226 from the Office of Naval Research.

REFERENCES

Bartz, R., R. V. Zaneveld, and H. Pak. 1978. A transmissometer for profiling and moored observations in water. *Proceedings of the Society of Photo-Optical Instrumentation Engineers. Ocean Optics V,* 160:102-108.
Butman, B. and D. W. Folger. 1979. An instrument system for long-term sediment transport studies on the continental shelf. *J. Geophys. Res.* 84:1215-1220.

Butman, B., M. Noble, and D. W. Folger. 1979. Long-term observations of bottom current and bottom sediment movement on the Mid-Atlantic continental shelf. *J. Geophys. Res.* 84:1187-1205.

Cacchione, D. A. and D. E. Drake. 1979. A new instrument system to investigate sediment dynamics on continental shelves. *Marine Geology* 30:299-312.

Carter, L., R. A. Heath, B. J. Hunt, and E. J. Barnes. 1976. Instrument package to monitor sediment-water interaction on the continental shelf. *New Zealand J. Geol. and Geophys.* 19:503-511.

Cravat, H. R. and R. Glaser. 1971. *Color Aerial Stereograms of Selected Coastal Areas of the United States.* National Ocean Survey, NOAA. Rockville, Maryland: U.S. Dept. of Commerce.

Ewing, M., A. C. Vine, and J. L. Worzel. 1946. Photography of the ocean bottom. *Optical Soc. of America* 36:307-321.

Ewing, M., J. L. Worzel, and A. C. Vine. 1967. Early development of ocean-bottom photography at Woods Hole Oceanographic Institution and Lamont Geological Observatory. In Hersey, J. B. 1967. *Deep-Sea Photography.* Baltimore: The Johns Hopkins Press.

Heath, R. A., L. Carter, E. J. Barnes, and B. J. Hunt. 1976. An instrument for remote monitoring of sediment movement and associated hydraulic conditions on the continental shelf. *New Zealand Engineering* 31:242-243.

Heezen, B. C. and C. D. Hollister. 1971. *The Face of the Deep.* New York: Oxford University Press.

Hersey, J. B. 1967. *Deep-Sea Photography.* Johns Hopkins Oceanographic Studies, Number 3. Baltimore: The Johns Hopkins Press.

Lonsdale, P. and F. N. Spiess, 1977. Abyssal bedforms explored with a deeply towed instrument package. *Marine Geology* 23:57-75.

Menard, H. W. 1952. Deep ripple marks in the sea. *J. Sedimentary Petrology* 22:3-9.

Miller, R. L., C. Albro, J. M. Cohen, and J. F. O'Sullivan. 1972. *A Preliminary Study of Tidal Erosion in Great Harbor at Woods Hole, Massachusetts.* WHOI Technical Report 72-12.

Owen, D. M., K. O. Emery and L. D. Hoadley. 1967. Effects of tidal currents on the sea floor shown by underwater time-lapse photography. In Hersey, J. B. 1967. *Deep-Sea Photography.* Baltimore: The Johns Hopkins Press.

Owens, J. S. 1912. The settlement and transport of sand in water. *Engineering* 94:862-864.

Paul, A. Z., E. M. Thorndike, L. G. Sullivan, B. C. Heezen, and R. D. Gerard. 1978. Observations of the deep-sea floor from 202 days of time-lapse photography. *Nature* 272:812-814.

Richardson, W. S., P. Stimson, and C. Wilkins. 1963. Current measurements from moored stations. *Deep-Sea Research* 10:369-388.

Sternberg, R. W. and J. S. Creager. 1965. An instrument system to measure boundary-layer conditions at the sea floor. *Marine Geology* 3:475-482.

Sternberg, R. W. 1967. Measurement of sediment movement and ripple migration in a shallow marine environment. *Marine Geology* 5:195-205.

Sternberg, R. W. 1969. Camera and dye-pulser system to measure bottom boundary-layer flow in the deep sea. *Deep-Sea Research* 16:549-554.

Sternberg, R. W. 1970. Field measurements of the hydrodynamic roughness of the deep-sea boundary. *Deep-Sea Research* 17:413-420.

Sternberg, R. W. 1971a. Boundary layer observations in a tidal current. *J. Geophys. Res.* 71:2175-2178.

Sternberg, R. W. 1971b. Measurements of incipient motion of sediment particles in the marine environment. *Marine Geology* 10:113-119.

Sternberg, R. W., D. R. Morrison, and J. A. Trimble. 1973. An instrumentation system to measure near-bottom conditions on the continental shelf. *Marine Geology* 15:181-189.

Sternberg, R. W. and L. H. Larsen. 1975. Threshold of sediment movement by open ocean waves: Observations. *Deep-Sea Research* 22:299-309.

Sternberg, R. W. 1976. Measurements of boundary-layer flow and boundary roughness over Campeche Bank, Yucatan. *Marine Geology* 20:M25-M31.

Summers, H. J. 1967. Time-lapse photography used in the study of sand ripples. *Coastal Research Notes* (Geology Department, Florida State University) 2(6):6-7.

Swallow, J. C. 1971. The Aries Current measurements in the western North Atlantic. *Phil. Trans. Royal Soc.* Series A, 270:451-460.

Thorndike, E. M., R. D. Gerard, L. G. Sullivan, and A. Z. Paul. 1980. Long-term time-lapse photography of the deep ocean floor. In *Bruce Heezen Memorial Volume,* New York: Wiley. ed. M. Talwani and R. Scrutton.

Thorpe, S. A. 1972. A sediment cloud below the Mediterranean outflow. *Nature* 239:326-327.

Weatherly, G. L. and M. Wimbush. 1980. Near-bottom speed and temperature observations on the Blake-Bahama Outer Ridge. *J. Geophys. Res.* 85:3971-3981.

Wimbush, M. and B. Lesht. 1979. Current-induced sediment movement in the deep Florida Straits: Critical parameters. *J. Geophys. Res.* 84:2495-2502.

Wimbush, M., L. Nemeth, and B. Birdsall. 1980. Current-induced sediment movement in the deep Florida Straits: Observations. In *The Dynamic Environment of the Ocean Floor,* ed. K. Fanning and F. Manheim. Lexington, Mass.: D. C. Heath.

Young, E. 1728. *Ocean—An Ode.* In Young, Rev. E., *The Complete Works,* Volume 1, 1854. London: William Tegg and Co.

13

Long-Term Remote Underwater Monitoring

C. E. Miller

Stroboscopic Light Laboratory
Massachusetts Institute of Technology
Cambridge, Massachusetts

INTRODUCTION

The invention of the simple glass-bottomed viewing box is recognition of the superiority of remote viewing of underwater subjects and activities by surface observers when feasible. Divers suffer from limitations of endurance and depth capability, and unless camera-equipped, can provide only verbal descriptions of their experiences. In many studies, divers may be considered to be intruders in the area of interest, causing possible unnatural influence on the activities of creatures under study. Modern technology has provided us with an embarrassment of riches in terms of equipment and techniques available to extend the visual reach of the above-water observer beyond the capabilities of either the viewing box or the diver.

As film and film cameras improved in performance, they were placed in underwater housings and began returning an apparently endless succession of new and exciting images to the surface. The best of both systems have continuously been exploited in equipping divers with cameras. The diver does an excellent job of taking the equipment to the area of interest, identifying the subject, precisely aiming and adjusting for proper exposure, and recording at the right instant of time. Beyond the depth capability of the diver, many excellent images are returned by cameras blindly suspended by cables, their exposures predetermined and controlled by intervalometers

or by weighted bottom switches, though with rather less predictable results. Sonar has been effective in positioning underwater cameras, particularly in terms of finding the bottom. More recently, sonar has been employed to determine the presence of swimming creatures in the camera format, thus increasing the efficiency of image recording many fold over simple time-lapse systems. The availability of inexpensive video systems, packaged in underwater housings, allows the surface observer to view at great depths in real-time, and to record the images continuously for extended periods of time. Even the magic of Polaroid® cameras and film have been utilized for remote recording in the marine environment!

UNDERWATER VIDEO

Early closed-circuit television (CCTV) equipment based upon vacuum tube technology was bulky and, though often erratic in performance, was successfully used underwater. Several companies began marketing improved versions of solid-state video systems tailored to the special requirements of underwater use. These systems have also tended to be bulky, and suffer particularly from the difficulties of obtaining power of sufficient quantity and quality. Typically, these systems employed a relatively inexpensive vidicon tube as the camera "eye," so it was seldom possible to exceed a depth of 100 feet before lack of sensitivity required the use of high-powered auxiliary lighting. Unfortunately, all the camera and light power, as well as video and control signals, if any, passed through the umbilical cable. Monitors suffer from poor brightness and contrast on a sunny deck, often a physical or a tactical necessity. Many systems have required that the prime power source have special characteristics, particularly minimum harmonic distortion and good voltage regulation. Most of these problems have been overcome in modern systems through good engineering and through the availability of new and improved video components spilling over from the consumer marketplace. The over-all penalty, unfortunately, has been that commercial underwater systems carry very high price tags.

It is possible, however, to put together an underwater video system at rather attractive cost, if one is willing to accept some of the drawbacks, such as somewhat reduced image quality, for example. Figure 1 shows an example of a simple CCTV camera in a PVC housing, used as a remote viewfinder for an Edgerton 35-mm camera. The fields of view, viewing angles, and lighting systems were intended to be approximately matched so that the video information (continuously recorded on deck) seen in real-time would be usable to position the rig (by means of remotely-controlled water pump jets visible at top of photograph) and determine the right instant for exposure by the camera (also controlled remotely by the operator). Power for the

Figure 1. Complete underwater film camera with video "viewfinder" system.

system is standard 120 volts, 60 Hz for the video components, since 500 watts at this voltage level is required for the lamp. All other components are standard off-the-shelf CCTV components.

Not apparent in the photograph is the lens, in this case a 4.5-mm f/1 CCTV c-mount lens. This unusually short focal length is required because the

Javelin camera used employs a ⅔'' diameter vidicon tube. A camera using a 1'' vidicon would permit the use of a correspondingly longer focal length lens for the same angle of view. The flat camera faceplate also forces the use of a short focus lens. It is fortunate that consumer CCTV applications, chiefly for surveillance, have created a substantial market for such a lens, making it available at surprisingly low cost. The author has often used this and other special lenses for normal and high-speed movie work with great success, thereby helping further to justify their cost.

Also not apparent in the photograph is the cable. Cable constitutes an appreciable cost in most systems, and is also a major handling problem on the deck of a rolling ship. In this case, we elected to attach the camera permanently to the cable, and to make direct connection of the cable to the deck station without the use of cable-reel or rotating (slip-ring) connections. The cable we used is rather unusual in that no coaxial line is included. Direct connection to the camera improves the reliability of water-tight integrity and eliminates the usual problem in the longer run, of increasingly erratic connections due to the inevitable contact corrosion. A cable length of 500 feet is employed, which is stored and transported in a plastic garbage can. The inability to disconnect the camera has not proven to be a serious handicap. The cable is stowed in the barrel in alternating clockwise/counter-clockwise direction in order to eliminate twists that otherwise would result from lack of a rotating joint. Elimination of slip-rings adds again to the reliability of the electrical connections, particularly in the salt air environment.

The use of noncoaxial cable for carrying a video signal a substantial distance is most unorthodox. Figure 2 is representative of the common, multiconductor cables we have used in several underwater cameras with great success. One can view a test target with coax and then alternately with our cable to see the relative decrease in picture quality. A key factor in minimizing picture degradation is to choose a conductor (by experiment) surrounded by lines carrying DC or other low-frequency signals, such that a pseudo-coaxial cable is formed to carry the video. The use of this technique may cut the cost of a suitable cable to as little as one-tenth that of commercial underwater video system cable.

This viewing and photography system has been used successfully to about 400 feet on a number of projects, including the searches for the U.S.S. *Monitor* and the *Bear.*

OBSERVATION OF LOBSTERS AND TURTLES

The author's first underwater TV system is shown in Figure 3 to illustrate the possible simplicity of the underwater portion of the system. In this case the camera was a General Electric 1'' vidicon model which was placed with no modification in an available composition tube housing with

RUBBER JACKET

SHIELD BRAID

RUBBER INSULATED
CONDUCTORS

Figure 2. Cross section of common multiconductor cable successfully used in video applications.

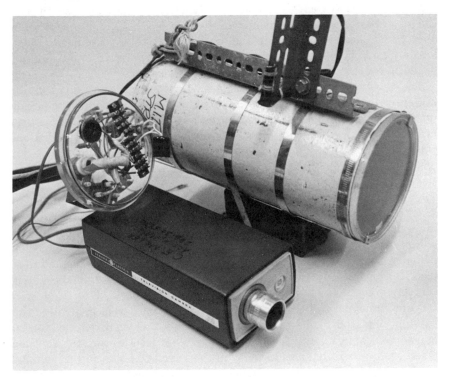

Figure 3. Inexpensive video camera and its underwater housing.

flat endplates. The bracket system on top supports the incandescent light, and the iron weight from an exercise machine below acts as a sinker. This was the first application of the standard, multiconductor cable to eliminate the high cost of instrumentation cable. All cable connections are made

within the housing, with leads out the back plate through Joy connectors for lamp power and film camera shutter control. Various cable types and lengths up to approximately 250 feet were used with about equal success in terms of image quality. It was also found that heavier cables seemed somewhat better mechanically in many instances where heavier sinkers were employed to minimize kiting of the camera due to tide and wind-induced boat movement. Also, it was found that in depths to about 150 feet, camera direction could be adjusted and maintained quite easily by merely twisting the cable when the camera was suspended from a boat.

An interesting application of this camera involved its use for approximately two months continuously submerged in 20 feet of sea water to study lobsters in Massachusetts in 1973. The object of the study was to monitor lobster behavior in the vicinity of a lobster trap. Documentation of behavior was to be in the form of long–term, real–time black–and–white video tape recordings, and in the form of high–quality color film transparencies. It was felt that the instrumentation in the vicinity of the trap should be as inconspicuous as possible so as to duplicate the lobster's natural environment. Most lobstermen indicated, when asked, that lobsters back into the trap, and we hoped to observe and record this behavior, for example.

The camera and lighting equipment were laid out on the bottom as shown in Figure 4, using a Nikon camera with its strobe light to obtain the color images on film. The TV camera of Figure 3 was set up with two incandescent lights illuminating the trap, and all equipment was connected by individual cables to appropriate shore power, monitor, and controls in a tent, used as an observation post, pitched on a dock. Since lobsters are nocturnal feeders, the problem of lighting for the TV camera without disturbing the subjects was simply solved by utilizing deep red filters in front of the TV lights. The sensitivity of the lobster eye is lowest in the red range, so they didn't know the light was on. The sensitivity of the camera's vidicon tube peaks in the red, and little gain is lost by having the filters absorb the green and blue portions of the spectral emission of the lamps. The net effect was that after dark, the lobsters thought it was night and the television system thought it was daytime.

Approximately 15 hours of video tape recordings were made over the two-month period. The film camera was brought up by a diver, the film (36 exposures) changed, and the camera replaced or reset during the daytime when there was little or no activity in the vicinity of the trap. It may be worth noting that the strobe flashes, which could not utilize the spectral filtration technique to mask their presence, did in fact cause a reaction on the part of the lobsters (clearly visible on the TV). It was also apparent that the subjects rapidly got accustomed to this outside influence and ignored it, or they became desensitized after the first flash. It was also interesting to find that *not a single one of the many lobsters entering the trap entered backwards!*

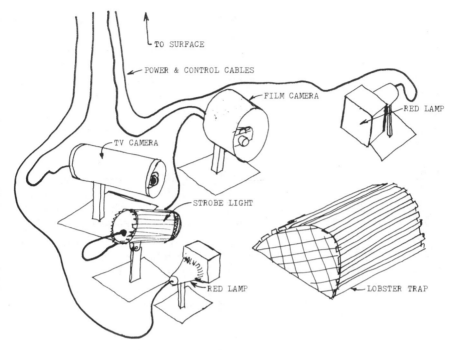

Figure 4. Experimental set-up for observing lobsters.

The author used a similar arrangement of the equipment, substituting an Edgerton underwater camera (35 mm) for the Nikon, in a study of the behavior of turtles in fresh water in Maine the following summer. During the turtle study, over a period of six weeks, the equipment was placed without the use of a diver, by lowering with a series of lines from a boat. Each line was tied off to a separate buoy, and no particular problems were encountered in servicing the film camera or in changing the layout of the components of the system. Again, many hours of videotape were accumulated to document the interesting behavior of these creatures.

THE USE OF SONAR

One problem with the observation of nocturnal feeders is the general mismatch of the active hours of the subjects and the observers. The problems of making records of activity increase dramatically as the number of subjects, or the frequency of their appearance before the cameras, declines. In the lobster study, there appeared to be perpetual activity in the vicinity of the trap after dark, to the extent that much of the activity was seen to be routine. This was not the case in the turtle study, where there were few

turtles appearing infrequently at odd hours of the night, and only persistent attention paid off in useful images. It was not reasonable to record continuously through the night. The long (compared to a movie camera) recording time of videotape still was limited to one hour per roll. Although the tape with no activity could be reused, all the tape would require review, taking one hour per roll. Also, with but a single machine available, the tape could not be reviewed while it was on line for recording. Clearly, some form of alarm to signal the approach of a turtle to the observation area would have been desirable.

These problems were overcome in some of the equipment assembled for use in Loch Ness, Scotland. Figure 5 illustrates some of the equipment used in the observation hut on shore, in an attempt to see any of the interesting things purported to be swimming in the turgid waters. With visibility of but a few feet at best, it was felt that every possible recording method should be available, ready, and operating if something happened to swim into view. Thus an observer was posted in front of the TV monitor 24 hours a day. Past experience with a time-lapse film camera indicated that at one exposure every 15 seconds, worthwhile recording times (about 8 hours) could be achieved, and that same camera was one of a battery of cameras suspended on a frame beneath a raft in an area suspected to be a good "seeing area." A special time-lapse videotape recorder originally intended for surveillance applications is to the right of the monitor. This recorder operates at one-seventh the speed of a normal VTR, and thus can record continuously, in time-lapse fashion, for seven hours on a roll of tape. That is, only every seventh frame is stored, and the intervening 6 frames of information are thrown away. This sampling rate, however, is still about 35 times greater than that of the time-lapse film camera previously mentioned. Further advantages of this recorder are that the tapes can be replayed instantly (unlike film that requires development), and a 7-hour recording can be reviewed on this, or any other EIAJ Type 1 standard recorder, in 1 hour.

Above the recorder is a novel device that can watch a given portion of a stationary video scene and sound an alarm should some change occur in the scene. This could have been used to bring the recorder up to normal speed recording or to trip one of the film cameras. It might also have alerted a drowsy operator, who otherwise was to operate the film cameras by means of the control box (upper left of monitor).

Again, power supply problems, in this case the use of 60-Hz equipment on 50-Hz lines, required a special solution. All the video equipment was supplied with power from lead-acid storage batteries (not shown), converted to 120 volts, 60 Hz by the solid-state inverter shown at lower left. Rectified 50-Hz line power was used to maintain a constant charge on the batteries, which, as is usual, acted like capacitors of extremely large value.

Previous experience and analysis of sighting reports suggested that the

Figure 5. Monitoring and control equipment for Loch Ness.

statistical probability of making a video sighting would be low. It was felt in addition to film and video equipment, sonar should be employed. Although the anticipated spatial resolution is less, the seeing distance of sonar in the murky water is vastly greater, and it could be employed as a "far-field intrusion detector" (Edgerton and Wyckoff 1978). The general layout of the sonar is depicted in Figure 6, showing how a standard side-scan sonar was used in an unconventional manner. Normally towed behind a moving boat past a stationary world, here the narrow sonar beam views a slice of the underwater features acoustically, and the recorder converts the returned echos into a map-like representation of the features. In this case, both the world and the sonar beam are stationary, and all echoes appear on the recorder chart at the same distance, in the form of horizontal streaks similar to those shown in the representation in Figure 7. The only nonuniform features that appear on such a recording are those due to an object that changes its position with time. The record yields an accurate value for the vector range of the thing from the transducer. Vector velocity is proportional to the *slope* of the echo tracing. Some idea of the dimension of the target may be gauged from the width of the tracing. Many such targets were, in fact

Figure 6. Sonar far-field detector used in Loch Ness.

Figure 7. Representative record of Loch Ness sonagram.

recorded, all at ranges known to be beyond the seeing distance of the film and video cameras. Thus, although no film or video records resulted from the experiment, the sonar evidence was strong enough to encourage the development of new forms of experimental apparatus. One of these is a time-lapse camera that might be carried to the target, having a built-in sonar to detect the target and turn on the camera when the target is properly formated and focused.

AN UNDERWATER POLAROID CAMERA

One of the novel cameras employed in the experiment consisted of a Polaroid SX-70 camera mounted in an underwater housing, shown in Figure 8. All the system components are attached to the ring-and-bar support structure to facilitate insertion into and removal from the housing as a unit. The camera has had a tray attached to the lip at the front to ensure that exposed pictures, when automatically ejected from the camera, will fall into the housing in such a manner that they will not block the faceplate and spoil

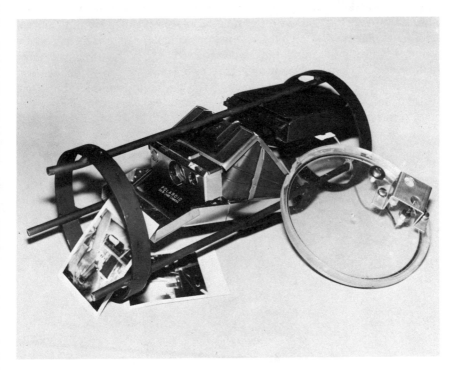

Figure 8. Polaroid SX-70 camera for underwater use.

succeeding exposures. A relay mounted under an auxiliary battery pack that acts as its power supply actually sets off the camera shutter, thus ensuring reliable triggering by a simple switch closure at the control panel several hundred feet of control line away. This camera also was provided with its own separate strobe for illumination. Very good test photos were made of a diver.

CONCLUSIONS

Many improvements have made better video equipment available at very low prices since the equipment described above was built. The use of integrated circuits has made improved image quality and stability available in ever smaller packages. The price of small, extremely high sensitivity cameras such as the silicon-intensified target vidicon (SIT), and the intensified-silicon-intensified target vidicon (ISIT) has dropped remarkably, opening the possibility of cameras requiring little or no auxiliary illumination. A major benefit is, of course, that the technical demands on the cable diminish, and a completely battery-operated, portable video system is possible, eliminating many of the various power supply problems as well. A host of small, inexpensive and low-power consumption color cameras have recently come on the market, and they will be used where the need warrants. Inexpensive black-and-white or color, battery-operated portable video cassette recorders are becoming plentiful. Indeed, the way is clear for many improved system configurations to be put together at low cost for future underwater monitoring applications.

REFERENCE

Edgerton, H. E. and C. W. Wyckoff. 1978. Loch Ness revisited. *IEEE Spectrum*, Feb. 1978:26.

A Simple Underwater Photographic Technique to Assess Growth and Seasonal Succession of Small Benthic Algae

R. E. Semple and J. D. Pringle
Department of Fisheries and Oceans
Government of Canada
Halifax, N.S., Canada

INTRODUCTION

Chondrus crispus Stackhouse (Irish moss) is a commercially important macrophyte in the coastal waters of eastern Canada. A program was initiated in 1975 to acquire biological information that would permit management of *Chondrus* (Pringle 1976). Studies were initiated to collect the following information: growth and reproductive phenology, morphological development, recruitment, community structure, and succession.

Underwater photography might permit the rapid collection of these parameters. Photography has previously been used to assess population structure and distribution (Taylor 1971) of *Chondrus* beds, but the technique employed would not give the detail needed to monitor individual frond growth, reproduction, and morphology. Preliminary data suggest it takes a minimum of 28 months to attain fronds of commercial size from a spore (Pringle and Semple 1980); thus, a method of long-term time-lapse photography would have to be developed that would allow monitoring with minimum disturbance. Johnson *et al.* (1969), Lundalv (1971), and Roslett *et al.* (1978) used underwater photography to show distribution and periodic changes in benthic organisms, but the equipment employed was too cumbersome to follow growth of relatively small marine algae. Taylor (1973) assessed increase in area of *Chondrus* by periodically exposing frond profiles on ozalid paper.

The technique was time consuming as the plants had to be removed from the marine environment; thus, only a few plants could be assessed. In an attempt to overcome some of these drawbacks, a technique using widely available underwater equipment was investigated. This paper outlines the equipment employed, the techniques developed, and the usefulness and limitations of photography for this work.

METHODS

A photographic method was developed to assess the qualitative and quantitative development of algal growth on primary pottery units (plugs) and secondary concrete units (blocks) placed in commercially harvestable areas in the Maritime provinces (Hanic and Pringle 1978). Up to 160 plugs with *Chondrus* germlings attached were planted in each of three locations: Miminegash, Prince Edward Island (46°55'10''N, 64°11'55''W); Morrissey's Cove, Prince Edward Island (47°02'20''N, 64°0'50''W); and Pubnico, Nova Scotia (43°38'50''N, 65°48'50''W). These plugs were placed at various depths in subtidal *Chondrus* beds. The study sites were semi-exposed. The waters around the Prince Edward Island sites are often extremely turbid due to heavy silt loads. Monitoring was monthly and bimonthly. Winter water temperatures of −0.5°C necessitated the use of dry suits. Thirty-kg weight belts were employed to enable the photographers to remain in position in ocean swells.

Figure 1. Diver using underwater camera with close-up attachment to film a series of pottery plugs with *Chondrus* germlings attached.

The camera used was a Nikonas II (Nikon Mfg. Co., Japan) with a 35-mm lens. This is a small and versatile self-contained camera. The close-up photography was done with 1:2 and 1:3 extension tubes (Aqua Craft Inc., San Diego, California) attached to the 35-mm lens. A wire frame was attached (Figure 1), which allowed the photographer to see exactly what was being photographed. An underwater electronic strobe, Subsea MK225 (Subsea Products, Riviera Beach, Florida), was used for close-ups. It has a light output of 225 watts/sec, a focusing light, 200 or more flashes per charge capacity, and is rechargable. The underwater camera/strobe connection was an E.O. (electro-oceanic) that permitted the interchange of cameras underwater. Film used was either monochromic Kodak Plus-X (ASA 125) or Kodachrome 63 (ASA 64).

Individual plugs being monitored were filmed from the same angle and distance (Figures 2-5). A small, cup-shaped cover was designed to fit over the algae on adjacent units to prevent them from coming between the lens and the frame. A small rod with cm bands was used during the filming for scale (Figure 5). Also, an accurate scale was obtained for measuring the

Figures 2–5. Plug 446, Block 3, Pubnico, Nova Scotia, planted on July 27, 1976, to assess the phenology of *Chondrus*. Figures 2, 3, 4, and 5 filmed respectively in February, March, April, and August, 1977. Note the scale rod in Figure 5.

plants interspersed on the plugs by placing a rule vertically at several distances from the frame (see Figure 9); from this, conversion factors were developed. The conversion factors vary with the size of the developed print or projected image (35-mm slide); therefore, a standard unit must be adhered to for ease in interpreting the measurements. For example, the projector should be kept at a determined distance from the screen or the prints enlarged to one convenient size.

A 15-mm lens was used to follow colonization and succession on the blocks. Seasonal variation in succession and recruitment could be interpreted from the photographs.

RESULTS AND DISCUSSION

The camera system worked well throughout the observation period. The MK255 strobe was adequate for both close-up and wide-angle photography (15-mm lens) but was bulky and could be replaced by a smaller, less sophisticated strobe (see Church and Church 1976 for various models). We found the bulkiness was compensated for by other features: (1) the rechargable system; (2) high light intensity for increasing depth of field; and (3) focusing light for accurate framing.

Monochrome film did not give the detail of the Kodachrome, and thus was rarely used. In addition, slides could be projected on paper and measured directly, which was more convenient than enlarging black-and-white prints. The only advantage of the monochrome film in this work was the greater exposure latitude.

The photographic method worked well for growth measurements (by area) of *Chondrus* fronds up to five dichotomies, or approximately two years old. When the fronds were larger than this, it was difficult to get the entire frond in one plane or depth of field. Frond density was also a problem at this stage as the fronds overlapped one another. A plexiglass press could be designed to alleviate these problems if fewer fronds were being assessed and measurements were made under calm conditions.

Assessing frond area from a photograph with a planimeter is time consuming. Various electronic means, including a density slicer, are being investigated.

When frond growth is assessed by nonphotographic means, changes in morphological detail, such as those evident in Figures 6 and 7, are often not recorded.

In addition to growth of *Chondrus*, the photographic technique employed was ideal in demonstrating the phenology of crustose algae (Figures 8 and 9) and the seasonal occurrence of ephemerals. The technique is also well suited to follow the development of such structures as the holdfast of *Laminaria longicruris* De la Pylaie (Figures 10 and 11) and cryptic animals such as bryozoa (Figures 12 and 13) and barnacles (Figures 8 and 9).

Figures 6-7. Plug 431, Block 2, Pubnico, Nova Scotia, planted on December 9, 1975. The fronds in Figure 6 demonstrate a broad morphology (July 1977). The same fronds in February 1978, with a terete morphology are shown in Figure 7.

Figures 8-9. Plug 383, Block 1, Pubnico, Nova Scotia. Figure 8 shows a thick carpet of a crustose alga in August 1976. Figure 9 shows a thinning of its cover six months later.

Figures 10-11. Plug 108, Block 3, Pubnico, Nova Scotia. Figures 10 and 11 show the development of the haptera of *Laminaria longicruris* between February 1977 (Figure 10), and March 1977 (Figure 11).

Figures 12-13. Plug 556, Block 3, Morrissey's Cove, Prince Edward Island. Fronds (arrows) partially covered (Figure 12) with a bryozoan (June 1977) and the same fronds two months later (Figure 13).

ACKNOWLEDGMENT

Special thanks are due to Mr. Dale Roddick who provided much assistance both above the water and below.

REFERENCES

Church, J. and C. Church. 1976. *Underwater Strobe Photography.* Gilroy, California: J. and C. Church.

Hanic, L. A. and J. D. Pringle. 1978. Outplant method for phenological studies of *Chondrus crispus* in mechanically harvested beds. *J. Fish. Res. Board Can.* 35:336-338.

Johnston, C. S., I. A. Morrison, and K. MacLachlan. 1969. A photographic method for recording the underwater distribution of marine benthic organisms. *J. Ecol.* 57:453-459.

Lundalv, T. L. 1971. Quantitative studies on rocky-bottom biocoenoses by underwater photogrammetry. A methodological study. *Thalassia Jugolsavica* 7:201-208.

Pringle, J. D. 1976. The marine plant industry—Commercially important species and resource management. In *Proceedings of the Bras d'Or Lakes Aquaculture Conference,* Sydney, N.S.: College of Cape Breton Press. ed. G. McKay and McKay, 161-181.

Pringle, J. D. and R. E. Semple. 1980. The benthic algal biomass, commercial harvesting, and *Chondrus* growth and colonization off southwestern Nova Scotia. In *Proceedings of the Workshop on the Relationship Between Sea Urchin Grazing and Commercial Plant/Animal Harvesting,* ed. J. D. Pringle, G. J. Sharp, and J. F. Caddy. *Can. Tech. Rept. Fish. Aquat. Sci.* 954:144-169.

Roslett, B., N. W. Green, and K. Kvalvagnaes. 1978. Stereophotography as a tool in aquatic biology. *Aquat. Bot.* 4:73-81.

Taylor, A. R. A. 1972a. A basis for the continuing assessment of natural and exploited populations of *Chondrus crispus* Stackh. In *Proceedings of the Seventh International Seaweed Symposium,* Tokyo: University of Tokyo Press, ed. N. Nisizawa, 263-267.

Taylor, A. R. A. 1972b. Growth studies of *Chondrus crispus* in Prince Edward Island. In *Proceedings Mtg. Atl. Seaweed Ind.,* Charlottetown, P.E.I., October 5-6, 1971. *Ind. Dev. Br., Env. Can.* 24-36.

Section IV

Photography from Submersibles

Submersible Photography in the North Sea Oil Industry

Lloyd Jasper
INTERSUB
Marseille, France

INTRODUCTION

As the oil fields in the North Sea expanded, new methods and technology were needed to cope with the depths and the extreme weather conditions. The integrity of the offshore installations and protection of the rich fishing grounds was of prime concern. With this in mind, INTERSUB and its research division INTERSUB Development have endeavored to provide its clients with a wide variety of tools and survey equipment.

Initially, our Perry submersibles were fitted with large front windows. This proved to be a great asset, making reasonably good video and photography possible from inside the sub. Then, in the space of just a few years, the manned submersible became a vehicle for carrying more and more types of sophisticated devices. One of these devices was the pipetracker (Figure 1). It enabled the submersible to detect, track, and record the degree of burial of a pipeline. (Since we introduced the pipetracker to the North Sea, more than half of our work has been pipeline survey). As Figure 1 shows, when the pipetracker is mounted on the sub, it is practically impossible to carry out video and still photography through the front hemisphere. The obvious solution was exterior mounted cameras. As will be seen later on, we ran into other problems when the sub was in the pipetracker mode.

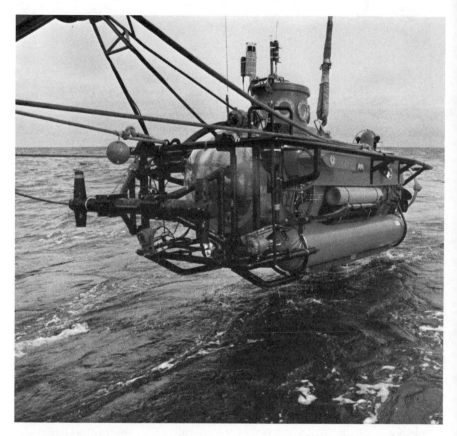

Figure 1. "Pipetracker" positioned on INTERSUB's Perry submersible. Note how this tool interferes with photography from inside the viewport.

EQUIPMENT

Prior to the purchase of our still camera equipment for the 1979 season, we discussed our requirements with Benthos, Inc., and then decided on a package that would meet most of our needs. This package consisted of a camera with a data chamber displaying the hour, minute, and second; day of the month; and dive number. The camera is equipped with a 22-mm lens and has a film capacity of 800 exposures. With slight modifications a 16-mm lens can be installed. The camera is housed in a stainless steel cylinder tested for 1400-meter depths. Its weight in water is about 10 kilos. The remote flash head has a rating of 200 watt seconds. This rating is greatly appreciated in the rather poor visibility we often encounter. The electronics

were redesigned for storage inside the pressure hull. In redesign we reduced the weight factor by about 10 kilos and, most important, we eliminated the possibility of taking water into the housing. The last item of the package was the remote control. There is a switch for half and full power, automatic or manual mode, ready light, and trigger. The recycle time of less than 3 seconds was another popular feature, especially in situations where almost rapid fire capability is a great advantage.

EQUIPMENT: POSITIONING AND TECHNIQUES

As noted above, the pipetracker cuts down the available space for positioning cameras and lights. For this reason, we decided to couple the video camera with the still camera. In this way we economized by eliminating one pan and tilt unit, but most important was the fact that the observer could now see on his monitor exactly what he was going to photograph.

Prior to the dive, we synchronize the data chamber with the video timer. Then at any time during the dive when the observer thinks it necessary to make still photographs, he will be sure to have an accurate record of when and where the photos were made (Figures 2 and 3). On the video screen, the A and B read-outs are distances to the transponders. After the dive these distances are converted to pipe kilometers or whatever other system of measurement the client wishes to use.

After some trial and error it was found that the best position for the cameras was the lower port side guard rail. If the particular submersible had demountable battery pods, the mounting had to be modified so as not to interfere with this safety feature.

The remote flash head was mounted on the lower starboard guard rail (Figure 4), giving us between six and seven feet between camera and flash. We found that in this position backscatter was considerably reduced and in some cases nonexistent. The flash head is in a fixed position, oriented slightly downwards towards a point about two meters directly in line with the sub's longitudinal axis. In order to gain more flexibility, in 1980 we will be coupling the flash head with one of the quartz iodide projectors, both to be controlled by a pan and tilt unit.

When performing a pipeline survey, the submersible generally flies the top of the pipe (Figure 5). Continuous video records the left-hand side of the pipe and shows the sea bed. This enables the camera to record free spans, damage, and obstructions when they are encountered.

When a still photo is required, the observer requests the pilot to stop. The pilot is then directed to position the sub perpendicular to the subject (Figure 6). The video continues recording while the observer announces that he is about to make a series of photos. He describes the damage or any other

Figure 2. Photograph showing an underwater pipeline electrode. In the original photograph, the time in hours (7), minutes (53), and seconds (39.19) is recorded at lower left.

Figure 3. Photographic reproduction of the television image exactly corresponding to the photograph of Figure 2. Note that the recorded time (07:53:39) and the fish are the same.

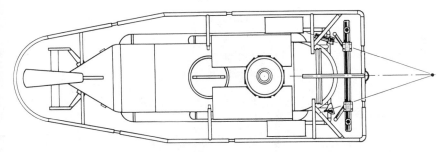

Figure 4. Diagram of submersible from above, showing positioning of cameras and light source on lower guard rails.

information he will require for his report. We like, if possible, to take at least six photos of each subject, varying the angle and distance. We also use the half and full power modes of the flash.

There are some occasions during a pipeline survey when the pipe lies in a narrow trench. If photos are to be taken in this situation, it is obvious that the normal procedure cannot be used. Our first experiences showed that the top of the pipe masked the flash and results were less than desirable. A partial solution was for the pilot to blow some ballast so as to gain altitude. Once it was high enough, the flash carried to the opposite side of the trench and reflected off the trench wall. The ultimate solution, which we intend to use in 1980, is to mount a second remote flash head on the port side.

Perhaps the biggest problem we encountered in the pipetracker mode was interference caused by moving the cameras, thus changing the pattern of the magnetic field. The following method was used to avoid this problem. Once on the bottom and before calibration of the pipetracker, the sub is positioned to fly the pipe. The observer aims the cameras to obtain the optimum picture for the survey. The pan and tilt are then shut off, and the cameras remain in a fixed position. Then the pipetracker calibration is made. Once a survey is started it becomes the pilot's responsibility to keep the proper image on the monitor. He is equally responsible for the correct positioning of still photos.

There are occasions during a pipeline survey when the client's representative aboard feels that a critical area should be examined in more detail. In those cases, we do a special video and photographic dive. The pipetracker is taken off and the observer can set up his lighting and camera equipment without any restraints.

STANDARDIZING CAMERA CONFIGURATION

At present, INTERSUB operates 12 manned submersibles, two remote-controlled vehicles, and five support vessels. We try to man each

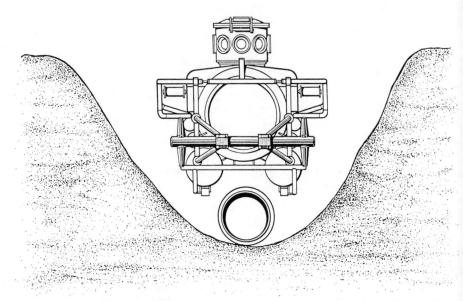

Figure 5. Diagram of submersible flying above trenched submarine pipeline in normal survey procedure.

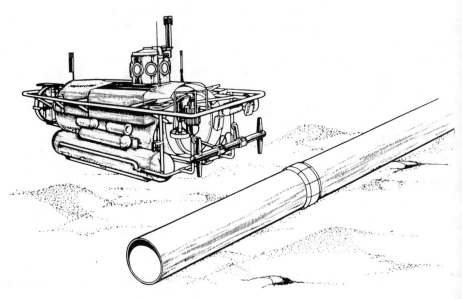

Figure 6. Diagram of submersible in photo recording position during survey.

vessel with the best crew for a particular job. There was a time, not too long ago, when anyone could be chosen to dive as observer. We soon recognized that professional results could not be obtained this way, and we created the position of submersible observer. These people were given training in all phases of the work they were to be responsible for. Lighting and still photography courses were included in the curriculum. Although most observers seem to be keen on photography, there are some that are just not photo oriented. To help them, and as a guide for new observers, we have been compiling a manual for basic camera configuration and exposure, based on our experiences on each type of job.

DIVE PLAN

More than 50% of a dive is preparation on the surface. We generally insist on a thorough predive briefing session with all parties concerned. Once we know exactly what is required by the client, the actual details are then decided on by the supervisor, pilot, and observer. The observer then sets up his equipment to suit the plan. A description of a job where still photographs were the prime requirement follows.

The amount and types of marine growth on a number of concrete platforms was to be studied by marine biologists to determine the effect the organisms were having on the concrete (Figure 7). In the starboard mechanical arm we placed a piece of tubing that was marked off in 5-cm increments. Also attached was a small scraper. At specific places on the platform during the survey we were to scratch the surface of the concrete and make a series of photos (Figure 8).

We decided to do the survey in a clockwise direction, starting at the base of the platform. Once a complete sweep was made, we moved up 10 meters. The camera was set up on the lower port guard rail and the flash on the upper port rail. Continuous video was also a requirement. When we reached a predetermined spot to be photographed, we announced our position. The pilot stopped, turned the sub perpendicular to the subject, deployed the arm, and made a scratch. A series of photos was taken with the measuring device appropriately positioned in the frame (Figure 9).

As we approached the surface, visibility rapidly deteriorated and strong currents made it impossible to continue the survey. The client was pleased with the results of the still color photos, however. The black and white video results proved to be much less effective because in areas where marine growth was minimal, it was hard to determine what was growth and what was concrete. In the future we will recommend doing this type of job in stereo.

Figure 7. Drawing of concrete offshore platform where underwater photography was used to determine effects of marine growth.

Figure 8. Photograph of a section of the concrete platform in Figure 7. Note 5-cm graduation marks on tube fitted to mechanical arm. A small scraper is also attached to this arm.

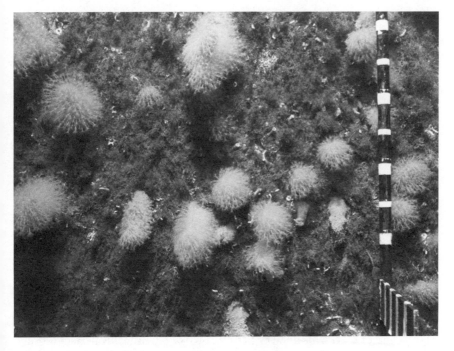

Figure 9. One of a series of photographs taken of the concrete platform. The 5-cm graduated measuring device can be seen on the right.

FILM PROCESSING

Even before we began using the exterior still cameras we were processing color negative film at sea. Our experience with Kodacolor 400 film has shown that it is well suited for our work. It is a sharp, fine grain film with sufficient latitude to produce acceptable prints even when negatives are underexposed. When it is overexposed we find that contrast increases but the grain is improved. Kodak does not recommend push processing because it only produces color shifts and undesirable grain. The only problem we had was in obtaining this film in 100-foot rolls. It is not normally supplied in these lengths but we were able to procure them by placing a special minimum order of 45 rolls.

We use the Kodak C-41 process and develop the film in a unit that was designed for our ships' darkrooms. Color analyzers for making prints have proved to be very useful, saving time and paper. At present we use the drum system, for print developing is found to be slow and somewhat limited. A small inexpensive processing machine would be ideal. If for any reason the results of a dive have to be seen as soon as possible, acceptable black-and-white prints can be made on Kodak panalure paper.

EXPOSURE

Since we generally do not have the luxury of making a quick dive to see what the visibility is like, we have to make an educated guess as to exposure. Through experience we find that for most pipeline surveys between f/5.6 and f/8 is about right. We use this setting as a guide for all other types of work. Distance is set for 2 meters, which gives us a depth of field from about 1.30 meters to 4 meters.

CONCLUSIONS

The principal role of submersible photography in the North Sea has been to record damage. There has been very little or no call for applications such as stereo and photogrammetry. One reason may be that at present existing oil fields are in diver depths. Therefore, it is generally more economical to have measurements made by divers using conventional methods.

One area in which the manned submersible has proven to be valuable to the oil industry is bathymetric surveys. These surveys are done prior to the positioning of platforms and the laying down of pipelines. A perfect adjunct to the bottom profile would be underwater mapping. All the necessary

components with which to produce photos of large underwater areas now exist. Even the problem of making photographs in bad visibility seems near to being solved through laser technology. These capabilities coupled with a system of digitalization of the images to produce contour maps yield a process that will be of great importance to the offshore oil industry. We are presently in contact with a group that can process up to 400 stereo pairs per day. They feel that this number can eventually be raised to 1000 pairs. We intend to carry out trials with this group in 1980.

Movies from a Submersible

Bob Kendall

Oceanic Engineering
Interstate Electronics Corporation
Anaheim, California

Underwater photography is 90% application of standard photographic technique and only 10% specialized underwater technique. I know; I learned the long way, taking pictures underwater but knowing nothing about photography (including my second roll of film shot in the MIT pool). Basic knowledge of exposure, focus, depth of field, type of film, lighting, lens perspective, and composition are necessary for good photography anywhere. Kodak Data Books are a very important source of these basics. The book *Lenses in Photography* by Kingslake is especially helpful. The text of my book *Photographs Underwater* discusses the 10% technique special only to underwater photography. For motion picture production, *A Primer for Film-Making* by Roberts and Sharples is outstanding.

To produce high-quality movies underwater, one should use standard techniques as practiced by cameramen in the film industry. For the movie shown at the symposium, I filmed in Eastmancolor 7247 so I could use a standard processing laboratory, such as Technicolor, in order to get good scene-by-scene color balance in the final prints. A Hollywood film industry laboratory offers a lot of services that are important to the success of the final film. The lab will safeguard your original negative and make you a working print to edit. Timing of the final work print and original negative cutting and splicing are tasks for professionals, and don't relate to the

composition of the completed movie. Working with Ektachrome films for movie work is never quite satisfactory, for you invariably handle the original film many times, editing, cutting, splicing, and viewing. Film processing costs are also much higher for reversal films.

Use a standard film industry movie camera in order to get the best pictures possible. For work in submersibles there are really only two good choices for a standard, battery-pack supplied, electric movie camera: the Arriflex or the Mitchell Reflex; I use the former. Focusing and framing and composition cannot be done better than through a reflex viewer. Other types of camera are possible, but you sacrifice quality by trying to save money that you are better advised to save elsewhere. If you don't get it right on film in the first place, you cannot conjure it up out of thin air later. I choose a zoom lens because as I film I can change very quickly from wide-angle all the way to mild telephoto. In a submersible you are limited in space and time. You have to work close to the porthole and shoot quickly as you see the action you want on film. Eliminate unnecessary equipment handling operations as much as possible, to make your filming operation as simplified and smooth as possible. To simplify my camera scanning and provide a stable place for the camera inside the submersible *Nekton Gamma,* I made a floor box just big enough for the camera to rest on. This custom wooden platform allowed me the option of shooting out of any of three different portholes. Your standard movie camera should be operated with its own battery pack, thus making the camera independent of the submersible's electrical supply. Be sure to bring an extra battery pack as a back-up.

Standard movie making technique is to take as much good footage as possible and plan editing later in order to get the final product. Shooting the maximum amount of footage possible should be a primary goal. A safe rule of thumb is to have enough film load to be able to run the camera, filming, during 50% of the bottom time of the submersible dive. Consequently, you should be sure to have one or two spare film magazines with you in the sub. There is considerable overhead expense involved in any kind of underwater movie just to get in position in the underwater setting. Ship time is always the biggest cost, whether you pay for it or someone else does.

Unlike taking movies with divers, taking movies from a submersible means the lights are attached to the vehicle and therefore fixed in position throughout the filming sequence. There is a great advantage in this since you do not have to reposition the lights periodically. With the portholes and the lights in a fixed position, the photographer in a sub is relieved from having to direct light positioning—a time-consuming process, particularly when photographing underwater. However, a good deal of forethought is necessary, planning the placement of lights on the submersible in relation to the camera and the position of objects to be filmed. Positioning the lights

with consideration for area and distance to be covered and for the desired shadow effect is important. The lighting set-up is just the same as if you were in a studio. On the submersible *Nekton Gamma* I used two lights spread out to light a distance (or depth of field) ranging from 1 to 3 meters from two side portholes. I always do some practice shooting in the same set-up combination I will use on the ocean bottom. Usually the sub operators are quite willing to participate in such practice runs. Practice is best done even if some ship and submersible bottom time is used, to check out the positioning of lights, camera, and cameraman in the sub.

The lights used on the *Nekton Gamma* consisted of a standard studio lighting system: generator, color transformer, 300 meters of cable for shooting at a depth of 150 meters, and two 1000-watt 3200°K lamps in Birns & Sawyer 5567 housings. Most of the actual shooting for this film took place at a depth of about 90 meters. For depths of less than 50 meters, I have used a pair of General Electric PAR64 medium flood globes with connections potted in epoxy, which cost a lot less than the 3,400-meter depth rated Birns & Sawyer lights.

Once the lights are mounted for a dive, you are committed, for there will be no repositioning of lights underwater. More than likely, you will be relying totally on artificial lighting when you photograph from a submersible. If the water happens to be shallow enough to use some natural lighting in the background, utilize this to add variety to your scenes.

A team effort is required to produce movies. Besides a capable cameraman, you need someone to move the cameraman around (the submersible pilot), someone to handle the cable, someone to handle the generator, someone to handle the boat the generator is in, and one or more others on a larger vessel to service the small boat and the submersible. A good working relationship with the submersible pilot is very important. The pilot is the one who moves you and your cinematography equipment into and out of position. Humidity is a problem to be coped with at depth. Lenses and the inside of portholes tend to fog. Calcium chloride dessicant in trays (changed every dive) and a small electric fan blowing lightly across the porthole help. Allow at least one day of sea time for a practice run with your new team and all equipment operating. The sea-going team covers just the taking of the movie, which is only the beginning of the movie–making or film–production process.

Many hours must now be spent editing the work print. This editing process requires a tremendous amount of effort in terms of hours as compared to the original taking of the footage. If you are the editor, you must go through the film, scene by scene, picking and choosing and then finally rearranging the sequence. Editing is ultimately important because it is at this point that you achieve what you want to say. When you were filming a subject, you presumably had knowledge of that subject—the way a fish

should be viewed—and now in the editing you choose the frames and the sequence to depict that creature in such a way as to create a message, telling on film an idea that you visualized when taking the original footage.

The illusive subject known as composition is one about which little is written. To describe composition as the intuitive processes of "eyeballing" is not scientific. Composition is (1) *knowing* about the object to be photographed and (2) *achieving* a message by imparting an understanding of the object though the picture, something which might take a thousand words. Today, the picture has almost replaced the word as a means of communication. *Knowing* includes what the object is (recognition), what it represents (appreciation), and how the object functions (perception). Why is the object where it is? What is its relationship to man? *Achieving* is to get a point across, to say something with a picture, compose a message, all accomplished through the mechanics of photography. *Lighting* emphasizes certain dimensions. *Angle* of view points to the center of interest. *Pose* means arrangement of objects, to capture the action into the picture. *Props* are used to establish correlations such as size. *Mood* means using design principles such as the "rule of thirds," dividing your picture area into thirds with nothing of interest ever at the exact center. Use the S curve for beauty, the three-point triangle for danger or uneasiness. If the eyes of the viewer are not moving around the picture, then you have not attracted interest to the object or have not focused on a message that needs to be said. The road to success starts in the mind, goes through the eye, through the viewfinder, through the laboratory modifications by cropping and corrections of color and contrast, to the final photographic picture. A true photograph penetrates and records the world we live in.

The movie shown at the symposium, "Beautiful Macrofauna," has a message. Due to internal wave surge at a depth of 90 meters on the Tanner Bank off Southern California, sand sediment scouring of rock on the seafloor does not allow a hold-fast for benthic organisms. Just 10 meters above the seafloor, on rock protruding above the seafloor, sea life is seen in abundance and diversity (Figure 1).

When the editing process is completed, the spliced work print goes back to the laboratory to be matched to the cutting of the original film negative. When the negative cutting and splicing is done, the negative footage will exactly match the work print. Both films are turned over to the "timer" at the film laboratory, who counts frames for each scene in the film and determines the color balancing or matching corrections with his experienced eye. The timer makes up detailed scene-by-scene filter instructions for the automatic film printing machine. After a few answer print passes through the color printer, you will have an evenly-lighted and color-balanced final film.

If you are lucky, you will also be involved with a sound track for your film.

Figure 1. Crynoid *Florometra serratissima* at a depth of 88 meters on the Tanner Bank (32°42.6′ N, 119°12.4′ W). From the movie "Beautiful Macrofauna." *(Copyright © 1980 Bob Kendall)*

Those of us who have had to "make do" without an accompanying soundtrack realize that a good half of the pizzazz of a good underwater movie, or any movie, is the sound backdrop. But so often in scientific and industrial films sound is not a budgeted item. If the film has to be silent, then the titling of the film could be very important to achieve a sense of quality. Don't rush this stage of your film, because after all the titling is your introduction to your film and first impressions can be important.

The work has just begun following taking the movie. In the producing of your movie, the laboratory is very important. Film laboratory services involves the talents and dedication of a group of technicians who process and print the film, do negative cutting, do color balancing, and titling. Production of a good movie is almost never done by one person; too many diverse talents are needed. One should have this in mind when one goes out to sea to take underwater movies, including movies from a submersible.

ACKNOWLEDGMENTS

The film shown was one of three 15-minute films from the Tanner and Cortez Banks (33°42.6'N, 119°12.4'W) produced under contract AA551-CT8-43 for the U.S. Bureau of Land Management.

Figure 2. Bob Kendall, underwater photographer, has won recognition at the Underwater Film Festival (Hollywood, 1960) for photographing sea life in the Red Sea, and the Man-in-Sea Award at Inner Space Pacifica (Honolulu, 1972) for underwater photography. He received a Ph.D. in physical oceanography from Nova University in 1970 and has written and illustrated two books.

Evaluation of Movie Lights for Use on DSRV Alvin

John Porteous
Woods Hole Oceanographic Institution,
Woods Hole, Massachusetts

PROBLEM

Evaluate and compare the color reproducing ability of the new Hydro Products 400-watt dysprosium-thallium quartz iodide lamp (D.T.I.) and the standard 750-watt EG&G quartz iodide lamp, which has been used on the DSRV (Deep Submergence Research Vehicle) *Alvin*. Also, determine whether the flat white parabolic reflector used by Hydro Products is an improvement over the silvered conical reflector that has been used on *Alvin*.

PROCEDURE

A light-testing frame was constructed by attaching legs to a 20-foot section of aluminum tubing. The tubing was then calibrated by painting one-foot sections alternately black and white (Figure 1). The stand holding the test lamp was positioned three feet to the left and five feet above the aluminum bar. The lamp was then aimed at a point about seven feet down the black and white bar.

Mounted on the aluminum tubing was a white placard with red, yellow, and blue color patches painted on it. The placard could be clamped anywhere along the bar and was placed at three-foot intervals for each lamp test. The

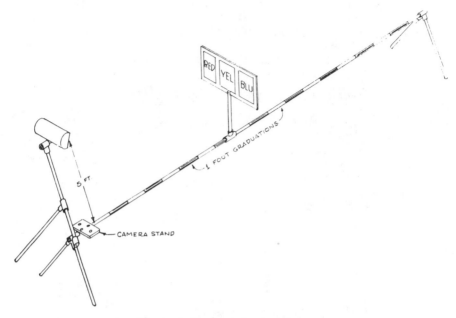

Figure 1. Underwater test frame.

distances used in the test were from a close setting of three feet to a far setting of twelve feet. Two Nikonos underwater cameras were used during the test. One was loaded with Kodak Plus-X black-and-white film (ASA 160) and the other with High Speed Ektachrome color reverse film (ASA 160). All the pictures shown here were taken at a shutter speed of 1/60 second and a diaphram setting of f 2.5. The black-and-white film was then processed and enlargements were made (Figure 2). All of the black and white prints were made at the same enlargement and were exposed and developed for the same amount of time. The color film was sent to Kodak for standard machine processing.

RESULTS

As a preface to the results, an explanation is in order for the use of a 400-watt lamp and a 750-watt lamp. The main purpose of this procedure was to test color rendition. It was the color of the light produced and the colors seen by the film that mattered.

The results of the color test showed that the quartz iodide lamp in a flat white parabolic reflector gave the best color quality. The quartz iodide lamp in a conical silvered reflector was next, and the D.T.I. lamp in its standard flat white parabolic reflector was last. All three color patches—red, yellow

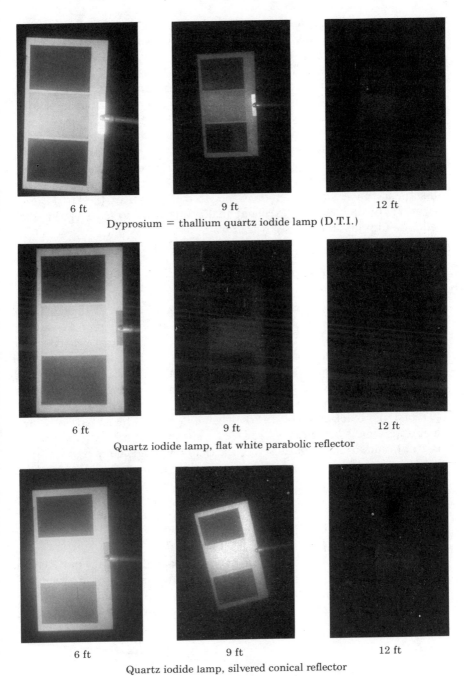

6 ft 9 ft 12 ft

Dyprosium = thallium quartz iodide lamp (D.T.I.)

6 ft 9 ft 12 ft

Quartz iodide lamp, flat white parabolic reflector

6 ft 9 ft 12 ft

Quartz iodide lamp, silvered conical reflector

Figure 2. Black and white photo results.

and blue—showed up clearly at nine feet using the quartz iodide lamp in either reflector. The wider angle coverage and lack of a hotspot with the flat white reflector made it an easy first choice. This reflector seemed to help cut backscatter also. The D.T.I. lamp, even at three feet, turned the red patch a dark brownish red. The yellow patch had a green tinge, and the blue went very dark and muddy. (Color slide duplicates are available to interested parties.)

In the black-and-white test the D.T.I. lamp produced excellent grey tones and had the greatest penetration. Next, and very close to the D.T.I. lamp, was the quartz iodide lamp in the flat white reflector. The silvered cone reflector produces a spotlight effect which for our motion picture purposes is unsatisfactory. A side note here is that to me, as a diver, the D.T.I. lamp seemed to put out a light of excellent quality and all colors looked right, even red. The film just did not see it that way.

RECOMMENDATIONS

For accuracy of color and even light output, the quartz iodide lamp in a flat white parabolic reflector should be used. It is my opinion that two of these lamps mounted near the observer's port on *Alvin* will give good results for color movies, out to at least fifteen feet, and perhaps farther.

Where color accuracy is not a prime requisite, two D.T.I. lamps could be used. These lights could also be used in conjunction with black-and-white movies or a television system.

When just black-and-white work is being done, on film or tape, or where just observing is being done, two D.T.I. lamps would provide good results. Better results could be gotten from the thallium iodide lamp (not included in this test, but I have seen it in operation). It is, in my opinion, the best television and black-and-white movie lamp available at this time.

ACKNOWLEDGMENTS

I would like to thank the *Alvin* Group in general, and George Broderson, George Gibson, William Page, and Warren Webert in particular, for their encouragement and assistance during this test. This work has been carried out under contract Nonr-3484; NR 260-107 with the Office of Naval Research.

Section V

Stereo Photography and Photogrammetry

Stereo Photography for Vertical and Horizontal Measurements

Donald A. Smith and
Michael M. Boyajian
C. E. McGuire
Providence, Rhode Island

INTRODUCTION

As part of a long-range research program, a deep-sea probe will descend to a depth of 5400 m in the western Atlantic. One portion of the experiment is programmed to monitor the relationship between water currents and movements of the bottom sediments. Using stereo cameras, photographs of an area 1 meter square will be obtained in order to measure, to an accuracy of ±1 mm, changes in the bottom contours over a period of from 3 to 6 months. The cameras will be programmed for time-lapse photography and linked to instruments used for measuring currents, so that during any period when an abrupt change in current velocity is detected the firing sequence of the camera will be activated to record the effects of the current on the bottom topography.

This paper describes results of preliminary experimental measurements obtained by photogrammetric methods from a pair of Benthos 35-mm Model 372 deep-sea cameras in a 6-meter test tank. The preliminary tests were conducted to evaluate the feasibility of the proposed system.

TYPES OF AVAILABLE SYSTEMS

Several types of optical systems, useful in obtaining measurements of small areas, were examined, and stereo photography was selected for the

project. Video systems, which are relatively inexpensive and flexible in their uses, were not selected because their resolution, which is essential in precision measurement, did not compare to film-type cameras. Moiré-type photography was also considered, but numerous problems involving calibration, refraction, and light scattering made this technique undesirable at this time. It was therefore decided to investigate the use of stereo photography and close-range photogrammetry as the method for recording and measuring bottom movements. This decision was based on the fact that film-type cameras provide the best image resolution, and their support frames allow precise positioning of both the cameras and their light source in a manner that minimizes the effect of light scatter between the lens and the subject. Furthermore, it had previously been demonstrated that accurate measurements could be obtained from underwater stereo photography, providing the cameras were properly calibrated, correct lighting equipment and techniques were employed, and accurate controls were used.

THE CAMERA SYSTEM

A Benthos 35-mm stereo camera system, consisting of two Model 372 cameras equipped with two Model 383 flash units, was chosen as the recording device. These cameras were selected for several positive features, including:

1. The ability to record a variety of information on each frame such as date, time, and exposure number.
2. The film capacity of the camera, up to 6,400 exposures, allowing continuous recording for extended periods of time.
3. The variety of fine grain films available that yield the best image, quality, and resolution.
4. Available lenses include Nikonos medium-wide angle lenses that have been corrected for underwater use.
5. The ability to add some type of reference mark to the film as an aid in the calibration of the cameras.
6. A glass window on the housing that reportedly yields a uniform distortion curve under pressure.
7. The camera's proven performance, reliability, and construction that allows minimum movement once the lens is inside the housing. This means that accidental rough handling of the system at sea would minimize camera damage prior to the start of the mission.

While other suitable camera systems were available, budget and time restraints limited our ability to investigate and test each system.

CONSIDERATIONS FOR CONTROL REQUIREMENTS

Stereoplotters, normally used with aerial photography, are precision instruments that utilize a series of horizontal and vertical measurements in their basic operation. In order to extract accurate data from stereo photography, certain measurements (commonly known as controls) must be provided as accurately as possible. When either aerial or deep-sea photography is being carried out, the photographer must know the distance from the camera to the subject, the attitude of the camera, focal length, lens distortion, and position of the principal point. When twin cameras are used, the distance between optical axes must also be known.

In underwater photography, a control frame utilizing precoordinated points is normally placed around the object to provide the necessary orientation data. However, exact placement of such a control frame at great depths would be difficult. The frame would be subject to movement or become buried and, most important, the frame could interfere with currents and alter the natural motion of bottom sediments. As an alternate solution it was recommended that very fine rigid rods with small disks attached at various heights be mounted on the camera frame in order to provide known dimensions. A diagram showing control placement is shown in Figure 1. These measurements provided the necessary horizontal and vertical references.

(A) PRIMARY PLACEMENT HORIZONTAL & VERTICAL CONTROL

(B) SECONDARY PLACEMENT HORIZONTAL & VERTICAL CONTROL

Figure 1. Control placement.

METHOD

The camera configuration shown in Figure 2 is recommended in order to obtain stereo photography. The proportion of camera height above the subject to the distance between the lens is generally considered to be a ratio of 3:1 for the type of system used. In Figure 2, the ratio is 2.67:1, and on occasion, imagery at a ratio of 2.3:1 has been used.

The stereo cameras were mounted parallel in a rigid frame and placed vertically in the test tank above a board having a grid of known dimensions. Placement locations are shown in Figure 1. The exact horizontal distances between the points were measured, and since the board was placed flat on the tank bottom, the vertical reference of the board was set at zero. The purpose of photographing a grid board was to allow for the measurement of

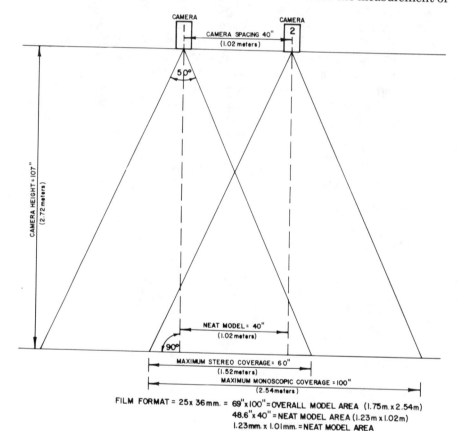

Figure 2. Camera configuration.

model deformation typical in nonmetric cameras. For the purpose of our test, the cameras were set at f 3.5 and 2.3 meters on the taking lens with the data lens wide open.

In order to measure accurately any model deformation caused by changes in the pressure on the camera housing, such as will be encountered at great depths, it is recommended that a small grid plate be photographed in the 6-meter tank and then again in a pressure tank that will duplicate the depth at which the camera will be positioned. This will provide a method for calculating image distortion introduced by changes in the camera housing window under pressure.

For this test, the actual photography was accomplished using Panatomic X film, in two stages, to provide a control for the experiment. The first stage consisted of photographing three objects that were placed in the tank on the grid board. All three objects were carefully measured by qualified technicians prior to placement. The measurements were recorded, and the readings were provided in order to check our initial work on the stereoplotter.

Next, the three known objects were removed and a group of fourteen additional objects were placed on the grid board and photographed. Again, all of the objects were carefully measured by the technicians, but no dimensions were provided. This was done to determine if an average accuracy of ±1 mm could be obtained by the photogrammetric process.

The objects used in the test were metal objects of various shapes and sizes as shown in Figure 3. Some pieces were entire castings, while a few were cut to duplicate sloping conditions that could be encountered by the deep-sea probe. Two objects were formed from sheet metal bent at angles to create a series of high and low points. The sheet metal was also painted a beige color to duplicate the actual color contrast conditions most likely to be encountered. In all, some eighteen objects, including those used for control, were actually measured, but only fourteen objects were recorded as part of the test.

THE STEREOPLOTTER

The actual stereo compilation was to be done using an affine solution on a Kern PG-2AT Stereoplotter equipped with a DC-2B digitizer. The PG-2 has been designed to use photography taken with metric cameras having focal lengths ranging from 85 mm to 172 mm and film formats up to 23 cm × 23 cm (9 inches). However, the plotter has proven itself adaptable for use with 35-mm and 70-mm film and has been used by scientists from various fields to obtain measurements from the smaller format photography.

In order to utilize the 35-mm film format on the PG-2, it was necessary to enlarge the negatives to at least 10 × 13 cm (4 × 5 inches) on a film positive to

Figure 3. Test objects.

fit the existing diapositive holders. The enlargement was accomplished by sandwiching the original negative under optical glass and using a standard enlarger to print each exposure on a positive piece of film. The exact enlargement was measured, since it was the basis for determining the affine focal length to be set in the PG-2. This was determined by the formula:

$$Ca = Ck(e)$$

where Ca = affine focal length, Ck = original focal length of the photography, and e = enlargement factor

Once the enlarged positives were made, it was then necessary to construct a template that allowed for the exact placement of the film positives in the stereoplotter. Ticks were added to the template so that alignment of reference marks was possible. Orientation of the stereo model was accomplished using an affine solution formula:

$$K = \frac{Ca \cos \mu}{Ck \cos \overline{\mu}}$$

Upon completion of the orientation procedure and compensation for vertical and horizontal distortion, the scale of the final graphic output, in this case the topographic map, was established on the automatic table (AT).

The AT is a flat-bed plotter equipped with two pens that can draw all features interpreted by the operator from the stereo model to an exact scale. Using the DC-2B digitizer coupled to the stereoplotter, it is also possible to encode the data on magnetic tape or punch cards that can be used for computer modeling. Another feature of the DC-2B is that volumes can be directly calculated from the topographic readings as they are done on the stereoplotter.

For the purpose of our test, only the topographic map was prepared so that size comparisons could be made. All stereo measurements were made using the horizontal control measurements taken from the grid board and assigning a zero vertical elevation to the entire grid. This enabled us to read the height of each individual object above the board. The average error in our combined readings was 1.3 mm, with the largest errors being in the height readings. After the test it was realized that the objects were fastened to the board by a putty-like adhesive having an estimated average thickness of 0.4 cm. This thickness was included as part of our height reading of the object above the grid board and accounted for the variance from the desired tolerance. When adjusted for this difference, the accuracy of the readings were within 0.9 mm which achieved the targeted tolerance of 1 mm.

CONCLUSION

These tests have demonstrated that close-range photogrammetric methods can be applied in a cost-effective manner to oceanographic research requiring precise measurements. Further, this technique allows the scientist the opportunity to select and analyze in detail any portion of the data obtained. The same principle can also be applied to photographs taken with hand-held cameras as illustrated in Figure 4. An additional photogrammetric test is planned prior to the actual deployment of the probe.

Figure 4. Topography from a hand-held stereo camera.

REFERENCES

Thompson, J. M. and A. R. White. 1979. The Heather Platform leg repair. OTC 3529.

American Society of Photogrammetry. 1979. *Handbook of non-topographic photogrammetry,* First Edition.

McNeil, G. T. 1969. Underwater photography. *Photogrammetric Engineering.*

Brock, R. H., Jr. 1972. Methods for studying film deformation. *Photogrammetric Engineering,* April 1972.

Karara, H. M. and Y. I. Abdel-Aziz. 1974. Accuracy aspects of non-metric imageries. *Photogrammetric Engineering,* Sept. 1974.

Wimbush, M. and B. Lesht. 1979. Current induced sediment movement in the deep Florida Straits: Critical parameters. *J. Optical Geophys. Res.* May 1979.

APPENDIX

Comparison of Measurements in Centimeters

Description		Actual measurement	Photogrammetric measurement	Variance
Object 1:	length	7.59	7.44	−0.15
	width	3.15	3.12	−0.03
	height	2.64	2.92	+0.28*
Object 2:	inside diameter	2.29	2.23	−0.06
	outside diameter	4.31	4.44	+0.13
	height	1.98	2.19	+0.21*
Object 3:	inside length	7.45	7.43	−0.02
	outside diameter	9.99	9.86	−0.13
	height to step cut	.952	1.46	+0.50*
	height over all	1.58	1.82	+0.24*
Object 4:	end width	1.95	2.01	+0.06
	over-all width	3.18	3.24	+0.06
	height	2.87	2.92	+0.05
Object 5:	length	8.31	8.35	+0.04
	width	4.44	4.41	−0.03
	height	3.81	4.01	+0.20*
Object 6:	length	7.64	7.67	+0.03
	width	3.19	3.29	+0.10
	height	2.64	2.19	−0.45*
Object 7:	over-all length	(not taken)	21.28	
	over-all width	(not taken)	12.21	
	height, layer 1	0.30	0.36	+0.06
	height, layer 2	0.61	0.72	+0.11
	height, layer 3	0.92	1.08	+0.16
	height, layer 4	1.23	1.45	+0.22

Comparison of Measurements in Centimeters *(continued)*

Description	Actual measurement	Photogrammetric measurement	Variance
Object 8: length	(not taken)	7.13	
width	6.85	6.90	+0.05
height	(not taken)	2.92	
Object 9: length	(not taken)	17.32	
width	(not taken)	13.32	
height, peak 1	1.46	1.46	0.00*
height, peak 2	1.46	1.46	0.00*
Object 10: inside diameter	10.29	9.94	−0.35
outside diameter	12.70	12.54	−0.16
height, layer 1	1.27	1.46	−0.19
over-all height	2.23	2.19	−0.04
Object 11: inside diameter	9.03	9.16	+0.13
outside diameter	10.14	10.28	+0.14
height	6.36	6.21	−0.15
Object 12: length	6.90	6.78	−0.12
width	(not taken)	4.64	
height	3.28	3.28	0.00
Object 13: length	9.22	9.04	−0.18
width	3.81	3.61	−0.20
height	(not taken)	3.65	
Object 14: length	15.24	15.39	+0.15
width	7.62	7.51	-0.11
height of base	1.58	1.46	−0.12*
height of top	3.'9	4.01	+0.52*

*Variance includes thickness of adhesive.

Underwater Photography for Quantitative Description of Bottom Roughness

T. Akal

SACLANT ASW Research Center
North Atlantic Treaty Organization
La Spezia, Italy

INTRODUCTION

Knowledge of the roughness of the sea floor is obviously of great importance in marine geology for understanding the processes of the ocean bottom, and in underwater acoustics for understanding the scattering process. The ocean bottom contains a wide spectrum of roughness, ranging from a few millimeters to several kilometers, where small features are superimposed on much larger topographic features (Akal 1984). This complex structure, formed by different physical, chemical, and biological forces, can be quantitatively described in terms of their statistical properties, i.e., power spectral density and autocorrelation functions.

The gross-scale roughness of the sea floor is reasonably well known due to well-developed echo-sounding techniques. However, little is known about small-scale roughness (amplitudes and wavelengths ranging from centimeters to meters) due to the difficulties of measuring them.

The major technique for studying this small-scale roughness is bottom photography. By using photogrammetric techniques, a single pair of overlapping photographs taken with stereo cameras can subsequently be used to provide fine-scale contour charts of the sea floor.

To analyze these contoured charts quantitatively, a numerical method has been developed to calculate the two-dimensional bottom-roughness power-

spectral density and autocorrelation functions (Akal and Hovem 1978). This information gives, quantitatively, two basic parameters of a rough surface: its amplitude and wavelength content and its orientation. These parameters are closely related to the type of sediment and to bottom currents and their direction, hence to the sedimentation, transportation, and erosion processes. This information is also the main parameter for modeling the acoustic bottom scattering and acoustic propagation process.

PHOTOGRAPHIC EQUIPMENT AND TECHNIQUES

The photographic equipment consists of two EG&G deep-sea cameras, two strobe lights (250 watts each), two battery packs, and a pinger system.

To simplify the photogrammetric analyses, the two cameras are oriented vertically with a fixed base. The strobes are usually placed with a 25° light angle to the field of view, providing the best position for uniform illumination and reducing back-scattering. The whole system is mounted on a sled-type protective frame with two fins to maintain a stable orientation. (Figure 1).

Kodak Ektacolor Professional (type S), and later Vericolor II (5025, type S), negative color films have usually been used. This universal film, which has a speed of 100 ASA (21 DIN), allows high-resolution color prints, black-and-white prints, and color transparencies to be made from one negative.

For maximum resolution the system is usually lowered to a distance of 2 to 4 m above the bottom (using a pinger to control the height) and then allowed to drift over the seafloor.

This system has been operational over the last ten years in different oceans from water depths of a few meters to several thousand meters and has provided high-quality photographs from which the analysis technique has been developed.

METHOD OF COMPUTATION

Two-dimensional Fourier transforms and correlation functions are straightforward extensions of the corresponding one-dimensional functions. The block diagram in Figure 2 illustrates the methods of computation, which is made in steps: first the x dependencies are transformed for each y, and then the y dependency is transformed. The method of computation is summarized in the Appendix.

Before the computational scheme can begin, the following preprocessing procedures are necessary (Figure 3):

1. Digitization of data. The shapes of the seafloor surface are described by contoured charts. Therefore, an important problem is a simple

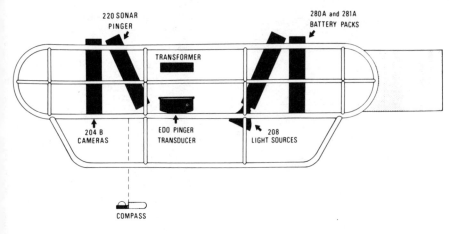

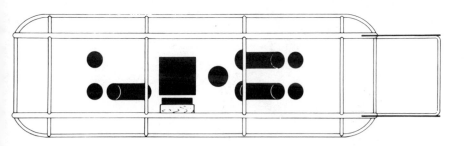

Figure 1. General view of the photographic equipment and the frame.

TWO DIMENSIONAL SPECTRUM

$$G(u,v) = \iint_\Omega g(x,y) \exp\{-2\pi j(ux+vy)\}\,dx\,dy$$

TWO DIMENSIONAL
AUTOCORRELATION FUNCTION

$$C(\tau,t) = \iint |G(u,v)|^2 \exp\{-2\pi j(\tau u+tv)\}\,du\,dv$$

Figure 2. The method of computation *(after Akal and Hovem 1978).*

and accurate analog-to-digital conversion of a given contoured chart. This phase of work has been done by two separate operations: (1) Digitizing the contoured level using an electro-mechanical digitizer, which gives the coordinates of the contour lines in computer-compatible (UNIVAC 1106) format. (2) Construction of a matrix. For spectral analysis, numerical samples have to be obtained from a certain equally-spaced grid covering the contoured chart to be treated. This has been done by interpolating contoured values onto a rectangular grid by applying Laplacian or spline interpolation techniques. The type of interpolation is decided according to the

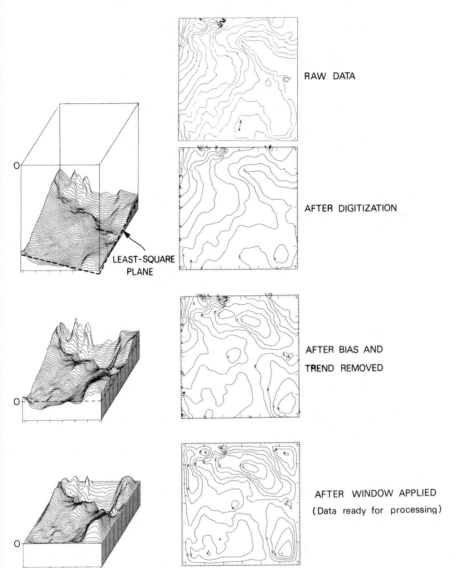

RAW DATA

AFTER DIGITIZATION

LEAST-SQUARE PLANE

AFTER BIAS AND TREND REMOVED

AFTER WINDOW APPLIED
(Data ready for processing)

Figure 3. Preprocessing procedures *(after Akal and Hovem 1978)*.

similarity obtained between analog and digitized data. Also, the grid size has to be carefully chosen to consider aliasing errors and available computer memory.

2. Removal of bias and trend from the data. The data we are dealing with are generally measured relative to a reference level. This means

that the surfaces we are interested in are superimposed on a rectangular box. For spectral analysis, it is desirable to transform the data to a zero mean value. After this, depending on the shape of the surface, a special correction may be needed to remove any wavelength longer than the surface being treated. This has been done by fitting a least-squares plane to the data for the two-dimensional detrending operation.

3. Windowing and filtering. To minimize the spectral distortion, there must be a broad and smooth data window without any sharp corners at the edges. Because of the size of the photographed area, the use of limited record size is inevitable in the two-dimensional spectral analysis, and truncation at the edges of a data window will erroneously introduce side lobes into the spectral domain. A two-dimensional filter that tapers off gradually with a cosine function towards both ends of the data window has been applied to suppress this effect. This certainly diminishes the effective area, but at the same time avoids severe distortion of the resulting spectral domains.

DISCUSSION OF RESULTS

Testing the Method

To facilitate understanding of the results obtained with this method, a simple test surface has been used. Figure 4 represents part of a cosinusoidal test surface $g(x,y) = \cos [2\pi(x \cos \theta + y \sin \theta)]$ in 30° orientation ($\theta = 30°$).

After this test surface has been analyzed by this technique, its resulting power spectrum and autocorrelation functions are as shown in Figure 4. As expected, the orientation and wavelength content in the $x,y =$ plane are converged by the impulse pair that constitutes the two-dimensional power spectrum of the test surface.

Examples from Bottom Photographs

Five surfaces obtained from stereo seafloor photographs have been treated by this technique. These surfaces and the resulting power spectra and autocorrelation functions are shown in Figures 5, 6, 7, 8, and 9.

The surfaces in Figures 5 and 6 are taken from stereo photographs 12 m apart. Although these surfaces look completely different, as can be seen on

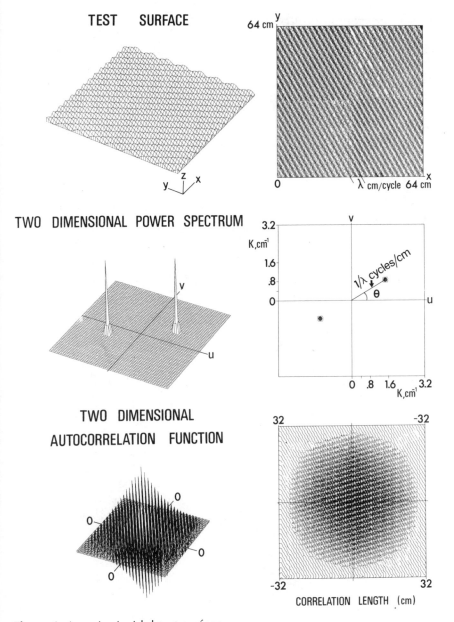

Figure 4. A cosinuisoidal test surface,

$$g(x,y) = \cos[2(x\cos\theta + y\sin\theta)], \quad \theta = 30°$$

its two-dimensional power spectrum, and autocorrelation function *(after Akal and Hovem 1978)*.

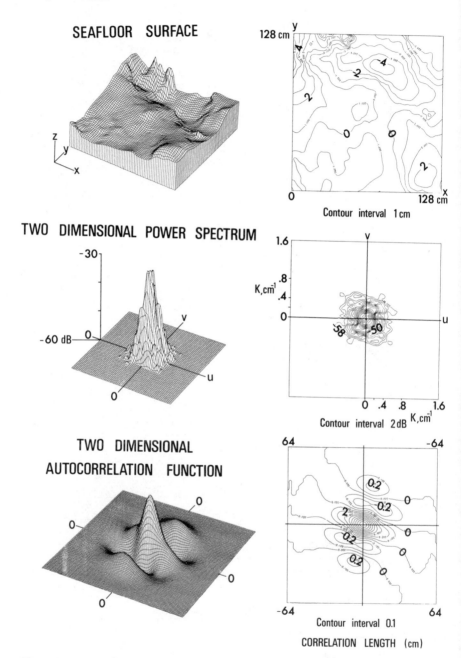

Figure 5. A surface obtained from bottom stereophotographs, its two-dimensional power spectrum, and autocorrelation function *(after Akal and Hovem 1978).*

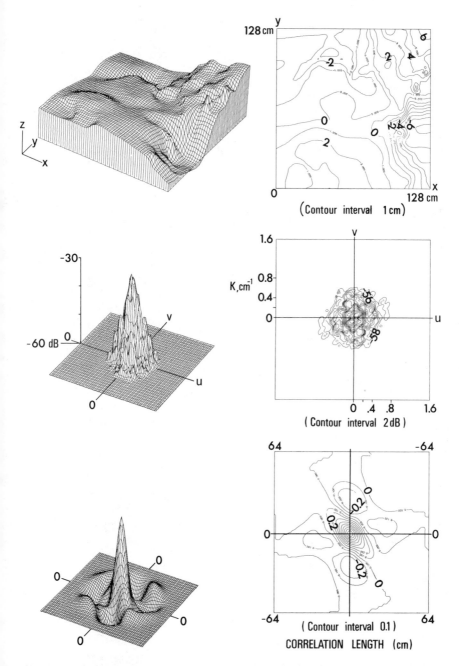

Figure 6. Another surface from bottom stereophotographs obtained 12 m away from the one shown in Figure 5, and the results obtained after processing.

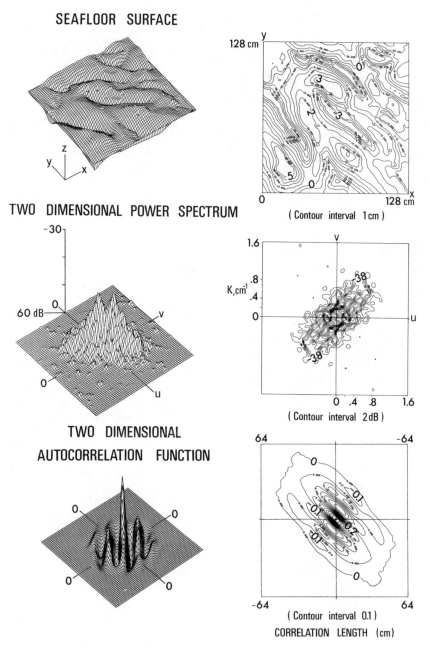

Figure 7. Seafloor with sand waves and the results obtained after processing.

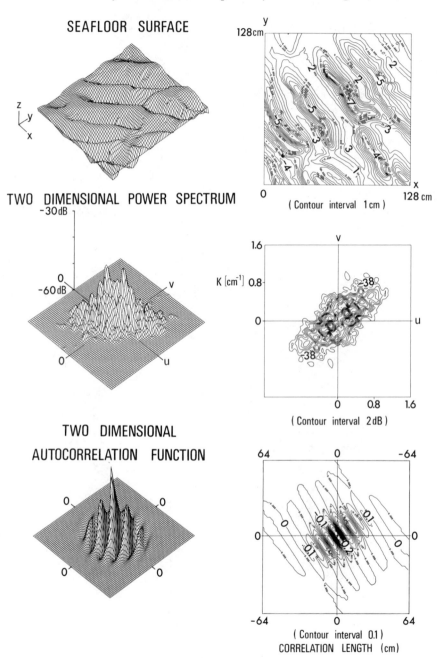

SEAFLOOR SURFACE

(Contour interval 1 cm)

TWO DIMENSIONAL POWER SPECTRUM

(Contour interval 2 dB)

TWO DIMENSIONAL
AUTOCORRELATION FUNCTION

(Contour interval 0.1)
CORRELATION LENGTH (cm)

Figure 8. Another surface from the same area and the results obtained after processing.

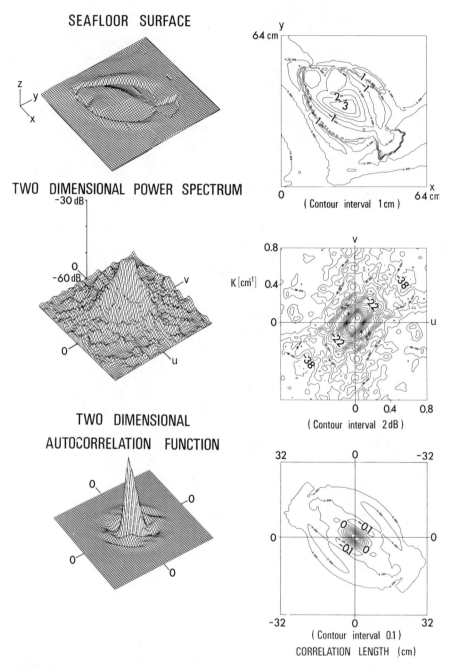

Figure 9. A plaice buried in the sediments, together with its power spectrum and autocorrelation function.

power spectrum plots, the wavelength components of the bottom roughness are the same, except that there is a small directional change in orientation that appears more clearly on autocorrelation plots.

Figures 7 and 8 represent two parts of the seafloor with approximately a one-mile separation. The spectrum plots show two peaks corresponding to the wavelength content of the sand waves that are present in the area. Figure 9 shows a fish (plaice) buried in the sediments, together with its power spectrum and autocorrelation function. As expected, due to its form it gives much broader wavelength content.

CONCLUSIONS

Using this method, the roughness of a contoured surface obtained from stereo photographs can be quantitatively described by its wave number composition and the direction of the roughness. This information is used for:

1. Investigation of the character, magnitude, and distribution of bottom roughness.
2. Classification of the quantitative roughness characteristics of the seafloor for different physiographic regions.
3. An input to different acoustic scattering and propagation models.

ACKNOWLEDGMENTS

We wish to thank the Istituto Geografico Militare, Firenze (Italian Military Geographic Institute), and Mr. B. Turgutcan for the stereophotogrammetric graphic results they obtained from seafloor stereophotographs, and Mr. P. Nesfield for his support during computer program development.

REFERENCES

Akal, T., 1984. Acoustic characteristics of the sea floor: Experimental techniques and some samples from the Mediterranean Sea. In *Physics of Sound in Marine Sediments,* ed. L. Hampton, 447-480. New York; Plenum.

Akal, T. and J. Hovem. 1978. Two-dimensional space-series analysis for sea floor roughness. *Marine Geotechnology* 3(2):171-182.

APPENDIX:TWO-DIMENSIONAL POWER SPECTRAL DENSITY AND AUTO CORRELATION FUNCTIONS

Let us consider a two-dimensional function $g(x,y)_\Omega$ representing a part of the seafloor surface in a rectangle of the x,y-plane (Figure 2). The Fourier transform is defined by

$$G(u,v) = \iint_\Omega g(x,y) \exp\{ -2\pi j(ux + vy) \} \, dx \, dy \qquad (1)$$

where

$$g(x,y) = \iint G(u,v) \exp\{ 2\pi j(ux + vy) \} \, du \, dv. \qquad (2)$$

The squared amplitude spectrum $|G(u,v)|^2$ is related to the two-dimensional correlation function $C(r,t)$ by

$$C(r,t) = \iint |G(u,v)|^2 \exp\{ -2\pi j(ru + tv) \} \, du \, dv \qquad (3)$$

or by making use of Equation (1):

$$C(r,t) = \iint g(x,y) \, g(x + r, \, y + t) \, dx \, dy. \qquad (4)$$

In the discrete case in which the function $g(x,y)$ is sampled at regular intervals, the functions become slightly modified. Assume that the function $g(x,y)$ is sampled at intervals Δx and Δy so as to produce a matrix

$$\begin{aligned} g_{k,i} &= g(k\Delta x, i\Delta y) \\ k &= 0,1,...,N-1 \\ i &= 0,1,...,M-1 \end{aligned} \qquad (5)$$

The discrete Fourier transform evaluated at frequencies

$$u = r/N\Delta x \quad \text{and} \quad v = s/M\Delta y$$

is then

$$G(r/N\Delta x, s/M\Delta y) = G_{r,s,} = \sum_{k=0}^{N-1} \sum_{i=0}^{M-1} \qquad (6)$$

$$g_{k,i} \exp\{ -2\pi j(Kr/N + is/M) \}$$

Using the Fast Fourier Transform (FFT) method for evaluation of $G_{r,s}$ requires normally that both N and M be powers of two, and then $G_{r,s}$ becomes evaluated for arguments $r = 0,1,...,N-1$ and $s = 0,1,...,M-1$.

The discrete correlation function evaluated at points $r = p\Delta x$ and $t = q\Delta y$ is

$$C(p\Delta x, q\Delta y) = \sum_{k=0}^{N-1-p} \sum_{i=0}^{M-1-q} g_{k,i}g_{k+p,i+q} \tag{7}$$

In principle, this function can be computed directly following Equation (7), but to save time it is often preferable to compute it by using the FFT, that is:

$$C_{p,q} = \sum_{r=0}^{N-1} \sum_{s=0}^{M-1} G_{r,s}^{2} \exp\{ -2\pi j (rp/N + sq/M) \} \tag{8}$$

The block diagram in Figure 2 illustrates the method of computation, which is in steps: first the x dependencies are transformed for each y, and then the y dependency is transformed.

High-Speed Digitally-Processed Unlimited Area Underwater Photogrammetry

D. Rebikoff

Rebikoff Underwater
Products, Inc.
Ft. Lauderdale, Florida

HISTORY

Early experimentation with stereo cameras in the twenties by Father Poidebard, the pioneer of aerial archeology who had called on Mr. Dratz, French Navy optical engineer, was an attempt to plot underwater stereo pairs showing drowned Punic Harbor jetties in Syria. In 1951, Jean de Wouters, the inventor of the Nikonos camera, developed an underwater stereo camera. Following these developments, we called on Mr. Carbonnel, the present director of IGN, the French National Institute of geography; Professor A. Ivanoff, now holder of the Chair of Physical Oceanography at Institut Pierre et Marie Curie, Paris University; and the Jules Richard Company, pioneer since the nineteenth century of the modern Verascope stereo camera.

The result was the development of the underwater V-40 2 × 24 × 30-mm stereo camera with a pair of Ivanoff-Legrand-Cuvier Patent correcting lenses, for which we had designed and built a double pressure-resistant optical barrel, all installed in a standard cast-aluminum pressure cooker (Figures 1 and 2). This system was completed by our 1950 oil-filled deep-sea 200 W/S strobe flash.

The result was brilliantly colorful and extremely sharp (to the 100 lines/mm of the early 8 ASA Kodachrome film) stereo pairs. IGN was able for the first

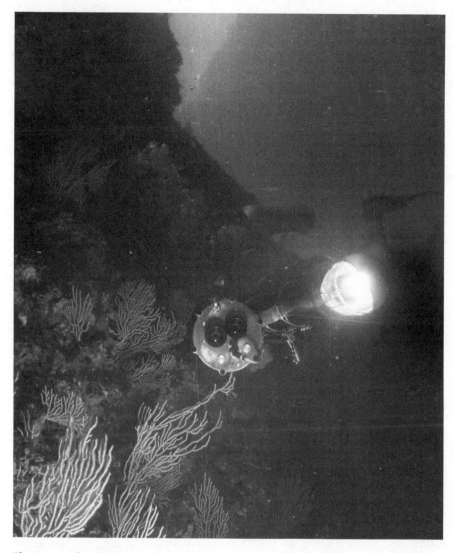

Figure 1. The 1953 Rebikoff V-40 2 × 24 × 30-mm lens, with two S101 60-mm Ivanoff corrected lenses, made possible the world's first precision underwater photogrammetry with IGN (International Geographic Institute), Paris.

time to draw a precision plot of the poisonous rascasse *(Scorpaena scorpaena)* or Mediterrean scorpion fish.

This first experiment established once and for all the absolute necessity of fully corrected optics to make possible an exact match between the two images making up a stereo pair. If, as happens all too often today, the two

Figure 2. The new Rebikoff V-40 II underwater close-range photogrammetric system supplied to the U.S. Naval Coastal Systems Center, Panama City, Florida, for ship hull inspection.

images are taken with uncorrected optics behind parallel-wall domes or flat portholes, they cannot coincide due to strong pincushion distortion. An example may be seen on pages 106-107 in *Handbook of Non-Topographic Photogrammetry*, American Society of Photogrammetry.

In 1965 Julian Whittlesey described a way to compute away such distortion in every frame, an expensive and time-consuming procedure at best. However, the above procedure cannot correct the major loss of definition away from the center area caused by the well-known plant diopter optical aberrations such as chromatism, spherical, astigmatism, coma, and 34% focal length increase. Only fully-corrected high-quality optics can do that, especially in the extreme wide angles required by limited water transparencies.

While multiplying the depth of focus, the Ivanoff-Legrand-Cuvier corrective lens also improves on all the original primary lens aberrations, while canceling all the air-water plane diopter aberrations.

In the thirties, it became obvious to all opticians that it is unthinkable to try to achieve any acceptable photograph of scientific value or any usable photogrammetry with ordinary air medium-computed lenses.

1. The structure must be very rigid and insensitive to shock, temperature variations, or water pressure. There must be precisely boresighted optics with all optical components on a common optical axis materialized by four cross-hairlike fiducial pointers appearing on the center of each frame's edge. These fiducial markers make possible exact angular plotting in all three dimensions of space relative to the optical axis at the film emulsion plane.

2. The film in turn must lie flat and square within very small tolerances because of the very short extreme wide-angle lens backfocus, typically 21 mm at a 92° diagonal angle in water for a 24 × 36 mm format. A resolution of one per thousand of 21 mm calls for ± 10 microns. For example, such a camera takes an area of 2.4 m × 3.6 m (8 × 12 ft) at an altitude of 2.1 m (7 ft) at a 1 to 100 ratio.

3. The film pull-down must be accurate and well timed by high-precision servo gears. The shutter release and subsequent film simultaneous and coincident stereo images.

4. The shutter must be either remotely or locally controlled by a precision intervalometer timer, ensuring a minimum 55% average overlap for normal stereomosaic coverage.

5. The primary and corrective lenses must be precisely matched and centered to ensure even negative exposure, necessary for good negative mosaic coverage.

6. In the Pollio method requiring the use of a pair of such metric cameras, the two primary lenses must be exactly matched in focal length to avoid the impossible task of trying to plot with two images of different sizes.

7. We usually order, and receive, primary lens pairs matched at the factory within 10 microns (0.0004″) of focal length.

8. Unlike aerial cameras, the lens must not be set at infinite, but at an "underwater hyperfocal setting" requiring a very accurate and stable back-focusing system.

9. Thanks to the increased depth of field inherent in the corrective lens, it is usually possible to leave the primary lenses on a fixed hyperfocal setting, taking advantage of the fact that under water there is no visible infinite.

10. Obviously, such a calibrated metric photogrammetric camera cannot be hand held. It must be mounted on a stable platform, either moving or fixed. The camera cradles or mounts must also be very rigid and solid although light in weight.

11. About the only thing that is seldom a worry is the water refraction, very little affected by water salinity, pressure, or temperature for most practical purposes.

12. As can be seen above, there is no way that such metric cameras and optics could be cheap. The metric camera is a money and time-saving continuous use tool, especially under water where we deal with ship, submarine, and diver time.

13. Finally, the underwater metric camera must retain its optical precision no matter how much housing or porthole deformation occurs because of the water pressure.

A new (U.S. patent applied for) lens barrel design common to corrective lens, primary lens, and film plane assembly, ensures complete pressure unloading over the whole optical system, except the front element of the corrective lens. This front element has been shown to undergo very little deformation or refraction changes under specified design pressure at either 600, 2500 or 4000 meters.

We had originally developed both a plastic dome and a 90° conical Piccard-type plexiglass flat port to be mounted in front of the corrective lens, but found that the pressure was not only inducing very large deformations [Dr. J. Stanchiw: Acrylic Viewports For Ocean Engineering Applications, NUC, San Diego, California] found to have a substantial effect on optical performance, but also was causing multiple refraction indexes within the crushed plexiglass mass, resulting in multiple edges and rather fuzzy images, in addition to all the other aberrations. This explains why very little good quality photography or television is ever achieved from within an observation submarine.

To the best of our knowledge, no serious research has been done on the optical performance of portholes or domes under pressure. It would actually be very easy to do this by taking full-aperature strobe-lighted photographs of a standard ABS target inside a pressure vessel at various depths.

"EXOTIC" PHOTOGRAMMETRIC SYSTEMS

Because we now have digital scanning and image processing of the hundreds to thousands of frames produced in a single daily dive, we may consider more sophisticated methods of remote sensing and imaging, just as in satellite mapping—but there are still a few major objections.

1. Blue-green range-gated LIDAR laser. This method seems to be primarily a detection rather than a photographic method. We have to question what is gained in water penetration, knowing three factors: (a) Absorption and scattering "noises" in the water medium are directly proportional to the intensity of light radiation. (b) Blue-green laser efficiency is about 1% at best. Where is the power supply under water? We already do not have enough energy for heat, propulsion and lighting. (c) Laser is monochrome radiation. Goodbye colors, the major identification tool with stereo measurements.

2. Panoramic cameras and continuous slot scanning with the Sonne camera. It could be great with a constant speed, track, and altitude platform, but light must be concentrated on the slot area unless operation is restricted to shallow and clear water during daylight hours. No strobe lighting can be used. Photogrammetry can be done, with two side-by-side cameras.

3. "Pushroom" electronic CCD single or multiple (for color, ultraviolet, etc.) strip sensor. The same lighting problem as for method 2 applies.

LIGHTING

It must be well understood that except for cinematography and television, both requiring energy-intensive continuous area lighting to make possible the illusion of continuous movement given by retinal persistence, proper large-area mosaic photogrammetry requires synchronized capacitor discharge strobe lighting. This type of lighting is the most efficient way to provide full solar spectrum large-area lighting with a very low watt-hour expenditure, especially when using high-voltage batteries recharging the capacitors in intermittent bursts allowing depolarization.

We believe we have been the first to publish (in "Science et Industrie Photographic," Paris Institute of Optique, August, 1952) a description of our 1950 oil-filled deep-sea 200 W/S strobe flash unit, used in conjunction with our first pressure cooker V-40 35-mm stereo camera. The first film

exposed the same year at some 40-60 meters revealed the magnificent colors of deep-sea fixed marine life beyond the chlorophyllian photosynthesis limit of some 500 lux of natural light. Others then rushed to imitate our results by ripping off the deep-sea red sea fans for shallow water magnesium flash artistic photos for press release purposes.

Of course, we did not invent undersea lighting. The pioneers in the field were biologist Louis Boutan with his magnesium powder blower bulb and oxygen barrel in 1895 and deep-sea arc lights in 1899; master film-maker Ernest Williamson; photographer and inventor Fenimore Johnson; and Dr. Allyn Vine of Woods Hole, all in the 1930s.

THE PHOTOGRAMMETRY PROCEDURE UNDERWATER

Two major methods are available. The first is classic controlled photogrammetry. This is a high-speed simultaneous triangulation method. Triangle bases must be established on the bottom prior to the mosaic strip stereo photography. The base markers or "monuments" must be correlated, for example through taut vertical mooring buoys that are themselves tied into any acceptable surface geodetic network.

Due to the large number of stereo pairs (by the hundreds or thousands), hundreds or even thousands of fixed-dimension numbered markers must be laid along each track, measured and aligned by a taut mason's line or surveyor's tape stretched between moorings in such a way that at least two markers show in each stereo frame.

In shallow waters, this is already quite a job for a diver team, as we found on French wreck sites in 1950, in Kenchreai/Corinth near Athens in 1964, and all over the well-known drowned cyclopean pier complex in 1969 at North Bimini, Bahamas. In deep water, this triangulation control procedure becomes impossible except when a properly marked and numbered cable or pipeline is being surveyed.

Most of the time, the bottom surveyed, whether sandy or rocky, has very few features or dimensions known to man.

Joe Pollio, following a joint research program of precision photogrammetry in the Bahamas (published by the U.S. Naval Oceanographic Office in 1968 as "Applications of Underwater Photogrammetry") and our book *Underwater Photography* (fourth edition, Amphoto, 1975, page 88) have demonstrated the necessity to use two matched focal length and timed pulse-controlled calibrated metric cameras with fully corrected optics and a relatively wide base, typically 2 meters or the beam of the survey submarine for practical snagging safety reasons.

THE PLATFORM

Just as in classic aerial photogrammetry, it is of course necessary to achieve a precise straight track, within one degree or better, on a pre-determined course, or, better, with gyro compass or inertial platform tracking. It is also necessary to have good pitch and roll attitude control; that is, the two cameras' optical axis must be convergent towards the vertical within two degrees or better, using a good artificial horizon. The altitude and horizontal attitude (or relative horizontal slant track along a slope) must be controlled within centimeters (or inches) of average "altitude" between camera lens and bottom. This is desirable to avoid excessive frame reduction ratio variations.

We feel that the ideal support vehicle for maximum economy, speed, efficiency, safety, and independence from weather is either a long-range manned survey submarine or a remotely-programmed stable platform. The most suitable manned submarines in service today may be the main computer-equipped long range *Auguste Piccard* built by Dr. Jacques Piccard and owned by Horton Maritime Co. of Vancouver, B. C., Canada, and the U.S. Navy's N.R. 1. Such a submarine will have sufficient stability and precise navigation to carry and support our larger deep-sea DR 584, 5841, and 5842 photogrammetric camera pairs about the bow with adequate large-area strobe lighting.

The lowest cost alternative we can afford (to be used in the summer of 1980 in a joint research effort with Armines and the CNRS/CRA, French Government Center for Archeology Research, in the Cannes and St. Tropez drowned cities; later we will survey major sites in the Mediterranean and Bahamas) is our operational remote-controlled photogrammetry and color television large-area high-speed survey platform DR 331 Sea Inspector System.

The tiny flyable 140-kg (about 300 lbs) Sea Inspector can be operated with its portable generator, control box, color monitors, and VTR recorder from any native fishing boat, from inflatable boats, or even from helicopters.

DIGITAL SCANNING, DATA PROCESSING, AND ISOBATH PLOTTING

Classic manual photogrammetry plotting has turned out to be unfeasible economically due to the shortage of properly trained personnel as well as to a lack of larger facilities for available volunteer explorer archaeologists. The only way out has been to replace man by the computer. A modern high-speed and relatively low-cost "number cruncher" thrives on the numerous repetitive small format stereo-pairs, enabling us at last to treat at realistic

cost an unlimited number of stereo pairs at about 30 seconds per frame and 60 seconds per stereo pair. This compares more than favorably with a new Matra "Traster" analytical stereoplotter shown to require about one hour per pair, a great advance over earlier manual plotters requiring up to all day for one pair only, a rate that was acceptable years ago when hours were cheap.

The new fully automatic digital scanning and processing system has been fully proven in January and February 1980, in joint research with Armines, the Paris École des Mines environmental LANDSAT METEOSAT, etc., NASA Satellite remote sensing data processing center in Sophia Antipolis on the French Riviera as illustrated in Figures 3, 4, and 5.

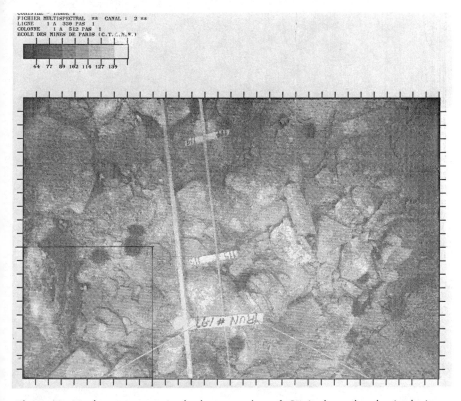

Figure 3. Underwater vertical photography of Corinth archeological site, using a Rebikoff camera. This image has been taken with 28-mm focal length optics in three meters' depth of water. Original image format is 36 × 24 mm negatives. It has been digitized at a resolution of 512 square pixels along the largest dimension, leading to a 70 μ pixel size. This gives an object resolution at nadir of about 7 mm. The outlined square area on lower left of the picture was digitally processed using stereo pairs.

CORINTHE - 3D MODEL -
IMAGE DU FICHIER IM3D COMPORTANT 256 LIGNES ET 256 COLONNES
LIGNE 1 A 256 PAS 1
COLONNE 1 A 256 PAS 1
ECOLE DES MINES DE PARIS (C.T.A.M.N.)

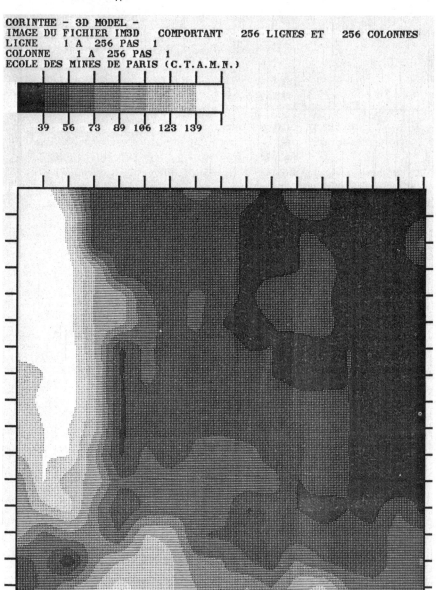

39 56 73 89 106 123 139

Figure 4 *(at left)*. Digital local bathymetry of Corinth archeological site determined from Rebikoff camera stereo pairs. The C.T.A.M.N. system computes a three-dimensional stereo model from overlapping couples of images. Digital photogrammetry is done in an interactive fashion where automatic correlation and parallax computations can be controlled by the operator on an image console. The grey scale contours of the present document are representative of isobaths. In the experimental conditions of the Corinth survey (Figure 3), the maximum attainable depth accuracy is 2 cm. However, the isobaths on the document are separated by 20 cm, due to lack of definition in grey-scale representation. The use of an array-processor would give an operational processing time of 2 to 5 minutes per stereo pair, depending on the complexity of the surveyed object.

Figure 5. The interim computer-traced precision isobaths of the Corinth experiments by Armines.

REFERENCES

Academie De Marine. 1958. Progres recents de l'exploration sous-marine (in French). *Communications et Memoires*. Paris.

Ball, G. M. 1967. A deep-sea camera system. *Photogram. Eng.* 33(8):913-920.

Bass, G. F. and D. M. Rosencrantz. 1968. Diversified program for the study of shallow water searching and mapping techniques, final report (AD-686-487). University Museum, Univ. of Pennsylvania, Philadelphia.

Beller, W. 1962. System yields fine sea-floor maps. *Miss Rock* 10:24-25.

Congresso Internazionale de Archeologia Sottomarina III. 1961. Exploration sous-marine archeologique (in Italian). Barcelona.

Hale, W. B. and C. E. Cook. 1962. Underwater Microcontouring. *Photogram. Eng.* 28(28):96-98.

Hohle, J. 1961. Reconstruction of the underwater object. *Photogram. Eng.* 37(9):948-954.

Johnson, Fenimore. 1935. Ardmore, Pennsylvania.

International Congress of Underwater Archeology. 1952. Albenga, Italy.

Ivanoff, A. 1951. On underwater photography. Lenses, optics. *I. Opt. Soc. Am.* 41:645-646.

Ivanoff, A. and P. Cherney. 1960. Correcting lenses for underwater use. I. Soc. Mot. Pict. TV Engrs. 69.

McNeil, G. T. 1968. Optical fundamentals of underwater photography. Rockville, Maryland: Photogrammetry, Inc.

McNeil, G. T. 1966. Underwater camera calibrator. *J. Soc. Photo. Instr. Engr.* 4(3).

McNeil, G. T. 1969. Underwater photography: Some photogrammetric considerations. *Photogram. Engr.* 35(11).

Meijer, J. G. 1964. Formula for conversion of stereoscopically observed apparent depth of water to true depth. *Photogram. Engr.* 30(12):1037-1045.

Meyer, L. and D. Rebikoff. 1969. An integrated underwater photogrammetric system. *Photogrammetry.*

Owen, D. M. 1951. Deep-sea underwater photography and some recent stereoscopic applications. *Photogram. Engr.* 17:13-19.

Owen, D. M. 1967. Multi-shot stereoscopic camera for close-up ocean-bottom photography. In *Deep-Sea Photography*, J. B. Hershey. Baltimore: Johns Hopkins Press.

Pollio, J. 1968. Applications of underwater photogrammetry (AD-851-692). Washington, D.C.: U.S. Naval Oceanographic Office.

Pollio, J. 1969. Applications of underwater photogrammetry. Deep Vehicles Branch, U.S. Naval Oceanographic Office. *Mar. Tech. Soc. J.* 3(3):55-72.

Pollio, J. 1971. Precision underwater mapping with photography and sonar. *Photogram. Engr.* 37(9):955-968.

Pollio, J. 1968. Stereo photographic mapping from submersibles. U.S. Navoc, Stereo photography: Mapping, vehicles, underwater photo-optical instrumentation applications. Proceedings, Feb. 4-6. SPIE, San Diego, California.

Pratt, R. M. and S. L. Thompson. 1962. Report on *Atlantis* cruises #280-281, AD-296. June-July 1962, p. 1611.

Rebikoff, D. 1967. The case for unmanned underwater systems. *Sea Frontiers* 13(3):130-136.

Rebikoff, D. 1969. Dirty and clear water mosaic and strip scanning underwater photogrammetry (Updated Paper). *Proc. SPIE* 13 Ann. Tech. Symposium No. 1, 69-75.

Rebikoff, D. and P. Cherney. 1955. A guide to underwater photography. New York: Greenberg.

Rebikoff, D. 1967. History of underwater photography. *Photogram. Engr.* 33(8):897-904.

Rebikoff, D. 1961. How photography helps underwater archeology. *Camera* 7-8:52-53.

Rebikoff, D. 1968. Mosaic photogrammetry survey of the Atlantic continental shelf off Port Everglades. *Proc. Mar. Tech. Soc.* Natl. Sym. Ocean Sci. Eng. Atlantic Shelf, 249-256. Philadelphia, Pennsylvania.

Rebikoff, D. 1966. Mosaic and strip scanning photogrammetry of large areas under water regardless of transparency limitation. *Underwater Photo-Optics Seminar Proceedings,* October 10-11.

Rebikoff, D. 1952. Photographie sous-marine en couleurs par lampe-eclair a decharge de condensateur (in French). Science et Industries Photographiques, CNRS 2 Series, Tome 23:289-294.

Rebikoff, D. 1952. Photo-sous-marine, cinema sous-marine, technique de la plongee (in French). Paris: Montel.

Rebikoff, D. 1968. Rebikoff Pegasus underwater photographic system: Evolution, design criteria and typical applications in 1967. *SPIE Underwater Photo-Opt. Instrum. Appl. Seminar Proc.:* 91-98.

Rebikoff, D. 1967. Underwater area stereophotogrammetry. *Ind. Phot.* 28-29, 64-68.

Shipek, C. J. 1961. Microrelief on the sea floor. *The Science Teacher* 28(6).

Shipek, C. J. 1965. Photogrammetric analysis of deep-sea floor micro-relief. In *Mapping In and Out of This World,* 109-135. Dayton, Ohio.

Thorndike, E. M. 1950. A wide-angle underwater camera lens. *I. Opt. Soc. Am.* 40(12):823-824.

Thorndike, E. M. and M. Ewing. 1966. Light-scattering in the sea. *Underwater Photo-Optics Seminar Proc.*

Wakimoto, Z. 1967. On designing underwater camera lenses. *Photoram. Engr.* 33(8).

Section VI

Special Methods and Applications with Results

Recent Developments in Deep-Sea Photography at the Institute of Oceanographic Sciences

E. P. Collins

Institute of Oceanographic Sciences
Surrey, England

INTRODUCTION

Over the past few years the Institute of Oceanographic Sciences has been experimenting with a combination of deep-sea cameras and an epibenthic sledge to improve the quantitive sampling of deep-sea macro-benthos. Many problems have been encountered but it is now considered that the system has reached a satisfactory level of efficiency.

The camera used during these recent trials is the latest in a line of units developed within the establishment over the past 24 years to cover a wide range of internally formulated requirements.

The initial system made its debut in 1957. The camera proved to be very successful at the time and many versions were produced over the years (Laughton 1957). This system was followed by a complementary stereo unit in 1966. Here again initial results were promising, but events overtook this project and it did not progress beyond the prototype stage. Both cameras embodied a 35-mm photographic unit that produced stereo-pairs on a single length of film at an interpupillary spacing of 65 mm.

These early systems were primarily designed for geological surveys. As such they operated in the single shot mode, with the camera triggered by a bottom weight.

In 1968 the Institute produced a third camera, designed to fill the

requirement for a small semidisposable system capable of operating automatically for prolonged periods at depths of up to 6,000 meters. The associated photographic unit was, in effect, a slow-motion 16-mm movie camera capable of cycling at fixed rates of up to eight frames per minute. When loaded with a standard 15.25-meter length of film, the system had a 2,000-frame capability.

This camera has been used for a wide range of projects and achieved moderate success when mounted on a simple deep tow body to gain a near continuous photographic profile of the bottom. However, the small format imposed severe limitations on the value of the results obtained and the decision was therefore taken to develop a compact 35-mm camera that could be used as a direct replacement to further this program.

In 1975 a related series of trials was conducted with an epibenthic sledge and camera combination using the same type of 16-mm deep-sea unit (Aldred *et al.* 1976). While the camera was very useful in monitoring the sledge performance, both on the bottom and in mid-water, the format, as in the geological survey, was inadequate for recording densities and relative positions of benthic animals. Plans were therefore made to accelerate development of the 35-mm system, then in the prototype stage, to cover further sea trials scheduled for the following year.

The completed photographic unit together with a new electronic flash, now designated as a Mark 4 (Mk 4) camera, were tested at sea early in 1976 and then mounted on a sledge in preparation for a cruise planned for October of the same year.

THE Mk 4 PHOTOGRAPHIC UNIT

The basic unit (Figure 1) has an over-all length of 380 mm and was tailored to fit inside an existing 76-mm pressure housing, thus imposing a 15-meter film capacity limitation, giving a capability of 400 frames. The film transport mechanism and drive motor plus gate and data chamber are located between two fixed plates to gain maximum structural rigidity. The whole system is enclosed in a light-proof case. Rechargable power cells, electronic circuit boards, and control switches are grouped together in a separate section attached to the rear of this main frame.

The standard solid state circuit, which embodies a crystal-controlled time base, is designed to operate the unit at any one of seven predetermined intervals of between fifteen seconds and sixteen minutes, these being selected through a bank of miniature switches. To conserve film the circuit also incorporates a hold-off function used to gain random operation at each preselected interval through an external switch. This circuit is located on a

Figure 1. Basic photographic unit of the Mark 4 camera showing the film transport mechanism and timing plus data circuits in tandem.

single plug-in card that can readily be interchanged with alternative boards designed to cover specific trial requirements if so desired.

A secondary board contains decoder and drive circuits to operate standard seven-segment digital display devices. The count system is activated by a sixty-second pulse derived from the time base, and is primarily designed to indicate elapsed time in minutes from switch-on. The input can be modified by a link change to gain frame count if required. The associated display, located in the data chamber, is back projected onto each frame at the instant of exposure. Both display and control circuits embody an automatic reset facility triggered by the master on/off switch to achieve a zero readout on initiation.

The prototype photographic unit utilized a modified 35-mm f/3.5 Wray lens, but subsequent units have been equipped with a 38-mm f/3.5 lens fully corrected for operation through a plane window into sea water having a mean refractive index of 1.343. The optical system, manufactured by J. H. Dallmeyer Ltd., was specially designed for the Mk 4 camera by Professor C. G. Wynne of Imperial College, London, who has actively assisted the Institute in a similar manner on many occasions in the past.

THE FLASH UNIT

The current system (Figure 2) incorporates a commercially available controlled-level electronic flash modified for installation in a special pressure housing. The tube and associated reflector are located in a glass dome attached to one of the tube end caps, while the light level sensor is situated behind a special window positioned on the housing body. Power for the system is derived from internally-mounted rechargable cells. The weight in water is 2.2 kg as compared with 4 kg for the photographic unit.

PRESSURE HOUSING

The housings are now manufactured entirely from Hiduminium 89 aluminum alloy giving a depth capability of 7,000 meters. For each case the main body is machined from a length of drawn tube having an external diameter of 103 mm and a wall thickness of 14 mm. End caps are retained in position by a 4 TPI square section thread undercut to ensure an even contact between the O ring seal and associated machined end face.

A plane acrylic plastic conical frustrum window, having an internal diameter of 29 mm and a thickness of 22 mm, is mounted in one end of the photographic unit housing (Figure 3). Great care is exercised to ensure a total register between cone and seating to achieve maximum structural efficiency, as local stressing in the acrylic plastic will inevitably result in image distortion when operating at depth.

To eliminate problems with links between the photographic unit and external circuits, the unit is plugged directly into the end cap carrying the electrical outlets. The two then rotate as a whole when the cap is finally screwed into the pressure tube.

EARLY SLEDGE TRIALS

The metal frame epibenthic sledge used initially embodied a net having a rectangular mouth 2.3 meters wide and 0.6 meters high that in mid-water was sealed by a blind. When the net was on the bottom the closure was automatically lifted clear by levers attached to the runners.

The Mk 4 photographic unit and electronic flash were located below the front cross members of the sledge frame, angled down 14° to aim at a common point some 1.5 m ahead of the system when it was operating on a flat surface. To facilitate the analysis of photographs, the sea bed area covered was determined by test exposures in a water tank on a 5 × 5 cm subunit grid. From this it was possible to create a master grid representing 20 × 20 cm

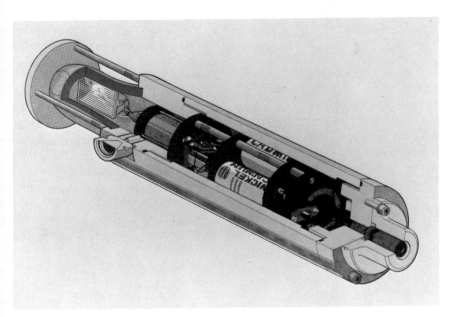

Figure 2. Mark 4 flash unit showing the flash tube and reflector at the far end of the case, with the auxiliary window for the light level sensor nearby.

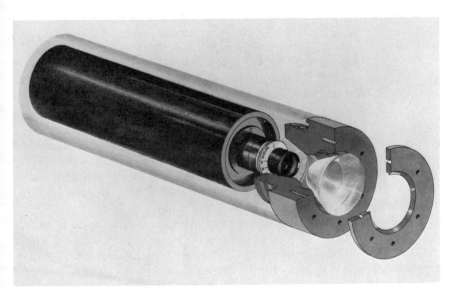

Figure 3. The photographic unit pressure housing showing the acrylic conical frustrum window mounted in the end.

squares. Suitable transparencies from the sledge trials were then projected onto this master grid to obtain size and relative locations of recognizable organisms and other features.

The viewing angle selected at this stage could produce excellent results and in many instances resulted directly in a positive identification of the species recorded (Rice *et al.* 1979). Unfortunately, the use of photographs for density estimates proved difficult since a slight variation in sledge attitude drastically changed the field of view and in many instances an undulating sea bed directly resulted in a total loss of the subject in a high percentage of records obtained. The latter problem was further aggravated by an unsatisfactory technique used in the early stage to start the camera. The associated trigger system actuated on contact with the sea bed, but was insensitive to sledge attitude. This could result in long photographic runs obtained with the sledge forepart held clear of the bottom during the start of recovery operations.

CURRENT SYSTEM

With the introduction of a more substantial and complex sledge having an increased frame height, the opportunity was taken to make the system less sensitive to slight variations in sledge attitude during hauls by moving the photographic unit to a more elevated position on the structure and increasing the deflection angle to 30° from the horizontal.

To protect the electronic flash from physical damage during handling over the ship's side, etc., this was again located under the forward cross members of the new sledge, but by virtue of the increased frame size a slight height and separation advantage was achieved. Modifications to the sledge camera installation resulted in a reduced but technically more acceptable and precise field of view for the photographic unit. The depth of field involved has now been reduced from 5 meters plus to 1.6 meters, thereby simplifying both focusing and lighting. It is now possible, with the aid of the controlled level electronic flash, to achieve prolonged runs of constant density, high resolution negatives during each station (Figures 4 to 7).

The sledge now also embodies a more sophisticated acoustic telemetry system, including a transducer designed to gain an accurate assessment of attitude. A method of controlling the camera hold-off facility was derived from this system over fairly precise angles, resulting in a greatly improved coordination of sledge and camera operation. In addition, flash initiation pulse signals were coupled into the acoustic system and these, together with other relevant data such as sledge attitude and distance traveled, are

Figure 4. (a) *Lepidion eques* (deep-sea cod) viewed from the old camera position (14° inclination) on the epibenthic sledge. At 1,400 meters in the Porcupine Sea-Bight (about 51°N, 13°W).

Figure 4. (b) *Lepidion eques* (deep-sea cod) viewed from the new camera position (30° inclination) on the epibenthic sledge. At 1,100 meters in the Porcupine Sea-Bight.

Figure 5. Small sea-cucumber (less than 1 cm long) and fecal casts at 1,100 meters in the Porcupine Sea-Bight. New camera orientation.

Figure 6. Sea-cucumber swarm (*Kolga hyalina,* less than 1 cm long) at 4,000 meters in the Porcupine Sea-Bight. Old camera orientation.

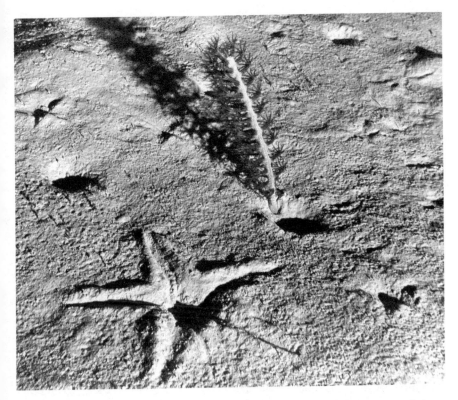

Figure 7. Sea-pen *(Pennatulid)* and the feeding impression from a starfish at 1,000 meters in the Porcupine Sea-Bight. New camera orientation.

continuously transmitted to the ship and superimposed on the echo sounder trace record to gain a complete picture of equipment performance during each station. A record of sledge depth, attitude, and distance run between frames can now be added to data achieved from each photograph obtained.

The camera has been subjected to a continual development program during this series of trials to improve general performance and to cover changes in requirements as new sledge handling techniques have evolved. Random false triggering of the control system was experienced initially on a number of isolated occasions. This was finally attributed to the extreme sensitivity of associated electronic components to minor fluctuations in circuit impedance caused, in this instance, by sea water contamination of external connectors. Modifications have therefore been introduced to counteract this problem. Well over 2,000 frames have now been obtained with the system in its present form and further trials are scheduled to take place during the latter part of 1980.

CONCLUSION

Following the recent success achieved during the sledge trials, there has been a steady upsurge in demand for the Type 4 deep-sea camera system within the Institute. Two photographic units have been equipped with shutter mechanisms to cover shallow water investigations, and a further unit, capable of operating independently at depth for periods of up to six months, is now under development. Further variants are planned for future projects associated with the disposal of radioactive waste. In general, attempts are being made to build up an operational stock of ten units to cover our own requirements in this field during the next few years.

ACKNOWLEDGMENTS

The author would like to thank Professor C. G. Wynne of Imperial College for his kindness in designing the Mark 4 underwater lens system. The Institute of Oceanographic Sciences is a component body of the Natural Environmental Research Council (U.K.).

REFERENCES

Laughton, A. S. 1957. A new deep-sea camera. *Deep-Sea Research* 4:120-125.
Aldred, R. G., M. H. Thurston, A. L. Rice, and D. R. Morley. 1976. An acoustically monitored opening and closing epibenthic sledge. *Deep-Sea Research* 23:167-174.
Rice, A. L., R. G. Aldred, D. S. M. Billett, and M. H. Thurston. 1979. Combined use of an epibenthic sledge and a deep-sea camera to give quantitative relevance to macro-benthos samples. *Ambio Special Report*, No. 6.

Underwater Photography and Its Application to Understanding the Coring Process

Floyd W. McCoy

Lamont-Doherty Geological Observatory
Columbia University
Palisades, New York

INTRODUCTION

Sampling of bottom sediments in the deep sea can be done by a variety of instruments such as grab samplers, dredges, drilling rigs, or corers. The latter device is most commonly used, particularly when cores of subbottom sediments need to be collected with minimal disturbance to the sedimentary sequence for stratigraphic studies. Piston corers have been the primary tool for sampling deep-sea sediments for three decades, and are the most effective and efficient technique yet devised for routine sampling operations from surface research vessels. Piston cores have been collected by all the major oceanographic institutions from well over 20,000 stations in the world ocean. About half of these were obtained by Lamont-Doherty Geological Observatory (LDGO) ships *Vema* and *Robert V. Conrad* (Figure 1) and are stored at the LDGO repository, the largest archive of cores in the world. These collections form the basis for marine research throughout the world.

Even after such extensive use, we know little about how this equipment functions in the abyss during the sampling process. The successful marriage of coring technology with another well-established technology, underwater photography, was achieved at the Lamont Geological Observatory in 1965 (Ewing *et al.* 1967) by simply mounting underwater cameras with their light

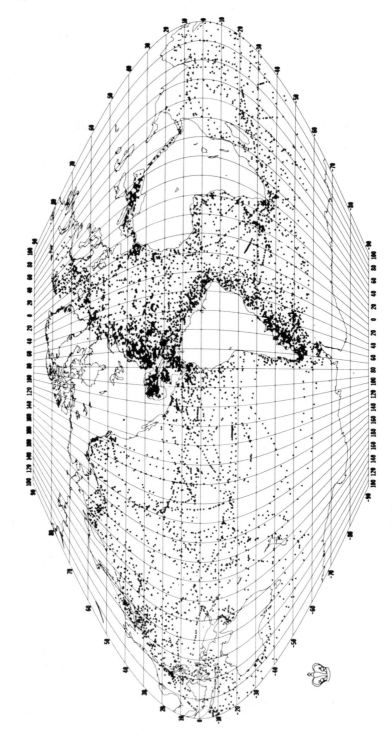

Figure 1. Map showing Lamont-Doherty Geological Observatory piston coring sites.

source within the corer weightstand or corehead. Designs for corehead camera systems were modified at the Woods Hole Oceanographic Institution (WHOI) in 1969 (McCoy *et al.* 1969; McCoy and von Herzen 1971). Corehead camera photography was routinely done during LDGO coring operations for nearly six years and has been done infrequently on various LDGO and WHOI coring stations over the past ten years. This activity has resulted in an enormous collection of photographs at both institutions—a pictorial record of coring, of bottom current activity, of the biological benthos, and of seafloor characteristics throughout the world.

While this entire collection has not been completely studied, observations from pictures taken at over a hundred sampling sites in the world ocean provide a dramatic portrayal of the coring process and demonstrate the value of corehead camera photography. The resulting analyses of sampler operation are applicable to engineering or design considerations of corers and are important to scientific interpretations of the recovered cores.

INSTRUMENTATION, TECHNIQUES, AND CALIBRATION

Piston Corers and Coring

The piston corer used for most bottom sampling programs today, the Ewing piston corer, is a combination of the Kullenberg piston corer (Kullenberg 1947, 1955) and the free-fall release mechanism developed by Hvorslev and Stetson (1946). The original piston sampler was a Norwegian device for sampling soils on land that was adapted for underwater sampling by Kullenberg to increase the length of core recovered and decrease physical disturbances to cores. Open-barreled gravity corers without pistons then in use could penetrate only a few meters into the seafloor because frictional forces between mud and corepipe both inside and outside the pipe prevented deeper penetration. By incorporating an internal piston adjusted to remain at the surface-water interface during penetration, a suction is developed between piston and sediment within the pipe helping bring or hold the sediment in place, thereby significantly diminishing internal frictional forces between sediment and corepipe. The Kullenberg piston corer was first successfully used during the Swedish Deep-Sea Expedition of 1947-1948. The Ewing piston corer is a larger, improved version of this design and is the standard sampler now in use. Piston cores up to 10 m long can be routinely collected; the average core length in the LDGO archive is 8 m, and the longest is 28 m.

A free-fall (through water) mechanism releases the piston corer 5-10 m above the seafloor, allowing it to drop unhindered for higher impact velocities,

thus contributing to increased sediment penetration. This mechanism is simply a lever arm, or trigger arm, from which the heavy (1,000-2,000 lb) piston corer is suspended and balanced by a smaller (100-300 lb) gravity corer, called the trigger-weight (TW) corer. The TW corer encounters the seafloor first during lowering from the surface ship (Figure 2), and when it does, the balance is upset so that the trigger arm swings upward (cable continues to be paid out from the ship) and the piston corer is released. Two cores are thus collected at each sampling site: a TW core and a piston core.

Even with this engineering and technical expertise in equipment design, many decades of extensive corer use throughout the world, and much interpretation of geologic history or paleo-oceanography based upon analyses of thousands of collected cores, we know little about what happens when the momentum of a ton of lead drives 10 m or so of hollow pipe into soft sediments. There can be no doubt that piston corers work, and work well. But there are also some indications of possible disturbances within cores, and it is in the interest of understanding these disturbances better that the technique of inserting cameras into the corehead has been valuable.

Camera and Corer Instrumentation

Two different systems of camera instrumentation are in use, LDGO and WHOI, although each uses similar equipment; specifications on these two designs are presented in Figures 3 and 4. Both systems mount cameras, light sources, and self-contained battery packs for power in the corehead inside cylindrical cavities. Other corehead cavities are often fabricated to hold additional instrumentation such as nephelometers (optical transmitometers or light-scattering meters for suspended sediment measurements), thermograd recorders (for measuring temperature gradients within sediments as an indication of heat flow from the earth, and heat transfer between bottom water and sediments, utilizing thermistors mounted on the exterior of core barrels), or pingers (transducers for monitoring distance between corer and the seafloor). Both photographic systems use standard 35-mm underwater cameras, strobe lights, and a 6-V power system from rechargeable batteries. Neither camera arrangement used shutters, unnecessary in the darkness of the abyss, so that exposure control was dependent upon the light source.

In the LDGO system, the camera was an adaptation of the Thorndike 35-mm deep-sea camera (Thorndike 1959). One camera was used and mounted in the corehead cavity nearest the trigger-weight (TW) corer (Figure 3). Focus for this camera was set for distances between 2.4 m and infinity, using an adjustable f/2.8 Leitz Summaron lens with an effective focal length (in air) of 35 mm; underwater angular field of view is $36° \times 42°$. A 12-second exposure interval was used, controlled by a timer to the strobe light; thus

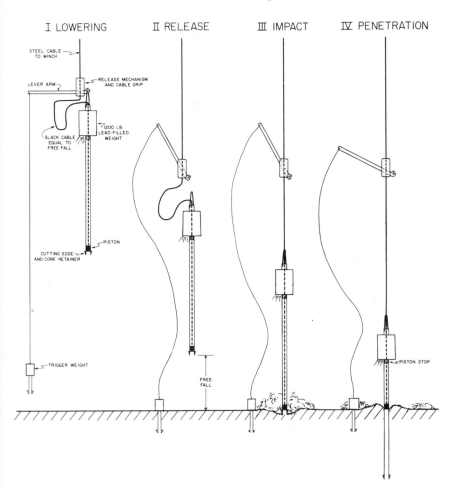

Figure 2. Schematic portrayal of the free-fall triggering method for coring using the Ewing piston corer.

the first good (unfogged) exposure was 12 seconds after corer tripping since the first frame in the shutterless camera was fogged by exposure on deck. When loaded with 20 ft of film, approximately 130 frames would be exposed at the 12-second exposure rate with a continuous film advance of 23 cm/min. A compass was usually mounted on the corebarrel within focus of the camera (Figure 3).

The WHOI system was a modification of the LDGO system that used two cameras, both standard EG&G 35-mm equipment, arranged within the corehead as shown in Figure 4. One camera was focused at 1.8 m (6 ft) on the compass-inclinometer unit mounted on the corebarrel, and the other at 4.9

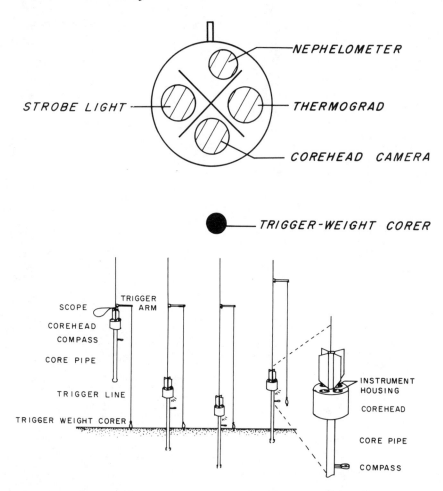

Figure 3. Position of cameras and the stroboscopic light source within the corehead in relationship to the trigger-weight corer in the Lamont-Doherty Geological Observatory corehead camera system; placement of other instruments is also indicated (top). Camera operation during and after seafloor penetration, including pull-out, is shown (bottom), including the position of the compass mounted on the corebarrels within focus of the camera. *(Modified after Ewing et al. 1967.)*

m (16 ft), the anticipated maximum range for clear photographs with partial penetration of the corer. With such a two-camera arrangement, it was presumed that at least one camera would show the bottom in focus. Lenses were Hopkins f/4.5 adjustable-aperature lenses with an effective focal length (in air) of 35 mm; angular field of view is $37° \times 53°$. The exposure (or flash) rate was 5 seconds. Cameras were loaded with 15-m (50-ft) lengths of film

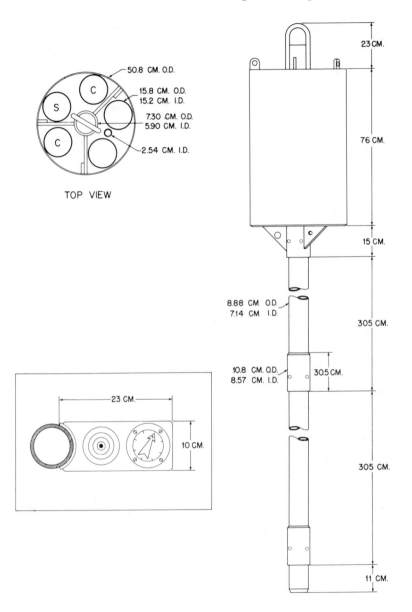

TOP VIEW

Figure 4. Piston corer, here shown rigged holding two corebarrels, with a top view to indicate positions of cameras (C) and stroboscopic light source (S) within the corehead, as used by Woods Hole Oceanographic Institution. The inset at lower left gives the dimensions of the bracket arm holding the inclinometer (left) and the compass (right). *(From McCoy and von Herzen 1971.)*

resulting in about 22 minutes of operation. Modifications necessary to the circuitry for a 5-second repetition rate of the stroboscopic light required lowering the energy input to the flash to 50 watt-sec, which proved sufficient. To decrease battery discharge, a microswitch sensed passage of the film and terminated camera/strobe operation. As with the LDGO design, the WHOI coreheads also contained additional instrument cavities (Figure 4). Additional modifications to this system have involved other strobe-flash repetition rates and mounting of 16-mm movie cameras within the corehead.

Operating Techniques

In both systems, conventional techniques for rigging, launch, and recovery of piston corers were used according to institutional and shipboard requirements. With the LDGO system, camera operation was started by tripping of the piston corer (Figure 3). The first frame was usually fogged due to light exposure prior to launch from the ship, and corer penetration was not often seen in photographs.

Because documentation of tripping—free-fall—penetration activity by the piston corer was desirable, camera operation with the WHOI system was initiated by a preset timer, set according to winch lowering speeds and water depth prior to launch from the ship. Frequently the corer remained suspended beneath the ship just above the sea-floor and the tripping (or free-fall) distance until adequate time had elapsed to be sure the timer had started the corehead camera system and the first, fogged frame exposed on deck in the shutterless cameras would have run through the camera. Corers often remained in the bottom for 5 minutes or more when thermograd measurements were being made.

A compass was mounted beneath but within focus of cameras in both the LDGO (Figure 3) and WHOI (Figure 4) systems for determining corer orientation in the seafloor, valuable information for paleomagnetic studies on the collected cores. Placement of the brackets holding these compasses was usually at a fixed distance beneath the corehead. An additional instrument to detect corer tilt within the sea-floor during and after penetration, an inclinometer, was also mounted adjacent to the compass on the WHOI corer (Figure 4). Specific design criteria for both the WHOI and LDGO compass/inclinometers are given in Ewing *et al.* (1967), McCoy *et al.* (1969), McCoy and von Herzen (1971), and McCoy (1980).

Calibration of Corehead Camera Photographs

A convenient reference for scale exists in all corehead camera photographs simply by noting corepipe size. Applying this technique was often difficult, however, because of problems such as accurately defining the seafloor-

corepipe contact or pipe edges, and measurements could not be used with much reproducibility or confidence. Often impact of the corer with soft seafloor sediments produced either an enlarged hole surrounding the core barrel (Figure 5), or a mound of sediment heaped 10 cm high or more around the barrels and extending out 30 cm onto the seafloor (Figure 6). Less frequently, depressions 15 cm deep or so, and 40 cm in diameter, were formed, complicating any good definition of undisturbed seafloor for scale.

Accordingly, another method for determining scale and corepipe penetration was determined in corehead camera photographs by measuring the width of the shadow cast by the bracket arm on the bottom and comparing it to the width of the bracket arm itself. To determine the shadow width with respect to varying distances below the corehead, the WHOI corer was rigged at night on land with two barrels, the cameras and strobe lights were mounted within the corehead (using the same cameras used at sea), and a large piece of cardboard was held at 30.5 cm (1 ft) intervals beneath the bracket arm to record the width of the shadow cast by the bracket arm. At least three pictures were taken at each interval. Figure 7 shows one picture taken by the camera focused at 1.8 m (6 ft) for a distance of 2.4 m (8 ft) beneath the corehead. Figures 8 and 9 are the calibration curves obtained from the camera focused at 1.8 m (6 ft) and the camera focused at 4.9 m (16 ft). By establishing this measurement as a ratio, no correction was needed for print enlargement or for differences in refractive indices between lenses, water, and air to equate shadow widths on land with those underwater. The shadow cast on the seafloor usually extended well beyond any disturbances such as mounds or depressions around the corepipe. Vertical deviations of the corer in the bottom did not significantly affect these measurements.

For the stations where the bracket arm was buried, the core barrel above the bracket arm was marked with black tape at 30.5 cm (1 ft) intervals. A transparent overlay showing these distances was then prepared and placed over the core barrels in the photographs, necessitating that the enlargement of the underwater photographs and the overlay or calibration photographs be the same. Other laboratory techniques are given in McCoy *et al.* (1969) and McCoy and von Herzen (1971).

PHOTOGRAPHIC DOCUMENTATION OF CORING

An estimated 80,000 photographs from about 140 coring stations have been studied so far, a dramatic pictorial record of coring done by different crews from a variety of ships, at all water depths throughout the world, in both good and bad weather, collecting all types of pelagic and hemipelagic sediments. The documentation is voluminous and the

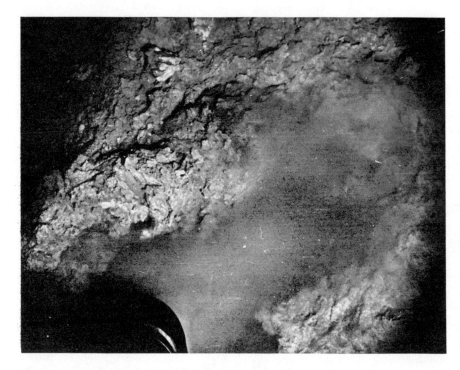

Figure 5. Enlarged hole in the seafloor surrounding the corepipe produced by wobbling of the corer after penetration was completed. Note surrounding sediment mound where bracket arm was buried and that some wobbling occured despite this.

Figure 6. Mound of sediment piled upon seafloor around corepipe, apparently resulting from displacement of sediment during impact of piston corer with the seafloor. To the left of the corer is chain that apparently was used for the WHOI TW corer; corer is lying on the seafloor. Tape wrapped around piston corer barrel marks 1-ft increments.

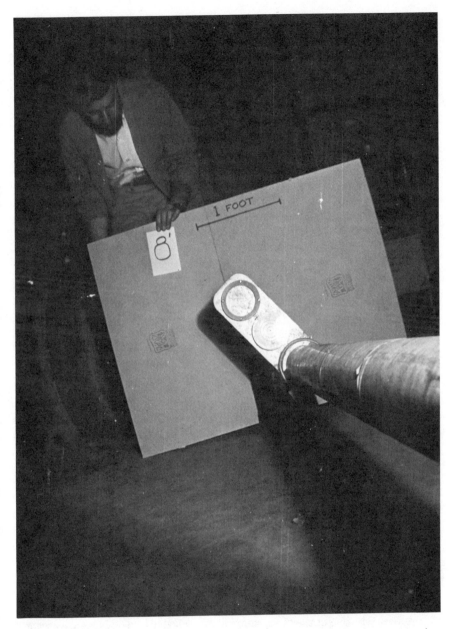

Figure 7. Example of calibration photograph made on land to determine the ratio of the width of the bracket arm shadow to the width of the bracket arm, in this case for penetration to 8 ft of the base of the corehead. Photograph taken by the camera focused at 1.8 m (6 ft).

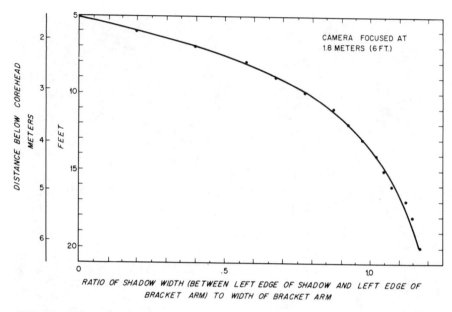

Figure 8. Calibration curve for the camera focused at 1.8 m (6 ft) to determine the amount of penetration as a function of the ratio between the width of the bracket arm shadow cast on the seafloor to the width of the bracket arm.

interpretation is complex. Only a general account can be presented here.

It is important to know how much the coring apparatus rotates or twists while it is being lowered. Any twisting that continues after tripping during piston corer penetration could seriously affect core orientation and determinations of directional fabrics within the collected sediments such as magnetic properties or grain-particle orientations. To minimize such rotation, for example, the traditional LDGO coring operation from *Vema* put the wind off starboard, where the coring A-frame was located amidship, so that ship's drift to port would tow the corer assembly with the trigger arm serving as a vane to minimize corer twisting to within about 30°. Corehead camera data of compass bearings prior to tripping substantiate this *Vema* tradition, indicating that instrument rotation usually remained within 30° per 5-second interval on 95% of the stations (Figure 10).

This amount of rotation by the coring gear persisted during tripping, free-fall, and complete penetration at least 42% of the time (Figure 10). Approximately 25% of the time, rotation increased up to 60°; severe rotational movements in excess of 60°, in one case up to 150°, occurred during an additional 25% of stations. Thus during nearly one-half of the stations increased twisting of the piston corer accompanied tripping, free-fall, and

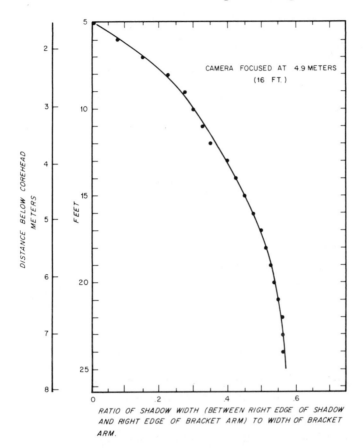

CAMERA FOCUSED AT 4.9 METERS
(16 FT.)

DISTANCE BELOW COREHEAD
METERS

FEET

RATIO OF SHADOW WIDTH (BETWEEN RIGHT EDGE OF SHADOW
AND RIGHT EDGE OF BRACKET ARM) TO WIDTH OF BRACKET
ARM.

Figure 9. Calibration curve for the camera focused at 4.9 m (16 ft) to determine the amount of penetration as a function of the ratio between the width of the bracket arm shadow cast on the seafloor to the width of the bracket arm.

full seafloor penetration, a factor of some potential significance in sediment analyses and future design of coring apparatus.

The angle of corer penetration in terms of a deviation from the vertical could also be determined from corehead camera photographs that recorded inclinometer measurements. Variability in this angle during lowering prior to tripping was between $0°$ and $12°$ (Figure 11). Once penetration was completed, this angle seemed to increase, usually within the $12°$ range of the inclinometer, although on 15% of the stations the angular change was in excess of $12°$. Such values of tilt are within detection limits of vertical angular variations of bedding planes (dip) within recovered cores and should

Figure 10. (Left) Rotational change of the piston corer assembly during lowering or suspension above the seafloor prior to tripping as recorded on corehead camera photographs. Note that this rotation is not severe but remains within a range of 0° to 30° on most (95%) stations where photographic documentation is adequate.

(Right) Rotational change after complete piston corer penetration into seafloor sediments. During 42% of these stations, rotation was within the limits measured during lowering but on the remaining stations a significant angular change occurred that was in excess of lowering values.

be considered when interpreting stratigraphic dips in terms of natural phenomena.

Penetration by the piston corer raised sediment clouds around the barrel (Figure 12). Once the clouds settled into the bottom, disturbances on the adjacent seafloor were often noticeable in the form of mounds or, less often, depressions (Figure 6). Enlarged holes in bottom muds surrounding the corepipe were caused by wobbling of the protruding pipe and weight stand (Figure 5).

The amount of penetration determined by either the shadow ratio or overlay method was compared to the length of core recovered. Few cores were equal in length to corer penetration, or 100% recovery (Figure 13). Average core recovery was 86%. The average core was thus 86% as long as the measured penetration or had been shortened somehow by 14%, an indication of either compression of the sediment column or missing sediment sections. Missing upper portions in piston cores are not uncommon and it is because of this that TW corers are used. The missing material probably forms most of the sediment cloud raised during sampler penetration (Figure 12) as well

Figure 11. Angular change of the vertical deviation of the piston corer between its lowering and complete penetration into the bottom.

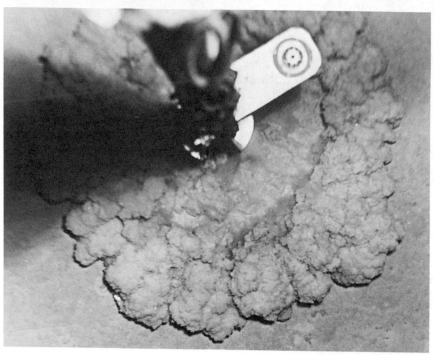

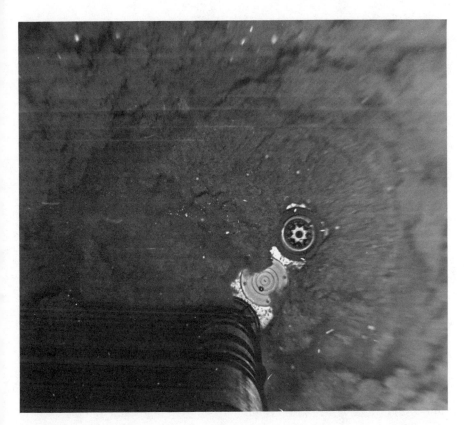

Figure 12. Cloud of sediment raised by impact and penetration of the piston corer into the seafloor during three stations. The cloud was usually about 40 cm high and dispersed within 10 seconds (2 frames) after penetration was completed. The inclinometer is registering a 10° to 12° angle or deviation from vertical (tilt) of the core barrels in the bottom, in two of the photos. Wires and tape on core barrel are for heat flow instruments.

as part of the mounds photographed on other stations (Figure 6). Data on compression of cored sequences are conflicting; open and unflattened worm burrows have been recovered in piston cores (Opdyke, personal communication) implying no compression, yet there often seems to be a decrease in sediment layer thickness at the base of cores suggesting some compression. Core lengths for five cores were longer than measured penetration, on two stations by 1.5 m, but was not obvious as stratigraphic disruptions in the core. Core recovery does not seem influenced by the dominant sediment-type sampled (Figure 13), although the effect by sand and/or silt layers could be influential. Where sand is the dominant lithology, corer penetration is

Figure 13. Corer penetration as measured in photographs in relationship to the length of core collected and the number of core barrels mounted on the coring rig (core barrels for these cruises were 10 ft or 3 m long). Long-dashed line is 100% recovery; short-dashed line is the average value of 86% for core recovery calculated from these data. Symbols indicate sediment type: circles are calcareous ooze/clay; triangles are sediment with a dominant biosiliceous component; diamonds are clays or silty clays. Cross symbols are for a station where there was either trouble during the station, such as pretripping or bending of corepipe, or penetration was inhibited by hitting basalt or a manganese pavement. Vertical bars give error range in determining penetration from the corehead camera photographs; where no bars are shown, error is about 10 cm. Horizontal lines connecting symbols indicate amount of flow-in between base of core (open symbol) and upper limit of detectable smearing in core (closed symbol); open symbol alone represents core with less than 20 cm flow-in; concentric circle symbol identifies one core of all flow-in.

usually inhibited, although sands were not a dominant sediment in any of the cores studied here. Recovery efficiency is, of course, an important consideration for studies on cored sediments and stratigraphic sequences because calculations of time-dependent factors (such as sedimentation rates, microfossil evolution rates, etc.) are based upon downcore thickness measurements.

The upper level of mud smeared along the corebarrels is the usual technique for estimating corer penetration. It is measured upon retrieval of sampling equipment on board ship as the distance between the mud line and the bottom tip of the corer, the core cutter. Determination of corer penetration from corehead camera photographs allowed the veracity of the mud line technique to be checked and it was found to be accurate usually within ±5% actual penetration (Figure 14). Note that these mud line determinations were made by different coring crews during six cruises over three years, thus demonstrating the value of this measurement during routine coring operations when photographic gear is not being used.

Much additional information has come from analyses of corehead camera photographs. Some has been presented elsewhere (McCoy 1980); other data are being assembled now and will be discussed in future publications. Among the data now being taken from these photographs are documentation of coring disturbances known as flow-in, analysis of TW corer activity (Figure 15) including possible multiple penetration, elastic rebound by the

Figure 14. Corer penetration measured in photograph compared with mud-line determinations. Dashed line is a 1:1 relationship between the two measurements; corebarrel spacing is indicated for reference. Symbols are explained in the caption for Figure 13.

Figure 15. Piston corer and TW core resting in the seafloor while heat-flow measurements were being made. The TW corer here is the WHOI type.

coring (trawl) wire, and additional studies of core shortening. In each case, these data must be scrutinized for applicability to scientific interpretations as well as to design considerations for possible modifications of the sampler apparatus to make it even more efficient as a marine geological tool.

CONCLUSIONS

Corehead cameras are a valuable instrumentation technique. As shown here, the resulting photographs provide an understanding of how corers work on the seafloor and of the effect of allowing a ton or more of lead to fall 30 ft (10 m) or so and push 40 ft (12 m) or so of hollow pipe into soft sediment. That this design works, and is the most effective apparatus designed for such sampling, is attested to by the extensive use of piston corers. Photographic documentation supports this, but these data also suggest engineering modifications to make the equipment even more effec-

tive. The large collection of corehead camera photographs is being studied for both design modifications and scientific interpretations.

In addition, the value of a photograph at each coring site is obvious for detecting bottom currents, for measuring corer orientation in the bottom, and for a record of the surrounding seafloor. Unfortunately it is an expensive technique and thus not practical for routine use. But the technology has been developed, tested, and proven, and forms another important technique for underwater exploration.

ACKNOWLEDGMENTS

Comments by N. Opdyke, L. Sullivan, and R. Gerard (LDGO), by A. Driscoll (University of Rhode Island), and by the core curating crowd at LDGO (R. Lotti, R. Martinson, S. Coughlin, F. Hall, S. Lewis, E. Halter, S. Stedman, C. Ahumada, and S. Selwyn) are appreciated. Assistance in working with the WHOI data from W. Dunkle, G. Witzell, and J. Broda is greatly appreciated. The LDGO core collection and curating facility is maintained through National Science Foundation grant OCE 78-25448; additional support in the preparation of this report came from Office of Naval Research contract N000 14 75 C 0210. This is LDGO Contribution No. 3224.

REFERENCES

Ewing, M., D.E. Hayes, and M. Thorndike. 1967. Corehead camera for measurement of currents and core orientation. *Deep-Sea Res.* 14: 253-258.

Hvorslev, M.J. and H.C. Stetson. 1946. Free-fall coring tube: A new type of gravity bottom sampler. *Bull. Geol. Soc. Am.* 57: 935-950.

Kullenberg, B. 1947. The piston core sampler. *Svenska hydrogr. biol. Komm. Skr., Hydorg.* 3: 1-46.

Kullenberg, B. 1955. Deep-sea coring. *Resp. Seed. Deep-sea Exped.* 4: 35-96.

McCoy, F.W. 1980. Photographic analysis of coring. *Mr. Geol.* 38: 263-281.

McCoy, F.W. and R.P. von Herzen. 1971. Deep-Sea corehead camera photography and piston coring. *Deep-Sea Res.* 18: 361-373.

McCoy, F.W., *et al.* 1969. Deep-sea corehead camera photography and piston coring. Ref. WHOI No. 69-19, 68p.

Thorndike, E.M. 1959. Deep-Sea cameras of the Lamont Observatory. *Deep-Sea Res.* 5: 234-247.

Verification of Side-Scan Sonar Acoustic Imagery by Underwater Photography

Arnold H. Bouma
Gulf Science & Technology Co.
Pittsburgh, Pennsylvania

Melvyn L. Rappeport
EXXON Production Research Co.
Houston, Texas

INTRODUCTION

Lower Cook Inlet is the outer half of a large estuarine system that connects Anchorage, Alaska, with the Pacific Ocean. The hydrodynamic regime is dominated by strong currents, principally of tidal origin.

During the summers of 1976-1969, we conducted environmental geologic hazard surveys, utilizing high-resolution seismic reflection profiling systems, side-scan sonar, an integrated bottom television-still photography system, profiling current meters, long-term *in situ* seafloor observation systems, and varying bottom sampling devices (Bouma et al. 1977a and b, 1978a, 1979, 1980; Rappeport 1980, 1981).

The bottom of lower Cook Inlet consists of a variety of glacial and fluvio-glacial sediments, principally semiconsolidated pebbly muds, partly covered by a blanket of sand that can reach a thickness in excess of 15 m. This sand veneer is molded into a variety of bedforms such as small ripples, sand waves, sand ridges, sand ribbons, and sand patches that range in height from a few centimeters to 15 m (Bouma *et al.* 1977b, 1979, 1980; Rappeport 1980, 1981).

The water circulation patterns within the inlet are extremely complex and the near-bottom flow is strongly influenced by the presence of the large

bedforms and other large-scale bathymetric characteristics (Figure 1) (Rappeport 1981). We observed that low-intensity bottom sediment motion took place only during spring tides for one to two hours at the end of each tidal cycle. Measurements taken during consecutive years showed, however, that measurable sediment transport had taken place during winter storms. Other than these episodic events, the strong, essentially bidirectional, tidal currents only appear to have a minor direct influence on net transport of sand-size material.

INTERPRETATION REMARKS

Side-scan sonar acoustic imagery interpretation requires knowledge of the physics of the side-scan sonar system in relation to the operational mode, an appreciation of resolution limits, and a feeling for target acoustic reflectivity characteristics and for the tonal constraints of the recording system. In addition, it is necessary to have a general familiarity for the features in the area to distinguish true geologic phenomena from background and instrument noise.

Theoretical calculations for the horizontal spread of a single sonar acoustic pulse (Fleming 1976) under typical operating conditions (ship speed 4 knots, slant range scale 125 m, sonal fish 10-15 m off bottom, water depth 40-60 m, paper feed speed 150 lines/inch, scan halfwidth 125 mm, pulse frequency 6.1 pps, horizontal beam angle 1.2°) show that the minimum speed of the beam width is 2.6 m at extreme slant range. Three to five reflections from a single target are required to make a target visually discernible on a sonograph made by a wet-paper recorder (Leenhardt 1974). After some familiarity with an area, a minimum of three consecutive sonar pulse returns are probably sufficient. This often allows a resolution of 6 to 8 m in the direction parallel to the survey track. The most reliable height interpretative slant range is from 50 to 100 m when a 125-m slant range setting is used on the recorder. Within these limits, the calculated minimum transverse discrimination length of a target, that has an aspect parallel to the ship's track, ranges from 3 to 8 m. It is nearly impossible clearly to distinguish on a wet-paper sonograph any tonal quality variation having a width of less than 1 mm in the direction perpendicular to the ship's travel. Such a record distance corresponds to a true distance across the seafloor of approximately 1 m. Therefore, our minimum cross-range solution is 1 m but interpretatively it is more likely to be on the order of 2 m.

The height of a seafloor object typically can be calculated using the acoustic shadow length on a sonograph (Leenhardt 1974). Such a calculation presupposes that the acoustic impedance mismatch difference causing the acoustic shadow is strictly a function of target aspect (that is, geometry). Based upon a minimum range resolution of 1 to 2 m and a slant range

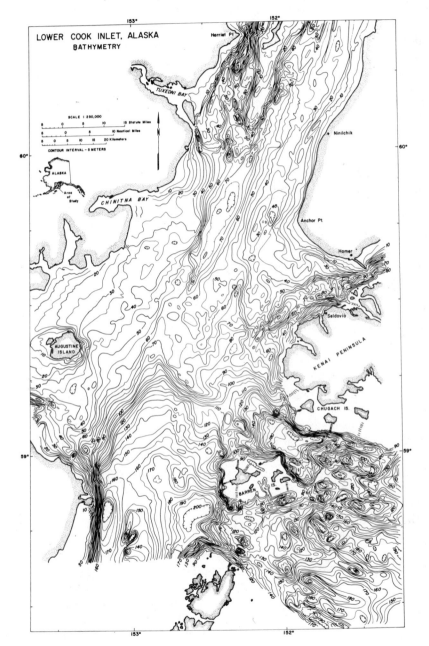

Figure 1. Bathymetry of lower Cook Inlet (contour interval 5 m). Sources: U.S. C&GS boatsheets, Continental Shelf Data Service (1967), and McGarity (1977). Minor improvements of Bouma and others (1978b) and Bouma (1981) are included.

between 50 and 125 m, the minimum detectable height of an object under ideal conditions is in the order of 15 cm. In a practical sense, it is more realistically in the order of 25 cm. In our field observations, we were able to distinguish bedforms with wavelengths of 2 m and greater and heights in excess of 25 cm if the crest lengths parallel to the ship's track were more than 6 m long.

FIELD OBSERVATIONS ON SMALL BEDFORMS

Several areas in lower Cook Inlet were selected for detailed studies on bedforms (Figure 1). The bathymetric profile shown in Figure 2 (top) indicates a sloping bottom with possible bedforms. The corresponding sonograph (Figure 2, bottom) shows the presence of straight-crested sand waves and a portion of the seafloor that appears sonographically smooth (lower left-hand corner). The zig-zag pattern visible in Figure 3 is caused by yaw and pitch of the side-scan sonar towfish when towed obliquely to a strong current.

Figure 4 presents a minor zig-zag pattern and a sand wave field that abruptly changes into a smooth bottom with indistinct bedforms. A large number of measurements from the side scan record along this track line, that parallels the bedform crest trend, yields an average wavelength of 4.2 m (±1.0 m) and a mean height of 0.36 m (±0.2 m).

Calculations made on the sonograph presented in Figure 2 (bottom) yield an apparent mean bedform wavelength of 6 m and a mean height of about 0.75 m. In this case, the bedform crest trend is perpendicular to the ship's track and therefore height calculations based on acoustic shadow lengths cannot be performed.

Bedform wavelengths and heights were also calculated from sonographs collected along a trackline run approximately at 45° to the crestal trend (Figure 3). The wavelength and height means are 6.4 m (±0.9 m) and 0.5 m (±0.2 m), respectively. Height calculations based on acoustic shadow length results in a comparable height value of 0.5 m (±0.2 m).

These discrepancies in both height and wavelength determinations resulting from the variation in target aspect suggest that other techniques have to be applied to resolve the problem. Underwater television and bottom camera observations proved to be the most suitable. Continuous television coverage enables an observer to assist the winch operator to fly an observational TV/camera sled over a bedform that is larger than the field of view of the system. An electrically controlled 70-mm camera can then record selected segments for later detailed study and measurements. Figure 5 presents four

Figure 2. Bathymetric profile (top) and corresponding sonograph (bottom) of a slightly sloping bottom with straight-crested sand waves and partly a sonographically smooth bottom (see lower left corner in sonograph). Ship's heading about 350°T, water depth ranging from 46 m to 55 m. (Part of Figures 3 and 4 in Bouma et al.1980.)

such photographs and it becomes directly clear that the bedforms are not 50 to 75 cm high as calculated but are rather low features, often with well-defined fronts and with heights less than 10 to 20 cm. Most of the low-angle slip sides are covered with shell hash (Figure 5a). When such lee sides are slightly higher, they are normally covered by small transverse ripples that indicate bottom flow parallel to the main crests (Figure 5b). Upcurrent from the crest the stoss side contains a number of different types of ripples. Often a pattern is observed consisting of lunate ripples near the crest and of slightly sinuous transverse ripples on the lower part of the stoss side (Figure 5). The broad troughs between the sand waves contain an abundance of

Figure 3. Sonograph of part of lower Cook Inlet containing sand waves and bands of exposed underlying seafloor. The zig-zag pattern of the sand wave crest is due to yaw and pitch of the side-scan sonar towfish. Horizontal lines 25 m apart.

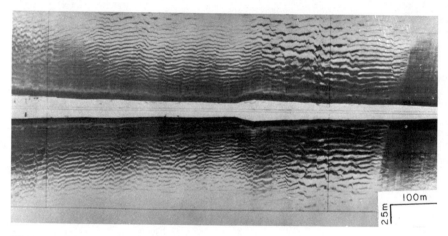

Figure 4. Sonograph of a field containing different sizes of sand waves. The field changes into a sonographically smooth bottom.

shells, which give a significant impedance contrast with the sand (Figures 5b,c,d). Such a contrast difference is seen on a sonograph as a strong acoustic shadow. This example demonstrates the use of bottom photography to "ground truth" the side-scan sonar acoustic imagery. At the same time, one can observe the different types of bottom materials and the detailed complexities of bottom transport directions. Single underwater camera shots would be confusing in an area where the major bottom features are larger than the coverage of a single shot. Integration of still photography

Figure 5. Bottom photographs of different aspects of small sand waves. The shell coverage in the broad flat troughs causes a strong acoustic return signal that can be misinterpreted as an acoustic return signal resulting from high incidence from the flank of a bedform. (a) Sand wave front with small slip face; ripples on sand wave differ in type (lunate) and direction from the straight-crested ripples in the sand wave trough. (b) High slip face with semi-longitudinal ripples caused by trough flow. Shells are oriented. (c) As (b) but with lower slipface. (d) Very low sand wave without slip face going over into shell-covered trough. Vertical bands on compass vane are 5 cm wide. Water depth 42 m (a) and 57 m (b,c,d). *(Part of Figure 5 in Bouma et al. 1980.)*

with underwater television is therefore essential. However, in lower Cook Inlet the strong tidal currents made it impossible to tow the camera-television sled smoothly over the seafloor. The combination of camera and television, even under more ideal conditions, might still lead to misinterpretation of sediment transport trends because the ripple crests reflect local bottom transport rather than the over-all current direction. Application of side-scan sonar, due to its larger coverage, is therefore a better means of covering a broad region and observing regional transport trends.

FIELD OBSERVATIONS ON LARGE SAND WAVES

Large, irregular sand waves are very common in lower Cook Inlet. Their heights typically range from 5 to 9 m and their wavelengths from 100 to 500 m. However, heights up to 15 m and lengths upward of 900 m have been encountered.

The larger these bedforms are, the more irregular in shape they become. Scour depressions in their troughs and variations in height along the crest become common (Bouma et al. 1979, 1980; Rappeport 1981). All large sand waves are typically covered by medium-size sand waves, oriented either parallel or obliquely to the crest of the large form. Small sand waves, often covered by lingoid, lunate, or straight-crested ripples, are in turn superimposed on the medium-size sand waves.

The large sand waves can be asymmetric in shape (Whitney et al. 1979) with their asymmetry reflecting the direction of dominant tidal flow. Their short crestal length and often large height/wavelength ratio suggest a trend toward dune morphology.

The side-scan sonar record and corresponding high-resolution seismic record of a typical large sand wave group is presented in Figure 6. An additional example is given in Figure 7. Both illustrations show bedforms that are from the same vicinity in lower Cook Inlet.

The seismic record (Figure 6, top) shows several large sand waves, 5 to 8 m high, overlying a well-defined horizontal acoustic reflector. This reflector may represent a gravel layer that tops Holocene silt and clay that locally infills topographic irregularities in the underlying deposits. These large bedforms are visible on the corresponding sonograph more as bathymetric highs near the center line of the record than as distinct features on the side scan record itself. The presence of medium and small sand waves subdues the distinctness of the large bodies, especially on the upper half of the sonograph. Comparing right and left portions of the sonograph, it is apparent that the direction of the ship track is crucial for optimizing the interpretation (Figure 6, bottom).

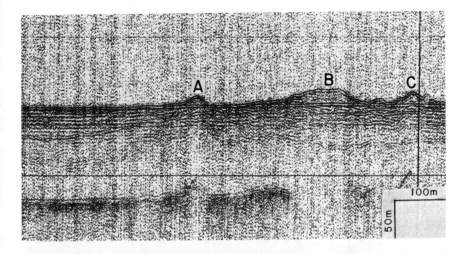

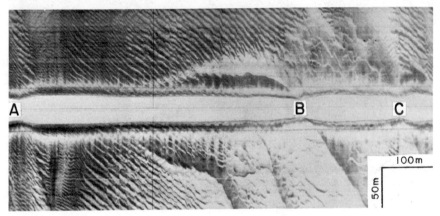

Figure 6. Seismic reflection profile (top) and sonograph (bottom) of large sand waves. Letters A–C denote corresponding features. Ship's travel from right to left. *(Modified from Bouma et al. 1980, Figure 6.)*

The group of large sand waves sandwiched in a field of medium-size sand waves (Figure 7) shows even more clearly the effect the direction of the ship's track and the prevailing bedform-crest orientations have on the value of the interpretation. The 12-kHz record (Figure 7, top) shows two to three high sand waves that change into irregular large sand waves with wavelengths ranging from 75 to 150 m. To the right of those large bedforms, a group of small to medium sized bedforms is visible between points C and D. More to the right the heights become less than 1 m and are in the scale range of the ship's vertical oscillations due to wave heave. The different size groups are extremely difficult to discern on the sonograph.

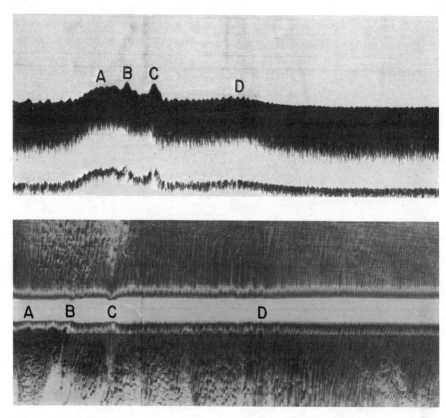

Figure 7. Bathymetric profile (top) and sonograph (bottom) of large sand waves that are covered by smaller ones. Letters denote corresponding features. Ship's travel from left to right. *(Modified from Bouma et al. 1980, Figure 7.)*

Although small sand waves cover the larger ones, it does not mean that these small sand waves are similar in shape, height, and lithologic aspects to the small sand waves discussed earlier. Because we are dealing with a thicker part of the sand blanket, significant differences can exist. Bottom photography and televison were the only means to provide acceptable ground truth. Four representative photographs are given in Figure 8. A rather continuous television run with several still pictures from trough to upper flank of a large sand wave reveals the presence of small to medium ancillary sand waves. The small sand waves typically exhibit characteristics similar to those previously described, with the following differences:

1. Slip faces normally appear more sharply defined and are slightly higher. (Figure 8a).
2. Shells and shell fragments present in the small sand wave troughs

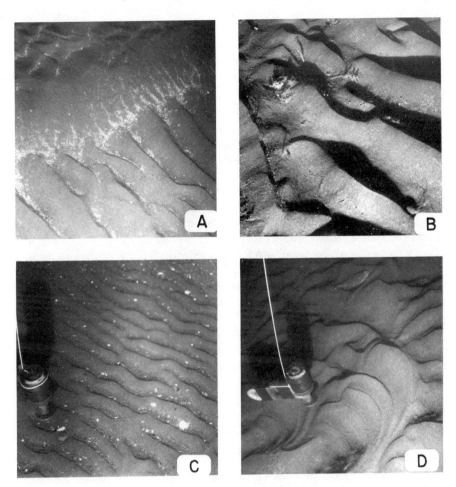

Figure 8. Bottom photographs of different aspects of features found in a field of large sand waves. (a) Small sand wave with lunate ripples on top, faint ripples on slip face, and straight-crested ripples in trough (cross current effect). Midflank of large sand wave. (b) Distinct current-ripples found near crest of large sand wave. (c) Very low sand wave located near trough of large sand wave. Note the slightly sinuous ripples that change without a slip face into a shell-lag covered trough. (d) Complicated trochoid-type ripples observed on medium-size sand waves present near the upper flank of a large sand wave. Vertical bands on compass vane are 5 cm wide. Water depths from 55 to 57 m. *(a, c, and d modified from Figure 8 of Bouma et al. 1980.)*

are typically restricted to sand waves located on the lower lee side of the large sand waves (Figure 5c).

3. The superimposed sand waves appear highest on the mid-to-lower flank regions of the larger sand waves with some decrease in height of these forms in the trough and near-crest regions (Figure 8a, midflank; Figure 8b, near crest; Figure 8c, near trough).

The ripple patterns located on upper or mid flanks of small sand waves can be complex (Figure 8d) and suggest local variations in the tidally-controlled bottom currents due to local macro topography. Lower lee-slope ripples on the small sand waves are often sinuous and well rounded (Figure 8c), while on the upper lee slope the ripples are higher, more linguoid to lunate (Figure 8a), have more sharply defined crests, and show local "jetting." Long-term bottom observations showed that some ripple crests reverse their asymmetry from flood to ebb, especially under storm conditions. In general, the asymmetry of the small sand waves reflects either flood or ebb current dominance depending on their location in lower Cook Inlet.

The trough areas of the large sand waves show concentrations of mostly dead echinoids in contrast to the shells and shell hash in trough areas of small sand waves located on mid or upper flanks of the large bedforms.

These local characteristics and the sedimentological information cannot be ascertained by any other effective system. The best interpretive system for regional studies would thus include both side-scan sonar and bottom camera/television.

OBSERVATIONS ON SONOGRAPHICALLY SMOOTH BOTTOMS

Lower Cook Inlet has a number of seafloor types that are either covered by features too small to resolve sonographically or contain different features that do not have sufficiently strong acoustic impedance differences to produce an image on a sonograph. The lack of tonal variations on a side-scan sonar record therefore makes those seafloor bottom areas acoustically or sonographically smooth. We will discuss three examples briefly and refer to a representative bottom photograph of each to show the nature of the bottom.

A shallow depression exists between Cook Ramp near latitude 59°15'N, where the water depth rapidly increases from 70 to 170 m, and a field of large sand waves to the north. This depression is about 4 km wide and 3 to 4 m deep (Bouma et al. 1978a and b; Bouma 1981). This shallow depth may be sufficient to form a bottom-current window and to prevent active sand transport. Sonographs from this depression show a few pitted targets; otherwise no return signal variations can be seen on the record. Underwater

television and still photography reveal that the depression is covered with very low sand waves, ripples, shell fragments, and animals (Figure 9). The low sand waves seldom have a distinct slipface. The lower part of their stoss sides contains straight to sinuous ripples that become more lunate and rhomboid higher up the stoss face. Scattered shell fragments are present in the broad sand wave troughs; however, the density is insufficient to produce good reflectivity differences with the surrounding sand and therefore they do not show up on a sonograph. In contast to the areas with large sand waves, sea pens are common and echinoids (sand dollars) are scarce. Animal trails can be seen on many photographs (Figure 9) and their sharpness indicates little or no sand transport at the time the picture is taken. Whenever the television/camera sled hit bottom, a cloud of fine material was stirred up.

Another type of sonographically smooth bottom is shown in the photograph in Figure 10. Locally, the bottom contains irregular patches of gravel, sand, and clay mixtures that often are densely covered by sessile animals, primarily anemones, mollusks, and hydroids.

A third type of sonographically and bathymetrically smooth bottom is shown in Figure 10. This type of bottom consists of the hard tillite material that covers most of the upper part of lower Cook Inlet and likely underlays most of the bedforms. Locally, the bottom contains thin sand patches, sand ribbons, small blocks, gravel, shell, or shell fragments. The strong reflective acoustic contrast between this type of a hard bottom and a sand patch or a sand ribbon normally makes detection on a sonograph easy. However, the scattered occurrence of these features or their gradual boundaries at this location make an effective acoustic impedance contrast impossible.

CONCLUSIONS

When conducting bottom observations in areas containing large and small bedforms as well as variations in lithology, an assortment of data collecting techniques should be applied. While bottom samplers cover the smallest surface area, underwater photography usually provides information for a larger segment of the seafloor. Normally the photograph has sufficient definition to obtain accurate lithological data. Side-scan sonar acoustic imagery covers a much larger surficial area but its resolution is too coarse to provide integrated overlap with most underwater still-camera systems.

Side-scan sonar provides an acoustic imagery based on differences in reflective characteristics of the seafloor elements. When impedance contrasts are sufficient, the resulting tonal variations will be visible on the sonographic record. The shapes of the tonal variations can be interpreted as geologic features and the dimensions of acoustic shadows are often used for quantitative

Figure 9. Bottom photographs from the sonographically smooth shallow depression north of lower Cook Inlet Ramp. (a) Slightly sinuous ripples. (b) irregular ripple pattern with coarse material (fecal pellets? and shell fragments) in the troughs, and sea pens. Water depth 72 m.

Figure 10. Bottom photographs from sonographically smooth bottoms. (a) Hard bottom adjacent to sand ribbons. Water depth about 42 m. Heavy overgrowth on rocks and small boulders of filter feeders. Note the presence of rock fish. (b) Hard bottom with very thin film of sand. Note partly exposed rock in left lower corner. Shells and shell fragments partly cover the ripples. Water depth 35 m. *(Part of Figure 9 in Bouma et al. 1980.)*

measurements. For this, the physical characteristics of the instrument and the operational conditions of the vessel have to be known. However, because the intensity of acoustic returns result either from differences of the angles of incidence or from variations in reflection coefficient, an error in interpretation and consequently in measurements can result. Our field observations in an area with strong currents and rather high turbidity clearly demonstrated that the use of bottom photography was the best means to provide ground truth for a more accurate interpretation of the sonographs. The strong currents made it difficult to steer the flying bottom camera/television unit properly. The resulting spot coverage made it necessary to photograph many similar bedforms to obtain proper insight into sequential changes of smaller elements over a sand wave.

ACKNOWLEDGMENTS

We thank David W. Prior of Louisiana State University and Paul Ferris Smith of Benthos, Inc. for their constructive reviews. All observations were made on board the R.V. *Sea Sounder* as part of the U.S. Geological Survey geo-hazards program. Robert C. Orlando photographed most of the seismic and sonar records. Betty Reed and Tina McClaine typed the different versions of the manuscript.

REFERENCES

Bouma, A. H., M. A. Hampton, and R. C. Orlando. 1977a. Sand waves and other bedforms in lower Cook Inlet, Alaska. *Marine Geotechnology* 52: 291-308.

Bouma, A. H., M. A. Hampton, M. P. Wennekens, and J. A. Dygas. 1977b. Large dunes and other bedforms in lower Cook Inlet, Alaska. *Offshore Technology Conf.*, Paper 2737, 79-85.

Bouma, A. H., M. A. Hampton, T. P. Frost, M. E. Torresan, R. C. Orlando, and J. W. Whitney. 1978a. Bottom characteristics of lower Cook Inlet, Alaska. U. S. Geol. Survey Open-File Report 78-236.

Bouma, A. H., M. A. Hampton, M. A. Rappeport, J. W. Whitney, P. G. Teleki, R. C. Orlando, and M. E. Torresan. 1978b. Movement of sand waves in lower Cook Inlet, Alaska. *Offshore Technology Conf.*, Paper 3311, 2271-2284.

Bouma, A. H., M. L. Rappeport, R. C. Orlando, D. A. Cacchione, D. E. Drake, L. E. Garrison, and M. A. Hampton. 1979. Bedform characteristics and sand transport in a region of large sand waves, lower Cook Inlet, Alaska. *Offshore Technology Conf.*, Paper 3485, 1083-1094.

Bouma, A. H., M. L. Rappeport, R. C. Orlando, and M. A. Hampton. 1980. Identification of bedforms in lower Cook Inlet, Alaska. *Sedimentary Geology* 26: 157-177.

Bouma, A. H. 1981. Submarine topography and physiography of lower Cook Inlet, Alaska. U. S. Geol. Survey Open-File Report 81-1325.

Continental Shelf Data Service. 1967. Bathymetric map, Shelikof Strait-Cook Inlet, Alaska; scale 1 inch = 4,000, 31 sheets. Denver, Colorado.

Flemming, B. W. 1976. Side-scan sonar: a practical guide. *Int. Hydrogr. Rev.* 53: 65-92.

Leenhardt, O. 1974. Side scanning sonar—a theoretical study. *Int. Hydrogr. Rev.* 51: 61-80.

McGarity, G. E. 1977. Bathymetric map, marine high-resolution survey, lower Cook Inlet (scale 1:96,000). U. S. Geol. Survey Open-File Report 77-358.

Rappeport, M. L. 1980. Depositional environments and Quaternary sedimentary units within lower Cook Inlet, Alaska—a high-energy tidally dominated embayment along the Pacific margin of the United States. Pages 73-88 in Pacific Coast Paleogeography Symposium 4, Pacific Section, of the Soc. Econ. Paleontologists and Mineralogists, Los Angeles, California.

Rappeport, M. L. 1981. Studies of tidally-dominated shallow marine bed forms, lower Cook Trough, Cook Inlet, Alaska. Ph.D. Dissertation, Stanford Univ., Stanford, California.

Whitney, J. W., W. G. Noonan, D. K. Thurston, A. H. Bouma, and M. A. Hampton. 1979. Lower Cook Inlet; do those large sand waves migrate? *Offshore Technology Conf.*, Paper 3438. 1071-1082.

The Application of an Underwater Color Video System to Fishing Gear Research

Patrick Twohig and
Ronald J. Smolowitz
National Marine Fisheries Service
Northeast Fisheries Center
Woods Hole, Massachusetts

INTRODUCTION

Fisheries engineers are charged with the responsibility of developing and improving sampling systems for marine scientists and designing and modifying fishing gear with regard to selectivity and nondestructive fishing for resource management purposes. In order to accomplish these tasks, many techniques are used, including model testing, comparison fishing, gear instrumentation, visual observation by SCUBA divers and from manned submersibles, photography, and video taping.

Model testing is a good starting point in many cases and is also quite useful when there is a need to fine tune the information on individual parameters. However, it is severely limited in fishing gear studies in that fish behavior can't be modeled. Modeling is also expensive.

Comparison fishing is an extremely effective technique and is the most commonly used. It basically consists of fishing with the gear being tested, varying one or more parameters, and comparing the results. The technique usually shows a net result, but has the disadvantage of not showing cause and effect relationships without extensive field testing.

The general category of gear instrumentation includes electronic and mechanical devices mounted on the vessel, or the gear itself, or both. Such devices include precise navigation systems, course plotters, speed logs,

trawl mensuration systems, odometers, flowmeters, depth recorders, strain gauges, pressure transducers, and numerous devices of special design. Instrumentation can provide good quantitative information on how the gear is functioning as well as allow a comparison of catch rates and composition to variations in operating parameters. Instrumentation used alone, without actual observations, has the same disadvantage as comparison fishing.

Direct observation, by visual, photographic, or video means, is the quickest and least expensive way of determining what occurs to and around a piece of gear. With this knowledge, a controlled experiment can then be set up to quantify the information.

Fisheries engineers have been using observational techniques for years and have found them very effective. This paper describes the video taping procedure now used by the Northeast Fisheries Center to record the operation of fishing gear.

The specific application discussed here involves an 8-foot (2.43 m) wide scallop drag (Figure 1). Those concerned with the management of the sea scallop fishery wanted to know whether the existing type of gear could be modified to select and cull out small scallops while it was on the bottom, and whether the scallops remaining on the bottom were being damaged. These tests were conducted from the 65-foot (19.8 m) RV *Rorqual* in June 1979 in waters around Cape Cod.

EQUIPMENT

Camera

During this experiment we used a Sub-Sea Systems Model CM-30 self-contained underwater color television camera. The camera itself is a Hitachi GP-5 utilizing a 1-inch (25.4 mm) tri-electrode color tube and having an automatic sensitivity control and an internal crystal-controlled color sync generator. The 12.5-mm, f/1.5 lens is fully corrected for color and underwater viewing and is equipped with an automatic iris. The housing is a hard anodized and painted aluminum cylinder 16 cm in diameter and 47.5 cm long, capable of operating to 1000-foot (300 m) depths. The over-all weight is 11.8 kg (26 lb) in air; 2.9 kg (6.4 lb) in water.

The surface-located camera power supply provides 1 amp of constant current at 12 volts DC (12 watts maximum). The camera puts out a 1-volt peak-to-peak NTSC signal with a resolution of 290 horizontal TV lines.

Lighting

Lighting is provided by two 250-watt quartz iodide lamps. The lamps and reflectors are mounted on the camera's diver-grip assembly. Lamp power is

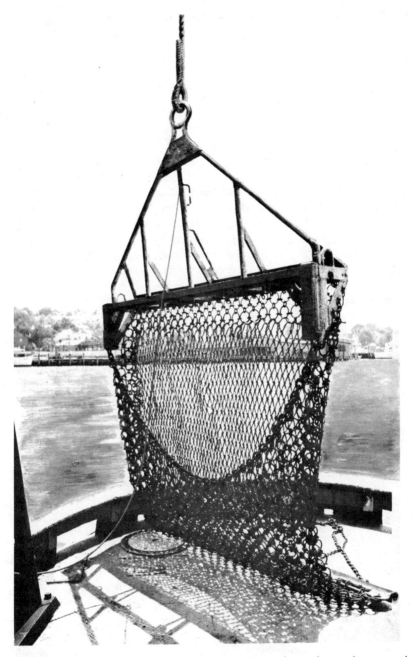

Figure 1. An eight-foot New Bedford style scallop drag, shown here on the stern of the RV *Rorqual*.

provided by a supply module on the surface connected to an isolation transformer.

Cable

A multiconductor cable, 500 feet (150 m) long, provides the video signals, camera power, lighting, and diver communications. It contains nine conductors plus an RG-59 coax for the video signal. Five of the conductors (three 18 AWG, two 20 AWG) are for camera power and control, two (16 AWG) are for lighting, and two (20 AWG) are for diver communications. The cable has a polyurethane jacket with a 0.50-inch (12.7 mm) outer diameter.

On the surface the cable is terminated with an Amphenol connector and underwater with a Trident Pigtail that is simply a three-way molded splice. The breakout for the communications system is a two-conductor, self-wiping plug. The camera breakout terminates in a seven-pin connector and the lighting breakout further divides into two leads each ending in a screw-on termination at each lamp.

Camera Cable Winch

The cable was handled on deck using a hand-cranked winch for setting and hauling with a slip-ring assembly for continuous monitoring of the signals. The cable's Amphenol connector is mated with another in-line connector on the winch drum, which in turn, connects to the slip rings via a short cable lead.

The winch dimensions are 26.6 × 21.6 × 16.5 inches (65 × 55 × 42 cm) high, and it weighs about 90 lb (40 kg) (including cable), so it is extremely portable on deck (Figure 2).

Diver Communications

Communications from the surface were maintained with one of the divers on the bottom using a Helle Wire Diver Phone Model WP-12, which is an intercom system consisting of a surface electronics package containing all the controls and a horn-type speaker-microphone. The system is connected, via the multiconductor cable passing through a hole in the diver's hood, to a "lollipop" transducer and a Diver Bone Conductor Receiver located under the diver's hood and held against his throat and ear.

The surface unit is hooked up so that all transmissions can be automatically recorded by the video tape recorder.

In addition, a Benthos Diver Signaling System was used as a back-up for emergencies or when the divers were not hooked up to the diver phone. This system consists of an underwater transducer connected to a surface control

Figure 2. The hand-cranked winch used for handling the camera cable. Using the winch is a lot simpler and safer than coiling the cable on deck, and the chances of damaging the cable are greatly decreased.

unit. Siren, yelp, or voice commands can be transmitted to the divers through the water over most working distances.

Video Recorder and Monitor

A JVC color portable video cassette recorder (Model HR-4100 AU) was used to record the camera video signal and surface and diver communications. This recorder uses a 0.5-inch (11.7 mm) VHS cassette format with more than

240 lines of horizontal resolution and a single audio track. The recorder can operate on batteries, thereby adding to the system's flexibility.

A JVC 13-inch (330 mm) color TV monitor (Model 7280 UM) was used for real-time viewing of the video recording. This enables the crew to direct the divers in proper camera placement and to insure good quality tapes. Both the recorder and monitor can operate from 50- or 60-Hz power sources.

Scuba

The divers wore Unisuit variable-volume dry suits and Cressi full-face masks. They used 72-ft³ (2.04 m³) capacity air tanks and Poseidon regulators.

Camera Trolley

A trolley was used to send the camera down the main towing warp. The trolley's main frame consists of ¼-inch (6.35 mm) aluminum channel stock and contains two 4-inch (101.6 mm) diameter sheaves. The sheaves ride on the towing warp, which is constrained by means of quick-release retaining clamps. A range of cable sizes from ¼ inch (6.35 mm) to 1 inch (25.4 mm) can be used with this method. The camera is held by detachable clamps to an adjustable carriage that allows the viewing angle, both pan and tilt, to be preset. The total length of the assembled unit is 16 inches (406.4 m) and it weighs 8.5 lb (3.86 kg) in seawater. A fin is attached to the assembly to provide stability.

METHODS

Diver Observations

When divers ride trawls they position themselves on the gear while it is in motion because the gear tends to collapse if motion stops. However, divers can get onto dredges or scallop drags while the gear is stationary on the bottom—a simpler and safer operation.

The procedure for having divers ride and record the scallop drag in operation is as follows. The vessel sets the drag in a regular manner heading down current (or wind or sea, whichever prevails) and then stops so as to be anchored by the drag. Two standby divers in a Zodiac rubber boat follow the towing vessel. The camera is lowered down the main warp via a snap hook arrangement to the water's surface. The two divers who are to ride the drag enter the water and escort the camera down the warp to the drag. There they unsnap the camera, mount the drag, and have the TV cable length adjusted via communications with the surface tenders. When ready, they inform the

surface, and the vessel starts up. Taping is monitored on deck, and instructions continuously pass back and forth between the surface and divers.

At the completion of the tow, the vessel stops, the divers snap the camera back onto the warp, and then surface. The camera is hauled up by the deck crew and then the drag is retrieved. In some cases, the drag is left on the bottom and a second team of divers enters the water to continue the observations.

An emergency float is attached to the drag by a small piece of twine. In an emergency, the divers would cut the twine, sending the float to the surface, thus signaling the vessel to stop.

Trolley Operations

The procedure used is to set the drag in the regular manner and then tow at slow speed. The camera trolley is attached to the warp and lowered, using the TV cable with the camera operating. The camera is lowered until it is in position, usually right up against the towing eye splice, and the vessel speed is then increased to normal tow speed (3.5 knots). Figure 3 shows the general arrangement.

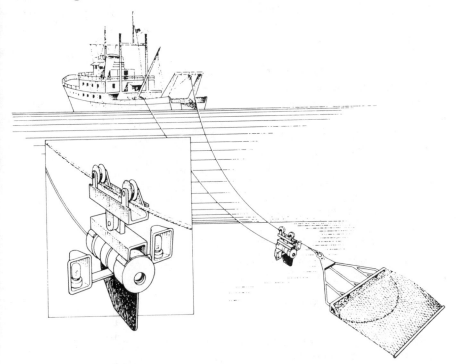

Figure 3. The camera trolley, shown here monitoring a scallop drag, can be made to ride on top of the towing warp when underway.

Camera Drops

Camera lowerings are used to determine bottom visibility, bottom type, and presence of scallops. The vessel is stopped and the camera lowered using its own cable with an attached strength member of heavy nylon twine seized on every two feet with vinyl tape (Figure 4). A 6-foot (2 m) long pole with a weight attached is lashed to the camera housing in such a manner that the weight is in the camera's field of vision 4 feet (1.22 m) distant to act as a target (in some cases an actual target is used). The camera is held so that the weight just contacts the bottom. The drift of the vessel provides enough movement to get a good idea of what the bottom is like. This technique saves lots of diver bottom time by determining visibility without sending divers down.

DISCUSSION

There are several other basic techniques that can be used to record fishing gear in action, one of which is to mount the camera directly on the gear. This can be done either before setting the gear or by divers when the gear is on the bottom. The latter case is best with gear that receives rough treatment in setting and hauling.

There are some disadvantages with mounting the camera directly on certain fishing gear. On scallop drags the ride can be quite rough and the vibrations can effect the tape quality and even damage the camera. Also there is no diver to tend the camera cable, which can get caught under the gear and break. A fixed mounting point, or even an expensive remote-controlled pan and tilt unit, does not have the flexibility of a diver-controlled camera, though in some cases this doesn't matter.

Prepositioned gear-mounted cameras do have the great advantage of minimizing the need for highly trained divers. Divers can't readily be used at speeds greater than 2 knots or depths greater than 80 feet (25 m). Even at depths between 40 (12 m) and 80 (25 m) feet, diver bottom time is limited.

Film has several advantages over video tape, among which are higher resolution and better keeping qualities. In gear research the higher resolution is usually not necessary. Special precautions must be taken with video tape to prevent interference from electromagnetic sources common around vessels (such as radios) from ruining the tape quality or destroying it completely. However, original or edited tapes can always be put onto film for storage or viewing.

Video tape seems to be better than film for gear research. The greatest benefit is that it allows for real-time viewing of the gear in action. This enables rapid decisions regarding the tests being conducted and serves as

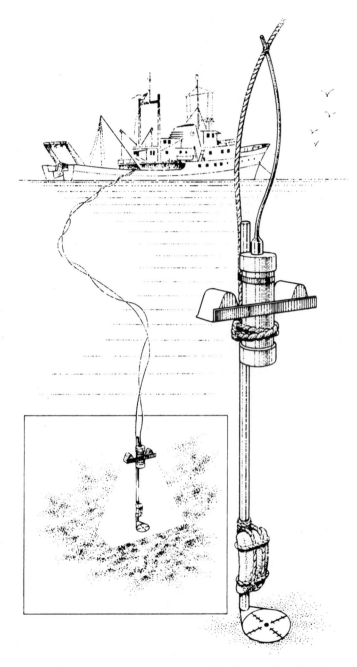

Figure 4. One of many ways a camera can be lowered to the bottom.

a quality check. With film, it is necessary to develop onboard test strips to determine quality. Secondly, tape is less expensive than film and is easily edited.

CCTV recording in color presents a much clearer, well-defined picture when compared to black and white. Before testing, the fishing gear is painted bright yellow so that it stands out clearly against bottom sediments and surrounding turbidity.

A visual record of a gear experiment is very useful. It allows shore-based engineers and scientists to study the gear in action. Most important, it is about the only scientific product that fishermen can easily understand and relate to. One good tape or film is worth dozens of scientific papers in convincing fishermen on a particular point.

High-Speed Silhouette Photography of Live Zooplankton

Harold E. Edgerton

Massachusetts Institute of Technology
Cambridge, Massachusetts

Harold A. Moffitt, II

Florida Atlantic University
Boca Raton, Florida

Marsh J. Youngbluth

Harbor Branch Foundation, Inc.
Fort Pierce, Florida

INTRODUCTION

The ninteenth-century art of shadow photography, as practiced by W. H. Fox-Talbot in 1834, has been revived by the use of a small-diameter electronic flash lamp and fine grain film (Edgerton and Wilson 1977; Edgerton 1977a). One practical application has been the photographic recording of living plankton from freshwater and marine environments (Edgerton 1977b; Ortner *et al.* 1979). Exposures of microsecond duration are made after pouring a plankton sample over a sheet of negative film under darkroom conditions. The resultant one-to-one silhouette images of these organisms are without appreciable edge blur, diffraction, or imperfection due to subject motion and may be identified to genus or species. The technique is nondestructive and several exposures can be made at sea before preserving a sample for other analyses onshore.

The purpose of this paper is to describe technical aspects of high-speed silhouette photography, such as resolution limitations, film types, exposure calculations, light sources, and practical techniques.

THEORY

The resolution of silhouette photography is influenced primarily by three factors: film grain, shadow error, and diffraction.

Film Grain

Grain is a fundamental limitation to the resolution of the emulsion of a film. Suppose the film is rated to resolve n lines per mm. Then the resolution can be given approximately as $1000/n$ microns. Examples of suitable films are (Ortner *et al.* 1979):

Eastman Plus X:$n = 50$ lines/mm, resolution $= 20$ microns
Eastman 7302: $n = 150$ lines/mm (fine grain positive), resolution $= 7$ microns
Eastman SO343: $n = 2000$ lines/mm (high resolution), resolution $= 0.5$ microns

Shadow error

The shadow error (equivalent to the penumbra) of a sharp edge can be estimated from the geometry of an effective point source (Figure 1) by:

$$B=A\frac{d}{D} \tag{1}$$

where B is the error in microns, A is the lamp diameter in microns, d is the subject-to-film distance, and D is the lamp-to-film distance (d and D are in the same units).

Diffraction error

The resolution error caused by diffraction can be calculated from:

$$I=0.85 \sqrt{d\lambda} \tag{2}$$

where I is the resolution error due to diffraction effects in microns, d is the subject-to-film distance in microns, and λ is the wavelength of the light source in microns.

Close spacing of the subject to the film (d) and the use of a light source of short wavelength (λ) both reduce the error caused by diffraction. This diffraction calculation is based upon parallel light for a small-diameter lamp at a relatively great distance from the film, that is, an effective point source.

The relative effects of penumbra and diffraction are shown in Table 1. Note that both penumbra and diffraction errors increase as the subject-to-film distance increases. However, diffraction is the more serious error. For example, if a resolution of 2 microns is desired, the subject-to-film distance (d) should be 14 microns ($I = 2$ microns $= 0.85 \sqrt{d \times 0.4}$), which is a very short distance. Eastman SO343 film is required for a resolution of this magnitude. Note also that Eastman SO343 demands considerably more incident light than Eastman 7302 film to produce an acceptable negative density of 0.7, as shown by the H & D curves of Plus X, 7302, and SO343 as obtained by use of a xenon flash lamp (Figure 2) (Edgerton 1979).

EXPOSURE CALCULATIONS

Exposure of the film can be calculated from the inverse square law:

$$IT = \frac{CPS}{D^2} \qquad (3)$$

where IT is the incident exposure on the film in lumen-sec/m², CPS is the source output in candela/sec, and D is the lamp-to-film distance in meters (Edgerton 1979).

LIGHT SOURCES

Any light source can be used for silhouette exposures. However, the selection of a light source for the best image resolution is influenced by four factors: penumbra, diffraction, flash duration, and source output.

Penumbra

The penumbra resolution is affected directly by the diameter of the light source. The diameter should be at least ten times less than the lamp-to-film distance. The xenon flash lamps commonly used in silhouette photography have diameters of 3-7 mm.

Diffraction

The diffraction error can be reduced by the use of an effective point source and by a source with an output of short wavelength. Most xenon flash lamps have a large component of near ultraviolet light. One flash lamp

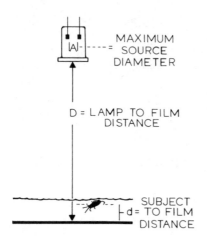

Figure 1. Spatial geometry of silhouette photography.

Figure 2. H & D curves for Eastman film types Plus-X, 7302, and SO343.

Table 1. Resolution Error Due to Penumbra and Diffraction for Three Subject-to-Film Distances.

Subject-to-film distance (mm)	Resolution error	
	Penumbra (μm)	Diffraction (μm)
0.1	1	5.4
1.0	10	17.0
10.0	100	53.7

Note: lamp diameter = 3 mm, lamp-to-film distance = 30 cm, and wavelength of blue light = 0.4 μm.

in particular (EG&G type FX-265) has a special quartz window that transmitts ultraviolet light (EG&G, a).

Flash duration

To stop the motion of any organism effectively, a flash duration on the order of 1 to 10 μsec is required. Flash durations of 3 to 5 μsec are readily obtainable with the xenon flash lamps.

Source output

The source must provide sufficient incident light to the film over the lamp-to-film distance (D) to produce an acceptable density of 0.7. Selected values of CPS for given distances, D, can be estimated from equation 3:

$$CPS = (IT)D^2$$

The light output of an electronic xenon flash source may be measured directly (Edgerton 1979) or calculated from

$$CPS = (\frac{CE^2}{2})n \tag{4}$$

where C is the flash tube storage capacitance in farads, E is the potential of the charged capacitor in volts, n is the efficiency of the flash tube in lumens/watt, and CPS is the calculated output of the source in candela/sec. Typical efficiencies of xenon flash lamps used in silhouette photography are 0.5 to 2.0 cp/watt (EG&G, b).

The EG&G Inc. line of small xenon flash lamps (such as type FX-6A) is particularly well suited to silhouette photography because of its small

Figure 3. GenRad Strobotac Model 1531AB with reflector removed for use in silhouette photography.

diameter (7 mm) and the near ultraviolet spectral component. This lamp is widely used in the GenRad Company lines of stroboscopic instruments for measuring speed and observing periodic motion (EG&G, c). Examples of models particularly adaptable to silhouette photography are numbers 1531, 1538, and 1539. These instruments have reflectors that can be removed to expose the bare lamp. The dial light of these units must be masked to prevent accidental film exposure (Figure 3). Set on the medium range, the lamp's single flash output is about 0.5 CPS, which works well with Eastman 7302 film at a lamp-to-film distance of about 1 m.

The EG&G FX-6A and FX-265 lamps can be incorporated into a single flash circuit dedicated to silhouette photography. Schematics are shown in Figures 4, 5, and 6. Battery and AC powered units have been field tested (Figures 7 and 8). In order to use Eastman SO343 film, an additional capacitor of 25 μF must be connected in parallel with the 2 μF capacitor. The SO343 lamp-to-film distance is 70 cm.

Another source of small size and ultraviolet output is the EG&G Microflash equipment with a point source adaptor. This unit is commonly used for the silhouette photography of bullets and shock waves (Edgerton and Wilson 1977).

Any photographic strobe lamp can be used if an aperture is placed over the reflector. The exact size of the aperture is dependent upon the particular system. A starting value for the experimental determination of the aperture diameter can be calculated from equation 3. Experimental exposures will determine the optimum aperture size for the desired negative density.

The use of a light source producing a double flash over a known time

Figure 4. AC line powered electronic schematic for EG&G FX-6A bulb type flashtube.

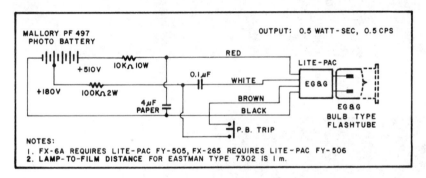

Figure 5. Battery powered electronic schematic for EG&G FX-6A or FX-265 bulb type flashtube. Orient lamp for maximum output.

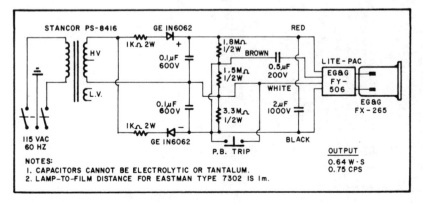

Figure 6. AC Line powered electronic schematic for EG&G FX-265 bulb type flashtube.

Figure 7. Assembled AC powered FX-265 flash unit.

Figure 8. Assembled DC powered FX-265 flash unit.

interval may be used to estimate average swimming velocities by measuring the placement of the subject on the film between exposures (Edgerton and Killian 1979). The duration of each individual flash must be 3 to 5 μsec to stop the motion of the subjects effectively without blurring. Equipment designed to produce a double flash over a very short and known time interval is described by Edgerton (1979) in *Electronic Flash, Strobe.*

PROCEDURE

The silhouette photography of zooplankton is usually conducted in a darkroom or in the field with the use of a suitably sized dark box (Edgerton 1977a). Fine grain negative film is commonly used in sheet format (4 × 5 or 8 × 10 in.). The blue sensitivity of these films responds well to the spectral output of the xenon flash lamp and enables the investigator to use a red safe light during the exposure (Eastman Kodak).

Upon the selection of the film, the lamp-to-film distance can be calculated for a source of known output. For example, to use Eastman 7302 film, the required incident exposure (IT) is 0.2 lumen-sec/m^2. For a source output of 0.3 CPS, the lamp-to-film distance should be

$$IT = \frac{CPS}{D^2} \quad \text{or} \quad D = \sqrt{\frac{CPS}{IT}} = \sqrt{\frac{.3}{.2}} = 1.2 \text{ m}$$

Note from equation 5 that the actual output of the source and, lamp-to-film distance are directly affected by the lamp efficiency at the energy input level used. The optimum lamp-to-film distance then is determined by experimental exposures based on the calculated distance of 1.2 m.

There are two basic methods for making silhouette exposures. The subjects can be placed directly on the film or they can be put in a sample holder that is placed on the film. With the first or wet method the subject is exposed to chemicals that leach from the film. Some species of gelatinous zooplankton are traumatized with this method (for example, tentacles not relaxed, swimming movements erratic, mucous secretions produced). Whether other zooplankton are similarly stressed is not known. Therefore, if several photographs are taken it is important to keep the water bath fresh.

With the alternative or dry method the subject is isolated from the film by a thin sheet of cellophane (Figure 9).* Care must be taken with

* *Saran Wrap* ™ [Trade mark of the Saran Protective Coatings Co., 1342 Gakmain Blvd., Detroit, Michigan 48238. (313)867-4900]. This material is preferred over other brands because it is thicker and has fewer imperfections.

Figure 9. Zooplankton sample holder for silhouette photography.

this material to avoid scratching or creasing its surface and to select a section where variations in thickness are not obvious since any of these imperfections will cast a shadow on the film. The ring of the sample holder should be black plastic or covered with black tape to prevent light scattering from the ring to the emulsion surface.

Dust and other particles present in the air or seawater can reduce the quality of the silhouette image. Most of this contamination can be prevented by placing subjects in 0.2 μ-filtered water and covering the photo chamber until ready for exposure.

The emulsion surface should be cleaned just prior to positioning the sample on the film to remove any extraneous particles. A low pressure jet of clean, dry, oil-free gas such as air, Freon, or nitrogen may be used (Eastman Kodak).

When photographs are taken at sea, the photo chamber should be isolated from vibrations of the ship's machinery since these vibrations ripple the water surface and cast shadows on the negative. This problem can be avoided by setting the photo chamber on a heavy steel plate supported by rubber pads.

Exposures are made under darkroom conditions. The first step is to place the emulsion side of the film under the subject. A red safelight can be used to provide enough illumination to position the specimen over the film if the safelight is kept at least 1 m away. The light source is then positioned at a predetermined distance from the film and with a single flash of the lamp the exposure is made (Figure 1). With both methods, the subject-to-film distance should be kept as small as possible to reduce the penumbra. Image resolution is also improved if the subject is covered with as little water as possible but enough to insure that the subject does not contact the air-water interface.

Development in Dektol or Ektaflo provides a denser negative than the D-76 developer recommended by Kodak for the 7302 film. If the wet emulsion method is used, the film should be rinsed with fresh water prior to processing.

The resultant one-to-one negative image may be studied with a hand lens, enlarged and printed, or mounted and projected. The contrast of a print may be enhanced by the use of Kodak opaque red to mask out areas of the negative surrounding a subject of interest.

EXAMPLE PHOTOGRAPHS

Gelatinous, marine zooplankton (such as ctenophores, siphonophores, and salps) are extremely fragile. As a consequence, the natural appearance of these semitransparent animals is difficult to record and some species cannot be preserved chemically. Silhouette photography of living specimens is one means of surmounting this problem. Examples of gelatinous zooplankton are shown in Figure 10.

Figure 11 illustrates an example of double flash exposure of live crustaceans in a seawater sample. The average velocity for the copepods shown in this example is 0.48 cm/sec (0.19 in./sec).

SUMMARY

The silhouette photographic technique produces a high resolution record without appreciable shadow error, diffraction, or blurring due to animal or ship motions. The resultant one-to-one black-and-white negative image may be studied immediately after development with a hand lens, enlarged and printed, or mounted and projected. Since the technique is nondestructive, a zooplankton sample may be preserved for further analysis onshore.

A 3 cm

B 3 cm

Figure 10. Examples of gelatinous marine zooplankton
(a) Siphonophore, *Agalma okeni* (live, enlarged × 1.2, FX-6A flashtube, negative masked).
(b) Heteropod, *Pterotrachea scutata* (preserved, ×.8, FX-265, masked).
(c) Siphonophore, *Rosacea cymbiformis* (live, ×.67, FX-6A, unmasked).
(d) Ctenophore, *Mnemiopsis mccradyi* (live, ×1.47, FX-6A, unmasked.)
(e) Aggregate forms of the salp, *Helicosalpa virgula* (live, ×1.12, FX-6A, unmasked).

D

1 cm

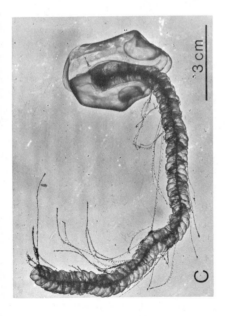

C

3 cm

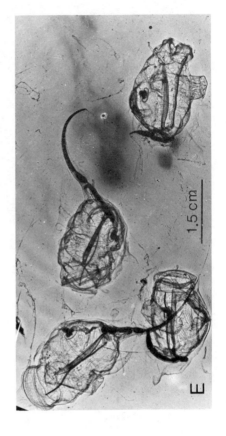

E

1.5 cm

Figure 11. Double flash exposure of crustaceans in a seawater sample (live, ×6, GenRad Strobotac Model 1531, flash interval 0.65 sec, unmasked).

ACKNOWLEDGMENTS

The technical assistance of John Holt, Tom Smoyer, Pamela Blades, and Bill MacRoberts is greatly appreciated. This paper is Harbor Branch Foundation Contribution No. 214.

REFERENCES

Eastman Kodak: Data Releases for type Plus X, type 7302, and type SO343 films.

Edgerton, H. E. 1977a. Shadow photography revived with a strobe. *Industrial Photography*, May 1977: 24-25.

Edgerton, H. E. 1977b. Silhouette photography of small active subjects. *Microscopy* 110 (1), May 1977.

Edgerton, H. E. 1979. *Electronic Flash, Strobe*. Cambridge, Mass.: M.I.T. Press.

Edgerton, H. E. and J. R. Killian, Jr. 1979. *Moments of Vision—The Stroboscopic Revolution in Photography*. Cambridge, Mass.: M.I.T. Press.

Edgerton, H. E. and J. S. Wilson. 1977. High speed silhouette photography of small biological subjects, In *Proceedings High Speed Photography 12th Inter-*

national Congress (Toronto, Canada) ed. M. C. Richardson, pp. 486-490. Bellingham, Washington: SPIE.

EG&G, a. FX-265 Data Sheet F1019A-1. EG&G, Inc., 35 Congress Street, Salem, Massachusetts 01970, (617) 745-3200.

EG&G, b. FX-6A Data Sheet F1005D-3. EG&G, Inc., 35 Congress Street, Salem, Massachusetts 01970, (617) 745-3200.

EG&G, c. Lite Pac Data Sheet F1017B-1. EG&G, Inc., 35 Congress Street, Salem, Massachusetts 01970, (617) 745-3200.

Ortner, P. B., S. R. Cummings, R. P. Aftring, and H. E. Edgerton. 1979. Silhouette photography of oceanic zooplankton. *Nature* 277 (5691):50-51.

A Camera System for Deep-Sea Photography From Drifting Ice Stations

Norman E. Fenerty

Photographic Unit
Bedford Institute of Oceanography
Dartmouth, N.S., Canada

INTRODUCTION

Deep-sea cameras are usually operated from a ship or a submersible. In this manner, photographs have been made of the seafloor in most of the open water areas of the world. The Bedford Institute of Oceanography, Canada's principal oceanographic center, has pushed into the unopened areas with icebreaking ships to film the seafloor of the Arctic channels and straits in Canada's extreme north. This is an area of potential gas and oil reserves, and the channels are barriers to the pipelines that may be required to transport oil and gas to southern markets. Bottom photography is part of the geological studies of the seafloor in these channels that will provide some of the information required to select pipeline routes. As researchers move farther north in their quest to solve the mysteries of the oceans, they find it necessary to leave their ships and to use the Arctic sea ice itself as their research vehicle.

THE WORK ENVIRONMENT

The ice platform is a very large area of huge "pans" or floes of ice that move continually with the influence of winds and currents. These large

pans drift and gyrate, break and crash together, and very often pile up on one another to form ice ridges. The moment movement ceases, the floes freeze in this new configuration, only to crack, spread, collide, and freeze again. The average ice thickness is about 8 to 15 ft (2.4 to 4.5 m), but can be considerably thicker through the ridges.

Oceanographers now have some understanding of the Arctic winds and currents and can reasonably predict the direction of ice movement. Using this knowledge, many ice camps have been set up, and have drifted along predetermined courses while the research people, housed in comfortable accommodations on the ice, have done their work.

The major topographic feature of the Arctic Ocean seafloor is a huge abyssal plain transected by three major oceanic ridges that are approximately parallel to each other. These are, from west to east, the Alpha Ridge, between Canada and Russia, the Lomonosov Ridge, and the Nansen Ridge. The largest area of abyssal plain is the Canada Basin west of the Alpha Ridge, where the average depth is 12,500 ft (3800 m).

BACKGROUND

The first photographs of the seabed of the Arctic were taken on two stations on the Alpha Ridge in 1957 from Arctic Drifting Station "A", reported by Hunkins et al. (1960). This paper offers a good interpretation of the content of the photos, but has very little reference to the equipment used.

The most ambitious bottom photography program to date was begun in 1963 from Fletcher's Ice Island, T3, which has drifted in a clockwise gyre for many years and has passed over all major topographic features of the western Arctic (Hunkins et al. 1970). Over 2000 usable photos were taken at 87 stations during the first seven years of life of T3.

In 1975, Canada's scientists were asked to participate in the U.S.-sponsored Arctic Ice Dynamics Joint Experiment (AIDJEX 75). One of the Canadian parties was a geological team from Canada's Department of Energy, Mines, and Resources. This group consisted of C. F. M. Lewis and B. D. Bornhold of Terrain Sciences Division, Ottawa, and myself from the Bedford Institute of Oceanography. The objective was to provide geological information on sediment type and dispersal in the Arctic Basin, and to examine the feasibility of core sampling, echo sounding, and seafloor photography from an ice platform.

PRELIMINARY CONSIDERATIONS

Operating from an ice platform was new to us, so we gathered all the information we could on previous Arctic seabed photography, which

was basically the previously mentioned papers by Hunkins and his associates. Two factors became evident: all the photos taken to date were oblique pictures; and the details and design of the cameras, frames, lights, or winches used was not recorded.

We concluded that we wanted vertical rather than oblique pictures. This would simplify scaling, and if the drift rate of the ice was reasonably constant, we could produce strip mosaics from the prints. To obtain vertical pictures, we would have to use either a vertical frame with an extending arm for the light, or a horizontal frame to keep the light and camera separated. The use of a horizontal frame is normal in open water, but is somewhat of a problem when the frame must be launched through a hole in ice 10 to 15 ft (3 to 4.5 m) thick. It was obvious that previous camera operators had used a vertical frame for this very reason, and hence their pictures were oblique.

The one specification on equipment for the AIDJEX operation that caused us the most concern was that no single piece of freight could exceed 200 lb! This meant that we had to design and build a winch capable of holding 15,000 ft (4500 m) of 5/32 inch (4 mm) wire that was strong enough to extract and lift a 150-lb (70 kg) corer, in components of 200 lb (93 kg) or less! It was done. The components were the aluminum A-frame, the aluminum winch body, the gasoline motor, and three reels of wire each 5000 ft (1525 m) long.

In 1974, we had purchased a new underwater camera system from a manufacturer in England. (Edgerton had ceased production of cameras and Benthos had not started to market the newer Benthos version of the old faithful EG&G 200 series). This new equipment was a UMEL system (Underwater Marine Equipment Limited, of Farnborough, England). It consisted of an aluminum-cased, plastic, curved-port camera, an electronic flash unit of 160 W S, which had a separate flash head (or heads), and was powered by a separate power pack of 7.5 V, 10 Ah Ni/cad cells.

THE CAMERA SYSTEM

An acceptable design evolved after many sketches and drawing-board versions (Figure 1). It consisted of a 7.5-ft (2.3 m) long frame that, when carrying its complement of equipment, was only 12 inches (0.3 m) in diameter. An attempt was made to keep the diameter as small as possible, to allow deployment of the camera system through holes cut by 12- or 16-inch (0.3 or 0.4 m) ice augers that were known to be in common use.

The frame contains the lamp head at one end, and the camera, mounted on a pivot, on the opposite end. Between them is the battery, the flash electronics, an Edo pinger, and the bottom contact switch.

The frame is lowered through the ice vertically. Under the ice it deploys into a horizontal position and the camera swings on its pivot to a vertical

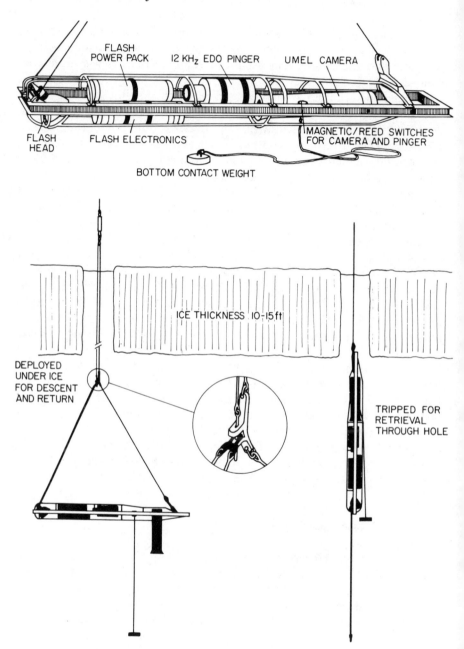

FLASH
POWER PACK 12 KHz EDO PINGER UMEL CAMERA

FLASH
HEAD FLASH ELECTRONICS

MAGNETIC/REED SWITCHES
FOR CAMERA AND PINGER

BOTTOM CONTACT WEIGHT

ICE THICKNESS 10-15 ft

DEPLOYED
UNDER ICE
FOR DESCENT
AND RETURN

TRIPPED FOR
RETRIEVAL
THROUGH HOLE

Figure 1. Diagram of the camera system.

position (Figure 2). It is then lowered to the bottom. When the bottom contact weight, which is suspended on a cord attached to the switch, touches bottom, the camera and flash will operate, and the pinger will cease transmitting until the unit is lifted from the seabed and lowered again for another exposure. On return to the surface under the ice, the frame is tripped into a vertical position for extraction through the hydrohole (Figure 3).

This capability is achieved by supporting the frame horizontally by a three-point suspension bridle attached to a single 15-ft (4.5 m) wire leader which, in turn, is connected to the main winch wire by a swivel. Two of the three suspension wires are attached to the lamp end of the frame and the other suspension wire is attached to a hinged V-shaped plate at the camera end. At the upper junction of these three wires, the two from the lamp end are attached to a small metal plate that fits into a supporting connector between the end of the single wire and the wire leader, and is held by a metal pin. A trip line is attached to this pin and lightly taped parallel to the length of the 15-ft (4.5 m) leader and tied off under the swivel.

OPERATIONAL DETAIL

The unit is serviced in a horizontal position until it is ready to launch (Figure 4). The three-wire bridle is connected by the release pin, which is held in place by an elastic band. The leader and swivel are connected to the winch cable. The bridle and leader are taped lightly across the top of the frame to prevent snagging during the launch. The unit is then raised to the vertical and rested on its lamp end. It is lowered by hand into the hydrohole, and then lowered to the undersurface of the ice by a slipline. As the weight of the assembly comes on the winch line, the slipline is pulled free. The unit swings into a horizontal position and the camera swings to vertical. The unit is ready to descend and operate.

The camera is tripped by a magnetically-operated bottom contact switch. A weighted cord, the length of which controls the camera-to-seabed distance, operates this switch as the weight is relieved by the bottom. The reed switch is a single pole, double-throw switch through which the pinger is wired on the normally closed side and the camera is wired on the normally open side. When contact is made with the bottom, the switch action stops the pinger transmission and operates the camera. This transmission is received by the hydrophone, and can be displayed on a recorder or monitored audibly by earphones worn by the winch operator. The instant the pinger stops the unit is raised until the ping is again received.

On completion of the photo run, the unit is returned to the underside of

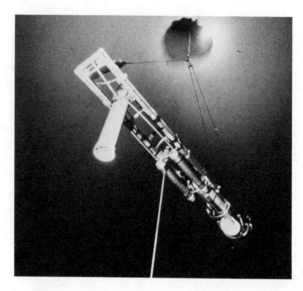

Figure 2. The camera system under the arctic ice, deployed in its horizontal configuration ready for its descent to the seafloor. (Photograph by J. McInnis.)

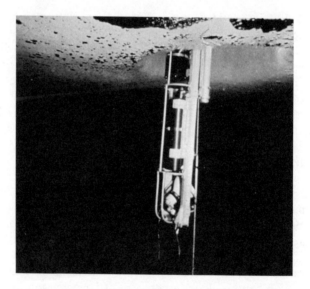

Figure 3. The camera tripped into its vertical configuration and being extracted through the ice. (Photograph by J. McInnis.)

Figure 4. The author making final checks on the camera system prior to launch, at the AIDJEX floating ice station. (Photograph by B. Bornhold.)

the ice, where the swivel and the end of the wire leader are eased through the ice to the surface. A pull on the end of the tripline, which is now accessible, extracts the pin and releases the lamp end of the frame. The unit, now being held only by the camera end, falls to a vertical position, the camera swings back into the frame, and the package is pulled up through the hole to the surface.

AIDJEX

On May 3, 1975, our group took off with our equipment from Tuktoyaktuk on the Arctic coast, and flew over 400 miles (6400 km) north and landed on an airstrip on the floating ice. We were at AIDJEX main camp, temperature −8°F. The support facilities at AIDJEX were excellent, and in a few days we had a workshop set up, our winch ready to go, and a hole in the ice 36 inches in diameter!

The operations at AIDJEX were successful (Bornhold et al. 1975), but due to an unrepairable breakdown of the winch our program was cut short after only 12 lowerings. Of these 12, four were camera stations. The first camera station had to be aborted as the pinger stopped transmitting at 7000 ft (2100 m). The unit was too light and we had lowered it too fast. It had rolled over and snarled the bottom contact cord and weight. This was quickly remedied by the addition of a 50-lb (20 kg) coring weight as ballast (Figure 5).

In addition to our geological samples and a wealth of experience, we returned with over 100 good pictures and two major equipment problems to overcome. The problems were: insufficient power for the winch, and inadequate receiving and amplifying equipment for the pinger transmissions.

Although we had not achieved everything we hoped for, the prime objective of this first trip was accomplished — to prove the feasibility of our prototype instrumentation for sampling and photographing the seabed from a drifting ice platform. We were to return to AIDJEX the following spring, but in October 1975 the ice under the camp and runaway broke up, and AIDJEX had to be evacuated.

THE NORTH POLE (LOREX '79)

The next ice camp operation came in the spring of 1979, when the Earth Physics Branch of the Department of Energy, Mines, and Resources sponsored LOREX '79. The objective of this multidisciplinary project was to define more clearly the geologic nature and origin of the Lomonosov Ridge, and to develop Canadian expertise for conducting such research from a floating ice platform (Figure 6).

Under the leadership of S. M. Blasco of BIO's Atlantic Geoscience Center, I (using the Arctic camera) joined B. D. Bornhold and F. D. Jodrey to form the initial geological group at LOREX to provide seabed photography, sediment sample recovery, acoustic profiling, and surface plankton sampling (Blasco et al. 1979).

Applying the experience gained at AIDJEX, we had improved the camera unit and pinger, and were now using a single active MIT-designed hydrophone for pinger reception and for the seismic airgun profiling system. The winch

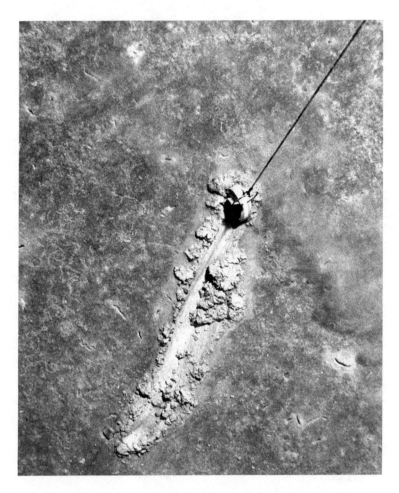

Figure 5. The seafloor of the Canada Basin at 3550 m, taken by the UMEL system from AIDJEX ice camp.

had been rebuilt and equipped with a stronger gasoline engine to provide more hydraulic power. A major change for this operation was the use of 5-mm Kevlar cable instead of 5/32-inch (4 mm) stainless steel wire. This cable has no weight in water, and if properly used is as strong as stainless steel.

As the station work commenced, the main LOREX camp was over the Makarov Basin on the Amerasian side of the Ridge in water depths of 4000 m (Figures 7 and 8). As expected the camp drifted over the Lomonosov Ridge (1300 m) toward the Fram Basin on the Eurasian side, where water depths averaged 4200 m (Figures 9, 10, and 11). The drift rate varied from 1 km a day to 1 km an hour.

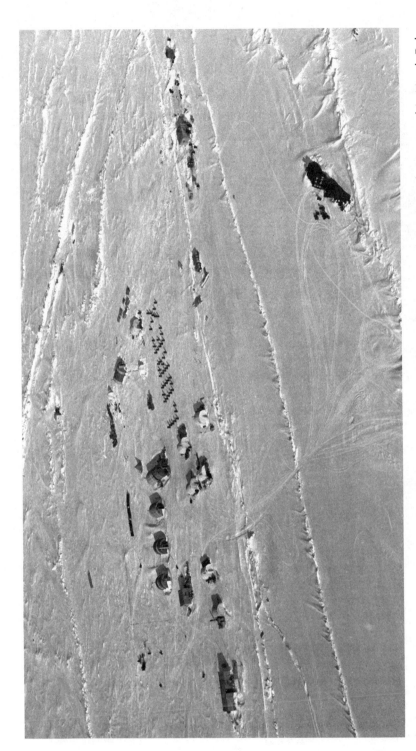

Figure 6. View from the air of LOREX main camp on the floating ice approximately 35 km from the geographic North Pole. (Photograph by J. R. Belanger.)

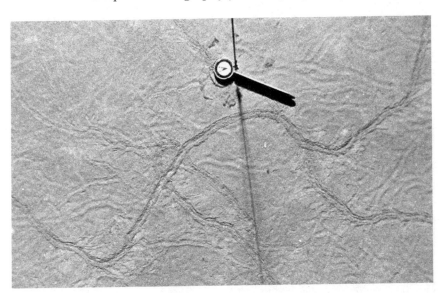

Figure 7. Photo Station 5: 3948 m. Abyssal plain on the Amerasian side of the Lomonosov Ridge. The soft sediments record several generations of tracks and trails of benthic fauna.

Figure 8. Photo Station 8: 3896 m. Abyssal plain at base of the ridge. Three crustacea apparantly are feeding on organic matter stirred up by previous impacts of the compass weight. Ice rafted material and shell fragments (white spots) are evident.

Figure 9. Photo Station 11: 1830 m. On the slope of the ridge. Current scour and associated coarse gravel pavement.

Figure 10. Photo Station 12: 1679 m. Near the crest of the ridge. Two outcrops of older semiconsolidated sediments with overlying lag deposits possibly derived from this substrate.

Figure 11. Photo Station 12: 1697 m. Near the crest of the ridge. Ripple marked seafloor with gravelly sediments infilling the troughs. At this proximity to the geographic North Pole, the compass points south to the magnetic pole.

In all, 14 camera lowerings were completed, with good return on all but two. Six of the lowerings were actually double or triple camera stations, in that each contained a series of approximately 50 contacts of the bottom, separated by periods of one or two hours. Some of the lowerings lasted over eight hours, and recorded three series of bottom contacts along the drift track.

CONCLUSIONS

Operating from an ice surface has some advantages over shipborne camera work, primarily lack of wave action and no nausea. Our control of the camera at the seabed was so precise that over flat abyssal areas we found we could expose successive frames by winching up and down only six inches (15 cm). When climbing the side of the ridge, the camera could be triggered by raising it a few inches and holding it until its trip weight drifted against the bottom slope.

The cold temperatures at LOREX in April ($-35°$F) were no particular problem, except for the hydrohole, which would freeze up unless a light were

kept burning under the ice surface. Each building was well heated, and we lived and worked in a comfortable environment.

The use of this camera system has proven quite feasible and successful. Small improvements, such as a vane to stabilize it and better distribution of its components, should be incorporated into it for future operations.

Now that we have a proven, lightweight, compact camera unit we are considering its operation from a helicopter. This would extend the range of potential deep-sea camera stations and would increase the cost effectiveness of sea-bottom photography from expensive Arctic ice camps such as LOREX and AIDJEX.

REFERENCES

Blasco, S. M., B. D. Bornhold, and C. F. M. Lewis. 1979. Preliminary results of surficial geology and geomorpholoy studies of the Lomonosov Ridge, Central Arctic Basin. Current research, Part C, Geological Survey of Canada, Paper 79-1C: 73-79.

Bornhold, B. D., C. F. M. Lewis, and N. E. Fenerty. 1975. Arctic marine surficial geology: AIDJEX 1975. Current research, Geological Survey of Canada, Paper 75-1C: 79-84.

Hunkins, K. L., M. Ewing, B. Heezen, and R. Menzies. 1960. Biological and geological observations on the first photographs of the Arctic Ocean deep-sea floor. *Limnol. Oceanogr.* 5: 54-61.

Hunkins, K. L., F. Mathieu, S. Teeter, and A. Gill. 1970. The floor of the Arctic Ocean in photographs. *Arctic* 23: 175-189.

Fish, Crustaceans, and the Seafloor under the Ross Ice Shelf

P. M. Bruchhausen
Lamont-Doherty Geological Observatory
Columbia University
Palisades, New York

J.A. Raymond
Alaska Department of Fish and Game
Fairbanks, Alaska

S.S. Jacobs
Lamont-Doherty Geological Observatory
Columbia University
Palisades, New York

A. L. DeVries
Department of Physiology and Biophysics
University of Illinois
Urbana, Illinois

E. M. Thorndike
Lamont-Doherty Geological Observatory
Columbia University
Palisades, New York

H. H. DeWitt
Department of Oceanography
University of Maine
Walpole, Maine

This paper originally appeared in *Science* 203, 449–451, 1978. Copyright © 1979 by the American Association for the Advancement of Science.

Until recently, the existence of life in the relatively deep cul-de-sacs beneath the large Antarctic ice shelves was primarily a topic of speculation (Lipps *et al.* 1977). Evidence for life was limited to the collection of specimens in or through natural cracks in the shelf ice: diatoms obtained near the surface 520 km from the open sea (Barrett 1975) and amphipods and a fish obtained about 25 km from the leading edge and at depths of 40 to 75 m (Littlepage and Pearse 1962). Fish have also been taken from a proglacial lake adjacent to another ice shelf (Heywood and Light 1975). Since the completion of an access hole through the Ross Ice Shelf at 82°22.5'S, 168°37.5'W, 475 km from the open Ross Sea (Clough and Hansen 1979) several additional pieces of evidence for life have been obtained. We report here some of the observations made with a camera and baited traps.

The camera system was designed to have a small diameter (15 cm) in order to fit through the proposed drill hole. When a larger hole became available the strobe reflector diameter was increased to 18 cm to provide better illumination. The length of the package is 137 cm. We use a 35-mm F/2.8 Leitz Summaron lens behind a plain glass window. A Brailsford motor transports 9 m of 35-mm film, giving 200 exposures with an interval between them of 40 seconds. There is no shutter. Severe lens fouling occurred as a result of DFA (Diesel Fuel Arctic) and slush ice in the hole. The system designed to locate instrument distance above bottom did not perform as anticipated. These factors reduced photograph quality and necessitated the fabrication on site of a lens cap that could be removed below the ice shelf and a trigger weight to sense the bottom. Bait (a piece of knockwürst) was suspended below the camera on some lowerings, including the two on which fish were photographed.

The traps were first constructed of 1.3-cm mesh steel screen around a cylindrical steel frame 20 cm in diameter, 60 cm in length. The end of the trap that was up during transit through the hole contained a funnel opening. Later modifications included a finer mesh screen over the bottom quarter of the trap and 12 holes, 2.5 cm in diameter, in the upper part. Traps were self-guided through the hole by way of 45-cm cones made from eight steel rods on each end. Each trap contained three bags of seal meat. Holes were cut in the bait bags to permit easier entry to smaller animals and to reduce specimen losses to turbulence during raising of the trap. Water was poured over the bags and allowed to freeze to avoid contamination from hydrocarbons in the hole. The ice would later melt in the water column (Jacobs *et al.* 1979). Two traps were used on each of three separate lowerings, and were set on the bottom for periods of up to 5.8 hours.

Our observations were made near the seafloor, 597 m below sea level and 237 m below the base of the ice shelf. Temperature was −1.86°C (0.5°C above the *in situ* freezing point) and salinity was 34.83 per mil (Jacobs *et al.* 1979). Tidal currents were measured with amplitudes up to 17 cm per second (Jacobs *et al.*, in press).

The traps collected over 130 large (4 cm) red gammarid amphipods, *Orchomene* cf. *O. rossi*, and small amphipods, *Orchomene plebes* sp. (identified by P. Slattery); and one 7-cm isopod, *Seriolis trilobitoides* (identified by J. H. Lipps). Examination of the guts of several of the large amphipods revealed no contents other than bait (examined by J. Bradford). Brood pouches of some of the large amphipods contained eggs and juveniles (examined by T. E. Ronan, Jr.). The amphipods and isopod were examined for bioluminescence while they were still alive, but no luminescence was observed. During several years of trapping benthic animals near the shelf edge in McMurdo Sound we (A. L. D. and J. A. R.) failed to trap either the large amphipod or the isopod. However, the isopod is common in other parts of Antarctica (Kusakin 1968). Baited hooks attached to the trap line in the lower 50 m of the water column failed to catch any fish. The lines were set for a total of 34 hook-hours (a product of time and number of hooks used). We (A. L. D. and J. A. R.) have used similar set lines in McMurdo Sound to catch the large antarctic cod (approximately 24 hook-hours per catch), which are abundant there between September and December (Raymond 1975).

Several hundred photographs were taken of the sea floor during five camera lowerings. They show a soft bottom littered with subangular pieces of material (Figure 1). Markings made by currents or by animals were not seen in any of the photographs, in marked contrast to many observations we (P. M. B. and S. S. J.) have made of the sea floor north of the ice shelf in the Ross Sea (Jacobs *et al.* 1970). A relatively small area was photographed beneath the ice shelf because the movement of ice is only about 1 to 2 m per day.

Two photographs of fish were obtained. We identify one (Figure 2, left) as *Trematomus* sp., most likely *T. loennbergii*, less likely *T. lepidorhinus*, both of which are common at similar depths in McMurdo Sound and the Ross Sea. The *Trematomus* identification was first made by B. Meyer-Rochow, University of Waikato, New Zealand. The animal in Figure 2 on the right is probably also a fish, but from the poor quality of the image we cannot exclude the possibility of its being a crustacean. The animal resembles a naked dragon fish, *Gymnodraco acuticeps*. The adults of that species are fairly common in shallow water in McMurdo Sound. However, a problem with this interpretation is that the presumed "snout" is too long for *Gymnodraco*, and the ratio of distance between the eyes to snout and lower jaw length is only half that of known *Gymnodraco* specimens. Another possible interpretation is that what appears to be a pointed snout is actually a crustacean being consumed by another species of fish, possibly a *Pogonophryne* or *Trematomus*. This is supported by the presence of three barely visible pairs of "appendages" attached to the "snout". L. Watling (University of Maine) believes the "appendages" could be the last three peropods of an amphipod whose pleon is folded ventrally. On the original Ektachrome film are indications of cross stripes on the portion with "appendages"—possible

Figure 1. Photograph of the seafloor 597 m below sea level and 237 m beneath the Ross Ice Shelf at 82°22.5'S, 168°37.5'W. The object appearing diagonally across the frame is a nephelometer with a width of 16 cm, lost when its supporting cable slipped from an iced-up sheave, breaking a weak link. The bottom at left of frame has been disturbed by another instrument. A weight with bait attached and supporting cable hangs beneath the camera.

body segments. Further, there appears to be a color change near the first "appendage" pair, possibly demarking the upper jaw of the fish.

In December 1976 we (A. L. D. and P. M. B.) lowered a trap through a crevasse on the Ross Ice Shelf near Minna Bluff, 80 km from the shelf edge (Clough and Hansen 1979). The ice thickness and water layer at this point are approximately 275 m and 500 m, respectively. A 28-g *Trematomus borchgrevinki* measuring 17 cm in length was caught 39 m below sea level during a 48-hour fishing period. This fish, which is also common to McMurdo Sound, had an empty gut.

It is likely that the fish beneath the ice shelf feed on the amphipods, but a food source for the amphipods and isopods is less obvious. The apparent

Figure 2. (left) An 18-cm *Trematomus (loennbergii?)* photographed near the sea floor beneath the Ross Ice Shelf. Bait is attached to the cylindrical weight that is suspended below the camera. (right) A 10- to 12-cm fish (?), possibly a *Gymnodraco acuticeps,* or a *Pogonophryne* or *Trematomus* with crustacean in its mouth, near the seafloor beneath the Ross Ice Shelf.

paucity of organisms in the water column (Azam *et al.* 1979) and the absence of natural contents in the amphipod guts indicate that the food supply is scarce. We made a plankton tow through the water column beneath the ice shelf with a 15-cm diameter, 0.25-mm mesh net. The collection vial yielded two sponge spicules and no bioluminescence. The net could have filtered a maximum of 4×10^3 liters of seawater, but may have retained ice collected during descent through the hole. The sighting of a possible mysid shrimp (Lipps *et al.* 1979), which may have drifted under the shelf with the current, suggests that these animals are one food source for the community

as well as a source of red pigment for the amphipods. The rapid aggregation at the site of amphipods with empty stomachs may support the concept of an opportunistic diet (Arnaud 1975). Amphipods with empty guts have been trapped in the abyssal depths (>5000 m) of the Pacific (Shulenberger and Hessler 1974). Crevasses through the Ross Ice Shelf (Barrett 1975) are very small in area and any phytoplankton food source is probably of negligible importance to the observed biota (Littlepage and Pearse 1962). The presence of these life forms beneath the ice shelf far from the open sea thus implies an active horizontal circulation that can move plankton and detritus southward from the Ross Sea. We do not know the extent of biological activity in the Ice Shelf Water that subsequently emerges from beneath the ice shelf (Jacobs *et al.* 1979), but oligotrophic conditions have been reported in the seawater moving away from the ice shelf in McMurdo Sound (Dayton and Oliver 1977). Although high productivity levels would not be expected in water emerging from this presumably dark environment, the resident population may also act as efficient scavengers.

The fishes and invertebrates sampled near the shelf edge in McMurdo Sound show both variety and abundance (Tressler 1964). On the basis of our samples from beneath the Ross Ice Shelf, diversity and abundance there are considerably lower. However, these findings indicate that a significant biological community, apparently without unique forms, exists in a remote region beneath a large Antarctic ice shelf. Similar marine organisms will proably be found as far south as this sea extends—to within 500 km of the South Pole.

ACKNOWLEDGMENTS

We thank J. L. Ardai, Jr., and the Ross Ice Shelf drillers from Browning Engineering, the U.S. Army Cold Regions Research and Engineering Laboratory, and the University of Nebraska for assistance with the fieldwork. This study was supported by NSF Division of Polar Programs grants C-726 (University of Nebraska), 76-11872 and 77-22209 to Columbia University, 76-82366 to the University of Illinois, and 76-21735 to the University of California, Davis. Lamont-Doherty Geological Observatory Contribution No. 2770.

REFERENCES

Arnaud, P. M. 1975. *Nature (London)* 256: 521.

Azam, F., J. R. Beers, L. Campbell, A. F. Carlucci, O. Holm-Hansen, F. M. H. Reid, D. M. Karl. 1979. *Science* 203: 451.

Barrett, P. J. 1975. *Nature (London)* 256: 390.

Clough, J. W. and B. L. Hansen. 1979. *Science* 203: 433.

Dayton, P. K. and J. S. Oliver. 1977. *Science* 197: 55.

Dearborn, J. 1965. Thesis, Stanford University.

Heywood, R. B. and J. J. Light. 1975. *Nature (London)* 254: 591.

Jacobs, S. S., P. M. Bruchhausen, and J. L. Ardai, Jr. In press. *Antarct. J. U. S.*

Jacobs, S. S., P. M. Bruchhausen, and E. B. Bauer. 1970. *Eltanin* Reports (unpublished). Palisades, N.Y.: Lamont-Doherty Geological Observatory of Columbia University, pp. 304-339.

Jacobs, S. S., A. L. Gordon, and J. L. Ardai, Jr. 1979. *Science* 203: 439.

Kusakin, O. G. 1968. *Biol. Rep. Sov. Exped. Antarct. 1955-58* 3: 220.

Lipps, J. H., W. N. Krebs, and N. K. Temnikow. 1977. *Nature (London)* 265: 232.

Lipps, J. H., T. E. Roman, Jr., and T. E. DeLaca. 1979. *Science* 203: 447.

Littlepage, J. L. and J. S. Pearse. 1962. *Science* 137: 679.

Raymond, J. A. 1975. *J. Mar. Technol. Soc.* 9: 32.

Shulenberger, E. and R. Hessler. 1974. *Mar. Biol.* 28: 185.

Tressler, W. L. 1964. In *Biologie Antarctique,* ed. R. Carrick and M. Holdgate, p. 323. Paris: Hermann.

An Inexpensive Deep-Sea Time-Lapse Camera System

Y. Agrawal and
A. J. Williams, III
Woods Hole Oceanographic Institution
Woods Hole, Massachusetts

INTRODUCTION

In July 1979, a multi-investigator cruise of the research vessel *Oceanus* was scheduled to test several instruments on a tripod assembly. Photographic monitoring was needed to determine the position of the sensors in their deployed condition, the character of the bottom immediately beneath the sensors, and changes to the bottom and to the sensors during the test deployment. Deep-sea cameras were originally developed to obtain high-resolution single-frame photographs of the seafloor, and these large and expensive instruments have been adapted to time-lapse photography without reducing their cost. The simple instrument monitoring function has not previously been implemented in the deep sea. We constructed such a system from an 8-mm battery-powered movie camera and electronic flash.

THE CAMERA

The Kodak Analyst is a Super 8 movie camera with a frame rate adjustable from 1¼ sec to 90 sec. Thin base MFX film provides 100 foot capacity, although other emulsions including color are only available in 50-foot magazines. In order to suit the application, we rotated the shutter

wheel 180° to ensure an open shutter except briefly after frame advance. This arrangement relaxed the synchronization requirements with the flash. A magnetic reed switch was installed to turn off the camera by means of a magnet outside the titanium pressure housing. The frame timing was set at approximately 8 sec to allow eight hours of photographic coverage on a 50-foot roll of film (3600 frames). The quality of 8-mm images is improved by the averaging effect of visual persistence when the film is displayed as a movie. Since there is little change between frames, in viewing the movie one becomes very sensitive to the changes that do occur, so that this technique is useful for event detection.

THE STROBE

A simple timing circuit, batteries, and commercially available photographic flash, Sunpak model 211 (Sunpak, Woodside, N.Y.), were packaged in a 10″ Benthos glass sphere (Benthos, Inc., North Falmouth, Mass.). Twelve alkaline-D cells were used to power the flash, although more batteries can be packed in the glass sphere. The timer was set at approximately 8 sec. The timer fired a silicon-controlled rectifier, triggering the flash. We found it unnecessary to collimate the flash, although a reduced beam spread may be necessary in very turbid waters.

The inexact synchronization of the flash and the camera leads to an occasional blank or double exposure in the film. A photocell-controlled film advance may be incorporated in the future to alleviate this, although at a projection speed of 16 frames/sec, the occasional faulty picture is barely noticed by the viewer. The glass ball, pressure tested to 900 m depth, was placed in a hard hat and sealed. Battery life tests showed that 12 alkaline-D cells would power 7500 flashes. Thus, in four deployments (4 × 50′ of film) the glass ball was opened once at sea to replace batteries. With a 100-foot film roll, a new battery pack would be required for each film.

The camera and strobe were mounted on a tripod approximately six feet from the spot being photographed. The camera, photographed area, and strobe formed a triangle with an approximately 90° angle at the photographed surface. The area photographed at this distance is small, 13″ × 18″ even with the Analyst lens at its widest angle. We have used both black-and-white (ASA 100) and color film (ASA 160). All black-and-white film was processed at sea.

We estimate that duplicates of the system described here can be built for under $2,000 (1979 prices).

Since this paper was presented, the authors have developed and tested a 35-mm camera system employing a Nikon E-M camera with

motor drive in a 10″ long, 6½″ ID aluminum case. The flash is placed in a 3″ long, 1¼″ diameter plexiglass cylinder and has been suspended at 10 feet from the camera on a ½″ aluminum rod to position the light source optimally. Timer and flash power supply are contained in the camera housing. The photograph in Figure 1 was obtained in the HEBBLE area at 500 m depth during October, 1981 from aboard the RV *Endeavor.*

Figure 1.

Section VII

New Techniques

Electronic Cameras in the Deep Ocean

Emory Kristof

National Geographic Society
Washington, D.C.

As staff photographer—a still photographer—for *National Geographic*, I've been seduced by television cameras, or as we say at the *National Geographic*, electronic cameras. This report is about our adventures in Television Land the last few years, as we tried to adapt television technology and standard television cameras into cameras that could make usable still images for the *National Geographic*. Since nobody has produced a fully electronic still camera, we've had to work with machinery meant to do other jobs to be able to do things for the magazine.

Probably the most impressive electronic still photographs made today are those coming from outer space. The ERT's imagery, the pictures from Jupiter, the pictures from Saturn, are probably the most impressive electronic still photographs that any of us have seen. If you have what amounts to a room full of equipment, you can produce very high-grade electronic images to be printed on paper.

My interest is in what can be hung on the back of one photographer to take into the field. Large disk drives, computer tape units, and large single-frame storage devices really are not feasible. At least Matthew Brady had a couple of mules and a wagon.

One of the things that comes up when people talk about electronic imaging is the amount of computer memory space necessary to put down the information in a photograph. The printing business, to a great degree, is

being limited by the television industry. Television monitors and television cameras are set up in the U.S. to work on a 525-line system. These are not very high resolution pictures. So you might ask, given the rather crude state of the art, why did we feel some things were worth doing with television cameras?

The area that I cover for the *National Geographic*, and have covered since 1974, is deep-sea oceanography. In 1974 I went out with Dr. Bob Ballard on the first expedition to look at midoceanic spreading centers. Most of these areas are deep in the ocean where the crust is thin. We went out to do stories in 9,000 to 20,000 feet of water, and we had to make images there.

When, in 1977, we went to the Galapagos spreading center, located off the coast of South America, it was the first time that man saw hot water volcanic vents on the bottom of the ocean in 8,500 feet of water. Normally we take a deep-sea camera and tow it over the section of the ocean we're interested in. This camera is loaded with 3,000 frames of Ektachrome film. It is flown very close to the bottom, and mostly you see rocks, lava fields, and a very few animals at that kind of depth. But in 1977 we found a lot of animal life down at the site where the hot water was coming out of the ocean floor. Gigantic animals: huge beds of giant clams (Figure 1), for example, and giant worms (Figure 2) 15 to 18 feet long.

After the sites were found on the bottom of the ocean, they were visited by scientists in the research submarine *Alvin* that is operated by the Woods Hole Oceanographic Institution. These dives are very expensive. This work is analogous to the pictures coming from outer space. *Alvin* can make about a nine-hour dive before the human occupants just wear out. It is a rather uncomfortable place to work. If you're diving to 9,000 feet, the time you spend in the elevator going up and down is one-third your work time. *Alvin* moves around very slowly on the bottom. It's similar to the *Peanuts* character, Pigpen—the movement that the submarine makes creates a lot of dirt.

In 1977, when we found these sites, *Alvin's* cameras included a SIT (Silicon-Intensified Tube) camera that made very low-grade black-and-white pictures of the whole site, and 35-mm cameras that gave an overview of the area in front of the submarine. The scientists also could take pictures out of the portholes, but the portholes were 3½ inches thick, which caused tremendous problems. If one tried to use a telephoto or macro-lens here, one seemed to be about 5 feet from the bottom and the subjects.

The animal life that we had discovered on the bottom was previously unknown. Since we didn't have any biologists on the expedition, we came back in 1979 to do a television show, with the aid of biologists this time, for *National Geographic* on what was possibly the most significant biological find in the ocean in 100 years. We also welcomed the opportunity to get pictures of these animals for the magazine.

Figure 1. Giant clams on the bottom at a depth of 8,500 feet, near pillow lava formations; in the Galapagos Spreading Center in the Pacific Ocean off the coast of South America.

Figure 3 shows what it looks like inside the submarine, *Alvin.* It's a seven-foot titanium sphere, very cramped and very cold. All of this leads up to the charge-coupled device (CCD) I looked at in 1977 and how we would build a camera system that would take care of all the problems we were facing at the bottom of the ocean. What we needed was a high-resolution television system that we could mount on a mechanical arm, that could move independently of the submarine, and that could be focused. The camera system had to be small enough to be enclosed in a half-inch stainless steel case and light enough for the submarine to manage it. The smallest minicamera that could be purchased in 1977 was an RCA TK76. This TK76,

Figure 2. Giant tube worms photographed at a depth of 8,500 feet, in the Galapagos Spreading Center in the Pacific Ocean off the coast of South America.

like all minicameras that are on the market today, used vidicon tubes or some form of TV tube imager that's about the same size.

The CCD is a solid-state silicon imaging device that is smaller than a Kodachrome slide and about the thickness of two Kodachrome slides (Figure 4). What is on this chip is the imager, that is 512 lines by 320 data points, plus a short-term storage capacity so that the image can be organized and then taken out electronically. This storage can also be used as a memory.

Figure 3. The cramped quarters inside the spherical titanium pressure hull of the submarine *Alvin,* showing equipment and two of the crew (the author on the left).

The problem that the CCD solved for us is that in a television camera you have an optical beam splitter to separate the blue, green, and red components. Normal television cameras now have long imaging tubes (see Figure 4) sitting on each of these three axes. This means that a normal TV camera has a fairly large cross section. Since we had to recase this whole thing in a stainless steel pressure case, the difference between using the CCD or using the TV tubes amounted to about 450 pounds of stainless steel. The resulting compact camera is shown on the manipulator of the deep-sea research vessel *Alvin* in Figure 5.

The smallest separations are two micrometers, or one-tenth of one ten-thousandth of an inch. What you have on a CCD is row upon row of photo diodes separated by about two microns. In effect these are little light meters. When the light strikes a CCD, an electrical signal is generated according to how much light has hit a picture point or pixel.

A CCD is either off or on, and the only time that it is recording information is during that 1/60 of a second that it is turned on. At the end of that time the information is rippled out of the CCD into a storage unit at the bottom of the CCD. Then the information is taken out of storage line by line. The CCD has an effective shutter speed of whatever you want to set into it. If you were

Figure 4. A solid-state silicon imaging wafer, the charge-coupled device (CCD), to the right compared with a conventional television imaging tube.

working with a still version of the CCD, theoretically you could turn on the CCD for forty thousandths of a second and you would have a shutter speed that would be forty thousandths of a second. And the moment you turned it off and took out the information the CCD would be ready to be used again. They're best thought of as re-usable electronic pieces of film.

The finished camera is inserted into a four-inch pressure housing that will withstand 25,000 PSI. The camera has a 12.5-75 mm zoom lens on it that has macro capability. It is mounted on the submarine (Figure 5) on its own

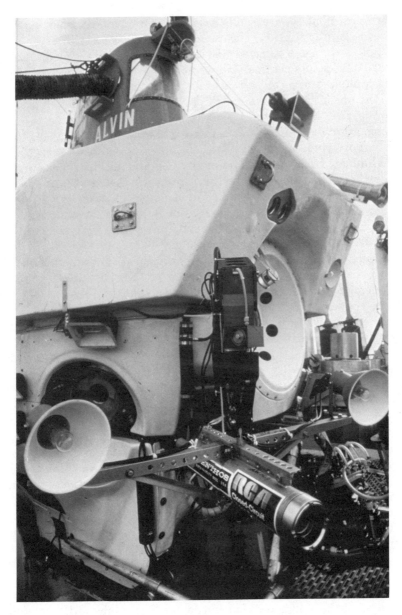

Figure 5. The CCD television camera in its stainless steel pressure housing, with lens port, mounted on hydraulic manipulator of the submarine *Alvin*. Two 750-watt quartz-iodide lights positioned on each side move with the camera.

hydraulic manipulator arm, and uses two 750-watt quartz iodide lights on either side for illumination. The camera has an effective ASA of 150.

To make an image, we started off with the CCD camera giving us 512 lines with 320 data points per line, and recorded the image on a high-band tape recorder, a one-inch recorder that sells for about $35,000. When we came back, the one-inch tape was edited. We took it to a production house in California that has the best reputation for taking high-band tape and converting it directly into color negative material.

They took the data lines and swelled them so they touched each other. They eliminated that area of noninformation in a television picture called the scan line. They then hardened and sharpened the edges, and ended up with the illusion of more sharpness in the picture than was in the imaging and recording system. They made a color negative for us that was then printed and handled in a normal fashion. We made 4 × 5 transparencies, and that's what went to the magazine's printer.

Now all this still results in very low-grade images. But they are something that you can show in a publication if you've shot these pictures on the backside of Saturn or two miles deep in the ocean, and they are the only pictures that exist.

Another area where television has been very useful to us is in the area of very high ASA. We have a SIT camera from RCA that produces a 600-horizontal line resolution picture that has an ASA of 200,000. There is another camera called an ISIT that will produce a 2,000,000 ASA. In a story we did on the new Air and Space Museum in the Smithsonian Institution, we wanted to show pictures of people watching the film "To Fly." It's a rather impressive film on a five-story high screen, and people hide their faces as the jets fly upside down. We tried using pushed Ektachrome film shot in the dark. We didn't want to use infrared flash bulb or any kind of flash in there. We finally set up the SIT camera and made a videotape of people watching the show just using the reflective light from the screen. The pictures were then photographed from a monitor. The result was very low quality, but the pictures made the point we wanted.

The next time we used the SIT camera, we knew how to transform the pictures directly without photographing from a monitor. I was sent out to photograph a sex orgy among crabs on the beach in New Jersey. It seems that horseshoe crabs only mate at the time of the high tide and a full moon, two months out of the year. We wanted to make some pictures using just the moonlight as the light source. I could not see those crabs without the aid of the TV camera but we got 200,000 ASA recorded on one-inch high-band tape put through the image transform process. It looks like a very low-grade type of film but it's 200,000 ASA, and there's no film that could approach that speed.

Figure 6. The submarine *Alvin's* electronic camera equipment, without the camera, spread out on a lab bench aboard the support ship *Lulu*.

Getting back to the submarine, we wanted to use the SIT camera to be able to illuminate large areas of the ocean. We'd been doing everything with Ektachrome and the 1500 watt/sec strobe and we could see only very small areas of the bottom. The geologists wanted to be able to see larger areas, even if at a lower resolution. So our first journey into building a camera that was a truly electronic camera and could deliver hard copy electronically was an experiment we did in January 1980 with the submarine. We mounted a SIT camera on the front of the sub and lights on the back of the sub, so we had a 21-foot separation between the camera and the lights. We also mounted a 1500 watt/sec light over 300 feet off the bottom and flew the submarine below it 100 feet off the bottom using the 200,000 ASA SIT camera. This time we used a digital memory, a single-frame storage device that would actually catch the image as it was taken off the TV screen. The pictures obtained cover an area of ¾ of an acre, and by changing the lens in that system we can cover more than two acres in one photograph. By building a side-looking camera system, using the light that we have and using the electronic camera, we can do a swath 200 yards wide through the ocean. The Navy has been very interested in this set of experiments and they've been involved with us. This technique replaces an acoustic side-scan sonar image that is now the best way of imaging something large on the bottom. There's a lot more information even in a degraded television image than there is in an acoustic image of an object.

The equipment for a completely electronic camera setup on board the *Alvin* support ship *Lulu* is shown in Figure 6. The image goes into a single-frame storage device that is about the size required to put one to four television images into random access memory. The picture can be shown on the high-resolution Conrad monitor. In the submarine we are recording the image from the single-frame storage device onto a high-band analog recorder. This is a recorder made by Recordtec by reworking a standard ENGU-matic recorder. It is a 4¼ mHz machine. We can bring out the hard copy on a Tektronic raster scan printer within 20 seconds after we push the button. So the equipment here replaces a whole van's worth of equipment that we had previously had to carry out to sea.

Undersea Cosmic Ray Photo Emulsion Experiments

Kurt Stehling

Manned Undersea Science and
Technology Office
NOAA
Rockville, Maryland

The detection and analysis of cosmic radiation has motivated a series of undersea submersible missions, beginning October 5-8, 1977, off West End, Grand Bahama Island. Innovative applications of undersea technology and engineering have been the distinctive features of these experiments, which have been mounted at roughly 6-month intervals since 1977.

A University of Washington-Western Washington University cosmic ray scientist has been the senior experimenter, supported during these missions by NOAA:OOE/MUS&T, and Office of Sea Grant, with the author serving as scientist observer, coordinator, and experiment monitor. The private Harbor Branch Foundation, Inc., of Ft. Pierce, Florida, generously provided most of the ocean engineering and operations support in the form of the *Johnson Sea Link II (JSL)* submersible and a cosmic chamber (Figure 1), among other things. The cosmic ray scientist locked-out two stacks of sensitive photographic emulsion plates, or pellicles, packaged inside Benthos, Inc. glass spheres, into a chamber sitting on the ocean bottom at 1080′. Twelve 6″ × 6″ glass plates 1/16″ thick were coated first with liquid photographic emulsion and then dried by the University of Washington's Dr. Peter Kotzer, who, with Harbor Branch's Richard Roesch, operated in the rear lock-out compartment of the *JSL*, which was locked onto the cosmic chamber. I was in the front plexiglass pilot sphere from where I monitored the procedures. The reason for preparing the photographic

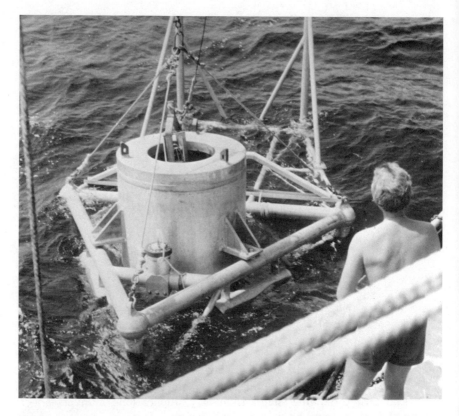

Figure 1. Harbor Branch Foundation's "Cosmic Chamber" being lowered to seafloor about 2000 feet deep off the Bahama Islands. The chamber contains glass spheres for one year deployment.

emulsions *in situ* at 1000' instead of on the ocean surface was to prevent fogging of the plates by the ever-present dense surface flux of unwanted nuclear* and extra-nuclear† particles (such as, electrons).

The ocean water is an isotropic and homogeneous filter that at depths below a few hundred feed filters out most cosmic ray particles except, for these experiments, detection sensitivity, muons or heavy electrons. These are important end products of the cosmic ray flux that at these depths consists mostly of neutrinos that produce concomitant muons.

The stacked emulsion pellicles, usually six in each sphere, are left for several months on the ocean floor‡ where the silver halide film accumulates

 * Hadrons, e.g., neutrons, protons, etc.

 † Leptons, e.g., electrons, positrons, etc.

 ‡ One sphere was left in the docking chamber at 1000' and the other was placed, for reference purposes, at 400' in 1977. In the spring of 1978 the 400' sphere was recovered. The 600' sphere was recovered in May, 1979.

tracks (Figure 2) resulting from muon collision processes within the sensitive granular structure of the films. The emulsions are developed in the *JSL,* again *in situ,* for the same reason as above, and then are shipped to the University of Washington's Physics Laboratory for analysis and measurement, with a microscope, of the collision events' tracks.

These unique, if not historic, experiments were attended by a number of novel features of undersea technology and ocean engineering, as follows:

1. The Harbor Branch Foundation designed, built, tested, and then deployed on ocean bottom at a depth of 1000 feet an aluminum lock-out chamber that became the receptacle for the glass sphere emulsion cassettes. The other locked-out glass spheres were moved by the submersible to 400' and 600', for reference purposes. The chamber, a spare *JSL* lock-out compartment having a 6000' crush depth, was mounted on a separate support structure.

2. Nine-inch diameter Benthos, Inc. glass spheres were used for the emulsion stack housings, with the pellicle stacks placed inside in a manner that maintained a vertical orientation. The stacks were enclosed in a black, opaque plastic box to prevent stray light from fogging the emulsions. The glass hemispheres were then sealed with special tape. The edges are ground to almost guage-block tolerances, so that with clean surfaces water leakage is essentially impossible at depth, even without sealing tape. After mission

Figure 2. Typical muon-nucleus collision event track recorded in emulsion.

2—spring 1978—it was decided to flood the sphere with helium and add desiccant, before sealing, in order to reduce long-term emulsion fading resulting from oxidation and high humidity.

3. Several pieces of novel emulsion treatment apparatus were also designed and built or provided by Harbor Branch engineers and technicians:

A drying oven for drying the emulsions in a thermostatically controlled low-humidity atmosphere (Figure 3). Harbor Branch also provided special desiccant containers.

Several cooling, washing, and storage receptacles.

A level-table whose heat transfer cooling fins were immersed in an ice water solution, keeping the table at essentially 32-34°F.

An insulated box containing the equipment used for developing, washing, and fixing the emulsions (at 1000' depth).

Miscellaneous timers, red photo-lights, stirrers, magnifiers, etc.

The pouring, coating, and drying of the Kodak emulsion within the rear *JSL* chamber is an uncomfortable and tedious process; some dives have taken as long as 10-11 hours from time of launch of the *JSL* from the RV *Sea Diver* or RV *Johnson* until its return.

The cosmic chamber has a sonar pinger installed which aids the *JSL* pilot(s), Jeff Prentice or Tim Askew, in locating the chamber once the *JSL* reaches bottom. This task is made easier since the surface support ship can position itself, via Loran C reference, almost on top of the site. The 1000' spheres within the cosmic chamber (which is covered by a plastic lid when not locked on, to prevent fish from getting inside with the cassette) are of course available without search. The reference cassettes at 400' (in 1978) and at 600' (1978-79) are located by the *JSL* by means of predetermined compass headings, as well as line-of-sight.

The history of undersea cosmic ray detection by photo emulsions prepared *in situ* goes back to early 1972 when I suggested to scientists at the University of Washington that the HYDROLAB habitat, then located off Grand Bahama Island, could be used as a residence or lab for cosmic radiation experimenters wishing to put some water between themselves and the sky. This suggestion was considered novel at the time; electronic detectors that do not reveal the exact nature of cosmic particles or integrate the particles' collision events in the same fashion had been lowered in the past beneath the sea from time to time. A mine shaft would of course also interpose a filter or shield between the detector and the sky. However, the overburden is not homogeneous or isotropic in a mine and there is much natural radioactivity. The last drawback is inconsequential for the detection of certain elusive particles such as solar neutrinos.

After some years of HYDROLAB work with P. Kotzer, it became evident that the shallow operating depths at or near HYDROLAB (50'-200') precluded

Drying Agent

Heater

Fan

Humidistat

Thermostat

Figure 3. Diagram of emulsion drying box, one of a number of pieces of novel emulsion treatment apparatus designed and built by the Harbor Branch Foundation.

much data acquisition; more depth — at least 1000' — would be needed before significant muon stopping processes (within the emulsion) could be observed. In 1976-77 I persuaded Edwin Link of the Harbor Branch Foundation to consider the notion of using the *JSL* for emulsion processing and somehow locking out emulsion cassettes — these being the Benthos glass spheres

mentioned above which are inexpensive, cosmic ray transparent, very water pressure resistant, and do not corrode.

In 1977, E. Link and S. Johnson, president of the Harbor Branch Foundation, in consort with the recommendations of their own staff, especially Bob Jones, Director of Science Laboratory, and those of their review and advisory groups agreed to the use of the *JSL*. Jean Buhler, Director of the Engineering Lab, and his staff, with Roger Cook, Director of Operations (who suggested the cosmic chamber), then proceeded to design and build the necessary support equipment described earlier.

The transfer of the cassettes is done at atmospheric pressure. Once a lock-on seal is achieved (the *JSL* bottom hatch flange was slightly modified to permit a mating/sealing contact with the cosmic chamber by means of a split O-ring, the 1000' pressure is relieved in the cosmic chamber's interior and the extension of the aft *JSL* rear dive chamber's hatch, by venting into the dive chamber's bilge. A little water squirts out and then atmospheric equilibrium is achieved. The sub then sits solidly and firmly on the cosmic chamber. It is brought down onto this chamber by two guide rods engaged by two V-cups on the *JSL*.

The cosmic ray data obtained so far from the HYDROLAB, and especially from the *JSL* experiments, while not historic, have yielded solid evidence of new types of muon interactions, yielding further clues to the composition and origin of cosmic rays. The undersea experiments have had other unexpected results. The ONR is now interested in neutrino (massless and chargeless subnuclear particles) propagation through the earth into the oceans from a neutrino generator such as the Fermi Accelerator Laboratory, Batavia, Illinois. The neutrino beam, which easily passes through the earth, could perhaps carry interception-proof message data to our nuclear and other submarines.

Various high-energy physicists and astrophysicists have suggested a giant deep-sea neutrino telescope or detector. That, unlike the *JSL* experiments, is BIG PHYSICS and will need multimillion-dollar, multi-agency support. However, it is intriguing to note that a greater consciousness among the physics community of the oceans' potential as a physics laboratory may lead to some new and perhaps dramatically productive physics and engineering physics. We are pleased that the modest HYDROLAB experiments of the early 1970s and the *JSL* missions may have helped to arouse this consciousness.

REFERENCES

Anderson, S., P. Kotzer, and J. J. Lord. 1974. Neutron production by muons at various depths underwater. *Amer. Phys. Soc.*, June.

Jones, R. S. and P. Kotzer. 1978. Manned submersible study of cosmic radiation deep in the sea. *Sea Technology*.

Kotzer, P., S. Anderson, J. J. Lord, and K. Stehling. 1975. Slow muons and other associated, locally produced particle fluxes at 60 meters underwater. *Proc. 14th Interntl. Cosmic Ray Conf.* Max Planck Institut für Extraterrestrische Physik, München, Germany.

Kotzer, P., S. Anderson, and J. J. Lord. 1975. Anomalous stopping particles at great depths underground. *Proc. 14th Interntl. Cosmic Ray Conf.* Max Planck Institut für Extraterrestrische Physik, München, Germany.

Kotzer, P., D. Davison, J. J. Lord, S. Neddermeyer, and K. Stehling. 1976. Design parameters of large scale underseas supernova neutrino detectors. *Bull. Amer. Phys. Soc.,* April 1976.

Kotzer, P., J. J. Lord, and F. Reines. 1976. DUMAND as a supernova neutrino detector. *Proc. 1975 Summer Workshop on Neutrino Interactions in the Ocean Depths and on Oceanographic Physics and on Marine Engineering.* Western Washington State University, Bellingham, Washington.

Stehling, K. R. 1973. Neutrino detection in an undersea habitat. *Sea Technology.*

Stehling, K. R. 1977. Keeping a watery eye on the universe. *NOAA Magazine* 7:2.

Analysis of Underwater Photographic and Visibility Systems by Mathematical Model Employing Observed Ocean Data

Joseph Pollio and Renkert G. Meyer

U.S. Naval Oceanographic Office
Bay St. Louis, Mississippi

INTRODUCTION

Underwater photographic systems, perhaps more than any other ocean data gathering system, are subject to speculation in the evaluation of their performance. This may be true because almost anyone can evaluate the product. Unlike most technical data, which describe observed variables with cryptic, squiggly lines or with reams of computer listings, photographs are data records familiar to everyone. This familiarity and the apparent ease of data evaluation and interpretation have caused underwater photographic systems to be included in the tool kits of many oceanographers, marine biologists, and geologists. This is as it should be; but too often, because of their deceptive simplicity, photographic systems have been either specified or purchased with little or not attention given to the harsh constraints imposed by the deep ocean environment.

Unfortunately, even when some of the constraints are taken into account, the conclusions drawn are often either misleading or incomplete. This is due to the complexity of the computations required to duplicate the environment and the photographic system. There are, for example, at least nineteen variables that should be introduced into a mathematical model of an underwater photographic system, including: the camera and film, the strobe light and its geometric relationship to the camera, the nature

of the water, the target and background reflectivities, and the geometric relationship of the target to the camera. Manual computations with all these variables are understandably tedious, but the use of minicomputers has made the duplication of the underwater photographic system by a mathematical model a reasonable approach.

The photographic system on Teleprobe (Figure 1), a remote tethered vehicle developed at the U.S. Naval Oceanographic Office (NAVOCEANO), was modeled to demonstrate the usefulness of this technique (Pollio 1972). The Inshore Projects Division, Special Projects Branch, U.S. Naval Oceanographic Office, conducts surveys to describe the environment in Naval Exercise Areas (NEA). These studies include descriptions of the

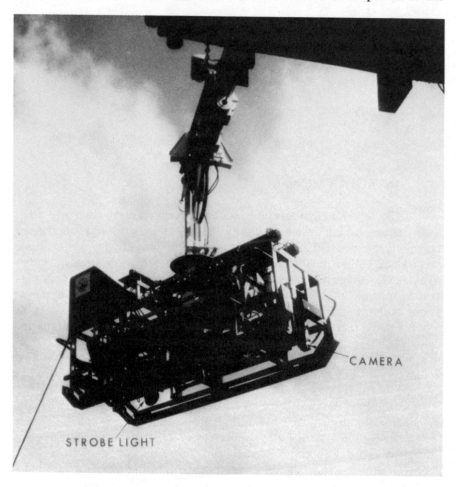

Figure 1. The photographic system on Teleprobe.

seafloor, the water column, and the atmosphere. Teleprobe was developed in support of this program and routinely collects side-scan sonar, photographic, television, magnetic, and bathymetric data, all of which are correlated to a geographic position by precise and accurate transponder navigation. Quality optical data are also required to describe adequately the visibility in these exercise areas. A mathematical model has been developed to predict large target visibility by duplicating the camera systems used in the deep ocean environment (Figure 1). This model assumes that light energy reaching the focal plane is provided by artificial illumination, such as a strobe light.

DISCUSSION

In designing a mathematical model, the question that arises first is: what numbers should be used as a quality index to describe a photographic phenomenon? The answer is not a simple one and has been the topic of several symposia. It is argued that to describe quality, several entities are required, such as resolving power, optical transfer function (or its modulus, modulation transfer function), and single bar acutance tests (Brock 1967). Even so, one expression— scene modulation—is basic to these descriptions (Lamberts 1958; Goodman 1968). Because of this, and because scene modulation is easy to describe, scene modulation was selected as a quality index. Both the scene modulation index and the total exposure index are the major program outputs for the focal plane. *The prediction of a viewing system's visibility is determined by the scene modulation and total exposure.* Both of these quality indexes are computed in the form of a marix of elements on the focal plane. The scene modulation and total exposure can be evaluated either independently for each element on the focal plane matrix or can be totaled as weighted averages over all the elements in the matrix (weights are determined by the element's location and area in the matrix). This quality index is called the "area weighted scene modulation" and represents, with one number, the over-all visual quality for the entire focal plane or any element in the focal plane. For example, the area weighted scene modulation provides a visual quality estimate for different positions in the photograph. This ability to determine whether or not a specific target is visible as a function of position in a photograph is especially useful for target detection during search operations. Maximum photographic visibility can be achieved by assuming or measuring the water clarity, then holding the water clarity constant, and finally adjusting the model inputs, that is, viewing and lighting geometry, spectral light source emittance, and the spectral camera (filter, lens) and film characteristics, until maximum visibility is achieved.

Depending on model inputs, the Visibility Evaluation for Underwater

Systems (VEUS) model has the flexibility to represent a variety of deep-sea viewing systems and situations. This flexibility enables the analyst to match the deep-sea camera, television, or human response with that ot the VEUS model. Teleprobe's deep-sea viewing system was simulated with VEUS and formed the basis for this model test. Here, computations are determined with Teleprobe's geometry shown in Figure 2. The camera and strobe are on the X-axis, with the camera located at the origin $(X, Y, Z = 0$ meters). The long axis of the field of view can be coincident with either the X- or the Y-axis (Figure 3). The camera focal length is a nominal 35 mm, with a lens fall-off exponent of 4.0 and an angle of view of 52° x 26° (Figure 4). The camera is vertical and the strobe is inclined 15° toward the camera field of view. The strobe light has a parabolic reflector that has a sharp edge cut-off of 45° radial to the parabolic axis. The parabolic shape of the reflector causes most of the light pattern to be directed toward the target plane (Figure 5). In the VEUS mathematical model the focal plane (film plane or TV receptor) is divided into a focal plane matrix of 15 elements that represent target locations. The position of this matrix of target location can be varied to include the entire photograph, or for detailed analysis, a selected portion of the photograph.

The VEUS program computes the following components of irradiance in the focal plane: (1) image-forming light from the target, (2) diffuse forward scattered light from the sea-floor areas that surround the target, and (3) back-scattered light from the water path (viewing distance) between the camera and the target (Figure 6). These components of focal plane irradiance are calculated for each element in the focal plane matrix. They reveal to the analyst how model inputs affect photographic results. An analyst with a background in marine optics or deep-sea photography can observe how variances in model inputs change the photographic response for a particular viewing system, in this case for Teleprobe.

The spectral irradiance reaching the focal plane from the light source is attenuated spectrally in the water column, and then is further reduced by reflection off the target and background (seafloor or water column itself). In VEUS,, the visible spectrum is divided into 16-wavelength bands, each twenty nanometers wide. Light contributions from each band are calculated separately and then added to obtain over-all image irradiance. The water path is divided into horizontal layers, or slabs, for the back-scatter computation. Spectral back-scattered light for each layer is computed separately and then totaled to obtain the total path back-scattered irradiance (Figure 6). Spectral light attenuation between the light source and target is assumed to be that of a wide-angle light, which, in turn, leads to the assumption that the light source emittance is attenuated by the diffuse attenuation coefficient $K(\lambda)$. Spectral light propagation losses from reflection off the target and background are assumed to be images and are attenuated by the spectral

TELEPROBE DEEP SEA VIEWING & MAPPING SYSTEM

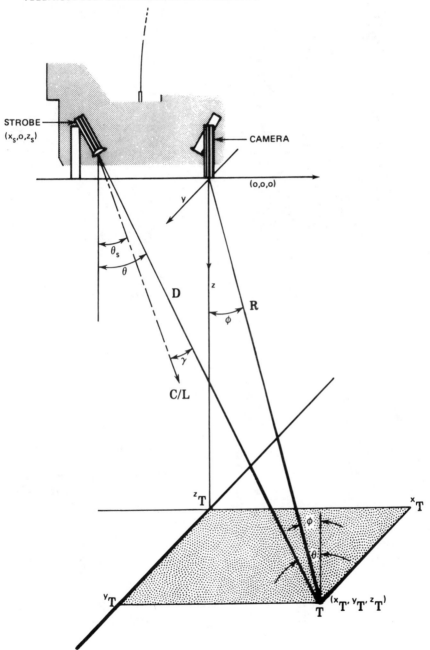

Figure 2. Geometric relationship between camera, strobe, and target.

Figure 3. Field of view related to *X*- and *Y*-axis.

1. f-NUMBER, APERTURE
2. LENS FALL-OFF EXPONENT, n
 (FALL-OFF = cos$^n\phi$)
3. LENS AND FILTER TRANSMISSION, T(λ)
4. FILM RELATIVE EFFICIENCY, h(λ)

Figure 4. Camera characteristics.

Figure 5. Strobe characteristics.

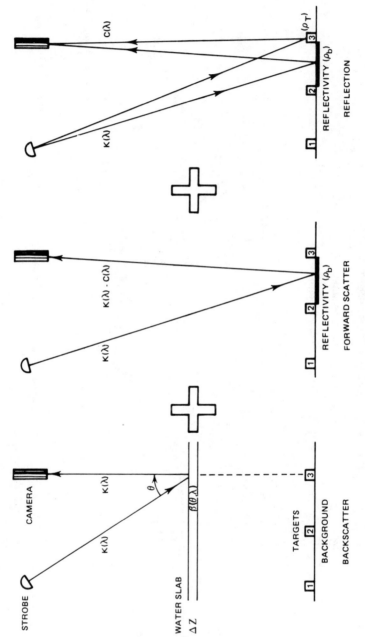

Figure 6. Light energy reaching the film plane.

volume (or beam) attenuation coefficient $C(\lambda)$. For forward-scattered light the attenuation is described by the diffuse attenuation coefficient $K(\lambda)$. Back-scattered and forward-scattered irradiance is not considered to be image-forming light and produces a fog level on the focal plane. This irradiance fog level increases total exposure but reduces scene modulation (visibility). Because of this fog level, image irradiance has to increase to a level where it exceeds the scattered fog irradiance for visual detection (Figure 6).

MEASURED DATA

As previously mentioned, the VEUS model estimates visual quality for deep-sea viewing systems. To accomplish this, model inputs have been measured whenever possible and are listed in Table 1. Measured data include geometric arrangement of the cameras and strobes, water clarity characteristics, and reflectance (both the target and the seafloor). Water clarity characteristics were measured spectrally and include: the volume attenuation coefficient, $C(\lambda)$, measured with a Scripps transmissometer (Austin and Ensminger 1968); the volume scattering function, $B(\theta, \lambda)$, measured with a Brice-Phoenix scattering meter coupled with a mono-chrometer (McCluney 1976); and the bottom and target reflectance, measured with a Gardner diffuse reflectometer (Austin 1974). Spectral light transmission and scattering measurements were made at selected wavelengths and interpolated over the full 16-wavelength band spectrum. Bottom reflectivities were estimated by obtaining bottom samples and measuring their reflectivities. The target reflectance, however, was assumed to be that of typical submarine hull paint (Austin 1973). The diffuse attenuation coefficient was either measured with a Scripps illuminometer or calculated from the measured volume attenuation coefficient (Shannon 1975; Ofelt 1976). See Table 1.

CONCLUSION

The VEUS model predicts the total light energy and scene modulation for each element in a focal plane matrix (see target positions in Figure 3). The total exposure irradiance reaching the focal plane is the total light energy contributed by back-scatter, forward-scatter, and target and background reflections (See Figures 2 and 6). The program lists each of these contributors to total focal plane exposure spectrally, and each contributor can be anayzed either for specific target element locations on the focal plane or on the entire focal plane matrix.

Table 1. Input Data

Name	Symbol	Units	Data Acquisition
Target position X	θ_{xi}*	Degrees	Selected
Target position Y	θ_{yi}	Degrees	Selected
Target depth	z_{Tj}	Meters	Selected
Strobe offset X	x_S	Meters	Selected/measured
Strobe offset Z	z_S	Meters	Selected/measured
Strobe orientation	θ_S	Degrees	Selected/measured
Target reflectivity	ρ_T	Fraction	Selected/measured
Seafloor reflectivity	ρ_S	Fraction	Selected/measured
Camera f number	F	—	Manufacturer, selected
Lens fall-off exponent	$n\theta$	—	Manufacturer, selected
Slab thickness	Δz	Meters	Selected
Strobe normalizing coefficient	a	Watt sec/ster	Estimated
Strobe intensity pattern normalized	$\ln(a,B)$	—	Measured
Wavelength Dependent Inputs			
Strobe Spectral Dist.	$g(\lambda)$	Fraction	Manufacturer, measured
Diffuse Attenuation Coefficient	$K(\lambda)$	$(\text{Meter})^{-1}$	Calculated
Attenuation Coefficient	$C(\lambda)$	$(\text{Meter})^{-1}$	Measured
Backscatter Function	$\sigma_B(\theta,\lambda)$	$(\text{Meter ster})^{-1}$	Measured
Lens and Filter Transmission	$T(\lambda)$	Fraction	Manufacturer, measured
Film Relative Efficiency	$h(\lambda)$	Fraction	Manufacturer

* Subscripts are defined in Table 2.

Table 2. Subscripts

Subscript	Meaning
i	Specified target angular position (target location in format matrix)
j	Specified target depth
λ	Specified wavelength
S	Strobe light
q	Specified water slab integer
b	Seafloor (bottom background)
n	Normalized strobe beam pattern
B	Backscatter as a function of angle and wavelength
F	Forward scatter
T	Target
$n\phi$	Lens fall-off exponent (superscript)

The versatility of the focal plane matrix is demonstrated in Figures 7, 8, and 9. In Figure 7, a profile of exposure and scene modulation as a function of target element is plotted for target locations, or elements, 1 through 5 in two deep-sea photographs (refer to Figure 3). All model inputs are the same for both photographs; only the bottom reflectivities are different. In Figure 7a, target element 5 demonstrates that insufficient light energy for proper exposure was rapidly approached as the strobe light reached its outer limits of coverage. The versatility of predicting light source illumination of the target allows the analyst to utilize the light source for best results. In Figure 7b, at target location 5, sufficient light energy for proper exposure exists; however, insufficient scene modulation for target detection is predicted. This low scene modulation results from the closely matched reflectance values between the bottom and the assumed target.

Another problem that can be analyzed with the VEUS model is the use of improper film and print developing (Figures 7 through 9). The top photograph in Figure 8 was taken too close to the bottom, and shows the familiar hot spot. Standard deep-sea film and print processing reveal little useful image information. However, the VEUS model predicted the contrary. Because the photograph negative contained imagery as predicted, enhancement techniques such as electronic printing (Log E electronic printing projector) produce the photographic print from the same negative.

As previously mentioned, visibility estimates are required for NEA areas. In order to predict this visibility, the area weighted averages of both total exposure and scene modulation are computed for the entire film focal plane matrix as a function of viewing distance. The area weighted average scene modulation is a quality index obtained by assigning weights to an evenly distributed target field as a function of the area each target represents. Thus, a single number can represent the visual quality of an entire photograph. For example, in Figure 9 the area weighted average scene modulation and total exposure are computed as a function of viewing distance. The variables used for this computation represent actual data observed in deep water. As expected with increased viewing distance, total exposure and scene modulation decrease. The total exposure approaches a constant value at 9 meters because the only contribution of light energy (exposure) reaching the film plane is produced by the water column irradiance (back-scatter). Similarly, scene modulation decreases from a target modulation of 40% (medium contrast target) to 2% at 9 meters.

Because the exact cut-off point of target detection is nebulous when modulation values fall below 2%, photographic quality degenerates to a point of uselessness. It is generally accepted in underwater applications that the threshold of detection for the human eye is 2% (Duntley 1963, 1967). This agrees with actual photographic observations and VEUS predictions. When a scene modulation of 2% occurs, the maximum visibility distance is reached. Note that although sufficient light energy may be

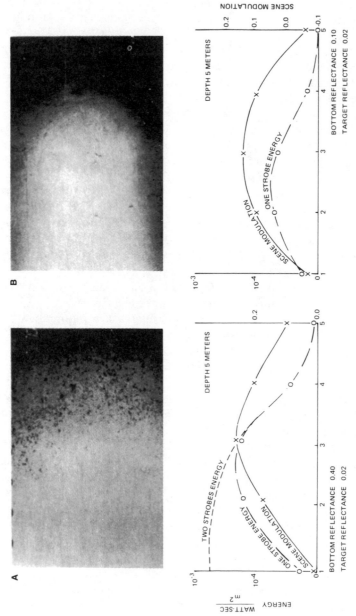

Figure 7. Scene modulation and total exposure.

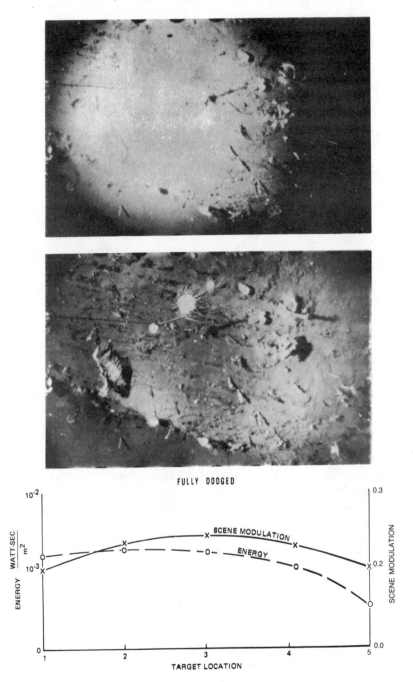

Figure 8. Scene modulation versus total exposure.

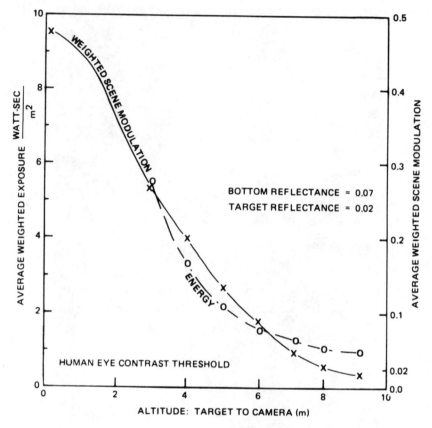

Figure 9. Area weighted scene modulation and total exposure.

available to expose the film, a scene modulation of less than 2% will result in no targets being visible in the photograph. Hence, either higher film efficiency or increased illumination under the same conditions will not improve target visibility!

The aforementioned results represent the ability to estimate the maximum range of target detection or visibility for a photographic system. These results are the first attempt to use the model with measured water clarity characteristics. The model allows us to test various hypotheses on camera and light arrangements, filter-film combinations, and types of strobe lights and reflectors.

The knowledge gained by practical experience in conjunction with this model analysis has generated two possibilities: (1) comparing the known reflectivities on the compass target (Figure 3) and their measured photographic densities with the measured sea floor densities on the photograph, an estimate of bottom reflectivities can be extrapolated; and (2) if VEUS can

predict photographic visibility (based on water clarity measurements), it may be possible with sufficient comparative observations to predict water clarity from a photographic response, that is, a computerized Secchi disc.

ACKNOWLEDGMENT

Special thanks to Dr. Lawrence E. Mertens (RCA) for his contributions toward the development, simplification, and assumptions used in this mathematical model.

REFERENCES

Austin, R. W. and R. L. Ensminger. 1968. A microprocessor controlled instrument for measuring the transmittance and reflectance of ocean waters. SIO Ref. 78-23, August 1968.

Austin, R. W. 1973. The performance of reflectance properties of submarine concealment paints. SIO Ref. 73-35, October 1973.

Brock, G. C. 1967. Reflections on thirty years of image evaluation. *Photographic Science and Engineering* II: 5.

Duntley, S. Q. 1963. Light in the sea. *J. Optical Soc. Amer.* 1967. 53: 214-233.

Duntley, S. Q. 1967. Visibility in the oceans. *Optical Spectra,* Fourth Quarter 1967.

Lamberts, R. L. 1958. Measurement of sine-wave response of a photographic emulsion. *J. Optical Soc. Amer.* 49: 5.

McCluney, W. R. 1976. Hydrosol optical properties experiment calibration measurement procedures and error analysis. Personal papers, January 1976.

Mertens, L. E. 1970. *In-water Photography Theory and Practice.* New York: Wiley-Interscience.

Ofelt, G. S. 1976. Relation between beam and diffuse attenuation coefficients in the Lower Chesapeake Bay area. Old Dominion University, TR-32, NASI-14193, TA-3, October 1976.

Pollio, J. 1972. Remote underwater systems on towed vehicles. *Photogrammetric Engineering,* October 1972.

Shannon, J. G. 1975. Correlation of beam and diffuse attenuation coefficients measured in selected ocean waters. *SPIE* 64: 3-10.

Woodleif, T., Jr. 1973. *SPIE Handbook of Photographic Science and Engineering* (ISBN 0-471-81N80-1).

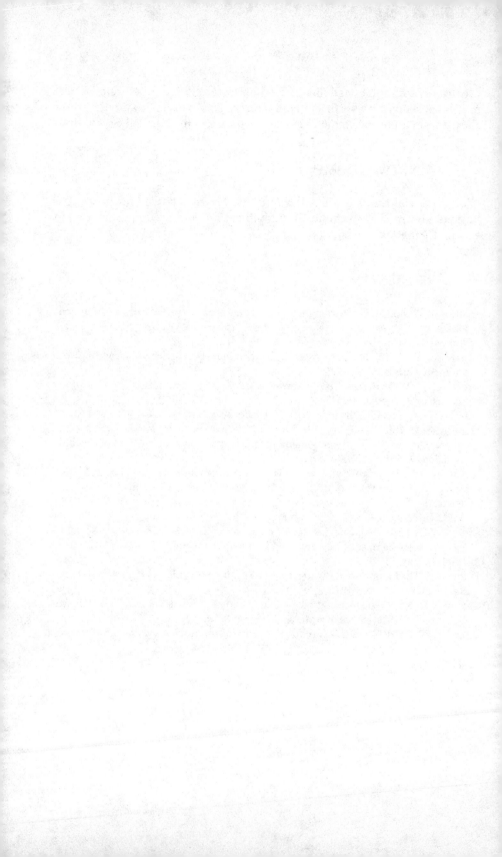

Section VIII

Films and Processing

Maximizing Image Quality in Underwater Photography

David C. Pitcher

Ocean Projects Division
U.S. Naval Oceanographic Office
National Space Technology Laboratories
Bay St. Louis, Mississippi

INTRODUCTION

A prerequisite for optimizing the performance of an underwater photographic system is the ability to predict how its performance will vary, depending on prevalent environmental conditions and the combination of system components utilized. System components, such as the sensitized materials, illumination source, lens, filters, and the exposure and processing of the sensitized materials, can then be manipulated to meet specific survey requirements within the expected range of environmental parameters.

This paper provides an overview of a few basic problems confronting an underwater photographer, characteristics of photographic materials desirable for various in-water applications, and exposure and processing techniques that enhance the contrast and resolution of underwater photographs.

PROBLEMS AFFECTING IMAGE QUALITY IN UNDERWATER PHOTOGRAPHY

Image Contrast

One basic problem encountered in underwater photography is the low contrast range of in-water subjects. The contrast transmittance of a scene

is reduced by (1) the superimposition of light scattered from particles in the transmission path on the desired image, known as back-scatter; (2) forward scattering of direct light rays from the scene; (3) refractive deterioration of the image; and (4) the selective absorption of light. A number of methods can be used to minimize the harmful effects of these four factors.

Back-scatter can be decreased by employing an illumination geometry that maximizes the distance from the film plane to the common field of view of the camera and light source. The amplitude of back-scatter can be further reduced by using polarization techniques when a 75% reduction in the intensity of light reaching the film plane will still produce acceptable film exposure levels (Gilbert and Pernicka 1966; Mertens 1970). Spectral filters can be used to compensate for selective absorption when a definite color difference between the subject and background exists and the total water-path distance from the light source to the film plane is less than 6-8 meters. Utilization of high-contrast sensitized materials and developers will enhance image contrast. Further increases in image quality can be achieved through print exposure techniques such as dodging and diffuse mask printing.

Light Attenuation

A second problem in underwater photography, due to the optical properties of the light transmission path in water, is a drastic reduction in the intensity of light supplied over relatively short water-path distances. Due to a minimum exposure level required for image recognition, the operating altitude and, consequently, the area per photograph is limited. Area coverage can be increased by modifying a number of system parameters: decreasing lens focal length, or increasing film sensitivity, strobe illuminance, and lens aperture. Various system performance characteristics are related to these modifications and require clarification.

Although decreasing the focal length of a lens increases its angle of view, it also introduces additional lens distortions and aberrations in most cases (Mertens 1970). As film sensitivity is increased, either by employing a film with a higher ASA rating or by pushing the effective film speed by special processing techniques, root mean square (rms) granularity also increases. This increase in rms granularity or noise can obscure details present in targets of high spatial frequency. Boosting strobe illuminance will not increase the operating altitude or performance of an underwater photographic system in turbid environments, due to an associated increase in scattering that can completely mask any recorded images. The reduction in depth of field corresponding to an increase in lens aperture places limitations on this approach to increasing film exposure level. In addition, lens performance usually decreases as lens aperture increases (Brock 1970).

Film Exposure

A third problem affecting the quality of underwater photographs is a fluctuation in the intensity of light reaching the film, due to variations in camera/strobe altitude, target reflectivity, and the topographic relief of the bottom. Automatic regulation of light source intensity would compensate for oscillations in film exposure level related to camera/strobe altitude and possibly target reflectivity. However, when a photographic system lacks automatic exposure control, when a survey area is characterized by high relief topographic features, or when an illumination geometry produces a wide range in the relative light intensity across the scene, then a film with an exposure latitude greater than 1.5 f stops is recommended.

FILM CHARACTERISTICS

A number of characteristics require examination before the film best suited for a specific underwater application can be selected. These are:

1. Speed
2. Exposure latitude
3. Contrast
4. Granularity
5. Resolution
6. Acutance

Speed

The speed or light sensitivity of a film is directly related to the size and number of silver halide grains suspended in the emulsion. The probability that a grain will receive the quanta of light required for subsequent development is proportional to the size of the grain. An emulsion composed of relatively large silver halide grains has, therefore, a high speed or ASA rating, and vice versa.

The speed of photographic materials is reflected by the position of the characteristic curve with respect to the exposure scale. The ASA speed rating is based on the number of photons required to produce a specific image density known as the speed criterion. The farther to the left the characteristic curve is situated, the shorter is the exposure required to produce any one density on the curve and, therefore, the faster the emulsion (see Figures 1 and 2).

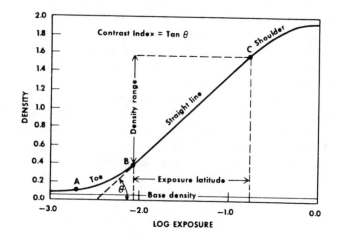

Figure 1. A characteristic curve for negative film.

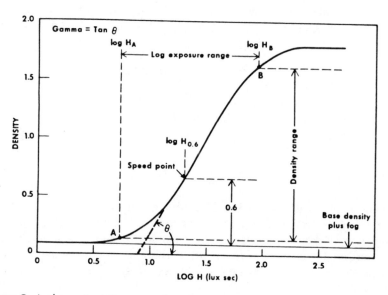

Figure 2. A characteristic curve for photographic paper. *(After Weiss 1973.)*

Exposure Latitude

Exposure latitude indicates the range of exposure levels over which a photographic emulsion will yield an acceptable negative or print. Latitude can be determined from the characteristic curve by analyzing the range of luminance values that a photographic material can reproduce as indicated

by the log exposure range between a point near the toe of the curve and another point located on the shoulder (see Figures 1 and 2). The exposure latitude of a particular emulsion will vary depending on the brightness scale or contrast range of the subject. In general, the higher the emulsion speed or the smaller the contrast range of the subject, or both, the greater the exposure latitude.

Color films have much less exposure latitude than most black-and-white films; the exposure must lie within narrow limits (less than 0.5 f stops) to achieve good results. Color-negative films may be preferred to color-reversal materials since they have somewhat more latitude, particularly on the overexposure side (Mertens 1970).

Contrast

The contrast of a photographic material is related to the rate of change of density *(D)* with log exposure *(H)*:

$$\text{Contrast} = \frac{29DD}{\varDelta \log H}$$

The contrast of photographic materials is described by the average gradient of the straight line portion of the characteristric *(H* and *D)* curve (see Figures 1 and 2). In general, the steeper the slope of the curve, the higher the contrast. The terms contrast index (film) and contrast grade (paper) are used to evaluate the contrast of photographic materials (see Figures 3 and 4).

The contrast rating of a photographic material will vary depending on the spectral compositon of the exposing light, time of exposure, and degree of development. When comparing contrast indices, therefore, it is important to establish that they were calculated under identical conditions.

Granularity

The rms variation in the density of a uniformly exposed and processed film is used as the measure of granularity (see Figure 5). The size and distribution of silver halide grains in an emulsion directly affects the granularity of a film. High-speed film emulsions (such as ASA 400) characterized by relatively large silver halide grains and, consequently, a low particle desity per unit area, produce grainy results. Conversely, slow emulsions (such as ASA 32) characterized by relatively small silver halide grains and a high particle density per unit area produce a fine image grain texture.

The granularity of an emulsion imposes a limit on the highest spatial

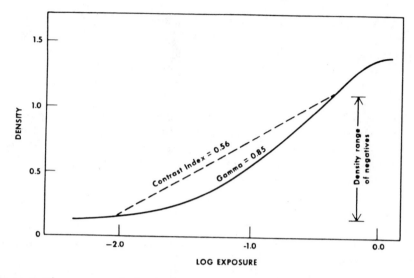

Figure 3. The contrast index is determined from the slope of a straight line between the minimum and maximum density points of the usable portion of the characteristic curve.

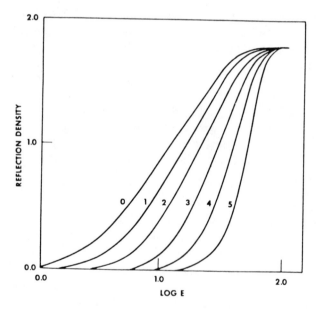

Figure 4. Characteristic curves for various contrast grades of printing papers. *(After Mertens 1970.)*

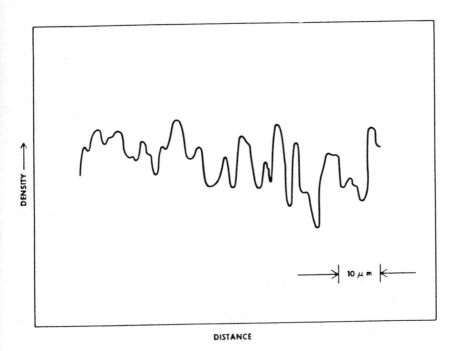

DISTANCE

Figure 5. Granularity is a measure of the standard deviation of density in a uniformly exposed and processed photographic material. *(After Scott and Brock 1973.)*

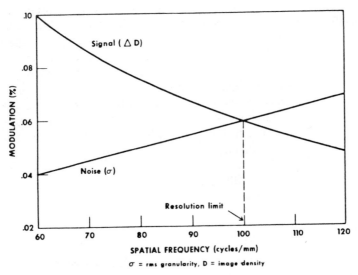

Figure 6. When noise level (rms granularity) exceeds signal level (image density), a resolution limit is reached.

frequency that can be resolved. As the spatial frequency of a target is increased, the modulation of granularity (noise) increases while the modulation of image density (signal) falls off. When the modulation of granularity just surpasses that for image density, a threshold for image recognition known as the resolution limit is reached (Figure 6). In general, rms granularity increases with density. Hence, overexposure or overdevelopment should be avoided.

The calculation of rms granularity depends on the scanning aperture of the microdensitometer and the density above support to which the film is processed. It is extremely important, therefore, to compare rms granularities computed for identical criteria.

Resolution

Resolution is a measure of the ability of an optical or photographic system to reproduce fine details present in a test target. It is usually expressed in lines/mm or cycles/mm and represents the highest spatial frequency that can be distinctly recorded on film.

The resolution of an underwater photographic system is limited by film granularity and lens distortions and aberrations. The resolving power of a lens-film combination can be determined by simultaneously plotting the optical transfer function (OTF) of the lens and the emulsion threshold curve characteristic of the film. The spatial frequency corresponding to the intersection of the two curves is the resolution limit or resolving power of the lens-film combination. The higher the characteristic film granularity, the higher the noise level (emulsion threshold) and the lower the spatial frequency corresponding to the resolution limit (see Figure 7). Since the OTF of a lens falls off when the target contrast ratio is reduced, resolution is inversely proportional to target contrast.

The measurement of resolution is affected by film exposure level, lens OTF, degree of development, and the contrast ratio of the test target. Thus, when comparing the resolution of films it is imperative to ascertain that measurements were made under identical conditions. Investigation of film modulation transfer functions (MTF) is also suggested. Films with different MTFs, and consequently different performance capabilities, can yield the same resolution limit (see Figure 8).

Acutance

Acutance is an objective measure of the physical characteristics that give the subjective impression of sharpness in a photographic image. It is measured in terms of the mean square of the density gradients across the image of an ideal sharp boundry or edge, as illustrated schematically in

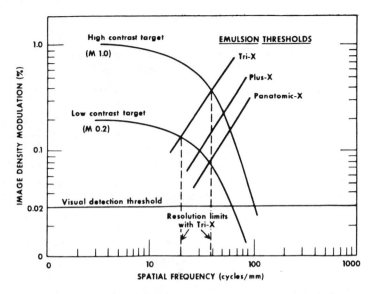

Figure 7. Resolution depends on the target contrast and the emulsion threshold. Although films A and B yield the same resolving power, they differ in their performance capabilities. *(After Mertens 1970.)*

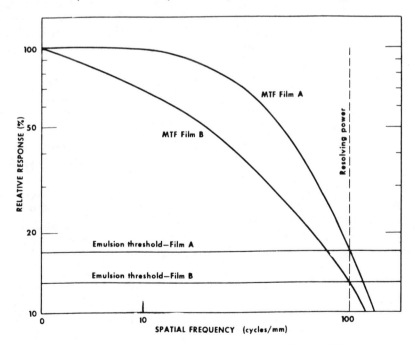

Figure 8. Determination of resolving power from film MTF and emulsion threshold. Although films A and B yield the same resolving power, they differ in their performance capabilities. *(After Mertens 1970.)*

Figure 9. The ideal density image would have the rectangular profile suggested by the broken line. Any real image has a gradually sloping profile determined by the edge spread function of the emulsion, the H and D curve, and any adjacency or other nonlinear effects (Brock 1970).

Acutance is a good indicator of the relative sharpness of emulsions in viewing conditions where grain is not an important factor. It has the merit of expressing qualities of the developed image, as distinct from the abstract nature of the film modulation transfer function. However, it does not offer the facility of the MTF for intergration into the total photographic system, and provides no information concerning the maximum spatial frequency that can be resolved.

EXPOSURE AND IMAGE QUALITY

In the use of any photographic material a fundamental objective is obtaining the correct exposure level. An underexposed photograph lacks detail in the areas corresponding to the shadows; overexposure causes the highlights to become flat and burn out. The art of correct exposure is to produce the least possible exposure that will show the required amount of detail in the shadow portions of the final product. The exposure level will then lie near the toe of the characteristic curve where granularity is at a minimum and, aconsequently, resolution is at a maximum.

Accuracy in determining the optimum exposure point is critical with color films because they have narrow exposure latitudes of ½ f stop or less. With black-and-white films the regulation of exposure is not as critical because they have exposure latitudes much greater than the range of brightness values typical for in-water scenes. However, achieving the optimum exposure level is still desirable from the standpont of maximizing the information storage capacity of black-and-white films.

The optimum exposure point can be determined by simultaneously plotting the sensitometric curve for the material in question and its corresponding signal/noise ratio curve, where signal is equated with density gradient and noise is described by granularity. The optimum exposure level is the point where the signal/noise ratio is greatest (see Figure 10).

Once the reflectivity of the target of interest and the light attenuation function for the survey area have been determined, system parameters such as strobe illuminance and lens aperture can be manipulated to achieve the desired exposure level. With towed systems the exposure should be made in the shortest time possible, thereby eliminating the blur caused by vehicle motion.

When film exposure falls below the optimum level, due to a high system altitude requirement, for example, acceptable photographs can still be

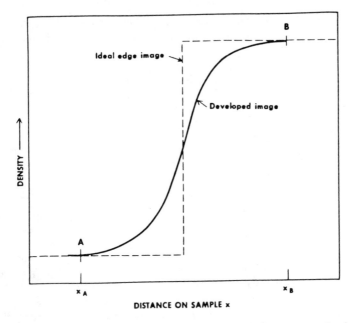

Figure 9. Distribution of density in the image of a geometrical edge.

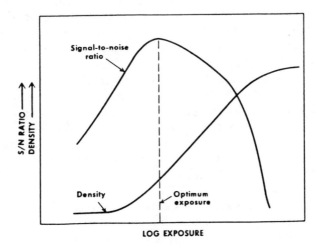

Figure 10. The optimum exposure level is the point where the signal/noise ratio is at a maximum. Signal/noise ratio is a plot of

$$\frac{\Delta D}{\sigma}$$

where ΔD is the density gradient and σ is the rms granularity.

obtained by push processing techniques. The effective film speed can be increased by changing the time of development in accordance with the table below.

Film Exposure	Increase in Developer Time	Effective Film Speed*
Optimum exposure	Use normal time	ASA 125
2× underexposure (1 f stop)	35%	ASA 250
2.5× underexposure (1.3 f stops)	50%	ASA 325
4× underexposure (2 f stops)	75%	ASA 500

* ASA values for Kodak Plus-X film.

SELECTING A FILM FOR A PARTICULAR REQUIREMENT

One common problem in underwater photography, due primarily to the absorption and scattering of light, is the low contrast transmittance typical for in-water subjects. One approach for amelioration of this problem is to employ high-contrast sensitized materials. Utilization of films with a contrast index greater than 1.0 and print papers of contrast grade 4 or 5 will result in the expansion of the range of brightness values present in the scene (see Figures 11 and 12).

Depending on film exposure level and processing, films with medium to high sensitivity (ASA125-500) are recommended. Due to the positive relationship between film speed and granularity, the slowest film that will meet the survey requirement should be selected. When subject details of high spatial frequency are of interest, films with a high resolving power (120 cycles/mm) and high acutance (95) are desireable. When wide fluctuations in the intensity of light reaching the film plane are anticipated, films with an exposure latitude greater than 1.5 f stops should be utilized.

Color film is recommended for situations where the range of film exposure levels encountered does not exceed 1 f stop and the recorded images possess a definite color contrast. Under such conditions color film improves differentiation between rocks of diverse types, sands of contrasting mineral composition, encrusted and recently abraded gravels and rocks, and living and dead organisms (Trumbull and Emery 1967). When film exposure level oscillations exceed 1 f stop or the recorded images lack color contrast, or both, either because of a low inherent color contrast or due to the selective absorption of light, the use of black-and-white films is advantageous.

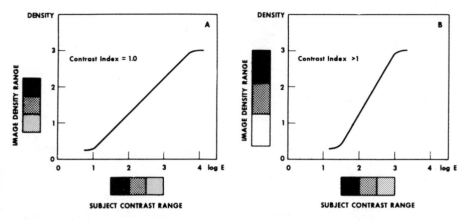

Figure 11. Influence of contrast index on image density range. A: When the contrast index = 1, the image density range is the same as that for the subject. B: When the contrast index is greater than 1, the range of image densities is expanded beyond that present in the subject.

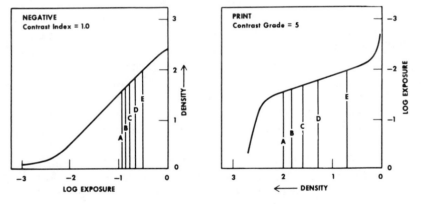

Figure 12. Expanding the range of image densities by printing on high-contrast paper (contrast grade = 5). *(After Mertens 1970.)*

The choice of a film for an underwater photographic requirement will depend on a number of parameters:

1. The information requirement.
2. The light attenuation function for the study area.
3. The intensity of light reaching the film plane.
4. The range of film exposure level oscillations.
5. The color contrast range of the subject.

ENHANCEMENT OF IMAGE
CONTRAST AND RESOLUTION

Although the contrast of a film is largely established during manufacture, some variation can be introduced by altering the degree of development. The contrast index of a film will increase with the time of development, the concentration of the developer, and the reactivity of the developer type (see Figures 13 and 14). The modulation transfer function of a film, and therefore film resolution, is also modified by the degree of development (see Figure 15).

Variations in contrast can also be introduced in the development of some print papers. However, the degree of response to development changes is considerably less with print papers than for most films, and overdevelopment or underdevelopment may cause mottle or stain (Mertens 1970). Therefore, most of the contrast control should be accomplished prior to print development.

Image resolution is reduced by forward scattering of direct light rays from the scene and refractive deterioration. One remedy for this attenuation of subject details is to accentuate or amplify the high spatial frequencies in the image. This may be accomplished by a technique known as diffuse or unsharp masking (see Figure 16).

The diffuse mask technique is accomplished as follows. A low-contrast, slightly out-of-focus copy of the original negative is made on negative film stock. Diffuseness, or unsharpness, can be produced by the rotation method or by using a diffusion sheet when contact printing the mask. The unsharp mask is developed, bound in register with the original, and then printed normally. One drawback to the diffuse mask technique is that it also accentuates the high-frequency noise such as that caused by granularity (Mertens 1970).

Image contrast and resolution can also be improved by using print exposure techniques known as dodging and burning-in (see Figure 17). Dodging prevents full exposure of certain areas of the print where the density of the developed image would otherwise be too high, thereby increasing the detail present in that area. Burning-in, unlike dodging, is accomplished after the basic exposure rather than during it. Resolution is increased by providing additional exposure to areas where the density of the developed image would otherwise be too low.

Electronic exposure control can be accomplished by using an electronic enlarger. A spot of light from a cathode-ray-tube light source is optically projected through the negative to expose the printing medium. This spot scans the negative in the manner of a television image, while a photomultiplier tube monitors the light transmitted through the back of the print during exposure. Depending on the varying densities in the negative, the scanning

Figure 13. Influence of developer activity on contrast index. *(After Mertens 1970.)*

Figure 14. Influence of time of development on contrast index (CI). *(After Mertens 1970.)*

Figure 15. Effect of degree of development on the MTF of Kodak Plus-X film. *(After Scott and Brock 1973.)*

velocity (or intensity) of the spot on the face of the cathode-ray-tube automatically reduces, or increases, to provide the proper incremental exposure control for each small area of the negative. The feed-back of the photomultiplier tube is variable, giving any desired degree of contrast reduction on intensification.

SUMMARY

Image quality in underwater photography is degraded by a number of environmental parameters. Image contrast is reduced by back scatter, forward scatter, refractive deterioration, and selective absorption of light. Illumination levels encountered in underwater photography are typically low due to the attenuation of light. The intensity of light reaching the film plane may fluctuate due to variations in camera/strobe altitude, target reflectivity, and bottom topography. To ameliorate such problems, systems components, film exposure, and the processing of photographic materials can be modified.

Selection of photographic materials for a particular survey may depend

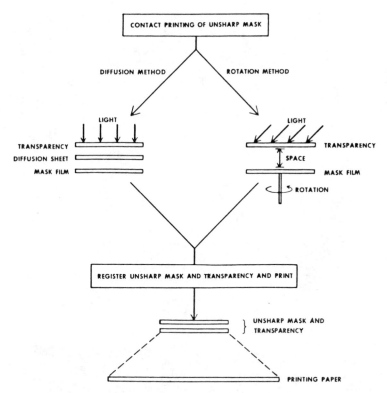

Figure 16. Diffuse mask technique for image enhancement.

on: (1) the information requirement, (2) the light attenuation function for the study area, (3) the expected range of film exposure levels, (4) the relative intensity of light reaching the film plane, and (5) the image color contrast range. Once these criteria have been delineated, the film most suitable for a given environment can be selected. Film choice may be based on such characteristics as speed, exposure latitude, contrast, granularity, resolution, and acutance.

Film exposure is critical to image quality, especially for color films that have typical exposure latitudes of 0.5 f stops or less. Film exposure can be regulated by manipulating the intensity of the light source, distance from the camera or strobe to the bottom, illumination geometry, and lens aperture. The art of correct exposure is to produce the least possible exposure that will show the required amount of detail in the shadow zones of the final product. The exposure level will then lie near the toe of the characteristic (H and D) curve where noise due to granularity is at a minimum.

After the optimum system design, film type, and film exposure level have

Figure 17. Print exposure techniques known as dodging and burning-in can be employed to increase resolution and contrast. Top: Original print. Bottom: Enhanced print.

been determined, further improvement in the quality of underwater photographs can be accomplished through image enhancement techniques. Processing techniques involving changes in the degree of development can be used to boost film speed and contrast. Exposure techniques known as dodging, burning-in, and diffuse mask printing can be employed to increase the contrast and resolution of photographic papers.

REFERENCES

Brock, G. C. 1970. *Image Evaluation for Aerial Photography*. New York: The Focal Press.

Gilbert, G. D. and J. C. Pernicka. 1966. Improvement of underwater visibility by reduction of backscatter with a circular polarization technique: *SPIE Underwater Photo-Optics Seminar Proceedings*.

McCamy, C. S. 1970. The evaluation and manipulation of photographic images: In B. S. Lipkin and A. R. Rosenfeld, ed., *Picture processing and Psychopictorics*, pp. 57-74. New York: Academic Press.

Mertens, L. E. 1970. *In-water photography, Theory and Practice*. New York: Wiley-Interscience.

Scott, F. and G. C. Brock. 1973. Image structure and evaluation. In T. Woodlief, Jr., ed., *SPSE Handbook of Photographic Science and Engineering*, pp. 925-980. New York: Wiley-Interscience.

Trumbull, J. V. A. and K. O. Emery. 1967. Advantages of color photography on the continental shelf. In J. B. Hersey, ed., *Deep-sea Photography*, pp. 141-143. Baltimore: The Johns Hopkins Press.

Weiss, J. P. 1973. Sensitometry. In T. Woodlief, Jr., ed., *SPSE Handbook of Photographic Science and Engineering*, pp. 765-828. New York: Wiley-Interscience.

33

Using Salt Water to Process Color Film at Sea

C. E. Petrone
National Geographic Society
Washington, D.C.

Prior to 1976, to my knowledge, there had been no large-scale processing of reversal color film on board ship. Black and white processing had been done at sea by various government agencies and research institutions very successfully. Our participation in the Caymon Trench expedition of 1977 on which we were to process color film at sea involved entering an area in which we had no previous knowledge or anyone to contact.

Fortunately, our first attempt involved E-4 chemistry which required a temperature of 80°F. This film could also be hand developed on long 100′ Nikkor reels. With back-to-back processing, the through-put time was not prohibitive.

Our equipment consisted of two 100 Nikkor 35-mm tanks, a Nikkor loading frame, and eight S.S. round tanks to fit. Our tanks were 90-mm tanks to allow for less spillage than when using conventional 35-mm depth tanks aboard ship. Accidents still occurred, dumping chemicals onto unsuspecting technicians in the dark. No contamination occurred because of the placement of the soup line fore and aft and as near amidships as we could plan it. A stainless steel Nikkor washer was tried and was found to be too slow, so a home-made PVC tank, top filling, was used in the sink. A Smith roll, hot-air dryer rounded out our 100′ capabilities.

Our apparatus for processing short lengths was a little simpler. After the 100′ processing in round tanks, we turned the solutions into red Cescoa

3½-gallon tanks with nonfloating light-tight lids. A Leedal open stainless steel rack, holding nine Nikkor "exploded" reels, was used to transport the film from tank to tank.

A drying cabinet roughly three feet square was built in one corner of the portable deck van housing our equipment. A small fan at the bottom exhausted the air from the dryer, while adequate vents at the top insured warmer air flowing through a cut-down furnace filter to pass through. The only real problem was figuring how to hold the films semi-rigid so they would not hit each other. This was solved by using conventional film clips with teeth on the top of the strip and toothed clips with rubber bands on the bottom. It worked very well.

Dirt, needless to say, was always a problem. It was necessary to filter chemicals when mixing them, and to change air conditioning filters, rolls, and Smith dryer filters frequently. Our fresh water supply was frequently dirty and required filtering through a towel and cotton. Temperature control was not by the book, but was effective nevertheless. We found out that the PVC tanks that WHOI fabricated in their shops for the expedition held their temperature longer than stainless steel, and therefore were more stable in use. Unfortunately, they break if they are dropped on a pitching deck.

We made a solution heater out of an electric stove heating element to "hot stick" solutions.

When we got the first solution up to temperature, we would then go dark and run with preloaded reels, taken from light-tight containers. After coming light in the hardener, we would "hot stick" on up the line while the film was washing in the first wash. If pressed for time, we could then start another run, back-to-back with the first one, with someone to watch the second half of the first run — if we were lucky enough to get a second body. It could get a little ticklish around the washes, but we survived.

For drying the 100′ or longer rolls, we had the excellent Smith dryer, which I heartily recommend for any hand-processed long runs.

After processing at sea proved itself, in 1979 we went on another expedition. This time E-4 chemistry was being phased out and E-6 was coming in. E-6 requires a temperature of 100.4°F and hand processing is very difficult to do.

WHOI at this time purchased a Kreonite CM-35 and a new fiberglass van to house it. The Kreonite was basically the choice of John Porteous at WHOI. I concurred, as it was my second choice. Time proved John's excellent decision. The machine is simple enough to work on, and sophisticated enough to produce good results. Also, the tanks are recessed enough to allow for almost 30° of ship list without self-contamination of the chemicals.

Consultations with Kodak confirmed a Porteous publication concerning the U.S. Navy's use of salt water for washing the film.

The only alteration we made to the van was to install bypass valves in

the hot water heater (built into the van), allowing water, hot or cold, salt or fresh, to flow into mixing tanks and wash compartments in the CM-35. A daily fresh-water rinse and hose-down of the machine became a must for machine longevity. Most of the parts are PVC, so salt really didn't do any damage except that occasional splatters would affect stainless screws and plates.

Twice the replenishment rate of the stabilizer was necessary to process in salt water. This was Kodak's recomendation and it worked well.

Step wedge control is of vital importance in this or any other machine processing. Our results were gratifying. If we did things correctly, the machine also did well. A change of machine speed would be necessary occasionally to correct a film speed shift, and over or under replenishment to correct color shift also was needed.

Cleanliness was a prime factor in producing good transparencies. Daily, and occasionally twice daily, vacuuming was necessary to eliminate dirt spots on transparencies. On the Galapagos II expedition we processed 93,500 transparencies of original film and 1,500 duplicates, exposed and developed and mounted. No gimmicks-all photoscience, and cooperative scientists, crew members, and technicians.

Section IX

ABSTRACTS ONLY

A Different View of the Seafloor: Low-Angle Oblique Photography From a Towed Sled (Troika)

James E. Andrews

Oceanography Department
University of Hawaii at Manoa
Manoa, Hawaii

Since 1975 the University of Hawaii has been using a towed sled of the Troika design for bottom photography. This tool provides a unique and useful view of the seafloor, with data available that is not seen with vertical angle photography. Animal morphology, mound building and displacement of sediment and manganese nodules, relationships between nodules and the sediment/water interface, and the effects of current scour are all more clearly established with low-angle observations. Of particular interest are the observations of the collapse of sediment clouds stirred up by the cable or the sled. Very rapid collapse is followed by the horizontal dispersal of a thin (1-10 cm) layer of suspended sediment. Relatively little mixing is seen, although the character of the surfaces varies with sediment type. Manganese nodules show the effects of such local sediment redistribution processes, and are often observed to be sitting on—rather than in—the sediment surface while having a light coating of sediment on their upper surfaces from recent settling. Linear arrays of nodules are a result of displacement by burrowing organisms in the process of mound or trail building. None of these features viewed from directly above gives any indication of its origin, and oblique photos would seem to be a prerequisite for any detailed seafloor studies.

Long-Term Observations of the Deep-Sea Floor Using Time-Lapse Photography

Lawrence Sullivan

Lamont-Doherty Geological Observatory
Columbia University
Palisades, New York

Beginning in 1975, as part of the I.D.O.E. Ferromanganese Nodule Project in the north Pacific, a time-lapse camera system was designed and built at Lamont-Doherty Geological Observatory by E. M. Thorndike. This instrument was used successfully in the Pacific, producing a total of 22 months of time-lapse photographs. The system was modified and used from a different platform in 1978 and again in 1979 at two locations in the north Atlantic.

Results of the 28 months of time-lapse photographic record have been studied using several analytical techniques. These results show evidence of more rapid benthic biological processes as well as more changes in sediment microtopography than had been previously assumed. These photographic data sets clearly show the value of this camera technique as a valuable tool for the marine sciences.

REFERENCE

Paul, A. Z., E. M. Thorndike, L. G. Sullivan, B. C. Heezen, and R. D. Gerard. 1978. Observations of the deep sea floor from 202 days of time-lapse photography. *Nature* 272 (5656): 812-814.

Photogrammetry and HEBBLE (High-Energy Benthic Boundary Layer Experiment)

Charles D. Hollister

Woods Hole Oceanographic Institution
Woods Hole, Massachusetts

Digitized photogrammetric data from stereo photographs of current-produced abyssal bedforms should distinguish whether erosion or deposition is responsible for their morphology. These photographs will be taken in an event-triggered mode from a stable platform before and after the "event," which will be identified by subjacent current meters, stress sensors, or transmissometers.

Data obtained from the HEBBLE area, about 400 miles east of Woods Hole, suggest that:

1. Benthic storms are responsible for present-day resuspension of vast amounts of fine grained sediment. These storms also produce symmetric, longitudinal triangular "ripple" marks in silty clay at depths of 1800-5000 meters along the continental margin.
2. The amount of resuspension is directly related in time and space to measured current velocity or bottom shear stress.
3. Photogrammetry done in the HEBBLE area indicates that precision contouring of seafloor morphology at the 100-micrometer scale is possible and that very subtle changes in bed shape can be quantified in abyssal depths.

Long-term Observations of Bottom Conditions and Sediment Movement on the Atlantic Continental Shelf: Time-lapse Photography from Instrumented Tripods

Bradford Butman, Cynthia G. Bryden,
Stephanie L. Pfirman,
William J. Strahle, and
Marlene A. Noble
U.S. Geological Survey
Woods Hole, Massachusetts

An instrument system that measures bottom current, temperature, light transmission, and pressure, and that photographs the bottom at 2- to 6-hour intervals has been developed to study sediment transport on the Atlantic Continental Shelf. Instruments have been deployed extensively along the United States East Coast Continental Shelf for periods of from 2 to 6 months to study the frequency, direction, and rate of bottom sediment movement, and the processes causing movement. Several modifications and improvements of commercially-available camera systems were made for the long-term deployment; for example, case and penetrator cathodic protection, lens antifouling protection, low-power and conditional trigger circuitry, long-term power supply, color reference, and thin base film.

The time-lapse photographs are used to (1) characterize the bottom benthic community and surface microtopography; (2) monitor changes in the bottom topography and near-bottom water column caused by currents and storms (for example, ripple generation and migration, sediment resuspension); and (3) monitor seasonal changes in the bottom benthic community and

qualitative effects of this community on the bottom sediments. The photographic data have been especially useful in providing information on the importance of the benthic population to sediment movement, particularly in armoring the surface sediments against scour. The photographs also have been invaluable in documenting the extent and nature of sediment movement and in supplementing the physical data to determine the major processes of sediment movement and the variability of movement with the seasons.

ACKNOWLEDGMENT

Work supported by the U.S. Geological Survey and the Bureau of Land Management (MOU AA550-MU6-29, AA551-MU8-24, AA551-MU9-4, and AA551-MUO-18).

1500 Watt/Second Flash for Towed Survey Operation

Gary Hayward

Benthos, Inc.
North Falmouth,
Massachusetts

Attempts to obtain ever wider underwater photographic search coverage by means of wider lens angles are fast approaching the point of diminishing returns. This is because the necessary placement of available underwater light sources (typically 200 to 400 watt/seconds) sufficiently near the bottom to illuminate the area to be photographed leads to a tremendous nonuniformity of illumination between the center and edge of each photographic frame. To overcome this limitation, a 1500 watt/second flash unit having the electronics enclosed in a 17″ glass sphere has been developed by Benthos, Inc. This unit, in combination with high-speed color film, permits photos covering approximately 1/3 acre to be taken at a repetition rate of 15 seconds from a typical altitude of 15 meters (45 feet). Figures 1 and 2 show the construction of this Model 387 Survey Flash. Figure 3 is a photograph taken with the system.

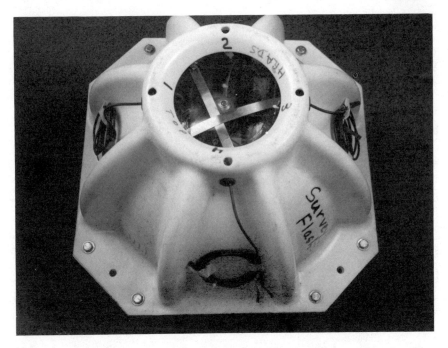

Figure 1. Model 387 Survey Flash, electronics enclosed in protective hard hat.

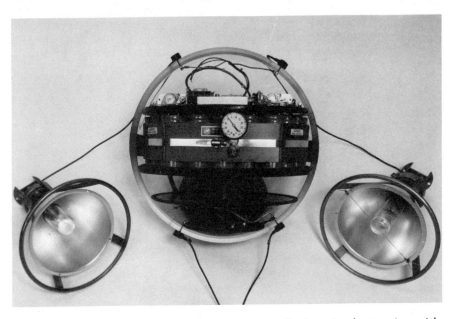

Figure 2. Cutaway view of 1500 watt/second flash unit electronics with dual flash heads.

Figure 3. Reproduction of a large-area bottom photograph (original in color) of a lava lake taken near the Galapagos Rift using Survey Flash (from *Journal of the National Geographic Society,* Volume 156 No. 5, Nov. 1979, pages 701–702).

An Illustration of the Value of High-Altitude, Large-Area Bottom Photographs

William Marquet
*Woods Hole Oceanographic
Institution
Woods Hole,
Massachusetts*

Using a photo of the Galapagos bottom structures taken by the WHOI ANGUS system, equipped with a camera having a 16-mm lens and flying at an altitude of 11 meters, various simulations were devised to show what would have been obtained by other lenses and other operating heights over the bottom.

These simulations were designed to illustrate some standard situations or common operating conditions. To get the effects, masks were cut to overlay on the original slide. To make the simulation more realistic, Frank Schlegel, of the Benthos photography department, rephotographed the projections of these portions of the original slide, so that we now have 35-mm slides of each of the appropriate segments. This technique of course reduces the image sharpness and causes a color shift, but the significant point is quite clear.

The sampling theorem is important to the design of physical oceanographic recording instruments: if the theorem isn't understood, improper samples are taken and aliasing of the data occurs. Here also mistaken identity can occur, or identification may result from an inadequate sample.

The smallest rectangle in the accompanying photograph (Figure 1) shows what a camera 5 meters off the bottom would get with a standard Benthos lens (Nikon U.W., 28 mm). The photo covers a width of 43/4 m and the area recorded is 15 m². This coverage is typical of many current

Figure 1.

systems. The middle rectangle in the photograph is of the same conditions but now the camera is 7 m off the bottom. The photo coverage width is now 6½ m and the area is 29 m². The largest rectangle on the photograph shows what happens if the ANGUS 16-mm lens is used at the height of 7 m. The width of the photo increases to 13½ m and the area to 120 m² (Olympus 16 mm).

Note that while true color information falls off fairly quickly after 7 m, the value of color photography is still significant. Of course, the color in the simulations is further degraded by the rephotographing method.

The entire photograph in Figure 1 is the actual bottom photograph taken by the ANGUS system with a 16-mm lens at 11 m altitude. The width is 21 m and the area 300 m². And, what is important and illustrates the point of this note, the information content is vastly greater than that of any of the smaller segments.

ANGUS has been used to an altitude of 18 m off the bottom giving an area coverage of 810 m² and a photo width of 35 meters. Tests in the Benthos pool show that there is some slight barrel distortion at the edges with the 16-mm lens but that this is quite acceptable given the tremendous improvement in information gained using this high-altitude wide-angle lens technique.

Mostly Submarine Canyon Crustacean Studies

Richard Cooper

*National Marine
Fisheries Service
Laboratory
Woods Hole,
Massachusetts*

The Manned Undersea Research and Technology dive team at the National Marine Fisheries Service Laboratory, Woods Hole, has conducted a variety of marine biological field projects using various underwater photographic equipment and techniques. This report presents methods and results of some of our work, in particular the community structure, behavior, and ecology of crustacean populations in the offshore canyons.

We also discuss joint biological and geological submersible surveys of offshore canyons to depths of 2000 meters using both hand-held and externally-mounted cameras to record a permanent record of the biota for later study and analysis. We also present information from the qualitative and quantitative photographs taken by SCUBA divers on Jefferies Ledge, Gulf to Maine, for base-line population densities of marine benthic organisms to be used to monitor changes in population structure of selected species at this site.

Know Your Chrome

Sheldon Phillips
Eastman Kodak
Company
Rochester, New York

The majority of the photographic material exposed underwater is of the color reversal or transparency type. In this report, the sometimes subtle differences among various Kodachrome and Ektachrome products was discussed, including the difference between amateur consumer color films and professional film products. Keeping characteristics were described along with color balance, effective film speed, reciprocity characteristics, and processing. Since image contrast is a major consideration in underwater photography, illustrations were given on how a photographer can enhance contrast by adjustments in processing. The presentation was illustrated with examples shot in the studio and representative photos taken underwater.